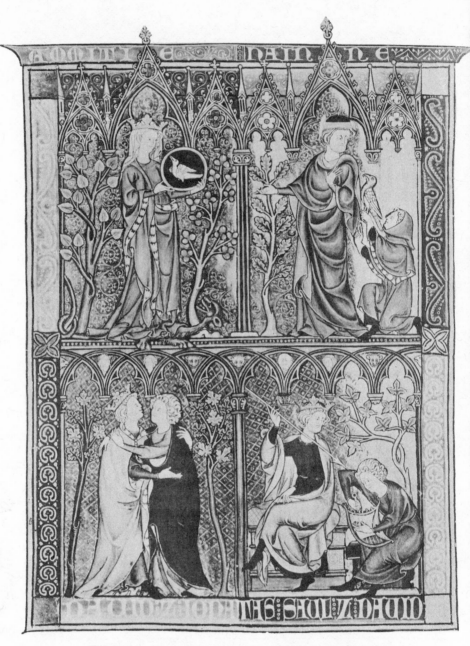

Friendship, Hatred; David and Jonathan, Saul and David
La Somme le Roy; London, Brit. Mus., Add. MS 28162, fol. 6v

SPACE IN MEDIEVAL PAINTING AND THE FORERUNNERS OF PERSPECTIVE

MIRIAM SCHILD BUNIM

AMS PRESS, INC.
NEW YORK

Reprinted from the edition of 1940, New York
First AMS EDITION published 1970
Manufactured in the United States of America

International Standard Book Number: 0-404-01229-9

Library of Congress Catalog Card Number: 70-121231

AMS PRESS, INC.
NEW YORK, N.Y. 10003

To
The Memory of
My Beloved Father

PREFACE

HE STUDY of space and its corollary, perspective, has been a fertile field of research in the past fifty years. Most of the investigation, however, has been limited to ancient art and the Renaissance. The studies of space in the painting of the Middle Ages that have appeared are devoted generally to an individual work or to a group of related manuscripts. My purpose is to present the development of space in the medieval period as a whole. I have endeavored to determine the characteristic forms evolved through successive modification and to show the broad geographic distinctions in type as well as their relationships.

Influences formative of the type of space of a given period are necessarily present in the characteristics of the preceding style, but the factors that are active on the whole in determining spatial form are numerous and involve consideration of function, technique, iconography, and cultural background. The scope of this book, however, did not permit an exhaustive analysis of the relationship of these factors to the development of spatial principles.

A study of space in medieval painting in which the purpose is to obtain a composite picture, so to speak, of characteristic forms, depends to a great extent on the quantity of illustrative material, for only by analyzing a great many paintings of a given period can one determine the general principles underlying the type as a whole. I have consulted many sources, but it would be presumptuous to assume that my references approach a complete review of the painting of the Middle Ages. The problem of illustrative material is complicated further by the indefinite chronology of the painting of this era and by the consequent controversial issues. The principles governing the spatial form of a period and the stages in the development of that form must be determined, as far as possible, by the dated works before the criteria thus obtained can be used in studying chronological problems or questions of

attribution. This consideration limits the source material for the initial inves-
tigation. I hope that despite these limitations, the information gained may be
helpful in solving individual problems and may throw some light on the
general character and development of medieval art.

The references to books and periodicals in the footnotes are in many
instances given in a shortened form. These titles are presented in full in the
appended bibliographical list.

The study of the material incorporated in this book would have been
impossible without library facilities. I wish to express my gratitude to the
Fine Arts Library and the Avery Library of Columbia University, the Pier-
pont Morgan Library, the Frick Art Reference Library, the New York
City Public Library, the British Museum, and the Bibliothèque Nationale
for their cooperation in according me the use of their manuscripts and
reference books.

I wish to thank the directors of the Institute of International Education
for granting me two successive summer scholarships to the Institut d'Art et
d'Archéologie of the University of Paris, which gave me the opportunity,
so essential for this work, of pursuing my studies abroad. I also wish to
acknowledge my indebtedness to the University Council of Columbia Uni-
versity for the fellowship that permitted me to devote my time exclusively to
the preparation of the manuscript.

It has been my good fortune to have had the privilege of turning to a
number of scholars for counsel during the preparation of this work. I wish
to thank Professor William Bell Dinsmoor, Executive Officer of the De-
partment of Fine Arts and Archaeology, Professor Emerson H. Swift,
Professor Millard Meiss, and Professor Margarete Bieber, of Columbia
University, for their many valuable suggestions and helpful criticisms.
To Professor Erwin Panofsky, of the Institute for Advanced Study, whose
publications on the subject of perspective are among the most important
sources in the literature for this study, I wish to express my deep apprecia-
tion for his kind encouragement and interest. To Professor Meyer Schapiro,
of Columbia University, I am greatly indebted for the suggestion of the
subject and for his thoughtful supervision of my work. His generous ad-
vice, stimulating ideas, and scholarly guidance have been of inestimable
aid to me in the preparation of this book.

Lastly, I wish to acknowledge my gratitude to the Committee on Re-

search and Publication in Fine Arts of the American Council of Learned Societies for the grant which helped to make this publication possible.

For permission to reproduce the paintings, which was so readily granted me, I wish to thank Dom Anselmo M. Albareda, Prefect of the Biblioteca Apostolica Vaticana (Figure 9); His Grace, the Duke of Devonshire (Figures 23, 24); Miss Belle da Costa Greene, Director of the Pierpont Morgan Library (Figures 20, 21, 22, 33, 47, 48, 73); Monsieur le comte A. de Laborde, Secretary-Treasurer of the Société Française des Reproduc-tions de Manuscrits à Peintures (Figure 65); Mr. Eric G. Millar, Deputy Keeper of the Department of Manuscripts, the British Museum, acting for the Roxburghe Club (Figures 23, 24); Dr. Gisela M. A. Richter, Curator of the Department of Greek and Roman Art, the Metropolitan Museum of Art (Figure 7); Mr. H. S. Kingsford, Assistant-Secretary, and the Com-mittee of the Society of Antiquaries of London (Figures 67, 68, 69, 70); the Trustees of the British Museum (Frontispiece, Figures 2, 3, 15, 17, 26, 34, 35, 37, 38, 44, 45, 61, 62, 66, 71, 72); the Director of the Fitzwilliam Museum (Figure 43); the Société des Amis de la Bibliothèque Nationale (Figure 16); Fratelli Alinari (Figures 5, 6, 8, 10, 11, 13, 14, 49, 51, 52, 54, 55, 56, 57, 58, 59, 77, 78); Les Archives Photographiques d'Art et d'His-toire (Figures 18, 25, 30, 31, 39, 42, 63, 76); the Julius Bard Verlag für Literatur und Kunst (Figure 46); Fratelli Bocca (Figure 27); the Karl Robert Langwiesche-Verlag der Blauen Bücher (Figures 19, 28, 29); the Nouvelle Société d'Editions, Société Anonyme, formerly Editions G. van Oest (Figure 50); and the Propyläen-Verlag (Figure 4).

M. S. B.

New York
October 15, 1940

CONTENTS

ILLUSTRATIONS

SPACE IN MEDIEVAL PAINTING AND THE FORERUNNERS OF PERSPECTIVE····

CHAPTER I

INTRODUCTION

FOR A LONG TIME it was thought that one of the essential functions of painting was the imitation of nature. The artist, by means of a mathematical system of perspective, was expected to give a convincing illusion of a tridimensional scene on his two-dimensional canvas. The painting of the periods in which such a form was not achieved was regarded either as preparatory or as defective. In more recent movements in art, however, this photographic function of painting has, in varying degrees, been disregarded, and, as a consequence, a similar disregard in certain periods of the past is no longer considered the result of ignorance or incapacity. This painting, in which the reproduction of a naturalistic image plays so little part, reveals rather the means of representation to produce an art that is symbolically adequate.

In experience space is perceived through a number of factors, such as overlapping, gradation of light and color, convergence of lines in depth, and the axial relationship of planes. A simple form of at least one of these factors may be observed in the painting of most periods. Both terms—"space" and "perspective"—have, however, acquired specific reference to the type of naturalistic representation in which the sky, the ground, the objects, and the figures are organized from a single point of view. The size and shape of these elements are governed by the distance from that point of view which theoretically corresponds to the eye of the spectator. In other words, we have a photographic experience of a particular scene. Thus space can be understood as a tridimensional extension, and perspective as the geometrical, central, or focused system of representing space. With this definition in mind we should have to characterize practically all the painting before the Renais-

sance as having no space and no perspective. Yet even in those paintings which do not show an approximation or a tendency toward this "space" and "perspective"—for example, in Egyptian and medieval art—there is some quality and organization of the pictorial elements which would be neglected by such an arbitrary negative characterization. Therefore it is necessary to revise the limited concept of space and perspective and to pro' vide qualifying terms which not merely will give us the positive and negative possibilities but also will express differences in kind and degree.

The character of space in a painting depends on two factors: the surface or picture plane, and the figures and objects represented. The picture plane is first of all a material surface. This may be used as it is found—that is, rough, as in palaeolithic art—or it may be prepared into a pictorial surface, smoothed, constructed, or manufactured, as it generally was in subsequent periods of art history. Furthermore, the pictorial surface may be left as it is—as an uncolored and unframed ground or background—in which case it may be called an untreated surface, or it may be colored or framed, where' upon it becomes a treated or a positive pictorial surface. Since the latter classification is general and may include any kind of picture plane that is colored in any way, it is advisable to make some distinction between a surface that is painted in a uniform color, such as yellow or green, and one that is gold or else divided into bands or panels of different colors. In the first type, in which the color chosen does not seem to have any interpretative significance, the picture plane may be designated as a neutral surface. In the second type, however, the color in some instances bears symbolic connotations, and in others it suggests a specific object, field, or substance. Therefore this picture plane may be described as an active pic' torial surface.

Up to this point the classifications have been concerned with the pic' ture plane as a surface only: the material surface and its preparation and the pictorial surface which involves the question of frame and color, that is, whether the surface is untreated or treated (positive) and furthermore whether the treated surface is neutral or active.[1] There are, however, fur' ther considerations. Although the picture plane as a material surface is

[1] The paintings in which the picture plane is treated as a surface would fall into the category of "no space" if one accepted without modification the general application of the word "space" as described on p. 3.

constant, it is not always present as a pictorial surface. It is very often penetrated by the imitation of the third dimension. Then, instead of a pictorial surface it becomes a pictorial space. The tridimensional picture space may be representative, that is, realistic, or it may be nonrepresenta' tive. Representative space is characterized by a picture plane that has as' sumed the appearance of visual depth, with ground, mountains, and sky, or floor, walls, and ceiling, obliterating any trace of the picture plane as the two-dimensional area which it actually is. But the third dimension may be depicted in a painting which is not particularized in this sense, as, for example, a stage without its scenery or with a setting unrelated to environment (a platform and a neutral backdrop). Here the third dimen' sion is introduced into a nonrepresentative form by the expedient of two planes at right angles to each other.

There are, therefore, a number of ways of characterizing a picture plane in general. More distinctive descriptive terms may be suggested by particular types of background which appear in the history of painting. In this way the necessity of referring to a work as having "no space," which has a derogatory implication, is overcome.

The description of the picture plane is, however, only part of the char' acterization of space in a painting. It was mentioned above that the repre' sentation of figures and objects is an important factor in spatial form. The organization of these elements on the picture plane involves spatial relations as much as does the character of the picture plane as a background. There are two major classifications for the representation of figures and objects: conceptual and optical. As has often been pointed out, the distinction be' tween the two terms is bound up with the conflict that exists between the real and the apparent in vision. We know that the top of a box is a rectangle, yet it appears in our retinal image most often as an irregular quadrilateral. The top of a jar is a circle, yet only if our eyes are directly above it do we see it as such. Distinguishing roughly between the two terms, "conceptual" representation emphasizes the generalized tactile or "real" form of an object; "optical," its apparent or visual form. This distinction, however, does not explain the difference fully. "Conceptual" representation in particular has a wider application. It may be extended to cover situations in which not only is the tactile form of the object a determining factor, but where other considerations, such as meaning and content, also have a significant influ'

ence on the size and position of the represented object or figure. Further-
more, in both conceptual and optical representation, what is true of indi-
vidual objects and figures is also true of the composition of a scene. The
conceptual relates things with reference to their tactile form and their mean-
ing. Optical representation limits itself to visual relationships in which the
retinal image is, roughly speaking, the primary determining factor of the
composition.

Despite the great variety possible in the manner of representation under
the general classifications of conceptual and optical, a few typical methods
have been recognized in the application of both systems. In conceptual rep-
resentation two methods called vertical and inverted perspective are gen-
erally mentioned, while in optical representation the principal reference is
to a vanishing point, or focused system of perspective. From this terminology
it is clear that perspective is related to space insofar as it is a method of
organizing the representation of figures and objects. To speak more accu-
rately, however, the word "perspective" is etymologically limited to optics
and represents a mathematical system of delineation concerned only with
the appearance of objects to the eye. It is misleading, therefore, to use per-
spective or perspective terminology, which has an optical and mathematical
significance, for conceptual representation. Moreover, the terms "vertical
perspective" and "inverted perspective" are themselves inadequate descrip-
tions of the types of organization to which they are applied. Therefore, in
order to describe these forms of conceptual representation, it is advisable to
select terms which do not suggest optical methods and which eliminate the
word "perspective."

In order to obtain concise yet descriptive phrases to designate conceptual
representation as it appears, for example, in Egyptian painting, it is neces-
sary to proceed from a general definition of the form. In Egyptian painting
the conceptually or the optically prominent elements of objects and figures
(whether these elements are vertical or horizontal) are drawn parallel to
the picture plane without foreshortening and not necessarily perpendicular
to a base line.[2] From this description the phrase "parallel-plane representa-

[2] Both Loewy and Lange describe the laws of representation in ancient art. Lange, "Gesetze
der Menschendarstellung in der primitiven Kunst," Darstellung des Menschen in der älteren
griechen Kunst, p. xxi. Loewy, Rendering of Nature in Early Greek Art, pp. 5-6. They describe
this form, however, as the representation of the figure or parts of the figure from the broadest
dimension (Lange) or aspect (Loewy). The phrase "broadest dimension or aspect" is not accurate.

tion" may be derived. In this type of representation the composition of the parts of the individual figure appears inconsistent from the point of view of the immobile spectator. It also applies to objects and groups of objects in which ground plans are combined with elevation silhouettes and to the com-position of the whole scene with no overlapping planes, that is, things that are behind an object or a figure are placed above or at one side.[3]

The particular kind of organization in which the size of the figures ap-pears to be determined by rank, either divine or secular, may be classed with the type of conceptual representation described above, inasmuch as it stresses the prominent factor—in this case the social or religious position of the figure. But since the expression of rank by size may also appear in paint-ing in conjunction with optical methods of representation, it should be rec-ognized as a distinct form, which is basically an affective means of determin-ing the proportions of the figures and which, when applied to size, may simply be called hierarchic scaling rather than by the usual term "inverted perspective." The term "inverted perspective" has been applied to composi-tions in which the figures are smaller the nearer they are to the spectator rather than larger as in normal perspective vision. There is no adequate reason to assume that in these instances the form is determined by an inver-sion of an optical system, as does Wulff. Wulff is of the opinion that the artists, guided by a principle of empathy, drew from the point of view of the most important person in the scene, who thereby became the largest figure, and that all other figures diminish in size in proportion to their dis-tance from him.[4] The smallest figures in this type of composition are not

For a criticism of this terminology see Schapiro, *The Arts*, VIII (1925), 170-72, and Schäfer, *Von ägyptischer Kunst*, p. 103. "Prominent elements" would be a more correct description.

[3] Parallel-plane representation is suggested as a substitute for vertical perspective, in which relative depth is indicated by placing the figures and objects above or beside one another, and also for perspective projection, which is used for a combination of ground and elevation plans. Cf. Panofsky, "Die Perspektive als 'Symbolische Form,' " in *Vorträge Bibl. Warburg*, 1924-25, p. 305, note 24. Schäfer (*Von ägyptischer Kunst*, pp. 88-99) criticizes the use of perspective terminology and employs the phrase *geradansichtig Vorstellung*.

[4] "Die umgekehrte Perspektive," in *Festschrift Schmarsow*. Wulff's explanation presupposes knowledge of optical perspective, which assuredly Egyptian artists did not have, although a simple form of hierarchic scaling occurs in Egyptian art. Wulff, however, does not include the pre-Greek and "primitive" arts in the application of his system. Nevertheless, the reference to social or religious position from an affective standpoint seems to be a more acceptable reason for the dis-tinction in size than Wulff's explanation, since it is a much simpler concept and since it holds true for all situations in which the distinction appears. For a critical discussion of Wulff's article see Doehlemann's review, *Repertorium für Kunstwissenschaft*, XXXIII (1910), 85-87.

invariably closest to the spectator. All the figures, though differing in size, may stand on the same line. For these reasons it is more accurate to avoid the suggestion of a perspective system and to call this type of representation "hierarchic scaling."

These forms of conceptual representation—parallel-plane representation and hierarchic scaling—exemplify only two general distinctions obtained from studies of early periods in the history of painting. Numerous varia-tions in the representation of figures and objects and in their relations to each other are possible when the optical point of view is subordinated. If one recalls that in contemporary art many features of optical organization are disregarded, it is easy to realize the extremely different forms of ex-pression that can be achieved in conceptual painting.

In optical representation, which may be defined in general as the repre-sentation of figures and objects as they appear to the eye, allowing for the disappearance of planes and changes in their size and shape by foreshorten-ing, various methods other than the mathematical focused system of per-spective can be distinguished in the history of painting. Kallab[5] describes a terraced form in which depth is suggested by the vertical alignment of figures and objects, those in front freely overlapping the ones behind. The result is the sort of bird's-eye view with which we are most familiar in Persian and Chinese landscapes, although it is also found in occidental painting. An-other method, which has more organization of the planes of the objects, though not according to a measurable mathematical system, may be called "axial perspective." According to this method, explained by Panofsky[6] in relation to classic and fourteenth-century painting, the orthogonals, or lines in depth, converge in more or less symmetrical pairs toward an imaginary central vertical line, called the "vanishing axis."

Still another form of nonmathematical but optical perspective that should be mentioned is the vanishing-area type of composition. This, like the terraced form, is a free rather than systematic method that derives its name from the fact that the lines in depth converge toward a general area somewhat circumscribed in extent. Finally, the optical system of representa-tion from which the word "perspective" has obtained its current definition

[5] "Die toskanischen Landschaftsmalerei," *Jahrbuch des oesterreichischen Kaiserhauses*, XXI (1901), 4.
[6] *Vorträge Bibl. Warburg*, 1924-25, pp. 266 ff., 277.

is the focused system of perspective.[7] The focused system of perspective is based on two important factors: first, that parallel lines which recede from the eye of the spectator converge to a single point, a vanishing point, and, secondly, that the size of an object or a figure diminishes in proportion to its distance from the spectator. The construction of a scene by this method, proceeding according to geometric principles, results in a composition in which the size and shape of the figures and objects represented are mathe-matically determined in relation to a fixed point of view which corresponds to the eye of the spectator.

Under the general classification "focused perspective" one should men-tion two methods, or systems, which are governed by the same general geometric principles but distinguished from each other primarily by the number of vanishing points employed in the construction of the repre-sented object and by the position of these vanishing points in relation to the point of sight which corresponds to the station point representing the eye of the spectator. "Parallel perspective," as the simpler of the systems is called, applies to the representation of an object whose front plane is parallel to the picture plane (Fig. 1a). The receding horizontal parallel lines of the sides of the object which are perpendicular to the picture plane converge to a single vanishing point that coincides with the point of sight. The second method is called "angular perspective" and is concerned with the object that is placed at an angle to the picture plane. Here the adjacent sides form two systems of parallel lines, each of which has a vanishing point (Fig. 1b). These vanishing points are situated on the same level, but on each side of the point of sight.

In both methods described the vanishing points are related to the receding horizontal lines. The vertical lines which are parallel to the picture plane do not converge. When a plane of the represented object is inclined at an angle to the picture plane, that is, when the plane is oblique, as in a pitch roof, another system of parallel lines is introduced which occa-sions an additional vanishing point. This point lies above or below the point of sight, but on a vertical which passes through the vanishing point of the horizontal projection.

[7] The practical application of the focused system of perspective is explained in a number of books designed to instruct students of painting and architecture in the practice of perspective. For reference: Helmholtz and Brücke, *Principes scientifiques des beaux-arts;* Wolff, *Mathematik und Malerei;* Lubschez, *Perspective: an Elementary Textbook.*

The focused system of perspective was for a long time accepted as the most accurate means of obtaining an immediate and orderly impression of the third dimension on the two-dimensional picture plane, although it was recognized early in the Renaissance, during the development of the method, that distortions would arise from choosing an eccentric point of view or a distance too close to the image.[8] More recently, however, the focused system of perspective has been criticized as not conforming in certain aspects with the psychology and physiology of vision. The principal argument advanced by Helmholtz and also by Hauck[9] is that the spectator sees with two moving eyes, the focus constantly shifting from point to point, rather than with one fixed eye, a retinal camera, as implied by the focused system of perspective. Hauck also points out that the retina which receives the image is a curved surface rather than a plane and, furthermore, that curvilinear modifications which result from the tendency of the eyes to see straight lines as curved are not provided for in the system.[10] He proposes another method of construction, which by geometric projection similar to the procedure in cartography takes into account the curvature of the retina and the psychological curvatures that appear in place of straight lines.[11] The method is more complex than the focused system of perspective and has not been adopted by artists, although, as Hauck observes,[12] in order to avoid an effect which is too mechanical and stiff the laws of focused perspective are not always strictly followed. In fact, it is recognized today that the application of the rules of perspective may be approximate rather than scientifically accurate.

This brief discussion of focused perspective concludes the review of the various methods of representation. The purpose of these introductory pages is to present the terminology which will be used in the study that follows and to clarify the concept of space in a painting by examining the character of the space as it is determined by the picture plane and the representation of the figures and objects. It was found that the picture plane may be retained as a surface or transformed into a tridimensional space. As a pictorial surface it is either untreated (unframed and uncolored) or treated (framed or colored). Further, the treated or positive pictorial surface may be active,

[8] Panofsky, *Vorträge Bibl. Warburg*, 1924-25, p. 293, note 8. Leonardo da Vinci in particular commented upon this fact.
[9] Helmholtz and Brücke, *Principes scientifiques*, pp. 53-54, 173-74; Hauck, *Die subjektive Perspektive*, p. 7.
[10] *Ibid.*, pp. 26, 32. [11] *Ibid.*, pp. 44 ff. [12] *Ibid.*, p. 61.

in which case it has a symbolic or substantial value, or it may be neutral. The tridimensional picture space, on the other hand, is either representative or nonrepresentative. For the representation of figures and objects there are the two general classifications "conceptual" and "optical." The form of the individual object and its relation to the rest of the scene in a conceptual composition is not governed by as definite rules as in optical representation, but certain tendencies can be distinguished as typical of a given period. What we have called parallel-plane representation is one of these. Hierarchic scaling, the other method of conceptual organization which was described, is also a general term, the specific details of its application varying from period to period. In optical representation, the terraced, vanishing-axis, and vanishing-area forms are less systematized than is the focused method of perspective, which if used accurately, is a geometrical means of constructing a scene.

It should be noted that the composition of a scene is not necessarily restricted to a single method of representation and that a particular method need not entail only one type of picture plane. Combinations of parallel-plane representation and optical methods are possible. Foreshortened figures may appear against a neutral background, and a representative tridimensional picture plane may contain hierarchically graded figures. The distinction between conceptual and optical representation is relative rather than absolute, for in the wide range of forms from a diagrammatic to a photographic image, instances occur in which the conceptual and optical methods overlap. In the history of painting, while the focused system of perspective was being developed until it was permitted to govern the form of the entire scene, the more obvious conceptual elements were gradually discarded in favor of a more unified organization from an optical point of view. In the period before this principle of systematic and unified organization became effective, the mingling of conceptual and optical forms may be observed. It is the painting of this period, the Middle Ages, which forms the core of the present study.

CHAPTER II

ANCIENT PAINTING

A SHORT description of the history of the representation of space in ancient painting is desirable as an orientation to the medieval period. Medieval art, despite its individual character and stylistic unity, may be seen as transitional between the Roman period and the Renaissance with regard to the evolution of space. In order to understand this transitional character better, and also the nature of the principles of medieval space itself, one should review the earlier as well as the later forms. In this description of the early history of space the purpose is to present a simple exposition of the spatial characteristics without a detailed analysis of the various cultural factors which may affect the representation of space. Function, technique, historical influences and contacts as well as iconographic traditions are active agents in forming a particular spatial style. To go deeply into these questions, however interesting they may be, is beyond the scope of this study. They should be borne in mind as possible sources for the explanation of certain forms, but only the end result, that is, the spatial form as such, is the primary consideration in this description of the changes from period to period.

In "ancient painting," a term which covers the long era from palaeolithic art through Roman art, the principal concern of the artist was with the figures and objects to be represented rather than with the picture plane as an active factor in the composition of a scene; or, to express it otherwise, the artist was more interested in action than in background and environment. In general, the trend of the evolution of space as judged from the form of the figures is from conceptual to optical representation.

Painting before the fifth century B.C. is often referred to as the childhood of art. In fact, pre-Greek painting, the art of present-day "primitive"

peoples, and the drawings of children or untrained adults are grouped to-
gether as examples of conceptual representation.[1] There are fundamental
similarities in the work of these groups, arising from the fact that the form
of the objects and figures is usually the combination of different aspects
which appear to be significant to the artist and which are chosen from his
fuller perception, combining the tactile and the visual impressions of the
object. In other words, there is an attempt to express the real form, as it is
understood, in a composite whole rather than the apparent form as a unified
whole. It is erroneous, however, to identify the drawing of children with
ancient art on the basis of these similarities, for one would be comparing
the work of an individual who is untrained and in a transitional stage of his
development with the work of a trained, mature artist who represents a
cultural tradition. The child begins by drawing conceptually. As he grows
older, through his education and contact with the work of adults he de-
velops the point of view of his culture, whether this be optical or con-
ceptual. Thus, without denying the evolution of spatial forms, the develop-
ment of an individual's mode of artistic expression may present a temporally
telescoped parallel to the history of art. Furthermore, pre-Greek art differs
from the drawing of children in that it was comprehended by the public
and generally had a community purpose—either religious, magical, or eulo-
gistic. Connected with this was a conscious and fairly consistent selection
of certain forms with the result that fixed types were established. The
establishment of definite pictorial traditions did not inhibit a gradual change
in the spatial forms, and, although pre-Greek art is noted for the uniformity
of its traditions, a continuous evolution may be observed.

In palaeolithic art the surface of the wall or the ceiling became the pic-
ture plane without preparation. The pictorial surface was used as it was
found—rough and uncolored. Some selectivity might enter into the choice
of a spot as especially adaptable to the curve or the bulge of an animal's
form,[2] but this area was not enframed in any way. In fact, a painting, once
completed, may be said to lose its right to possession of the surface on which
it is painted, for it may become the picture plane of another representation.

[1] Hauck, Die subjektive Perspektive, p. 54; R. Müller, Über die Anfänge und über das Wesen
der malerischen Perspektive, p. 16; Schäfer, Von ägyptischer Kunst, pp. 92 ff.
[2] Parkyn, Prehistoric Art, p. 81; Swindler, Ancient Painting, p. 8.

Over-paintings and the overlapping of one form on another by a subsequent artist are commonly found in the caves of the Pyrenean regions.

The repertory of forms, with few exceptions,[3] is limited to animals. Generally they are not arranged in groups,[4] but are depicted as individual isolated compositions. The representation is conceptual; the animal has a profile body and head and frontal eye and hoofs. Usually all branches of the horns are visible. Although this combination of points of view is optically inaccurate, an astonishing degree of reality and vitality is obtained through the continuous, fluid outlines of the figures. Naturalistic effect does not, therefore, require an optical method of representation. The continuous closed contour of the forms and the selection and distinction of the animals show a development in representation that cannot be called the most primitive, although the method is conceptual.[5]

The few compositions of groups of figures that appear are of the simplest type. The "Herd of Reindeer" is cleverly suggested by a series of antlers and diagonal strokes between two fully drawn animals. In the "Ceremonial Dance" the human figures are spread out roughly in a circle; each figure is a silhouette. In general the method of composition may be called parallel-plane representation. Thus, in palaeolithic art, the earliest extant painting, the picture plane is an unprepared, untreated surface, and the representation is conceptual, consisting principally of isolated figures. There is some degree of spatial development in the continuous closed outline of the forms.

As compared with palaeolithic painting Egyptian painting presents several advances in spatial evolution. The picture plane is part of a surface which has been constructed—either a brick wall or one that is cut into the rock. It is not a surface made especially for representation, such as a panel, but is, however, plastered and stuccoed to offer a smooth ground. Since the

[3] Exceptions: Cogul, "Ceremonial Dance" (Parkyn, Prehistoric Art, Fig. 146); Alpera, "Bow and Arrow Scene" (ibid., Fig. 149).

[4] A few exceptions occur, such as, La Mairie, "Herd of Reindeer," engraved on bone (Swindler, Ancient Painting, Fig. 20).

[5] As Professor Meyer Schapiro has pointed out to me, this conceptual form in palaeolithic art, which is consistent with the conceptual principle of pre-Greek art in general, is a strong argument against the opinion that palaeolithic art is physioplastic in the sense of being an instinctive, direct rendering of the perception as distinguished from the ideoplastic imagery of other pre-Greek arts. For a discussion of the physioplastic principle and a bibliography on the subject see Adama van Scheltema, Die altnordische Kunst, pp. 2 ff.; also Snÿder, Kretische Kunst, chap. iii. Snÿder is of the opinion that Cretan art is also physioplastic.

picture plane is usually white[6] and unframed, it can be characterized as an untreated though prepared pictorial surface. For any active spatial quali' fications such a picture plane is entirely dependent on the representation of the figures and the objects. This is especially true in Egyptian art, because the pictorial absolutism of the picture plane is broken by inscriptions that are not demarcated from the figures and objects. The presence of hieroglyphs between the figures indicates that the picture plane was not felt to be a material part of the environment of the figures, but is simply a necessary structural support, mechanical rather than artistic in nature. The absence of a frame, which if present would help to make the pictorial surface an autonomous artistic area, is compensated for, in part, by the occasional appearance of sections of decorative borders[7] and, what is more important, by the institution, appearing early in the history of Egyptian painting, of a base line. At first the base line occurs as an individual support for single figures.[8] Later it is extended under the whole scene as a collective ground line. Although it acts as a ground'line support for the figures, it also marks the lower limits of the picture plane.[9] The twofold function of the base line as a segment of a frame and as an indication of the supporting ground con' verts the picture plane into a vertical surface that extends behind the figures. The presence of hieroglyphs on the same surface also tends to give it a vertical character.

The verticality and the two'dimensional character of the picture plane is preserved by the conceptual method of representing the figures and objects. The method is that which we have called parallel'plane representation. In the individual figures, profile and frontal views are combined, giving the impression of a flat two'dimensional form. There is seldom overlapping in the planes, although it occasionally necessarily occurs, as when an arm crosses the body. In such cases one plane seems parallel to the other and

[6] Schäfer, Von ägyptischer Kunst, p. 220.

[7] Thebes, hunting scene from the tomb of Antifoker, Middle Kingdom (Schäfer and Andrae, Die Kunst des alten Orients, p. 289).

[8] Cairo Museum, palette of King Narmer (Schäfer and Andrae, Die Kunst des alten Orients, p. 183).

[9] One of the rare instances in which an irregular ground line was used in Egyptian painting occurs in the hunting scene in the tomb of Antifoker at Thebes (Schäfer and Andrae, Die Kunst des alten Orients, p. 289). Since the irregular line, which suggests the hilly contour of the terrain, is placed above the base line and since the animals stand on the irregular line, the result is a vertical ground plane.

in front of it. The same relation exists between the figures and the picture plane.

Groups of figures and objects are also conceptually composed. A whole scene may be a combination of profiles, or elevations, with a ground plan, presented in a series of planes. Where the ground plan is significant, as in a courtyard or a garden, it is usually indicated with the accessories, which in nature are perpendicular to the ground, profiled in orderly fashion around it (Fig. 3). More common than this type of representation is what is called the strip composition in which the figures are supported on a series of base lines, one above the other, that divide the pictorial surface into horizontal zones.[10] Subsidiary individual ground lines may appear between the collec- tive base-line divisions. In this type of horizontally aligned composition the story is not necessarily continuous from strip to strip.[11] The scenes may be unrelated in place and time. In the individual scenes the elements are aligned with little overlapping. When one object is placed above another, this does not necessarily indicate that it is behind. In Fig. 4, where the river is ex- tended upward to allow the fisherman to make his catch, what is raised is in nature actually below the figure. From the variety of forms and composites, it is evident that the conceptual method of the Egyptian artist was very flexible, permitting in the choice of planes and in the manner of their juxtaposition a consideration of the total decorative effect.

The use of hierarchic scaling to distinguish the rank of the figures occurs frequently. Examples are to be found in the hunting and fishing scenes, where the nobleman is many times as tall as his boatmen.

In Egyptian painting there are occasional departures from conceptual representation in favor of an optical point of view. Attempts to foreshorten the figure were made, resulting in a head in three-quarters view rather than in profile,[12] and the rear view of a torso in place of the frontal shoulders and profiled trunk.[13] Simple attempts to foreshorten the shoulders were also made.[14] In many instances where a row of figures is represented, each figure

[10] London, Brit. Mus., "Inspection of Geese Belonging to Amenemheb at Thebes" (Fig. 2). Thebes, Tomb 100, "Craftsmen Working" (Farina, La pittura egiziana, Pl. LXVI).

[11] Schäfer, Von ägyptischer Kunst, p. 169.

[12] Delbrueck, Beiträge zur Kenntnis der Linienperspektive, p. 7.

[13] Thebes, tomb of Rechmiri, New Kingdom (Schäfer and Andrae, Die Kunst des alten Orients, p. 349).

[14] Berlin, Staat. Mus., relief of captives from the tomb temple of Sahure at Abusir, Old Kingdom (Schäfer and Andrae, Die Kunst des alten Orients, p. 239). Beni Hasan, wall painting in the tomb of Chnemhotp, "Feeding Antelopes," Middle Kingdom (ibid., p. 290).

overlaps the one next to it, a form of composition which may indicate a concern for the expression of depth in the scene. The suggestion of depth is limited, however, because all the figures stand on the same level. This type of alignment does not occur in the Old Kingdom and is more frequent during the Empire than in the Middle Kingdom.[15] The chronology suggests that although the manner of representation remained consistently con' ceptual in Egyptian art for centuries, there was also a slight tendency toward an optical point of view.

In Mesopotamian art, due to the lack of extant paintings, the spatial form must be judged for the most part from low reliefs. As in Egyptian art, the picture plane is a constructed and prepared surface and the method of representation is conceptual. Subsequently, in the Assyrian period, an im' portant change in the form of the picture plane was introduced by the addi' tion of color and a frame. The picture plane became a positive pictorial sur' face when it was formed by colored glazed tile. Furthermore, the character of the picture plane as a special pictorial area is emphasized by a frame or a decorative border.[16] The importance of the frame as an aid in focusing the composition and to indicate to the spectator his relative distance from the scene is not as great in conceptual as in systematized optical representation, yet it does serve to distinguish and to set apart the pictorial surface from the remainder of the wall, and, at the same time tends to link the picture plane with the representation. A picture plane that is framed becomes a definite pictorial area which defines the proportions of the scene. The hieroglyphs which run across the figures and the picture plane in many reliefs do not appear in the glazed-tile friezes, a fact which confirms the pic' torial character of the picture plane already provided for by the addition of color to the surface and a decorative frame.

In Assyrian art a slight modification in the representation of the figures may be observed. The conceptual combination of frontal shoulders with profile head and trunk is frequently replaced by the figure seen in complete profile, consistent from an optical point of view.[17] The rest of the repre' sentation is primarily conceptual. Although figures in a series are frequently

[15] Schäfer, Von ägyptischer Kunst, p. 191.

[16] London, Brit. Mus., engraved ivory plaque from Nimrud-Kalach (Schäfer and Andrae, Die Kunst des alten Orients, p. 495). Khorsabad, frieze of glazed tile (Swindler, Ancient Painting, Fig. 114). London, Brit. Mus., "King with Eunuch and Spearbearer," glazed tile (ibid., Fig. 111).

[17] Berlin, Staat. Mus., marble relief of Mardukballidin (Schäfer and Andrae, Die Kunst des alten Orients, p. 487). London, Brit. Mus., alabaster relief from Kuyundjik-Nineva (ibid., p. 527).

made to overlap one another, the alignment of figures and objects alongside or above one another is also characteristic.

Hierarchic scaling is often a determining element in the size of the figures. Even when the highest ranking personage in a scene is reclining or seated, his couch and throne are usually placed on a dais, which raises him above the level of the other figures in the composition.[18]

The naturalism for which the Assyrian hunting scenes are noted may be attributed to an optical spatial tendency only insofar as it signifies that the artist is becoming interested in the visual form of the object. The naturalistic effect is due to skillfully rendered details of contour, but the figure of the animal remains an unforeshortened profile. Furthermore, one should bear in mind the fact that these scenes are reliefs and that the modeling which so effectively aids the impression of nature does not appear in painting.

The characteristics of the spatial form in Aegean art may be ascertained from the fragments of Minoan and Mycenaean paintings that have been preserved. The surface is constructed and prepared, but more than that, it has a positive pictorial quality. The picture plane, often framed by a narrow band or a decorative border,[19] is a definite area which is colored. Thus, it is a treated surface. Occasionally the picture plane has an active rather than a neutral character, for a contrast in color is introduced by the division of the pictorial surface into irregular curvilinear bands.[20] In some frescoes, along the base and the top of the picture plane curvilinear areas appear which have a remote resemblance to features of the environment. Those along the

[18] Hierarchic scaling with standing figures: London, Brit. Mus., "Assur-bani-pal Pouring out a Libation over Dead Lions," relief (Schäfer and Andrae, Die Kunst des alten Orients, p. 529). Reclining figure: London, Brit Mus., "Assur-bani-pal Reclining at Meat," relief (ibid., pp. 542-43). Instances of isocephaly, a form in which the heads of all the figures in a scene, whether they are seated or standing, are at a uniform height, may also be found in Assyrian art. In the alabaster relief of "Assur-nasir-pal III with a Servant" (London, Brit. Mus., prov. Nimrud-Kalach [ibid., p. 500]) both figures are standing and are the same size. Where the king is seated in an isocephalic composition, however, the uniform height of the seated figure and the standing attendants may be interpreted as conceptual hierarchic scaling, for such an arrangement is not in accord with optically determined proportions. Example: London, Brit. Mus., "Assur-nasir-pal III Drinking, Accompanied by Attendants," alabaster relief, prov. Nimrud-Kalach (ibid., p. 502).

[19] Cf. Rodenwaldt, Megaron von Mykenai, p. 11. Candia, Mus., "Toreador" fresco from Knossos (Swindler, Ancient Painting, Fig. 159). Knossos, "Chieftain" (ibid., Fig. 161).

[20] Evans (The Palace of Minos, II [Pt. II], 728) interprets the wavy bands as "the simplified tradition of the rocky Cretan landscape, as rendered in their peculiar manner and with naturalistic details by the indigenous artists of a much earlier period." Examples: Candia, Mus., "Cupbearer" from Knossos (ibid., Pl. XII, in color). Thebes, Mus., "Procession" fresco (ibid., Supplementary Pl. XXVII).

base represent the ground in a more or less conventionalized manner. The forms that appear along the top of the picture plane have been interpreted as rocky ground cliffs.[21] In several instances these forms mirror those at the base,[22] thus indicating that the background is not a two-dimensional repro-duction of the naturalistic spatial order, but that it is composed in a con-ceptual manner similar in principle to the method found in Egyptian pond scenes (Fig. 3). These stylized areas do not transform or penetrate the sur-face, but have the same relation to the picture plane as the figures have; they are forms in a plane parallel to it. Thus, in Minoan art the picture plane remains a surface, but it is more active pictorially than in Egyptian painting. Its vertical character is stressed in those representations in which a base line is present on which the figures and trees stand.[23]

The individual figure is composed in the traditional conceptual form of parallel-plane representation most common in Egyptian painting, but the complete profile found in Assyrian art occurs. In the profile of the body and head there is an attempt to foreshorten the shoulders. The consistency in point of view is kept only in the general contour and does not extend to such details as the eyes, which remain frontal. This optical tendency, as far as can be judged from extant monuments, occurs in Minoan art several hundred years before it appears in Assyrian reliefs.[24]

[21] Evans, The Palace of Minos, II (Pt. II), 452, 706. Rodenwaldt, Megaron von Mykenai, p. 9. K. Müller, "Frühmykenische Reliefs," Jahrbuch des Instituts, XXX (1915), 327-28. In his essay on the Vaphio cups, Riegl (Gesammelte Aufsätze, p. 75) interprets these forms on the cups as clouds. Hoernes (Urgeschichte der bildenden Kunst, p. 584, note 2) in contradistinction to Riegl, describes them as branch forms. The explanation offered by Evans, Rodenwaldt, and Müller, that they are rocky ground cliffs, seems most acceptable in light of the fact that where these forms appear in a less conventionalized manner, as in the fresco of the "Blue Monkey" (Evans, The Palace of Minos, Vol. II [Pt. II], Pl. X, in color), their resemblance to veined and jagged crags rather than to clouds or branches is clearly discernible. Furthermore, as mentioned below, in some frescoes, including the "Blue Monkey," the forms at the top of the picture plane are the same as those at the base.

[22] "Saffron-Gatherer" fresco, also called "Blue Boy Gathering Crocuses" (Evans, The Palace of Minos, Vol. I, Pl. IV, in color); "Partridge" fresco (ibid., Vol. II [Pt. I], Pl. VIII, in color); "Flying Fish" fresco from Phylakopi (ibid., Vol. I, Fig. 393).

[23] Candia, Mus., "Cupbearer" from Knossos (Evans, The Palace of Minos, Vol. II [Pt. II], Pl. XII, in color); fresco of the throne room from Knossos (ibid., Vol. IV [Pt. II], Pls. XXXII, XXXIII, in color).

[24] In connection with the early occurrence of the consistent profile from an optical point of view, one should mention its appearance in the rock sculptures of Kurangūn, dated ca. 2400 B.C. Herzfeld, Archaeological History of Iran, p. 5, reproduced Pls. II-III.

The representation of the bull caught with a net on one of the Vaphio cups (Athens, Nat. Mus.), although a relief, should be mentioned in relation to optical form in Minoan art because of the impression of depth in this scene. Actually the artist departed very little from the con-

Groups of figures are presented, for the most part, as in Egyptian and Assyrian art, but in Minoan painting the composition tends to be less schematic. Isolated figures in alignment (a form well adapted to the proces- sional type of scene) and figures scattered one above the other or else placed in overlapping rows are the means used to represent spatial relationships.

The Aegean concept of space differs from the Egyptian in that the pic- ture plane is a truly pictorial surface, distinguished from the material surface of the wall by color and by a border. The method of representation is pri- marily conceptual, with deviations in favor of the optical, such as the at- tempts to foreshorten the shoulders in profile. The naturalism which dis- tinguishes Minoan painting from Egyptian is due partly to the less schematic composition and to an interest in the representation of details of landscape. This naturalism is a stylistic factor which may be considered to some extent a preparatory step in the development of an optical principle of representa- tion, but which does not necessarily affect the spatial form.

A discussion of Greek painting, no matter how limited in scope, must be for the most part conjectural. This is particularly true with regard to spatial analysis, in which the absence of illustrative material cannot be com- pensated for satisfactorily by vase paintings, literary descriptions, or Roman frescoes. In the first case, although we may expect to find reflections of con- temporary monumental representation in vase painting, the fact must be borne in mind that this is a technique with special limitations. Literary descriptions are likely to be insufficient and misleading, for, as has been pointed out, what appears realistic to a contemporary may be incompre- hensible to a spectator of a later period.[25] Reconstruction from literary de- scription is also of doubtful value, as is proven by the well-known example of Botticelli's painting of the "Calumny of Apelles," which can scarcely be judged a true reproduction of the original. Finally, in Roman painting an especially difficult problem is presented: that of distinguishing between what faithfully reproduces the Greek and what is an addition or adaptation of the later artist. With all these hazards in the path of the investigator, it is

ceptual method. The front and hind quarters of the bull are two juxtaposed profile views, and he indicated the depth of the net by placing what is behind the front part, above it. The slight overlapping that is shown, however, and the effect of movement expressed in the forms create the illusion that the bull is coming forward from the picture plane. Reproduced in K. Müller, *Jahrbuch des Instituts*, Vol. XXX (1915), Pls. IX-XII. Figs. 33-34.

[25] Panofsky, *Vorträge Bibl. Warburg*, 1924-25, p. 306, note 24.

hardly surprising to find that the subject of Greek painting is a controversial field.

In the matter of space an important controversy centers on the method of representation. Briefly, the question is whether the Greek artists or scenographers used a mathematical perspective system and if they did, whether it was similar to that developed in the Renaissance. The existence of such a problem immediately indicates that significant changes in the direction of optical representation took place. These changes were so far-reaching that any optical tendencies in the history of painting before the sixth century B.C. are insignificant when compared with the course of development in Greek painting in the succeeding centuries.

Before the middle of the sixth century B.C. the spatial form is similar to that in the pre-Greek painting reviewed above, although at first it is less developed. The picture plane is an untreated or neutral surface upon which the figures and objects are silhouetted according to conceptual traditions. The individual ground line and then the collective base line, affording a strip composition, appear.[26] The sketchy silhouetted forms are gradually replaced by more carefully contoured figures with indications of the divisions of the body within the contours, but the conventional profile head and legs with frontal shoulders remain unchanged until the last quarter of the sixth century B.C. At that time, in the red-figured ware, and during the first decades of the fifth century B.C. a complete transformation in the representation of the human figure was effected. Step by step variations in the point of view and in position were introduced in order to obtain a figure correctly delineated according to the retinal image.[27] In order to represent the various parts of the figure from a consistent, optical point of view, foreshortening was studied.[28] The development of optical forms in the representation of the figure was more rapid and more accomplished than it was in the depiction of objects, although acutely foreshortened planes were gradually introduced for the latter.[29] In Greek representation, on the whole, as has often been stated, the emphasis is primarily on the human figure with slight reference

[26] Athens, Nat. Mus., Dipylon crater (Swindler, *Ancient Painting*, Fig. 199).

[27] Richter, "Perspective," *Scritti in onore di Nogara*, p. 385. Delbrueck (*Linienperspektive*) traces the steps in the development of foreshortening.

[28] Foreshortening was developed only insofar as it was needed for a normal point of view, that is, only in the horizontal planes (Rodenwaldt, *Pompey. Wandgemälde*, pp. 8-9).

[29] Delbrueck, *Linienperspektive*, p. 35; Panofsky, *Vorträge Bibl. Warburg*, 1924-25, p. 305, note 24.

to the accessories of the scene which indicate the environment of the action. The composition of the scene, in general, consists simply of the alignment of figures—overlapping wherever necessary because of the content—on a collective base line and against a neutral picture plane. In such a representation the tridimensional effect depends on the position and foreshortening of the figures and the few accessories that appear, such as couches, shields, and chariots.

The next contribution to the spatial form is usually credited to Polygnotus. As far as can be judged from contemporary vase painting[30] and from Pausanias's description of the wall paintings at Delphi,[31] the innovation of Polygnotus consisted of the introduction of irregular ground lines on which the figures stand or behind which they disappear. The figures standing on different levels and the overlapping of planes produce an effect of depth. The point of view of the figures, however, remains the same for the different levels, and there is no notable or consistent observation of diminution in size in the figures supposedly farther away.[32] The scene is still composed of isolated forms rather than of closely interrelated figures making use of the possibilities of movement in depth. The landscape environment is briefly indicated by an occasional tree and by the irregular form of the ground line. How much of the picture plane was transformed in a representative manner by the color is difficult to say, although it is highly probable that it remained a neutral surface.[33]

From the isolated unsystematized type of composition of Polygnotan painting to the postulation of a geometrical system of perspective seems an incredibly great step, yet such a step must have been taken, if we are to believe that Agatharchus, the contemporary of Polygnotus, painted stage scenery with the aid of a mathematically unifying method of representation. The attribution of such a system to Agatharchus rests on the interpretation of a passage in Vitruvius.[34] Opinions on this issue differ widely, ranging from an acceptance of Agatharchus as the first to follow a mathematical system of perspective in the architectural compositions of the stage back-

[30] Paris, Louvre, Orvieto crater (Pfuhl, Malerei und Zeichnung, Vol. III, Fig. 492).
[31] x, 25-31.
[32] A possible exception is one figure on the Orvieto crater (vide supra, note 30) noted by Fowler and Wheeler (A Handbook of Greek Archaeology, p. 532).
[33] Loewy, Rendering of Nature in Early Greek Art, p. 80; Pfuhl, Malerei und Zeichnung, p. 619.
[34] De architectura vii, Praef., 11. Vide infra, p. 195.

ground to a denial that there was any classic system of perspective.[35] The evidence is, on the whole, scant. Vitruvius's paragraph gives little information and is complicated by the obscurity of the language (vide infra, p. 195).

The architectural representations that appear later in the South Italian vases and in the reliefs of Xanthos (Nereid monument) and Gjölbaschi (frieze of the Heroön) do not offer any adequate proof of a systematic construction, but indicate simply that the observation that the side walls of a building appear foreshortened is carried out by the general convergence of the lines in depth, a principle which is not always followed consistently in a single building. Moreover, it is questionable whether the reliefs can be used as examples of the influence of theater painting.[36] In summing up the contribution of Agatharchus, the most one can say is that he observed that planes in depth appear foreshortened, but he did not formulate a geometrical method of unifying the organization of the receding lines of these planes.

The problem of classic perspective cannot be concluded with a conserva-

[35] Bulle (Untersuchungen, p. 217), Friend ("Portraits of the Evangelists," Art Studies, VII [1929], 15), and Beyen (Pompey. Wanddekoration, I, 157 ff.) are inclined to accept the passages by Vitruvius as proof that a scientific mathematical perspective (one-point perspective) was known to classic scenographers. Bulle modifies the interpretation to mean that Agatharchus approached the problem empirically and that Anaxagoras and Democritus solved it theoretically. Beyen believes that the source of Vitruvius was either Euclid or earlier writers on optics (Pompey. Wanddekoration, I, 161). Hauck is of the opinion that a single-vanishing-point system was known in the time of Vitruvius at least (Die subjektive Perspektive, p. 57). Delbrueck believes that a rational system of perspective was developed from Euclid's optics (Linienperspektive, p. 43). Wulff holds that although classic art did not have a focused system of perspective, the essential points in its theory were known to Euclid and Vitruvius (Festschrift Schmarsow, p. 6 and p. 35, note 15). On the other hand, Kallab (Jahrbuch des oesterreichischen Kaiserhauses, XXI [1901], 6-7), Kern (Grundzüge, p. 31) quoting Witting (Kunst und Christentum, p. 90), R. Müller (Über die Anfange und über das Wesen, p. 20), Schäfer (Von ägyptischer Kunst, p. 250), and Richter (Scritti in onore di Nogara, pp. 382-83) believe that the ancient artists did not have a theoretical system, but that their method of representation was empirical, that is, their foreshortenings were made from observing the receding planes in nature. See also Richter, "Two Athenian Jugs," Bulletin of the Metropolitan Museum of Art, XXXIV (1939), 232.

[36] Bieber, review of Bulle, "Untersuchungen," Gnomon, VIII (1932), 479. On a fragment of an attic crater from Tarentum, in the Martin von Wagner-Museum of the University of Wurzburg, there is a temple in angular perspective. The roof lines incline downward, but there is no evidence of systematic construction, and there are a number of inconsistencies in the foreshortening of the architectural members. From the subject, which is the "Battle of the Amazons," Bulle deduces a connection between the representation on the vase and the painting of Micon in the fifth century B.C., and accepts the fragment as proof of correct perspective construction in monumental and scene painting in the time of Agatharchus. The shortcomings in the perspective of the temple, observed by Bulle himself, and the fragmentary condition of the example make the evidence with which Bulle confirms his opinion of classic perspective inconclusive. (Bulle, "Ein Beitrag zur Kunst des Mikon und des Agatharchos," Archailogike Ephemeris, 1937, pp. 473-82). See also Dinsmoor, "The Temple of Ares at Athens," Hesperia, Vol. IX (1940), Fig. 18.

tive statement about the contribution of Agatharchus, but must be consid-
ered in relation to the subsequent development of ancient painting. The
notes by Vitruvius on the subject of scenography may reflect a method
developed during the Hellenistic period or under the Roman Empire, and
the possible influence of Euclid's optical and mathematical observations on
representation must be considered. In connection with the latter the impor-
tant fact has been noted that Euclid's *Optics* is concerned with the laws of
seeing only, not with the bearing of these laws on representation as a specific
problem of painting.[37] It can also be assumed that other scientific writers
limited themselves to the physical and astronomical aspects of their specula-
tions without relating them to the specific problem of the artist.[38] The opin-
ion may be advanced that, although the scientists themselves did not deter-
mine the rules of perspective representation from the results of their studies
in optics, the basis of a focused system of perspective is in their observations
and could have been formulated by the artists. Unfortunately, such an
argument is very tenuous when not bolstered by factual data, and so far no
examples of Greek or Roman painting have been found which illustrate a
completely unified construction based on a single vanishing point.[39] Further-
more, Panofsky's arguments against the assumption of the existence in

[37] R. Müller, *Über die Anfange und über das Wesen*, pp. 20-21.

[38] *Ibid.*, p. 21. Panofsky suggests that the writings of Democritus and Anaxagoras alluded to
by Vitruvius were concerned with optics in general (*Vorträge Bibl. Warburg*, 1924-25, p. 304,
note 19). It should also be noted that the optical treatises (sometimes called "perspective") of
medieval writers such as Peckham, Bacon, and Vitellio which combine classic and Arabic sources
are limited to studies of the eye and vision and the laws of reflection and refraction.

[39] Hauck, *Die subjektive Perspektive*, p. 57; Kallab, *Jahrbuch des oesterreichischen Kaiserhauses*,
XXI (1901), 8; Panofsky, *Vorträge Bibl. Warburg*, 1924-25, p. 266; Richter, *Scritti in onore di
Nogara*, pp. 381-82. Riegl not only observed that the Romans did not have a system of focused
perspective but also claimed that in accordance with their stylistic concepts the artists could not
have desired such unity (*Spätrömische Kunstindustrie*, pp. 12, 111 ff.). Bulle published an article
on a fragment of a crater from Tarentum (in the Martin von Wagner-Museum of the Univer-
sity of Wurzburg) dated in the second quarter of the fourth century B.C., in which he states that
the parallel lines in depth of the coffers of the ceiling in the building represented converge to a
single point. ("Eine Skenographie," 94. *Winckelmannsprogramm*, pp. 1-26.) Only this plane is
constructed on a single vanishing point. The building as a whole is not consistently and sys-
tematically represented from a single point of view. This example introduces the possibility of a
Greek system of perspective based on a vanishing point for single planes. While this book was in
press, Beyen published an article ("Die antike Zentralperspektive," *Jahrbuch des Instituts*, LIV
[1939], 47-72) in which he reaffirms his opinion that a single vanishing-point system based on a
central system of perspective was known and applied in Hellenistic scenography. In the prospect
scenes of the second Pompeian style, which form the pictorial basis for Beyen's system, although
a number of orthogonals converge to a vanishing point and may reveal in one or two instances
the presence of a single vanishing point for a whole plane, the system is not applied consistently
to all the orthogonals in the scene.

ancient painting of a focused system of perspective, or, as he calls it, "plane perspective," are derived from ancient theory of optics itself and are extremely convincing.[40] The fact that the visual field was noted to be spherical,[41] that the size of the objects was said to depend on the visual angle rather than on the proportional distance from the eye, and that curvilinear distortions in straight lines were observed,[42] all tend to disprove the possibility of a focused system of perspective, for these are the very factors disregarded in such a method.[43] Panofsky offers the tentative suggestion that, although the ancient artists did not develop the focused system of perspective, they may have had a method of construction based on the use of a spherical rather than a plane surface. By a procedure similar to that employed in the projection of plan and elevation in focused perspective, but by using a curved surface for the plane of projection and by substituting chords for the arcs on the curved surface intersected by the lines in depth, a projected image is obtained in which the parallel lines in depth converge in pairs toward a central vanishing axis rather than toward a single point.[44] Panofsky finds this compatible with an interpretation of the passage in Vitruvius and with the representation of the ceiling coffers in the aedicules on the South Italian vases and the construction of the buildings in Roman prospect scenes.[45] Such a system may have been the result of conclusions drawn from the science of optics, but it should be noted that in the extant paintings the vanishing-axis form is limited to architecture depicted on a large scale, and even in this is not used consistently.[46] The development of linear perspective, in general, for smaller buildings within a landscape, seems not to have gone beyond the stage in which in the foreshortened planes of a

[40] Panofsky, Vorträge Bibl. Warburg, 1924-25, p. 264.
[41] Vide infra, pp. 197 ff.
[42] Panofsky, Vorträge Bibl. Warburg, 1924-25, p. 296, note 12. For detailed discussion of the use of curvatures in place of straight lines, that is, optical refinements, see Goodyear, Greek Refinements.
[43] Vide supra, p. 10.
[44] Panofsky, Vorträge Bibl. Warburg, 1924-25, pp. 265 ff. Little (Art Bulletin, XIX [1937], 491-95), from his studies of Roman architectural decoration, reached the same conclusions as Panofsky.
[45] Panofsky, Vorträge Bibl. Warburg, 1924-25, p. 267; Pls. III-IV.
[46] An inconsistent application of the vanishing-axis procedure may be seen by supplementing Little's perspective reconstruction of approximately an entire wall from the Boscoreale room in the Metropolitan Museum of Art, New York (Art Bulletin, Vol. XIX [1937], Fig. 4) with Richter's perspective reconstruction of a detail from the same architectural decoration (Scritti in onore di Nogara, Pl. LII).

building the roof lines incline downward and the parallel lines in depth con-verge;[47] nor is there a regular and consistent application of these rules in Roman painting.[48]

Recently Kern suggested another system which the ancient artists may have used as a method of perspective construction.[49] This system is also based on an interpretation of the passage in Vitruvius and the general form of convergence—found in South Italian vases and Roman painting—in which the orthogonals of horizontal planes in depth recede roughly in paral-lel pairs. Kern finds the key to his system in the decorative border of dentils that surrounds a mosaic of the second century A.D.[50] In this mosaic, on each side of the square picture plane the parallel lines in depth of the dentils converge in pairs. From the points of intersection of the corresponding orthogonals of the four sides of the square a series of concentric circles may be traced.[51] Kern relates this form of concentric circles to the cone of vision described in classic sources on optics and also to the reference made by Vitruvius to a correspondence of the lines of a foreshortened plane to the center of a circle.[52]

There are, however, several limitations to Kern's reconstruction of a system of classic perspective. His ideal form of construction depends on a decorative border that surrounds a mosaic of comparatively late date. In architectural representations of interiors or exteriors the underlying scheme of concentric circles cannot be traced so readily. Where the representation in depth is limited to the orthogonals of a horizontal plane, such as a coffered ceiling—as is frequently the case—only one-quarter of the schematic re-

[47] Richter, Scritti in onore di Nogara, pp. 382-83. These points could have been derived from Euclid's optics. See Kern (Grundzüge, p. 30) and Richter (Scritti in onore di Nogara, p. 384) for relevant theorems. One must stress the fact, however, that the problem is not whether the fundamental laws of optics were observed in ancient times, but whether a consistent system of perspective, derived from these laws, was applied to painting.

[48] The term "Roman painting" employed here and elsewhere in this study is not used in the local sense but as a general reference to painting, Greek or Latin, under the Roman Empire.

[49] Kern, Jahrbuch des Instituts, LIII (1938), 245-64.

[50] Munich, Glyptothek. The subject is the personification of the seasons. Kern, Jahrbuch des Instituts, Vol. LIII (1938), Fig. 1.

[51] Ibid., Fig. 3.

[52] Vide infra, p. 195. Thus, Kern interprets the center of a circle mentioned by Vitruvius as a reference to a part of a pictorial construction, not a reference to the eye of the spectator. The latter interpretation, which is the one suggested by Panofsky, is, as he says, in accordance with classic optics, in which the eye is described as the vertex of the cone of visual rays and the size of the object at the base of this cone is measured by the visual angle formed at the vertex. Panofsky, Vorträge Bibl. Warburg, 1924-25, p. 266. Vide infra, p. 197.

quirements of the concentric circle plan is satisfied. In more complex archi-
tectural compositions, such as the prospect scenes, the pattern of convergence
for the receding lines of the numerous planes in depth does not form the
complete concentric circle arrangement. Kern himself is aware of the lim-
ited possibilities of applying his system to the extant paintings. He observes
that the unified spatial form that can be traced from the border of his mosaic
is almost always employed for individualized planes, that irregularities and
variations are introduced into the pattern of convergence in order to obtain
greater depth, and that those architectural representations which do not
conform to the schematic plan are empirically drawn constructions.[53] On
the whole, the question whether the ancient artists had a system of perspec-
tive construction is still problematical. The theoretical suggestions advanced
have not been proven conclusively, for the evidence in the paintings them-
selves is indecisive and contradictory.

Besides the linear construction of a scene, other questions relative to
spatial form must be considered in the development of ancient painting. The
optical representation of figures and objects introduces the third dimension
into a picture to some extent but the form of the picture plane, the composi-
tion of the figures, and their relation to the background are also important.

Apollodorus, who worked at the end of the fifth century B.C., was
famous in antiquity for his effects of light and shade. It has been suggested
that it was he who introduced cast shadows,[54] although he may only have
employed shading within the figure and a later artist may be responsible for
this spatial innovation.[55] In any case, the cast shadow appears throughout
Roman painting. The result of such an innovation would be to increase the
tridimensional effect of space created by the optically represented figures

[53] Kern, Jahrbuch des Instituts, LIII (1938), 262 ff. One would have to place the prospects of
the Boscoreale type in the class of empirically constructed scenes. This form of architectural
background, if too elaborate to be associated with the scene painting created by Agatharchus to
whom Vitruvius refers in the passage on perspective, is nevertheless generally used to gain some
idea of the theatrical sets in the period of Vitruvius himself. The lack of a more definite connec-
tion between this type of prospect and Kern's scheme of classic perspective should be noted. The
scaenae frons of the Domus Aurea, which Kern illustrates because the convergence of the
orthogonals of the ceiling coffers show a partial or individualized application of his system are
derived from a Roman type of theater architecture of a later date (ibid., Fig. 16).

[54] Pfuhl, Malerei und Zeichnung, p. 620; Loewy, Rendering of Nature in Early Greek Art,
p. 81.

[55] Wickhoff (Roman Art, p. 94, note *) cites Pliny (Natural History xxxvi, 184) as the
first literary reference to cast shadows. Pliny speaks of the "Cup with Doves" by Sosos of
Pergamon.

and to bind the form to the picture plane. The cast shadow tends to make the lower part of the picture plane perpendicular to the figure, thus creating the effect of a horizontal ground plane. How effectively the neutral picture plane may be transformed into tridimensional space by a judicious grouping of objects and figures is illustrated by the mosaic from Pompeii of the "Battle between Alexander and Darius" (Fig. 6), which is generally accepted as a dependable copy of a Hellenistic work.[56] The free foreground littered with objects and the closely massed figures beyond, whose contact with the ground is emphasized by the cast shadows, transform part of the picture plane into a horizontal ground plane. The remainder of the picture plane behind the figures and the shouldered spears is a vertical surface. Thus, without actually altering the pictorial surface the artist changed its spatial character.[57] The Alexander mosaic may be said to illustrate the first steps in the development of stage space, a term which will be used hereafter to describe the limited depth resulting from the juxtaposition of two planes at right angles, one forming the ground, the other the rear wall.[58] The use of the term stage space does not necessarily connote a direct influence from the theater, although there are examples such as the Dioscurides mosaic,[59] which is a representation of a scene from the New Comedy of the Hellenistic period, and the extant paintings as a whole are an important source in connection with the form of presentation in classic drama.

The next step in the development is the actual transformation of the picture plane into stage space by the differentiation of ground plane and background. The Dioscurides mosaic mentioned above is a good example of this, as well as the "Aldobrandini Wedding."[60] In the latter the ground is more or less naturalistic in form and color. At the rear of the ground plane,

[56] The Hellenistic source is generally believed to have been the painting of this subject by Philoxenus of Eretria. Winter, Das Alexandermosaik, p. 8; Pl. I, in color.

[57] Wickhoff (Roman Art, p. 93) and Rodenwaldt (Pompey. Wandgemälde, pp. 2-3) observed the spatial enclosure resulting from the closely massed figures.

[58] Although the part of the picture plane of the Alexander mosaic on which the battle is represented is uncolored, there is a brown strip across the bottom which has the effect of the vertical edge of a platform and thus adds to the impression of tridimensional stage space. A similar form appears in the Dioscurides mosaic (Herrmann, Denkmäler, Pl. CVI). According to Bieber and Rodenwaldt (Jahrbuch des Instituts, XXVI [1911], 11 ff.) the strip across the base of these and other Roman paintings and mosaics cannot be associated with any actual form of the Greek or Roman stage, but was derived from Greek votive paintings or reliefs, in which a similar form appears. In the votive reliefs this base occasionally bears an inscription.

[59] Naples, Nat. Mus. (Herrmann, Denkmäler, Pl. CVI).

[60] Rome, Vatican (Pfuhl, Malerei und Zeichnung, Vol. III, Fig. 709).

really on its upper contour (an indication that it is not fully understood or exploited as a horizontal plane), the figures appear still composed as a frieze rather than grouped in depth. Behind them, against the light blue background, a wall is represented. The linear perspective of the wall is not unified. The foreshortening of the planes in depth is indicated more clearly at the top than at the base where the object meets the ground plane.

The type of stage space illustrated by the "Aldobrandini Wedding" may very well reflect the degree of tridimensional spatial development reached in late Hellenistic painting.[61] The Hediste stele from Pagasae,[62] dated at the end of the third or the beginning of the second century B.C., does not indicate that further development in the construction of tridimensional space had been accomplished. Behind the figures the interior is represented, but it is depicted by a series of walls set up one close behind the other like the "flats" or "coulisses" of a stage. Despite the fact that the head of a figure peering out from behind one of the walls helps to create some impression of depth, the effect is of extreme shallowness.

If we assume, from Roman paintings which appear to be copies of Greek works and from the few remains of provincial Hellenistic paintings, that in the Hellenistic period optical representation had reached a point where the artists were beginning to transform the vertical pictorial surface into a limited tridimensional area whch may be designated as stage space, we are also confronted with the problem of deciding how much of another type of spatial form found in Roman painting was developed by their predecessors. This type concerns the transformation of the picture plane into a vista. The problem is bound up with landscape painting. Unfortunately our source material is limited to a few monuments, such as the Telephos frieze[63] and several smaller reliefs, presumably of the third century B.C. or later.[64] There is also a brief reference to a Demetrios, who may have been only a topographer.[65] Judging from the reliefs which, one must bear in mind, are in

[61] Panofsky (Vorträge Bibl. Warburg, 1924-25, p. 305, note 24) mentions the appearance of a ground plane with figures standing on its upper contour, not within it, in the Helixo Stele, dated ca. 280-20 B.C. (Pfuhl, Malerei und Zeichnung, Vol. III, Fig. 747).

[62] Pfuhl, Malerei und Zeichnung, Vol. III, Fig. 748.

[63] Winnefeld, "Die Friese des groszen Altars," Altertümer von Pergamon, Vol. III (Pt. II), Pl. XXXI.

[64] Munich, Glyptothek, "Peasant Going to Market"; Paris, Louvre, "Satyr after the Chase" (University Prints, A313-A314).

[65] Swindler, Ancient Painting, p. 307.

a different medium, and from the general development of painting up to this time, it seems probable that the picture plane was not transformed into a vista; that it often remained neutral,[66] but that an increased number of rep' resentative elements handled as individual objects and placed on the picture plane in an optical rather than a conceptual manner managed to create some illusion of continuous landscape, although not a very deep one.

In Roman painting three different kinds of representation are generally distinguished. The first is the mythological scene with its single dramatized incident (megalography). It is from these pictures that knowledge of Greek painting is sought. The second type is the prospect scene which is incor' porated into the architectural styles of mural decoration. These are generally said to be derived from the *scaenarum frontes* of the theater.[67] The third kind of representation is the panoramic scene appearing as a mythological, sacral, or villa landscape. The origin of the panoramic landscape is much dis' puted. It has been attributed to Alexandria[68] and to Asia Minor,[69] and it has been claimed as native Roman,[70] by various scholars. Whatever its source, its development took place in Roman painting. Each of the three types of representation mentioned has a somewhat different spatial effect. They are related in that the degree of achievement in optical representa' tion in the figures and objects is approximately the same, but the treatment of the picture plane differs, affecting the impression of depth. Furthermore, the choice of the setting—whether a wall, a prominent group of buildings, or an interior—has a varying influence on such factors as spatial enclosure and the problem of linear perspective.

The mythological scenes which dramatize a single incident generally give

[66] Wickhoff (*Roman Art*, p. 91) suggests that the change from the principle of conventional to local color occurred about the second century B.C.

[67] One of the chief reasons for the association of the prospect scenes with stage design is the close correspondence between the description of the theatrical settings for tragic, comic, and satyric plays, given by Vitruvius (*De architectura* v, 6, 8) and architectural mural decoration such as found in the Boscoreale Villa. Furthermore, Vitruvius (vii, 5, 2) mentions that the walls in private houses were decorated with copies of theatrical scenes. Friend, *Art Studies,* VII (1929), 15, 20; Little, "Scaenographia," *Art Bulletin,* XVIII (1936), 407 ff.; Beyen, *Pompey. Wand' dekoration,* I, 97 ff.; Bieber, *Greek and Roman Theatre,* p. 252.

[68] Diepolder, "Untersuchungen zu Komposition der römisch-campanischen Wandgemälde," *Römische Mitteilungen,* XLI (1926), 10.

[69] Rostovtzeff, "Die hellenistische-römische Architekturlandschaft," *Römische Mitteilungen,* XXVI (1911), 135 ff.

[70] Rodenwaldt (*Pompey. Wandgemälde,* pp. 21 ff.) derives the panoramic landscape from the prospect scenes.

the effect of stage space such as that in the "Aldobrandini Wedding." Rocks, hills, or a temple front were substituted for the wall, as indicated by the content. Above the limited depth of the ground plane, the picture plane is sometimes white[71] and in some cases blue. When it is blue, there is occa- sionally a gradation in the tonalities which creates a more naturalistic at- mospheric environment and suggests greater depth.[72] The structural tri- dimensional recession, however, is limited to the stage of the foreground. On this stage the composition of the figures varies, the suggestion of depth having been exploited to a greater or lesser degree. Thus, in the Pompeian paintings of the third architectural style a comparatively wide unencum- bered space is generally left in front of the action which is composed in a more or less frieze-like manner.[73] In the fourth Pompeian period, on the other hand, a greater effect of depth is achieved by a semicircular or chiasmal grouping of the figures and by diagonal movement inward. This is accom- panied by a tendency to place the objects, such as seats and pillars, at an angle rather than parallel to the picture plane.[74]

In the representation of interiors the effect of spatial enclosure, which is suggested in other scenes by a wall or by hills at the termination of the ground plane, is increased by the nature of the construction itself. The spatial enclosure is directly proportionate to the completeness and clarity with which the adjacent planes of rear, side walls, floor, and ceiling are represented. Furthermore, the depiction of adjacent planes in depth brings the problem of foreshortening through a more organized method of linear perspective into greater prominence. In the paintings of the Roman period, although the setting of the interior may have a definitely boxed form with openings by doors and windows to rooms beyond (Fig. 5),[75] a unified method of perspective delineation was not developed. Moreover, the inter-

[71] Naples, Nat. Mus., "Herakles and Telephos," from Herculaneum (Herrmann, Denkmäler, Pl. LXXVIII). Naples, Nat. Mus., "Venus Punishing Eros," from Pompeii (ibid., Pl. I). Naples, Nat. Mus., "Europa and the Bull," from Pompeii (ibid., Pl. LXVIII).

[72] Naples, Nat. Mus., "Achilles Surrendering Briseis" (Herrmann, Denkmäler, Pl. X). Naples, Nat. Mus., "Perseus and Andromeda," from Pompeii (ibid., Pl. CXXIX).

[73] Rodenwaldt, Pompey. Wandgemälde, p. 83. Naples, Nat. Mus., "Venus Punishing Eros," from Pompeii (Herrmann, Denkmäler, Pl. I). Naples, Nat. Mus., "Europa and the Bull," from Pompeii (ibid., Pl. LXVIII).

[74] Cf. Rodenwaldt, Pompey. Wandgemälde, p. 155; Diepolder, Römische Mitteilungen, XLI (1926), 40. Examples: Naples, Nat. Mus., "Wrestling Match between Pan and Eros" (Herr- mann, Denkmäler, Pl. XLIV). Naples, Nat. Mus., "Herakles and Telephos" (ibid., Pl. LXXVIII).

[75] Naples, Nat. Mus., "Actor of Tragedy," from Herculaneum (Pfuhl, Malerei und Zeichnung, Vol. III, Fig. 653). Naples, Nat. Mus., "Musicians," from Herculaneum (ibid., Vol. III, Fig. 654).

relationship of the planes, particularly with regard to floor and side walls, is frequently obscure, thus preventing a complete and definite impression of tridimensional enclosure. On the whole, the representation of depth corre-sponds to the comparatively shallow and long proportions of stage space, while the walls act somewhat as the coulisses of the set.

In the second type of representation found in Roman painting, the prospect scenes, the nature of the structural features, as in the interior set-tings, favors the effect of enclosed space and organized perspective delinea-tion. The prospect scenes, as exemplified by the decorations in the Villa of Fannius Sinistor, Boscoreale (Fig. 7), and the House of Livia,[76] are street or garden views especially notable for their architectural constructions. The effect of enclosure is derived from the fact that the buildings are usually arranged compactly across the picture plane. Although the picture plane above the architecture may be colored blue, and although there are occa-sional compositions in the form of receding streets, the representation of depth is limited primarily to the tridimensional structure of the buildings, and does not depend upon the transformation of the picture plane into a deep naturalistic space or a vista.

The prominence of the buildings in this type of representation and the number of planes in depth add to the importance of the problem of linear perspective. In general, the roof lines incline downward, and the base lines, where they are visible, ascend. In several instances where receding parallel lines are traced, opposite pairs of lines intersect in such a way as to form, roughly, a vanishing axis.[77] In the same paintings, however, groups of two or, occasionally, more parallel lines lying in the same vertical plane—for example, the courses of a cornice—converge to a point.[78] These vanishing points are numerous for a single scene or even for a single object, and their arrangement suggests no systematized method of construction. The absence of a consistent pattern of convergence leaves little room for the possibility that a focused system of perspective was developed in ancient painting[79] and

[76] Pfuhl, Malerei und Zeichnung, Vol. III, Fig. 708.

[77] Little, Art Bulletin, Vol. XIX (1937), Fig. 4.

[78] Richter, Scritti in onore di Nogara, Pl. LII. The same combination of convergence to points and to a vanishing axis may be observed in the architectural mural of the Villa of Diomede in Pompeii, if the receding lines are traced. (Reproduced in Pfuhl, Malerei und Zeichnung, Vol. III, Fig. 710; Little, Art Bulletin, Vol. XIX [1937], Fig. 5).

[79] The suggestion that the absence of definite evidence of a focused system of perspective in the extant monuments is not conclusive proof that such a system was not used in Roman times

also argues against the assumption proposed by Panofsky and Little, that the vanishing-axis form has a geometric basis. An empirical explanation for the vanishing axis may be found in the simple and orderly alignment of buildings and the predilection for symmetrical compositions.[80] On the whole, one can accept with certainty only the conservative conclusion presented by Richter,[81] that just the general principle that parallel lines converge was observed in Greek and Roman painting.

The panoramic views, in contrast to the prospect scenes and the majority of megalographic representations, achieve the effect of deep tridimensional space even where the picture plane remains a neutral surface. In these panoramic scenes (Fig. 8),[82] as in the Alexander mosaic, the neutrality of the picture plane is overcome by the effective optical representation of figures and objects. The sketchiness and minuteness of the features of the landscape scattered over the picture plane create an illusion of a vast area in depth on what is actually a vertical pictorial surface. Although there is no unity of point of view, and although often the foreshortening is not consistent with the level in depth depicted, diminution in size with apparent recession is frequently observed and the relative scale of the figures to the objects in the landscape is roughly indicated. It is this type of landscape which illustrates the great effect that optical representation may have on the character of the space. Actually, the organization of the scene is not far removed from the type of parallel-plane composition found in Egyptian and in Mesopotamian art, where the figures and objects are spread out alongside and above one another on the untreated or neutral picture plane. But there the conceptual method emphasizes the vertical and two-dimensional form and prevents an illusion of depth. In the Roman landscapes, on the other hand, although the picture plane is neutral and the figures and objects spread out over the entire surface with little overlapping, the impression of depth is remarkably strong. The optical form of the figures and objects, the frequent use of angular views in the buildings, the observation of diminu-

loses much of its force when we consider that in the Renaissance some trace of a consistent vanishing-point perspective may be found in numerous mediocre paintings as well as in the better works.

[80] Hauck, *Die subjektive Perspektive*, p. 56.
[81] *Scritti in onore di Nogara*, p. 382.
[82] Rome, House of Livia, "Yellow Frieze" (Rizzo, *La pittura ellenistico-romana*, Pl. CLXIX).

tion, and the sketchy, or impressionistic, technique create an impression of a bird's-eye view.

There is another group of panoramic scenes, exemplified by the well-known Odyssey landscapes (Fig. 9), in which the picture plane itself becomes tridimensional representative space. In these paintings the representation of figures and objects is essentially the same as in the landscapes described above, although the handling of the individual elements is less cursive. These, especially the coulisse rocks and the statuesque women, resemble the forms used in megalographic scenes. In the Odyssey landscapes the entire pictorial surface has become the ground and sky of an uninterrupted landscape.[83] A sense of depth is created by the vista and by the impressionistic technique—a gradual fading of the colors as they approach the horizon.[84] It is a pseudo-impressionism, however, as has often been observed, for there is no unity in the lighting nor is there any systematic distribution of the color as related to a particular time and place.

The lack of naturalistic unity or systematization, whether in linear perspective or in the treatment of color and light, is a negative characteristic of the painting of the Roman period. The individual components of tridimensional representative space are present; the picture plane may be transformed into the naturalistic environment, and the figures and objects are depicted from an optical point of view, but these factors have not been coördinated according to a measurable system. The figures are foreshortened, and the objects are drawn in parallel or angular views with regard for some of the rudimentary laws of linear perspective. The composition of the whole scene, however, is not constructed with reference to a single point of view which corresponds to the eye of the spectator. Furthermore, although the picture plane may become the environment in which the action takes place, this environment is generalized and vague rather than systematically defined and measurably related not only to the figures and objects but also to the spectator.

[83] In the Odyssey landscapes this holds true for a series of scenes, and the impression received is that a continuous landscape is viewed behind the columns of the architectural framework. Panofsky, Vorträge Bibl. Warburg, 1924-25, p. 269.

[84] The impressionistic effect in the representation of the sky may be observed in some of the large megalographic scenes, such as the "Sacrifice of Iphigenia" (Naples, Nat. Mus., from Pompeii [Herrmann, Denkmäler, Pl. XV]). The "Punishment of Dirce" (Naples, Nat. Mus., from Pompeii [ibid., Pl. CL]) presents an exceptional instance of the suggestion of vista in this type of representation.

Our preoccupation with the question whether the Roman artists em-
ployed a consistent system of perspective tends to overshadow the positive
qualities of their representation of space. The relief composition, the illu-
sionism, and the atmospheric effect of the background are significant char-
acteristics of Roman spatial form that should not be overlooked.

With Roman painting the first stage in the evolution of space and per-
spective is concluded. The table below shows at a glance the chief charac-
teristics of spatial form in ancient painting and summarizes briefly the main
steps in the development. Some of the features do not necessarily appear for
the first time in the culture with which they are related, but they are
dominant in that culture.

DEVELOPMENT IN ANCIENT PAINTING

Culture	Picture Plane	Form of Representation
Palaeolithic	Unprepared	Conceptualized single figure
Egyptian	Prepared; unframed; base line	Conceptualized, synthetic group composition
Minoan	Active; framed	Pure profile of entire body
Assyrian	Neutral; framed	Pure profile of entire body
Greek	Irregular ground lines; cast shadows	Optical
Hellenistic	Tridimensional stage-space	Optical
Roman Empire	Deep tridimensional space; atmos-pheric gradation	Optical, synthetic group composi-tion in depth

During most of the period of ancient art the attention of the artist
was focused principally on the representation of the figures and the objects.
In general, the picture plane played a secondary role. It is important for the
evolution of spatial form to note that in the course of time this plane
changed from an unprepared material surface to a prepared, framed, and
colored pictorial surface. For a long time the picture plane was treated as a
surface, and only in the late Hellenistic and Roman periods have we evi-
dence of its transformation into a tridimensional space. The last step, which
appears as stage and impressionistic, or illusionistic, space, occurs after the
representation has become optical.

The representation of the figures and objects evolved from a conceptual
to an optical form. If the period of ancient art is taken as a whole, the stages
in the evolution follow each other successively, although they may coincide
with the transfer of ascendency from one cultural tradition to another.

Thus the principle of representation in Egyptian painting is conceptual. In some work of the New Kingdom a slight tendency in the direction of an optical point of view may be detected. This tendency also appears in Minoan and Assyrian art. The more revolutionary changes toward optical representation—revolutionary in that they were apparently more consciously directed and comparatively more rapid—occurred in Greek art. Thus the evolution is not necessarily continuous and steady, but irregular, with the trend more marked at some times than at others.

It may be noted that in both conceptual and optical painting the representation of the single figure developed into the composition of a group. Although in conceptual representation group composition is necessarily limited by the parallel-plane method, the development may be illustrated by comparing palaeolithic painting with Egyptian painting of the New Kingdom. In optical representation, with the emancipation of the figures and the objects from the confines of the vertical plane[85] the development reaches a stage in which figures are composed in a group which shows some degree of intercommunication among the figures in the scene. This may be seen by comparing the Polygnotan type of spatial composition, found in the Orvieto crater, in the Louvre,[86] with the Hellenistic form as exemplified in the mosaic of the "Battle of Alexander and Darius." In Roman painting a step farther is taken when the picture plane is made the general environment of the optically depicted figures and objects. Besides the communication between the figures, their coexistence in a naturalistic setting is indicated. It should be mentioned once more, however, that although in Roman painting optical representation reached this stage of coördination, as far as can be judged from extant paintings no systematic method unifying the whole scene with reference to the eye of the spectator was employed. Figures and objects were not constructed according to a definite interrelated system extended to include the picture plane as a whole. The relation of the figures to the background was casual rather than integrated in such a way that they would be inseparable, as it is in the organization afforded by the focused method of perspective.

A systematic and mathematical method of representation was not developed immediately from the heritage of Roman painting. Such a system re-

[85] See Riegl, *Spätrömische Kunstindustrie*, p. 249.
[86] Swindler, *Ancient Painting*, Fig. 351.

quires interest not only in the optical form of representation of individual objects, but also in a more pervasive unity in depicting optically figures and objects in a tridimensional environment—the whole to be conceived from a consistent point of view with reference to a spectator. To obtain this effect the picture plane as such must disappear entirely. It must be transformed into a concrete representation of what surrounds the figures and is subject to the same visual laws as the latter.

EARLY CHRISTIAN PAINTING AND THE CAROLINGIAN PERIOD

EARLY CHRISTIAN PAINTING

THE BASIC forms of spatial representation found in Roman painting, stage space and the impressionistic, or illusionistic, backgrounds, pass into early Christian art[1] and then in turn into medieval painting.[2] Until this time the figures and the objects have been the principal carriers of the spatial form. The stage space and the illusionistic effect of Roman painting are due more to the optical representation of the figures and objects than to a substantial construction of the space itself.

In the course of early Christian and medieval painting the evolution of a substantial picture plane may be discerned. The change begins, paradox ically, with the gradual elimination of tridimensional values and the devel opment of conceptual arrangements which are mingled with vestiges of optical forms.[3] These tendencies do not start abruptly with early Christian

[1] Wickhoff, *Roman Art*, p. 1; Riegl, *Spätrömische Kunstindustrie*, p. 11; Degering and Boeckler, *Die Quedlinburger Italafragmente*, p. 165.

[2] Morey, *The Sources of Medieval Style*. The distinction between stage and illusionistic space differs from Professor Morey's two divisions of Hellenistic art, the "Neo-Attic" and the "Alex andrian" in that it is based on more specific spatial elements. The term "Alexandrian," in par ticular, as employed by Professor Morey has broader implications. From his general divisions of Neo-Attic and Alexandrian, Professor Morey makes further classifications in the course of early Christian and medieval painting based on combinations of features of both styles or on a develop ment of part of one. In this study, however, the original distinctions based primarily on the principles of stage space and illusionistic space are maintained throughout. Since these spatial principles are not the sole determining factors in Professor Morey's sources of influence, his classifications of some of the paintings differ from those suggested in this study.

[3] The term "optical" is used here in the same sense as described in the Introduction (*vide supra*, p. 5). This differs from Riegl's use of the term and from his *fernsichtig*, which have psychological significance.

painting, having been observed in late classic sculpture, in which decorative colorism gradually replaced the illusionistic method. This was accompanied by the substitution of linear, individualized, and schematic forms for the earlier intercommunicating groups of figures composed from an optical point of view in a tridimensional, if cursive and limited, environment.[4] The late classic movement toward the elimination of tridimensional space and the solidification and telescoping of the optical forms was continued and intensified in early Christian painting, but although modified by these tendencies, the two types of picture plane, the stage and the illusionistic, may still be distinguished.

Stage space in Roman painting depended on the more or less definite indication of a ground plane. The perpendicularity of the ground plane to the picture plane was clarified by its relation to figures with cast shadows and to the coulisse arrangement of rocks and architecture. In the early Christian period the ground plane gradually becomes a solid, crisp, sharply defined band (Fig. 10).[5] The perpendicularity, insofar as it depends on the figures and the cast shadows, disappeared slowly as the misunderstanding of the nature of the shadows and the method of representing them increased and as the tendency arose to place the figures themselves in isolated alignment along the upper edge of the ground plane or on the base line of the picture plane. When this happened the ground plane recovered the status of a vertical surface, but a substantial surface whose tridimensionality, although not employed, was made implicit by preserving the band. The coulisse-like objects tended to diminish in size in proportion to the figures and the extent of the picture plane or to disappear altogether. This is especially noticeable in the Italian mosaics other than those at Ravenna. The rear boundary of the ground plane is formed no longer by rocks and buildings but by the background itself, which is an active pictorial surface of a uniform blue or gold. This type of picture plane—actually a two-dimensional surface, but with vestiges of stage space and yet more concrete in form than the picture plane was in Roman painting—with only slight modifications appears in Italian and Byzantine painting until the end of the Middle Ages.

[4] Riegl, *Spätrömische Kunstindustrie*, pp. 127 ff.; Strong, *Roman Sculpture*, pp. 333 ff.; Degering and Boeckler, *Die Quedlinburger Italafragmente*, pp. 164-65; Lehmann-Hartleben, *Die Trajanssaüle*, p. 154.

[5] Rome, SS. Cosma e Damiano, mosaic of the apse (Komstedt, *Vormittelalterliche Malerei*, Pl. LXXI).

In the other type of picture plane, which is derived from the illusionistic representative backgrounds as found in the Odyssey landscapes, the tend-ency was also to reduce the pictorial space to a two-dimensional surface. Although in some instances the impressionistic effect of Roman painting persisted to a great degree in early Christian art, the color (which played freely over the picture plane, creating the effect of atmosphere) began to fall into horizontal zones, which were gradually more sharply defined (Fig. 11).[6] As long as the color is related to representative elements, this may be called stratified space.[7] Although examples of it are somewhat limited in the early Christian period, in the Carolingian Renaissance it was employed with important consequences for the subsequent course of painting in the north.

In the representation of figures and objects the same predisposition toward surface composition is evident. Again it must be stressed that the change was gradual and can be followed step by step. The optically repre-sented figures of Roman painting were arrested in a few typical positions so that eventually a uniform, conventional figure became traditional. The figure turned in three-quarters view toward the spectator is the most impor-tant type. So frequently was it used and so persistently does it appear in painting until the Renaissance, that it acquired the character of a fixed rule analogous to the crystallization of the form of the figures in Egyptian paint-ing. The choice of the three-quarters view is a natural one, for it is the posi-tion most often used in the presentation of the figures in an intercommuni-cating group. But in early Christian painting the original purpose of that position lost much of its significance due to the uniformity of the angle at which the figure is turned and the tendency to align the figures as isolated forms on the picture plane. The result was a figure only partially related to

[6] Other illustrations: Rome, Vatican, MS lat. 3225, Virgil (Codices e vaticanis selecti, Vol. I). Berlin, Preuss. Staatsbibl., and Quedlinburg, St. Servatius Stiftspfarre, Itala (Degering and Boeckler, Die Quedlinburger Italafragmente). Rome, Vatican, MS lat. 3867, Virgil (Codices e vaticanis selecti, Vol. II). Milan, Ambrosiana, MS F. 205. P. inf., Iliad (Ceriani, Homeri Iliadis pictae fragmenta Ambrosiana). Florence, Bibl. Med. Laur., MS 1, Amiatinus (Komstedt, Vormittel-alterliche Malerei, Pl. CXIII). For a detailed discussion of the spatial form and the chronological relationship of the two Vatican Virgils, the Quedlinburger Itala, the mosaics of Santa Maria Maggiore, and the Ambrosian Iliad see Degering and Boeckler, Die Quedlinburger Italafragmente, pp. 165 ff.

[7] Köhler (Die karolingischen Miniaturen, I [Pt. II], 310) uses the term Schichtenraum, here translated "stratified space," to describe the same form in Carolingian manuscripts.

the rest of the scene and, for the most part, apparently staring contem-
platively into the void in front of the picture plane. The representation of
the eye plays an important part in this impression, for its shape is not con-
sistent with the point of view in which the rest of the figure is drawn. The
frontal eye is used almost exclusively, and when the pupil is in the center it
enhances the effect of meditative preoccupation beyond the immediate vicin-
ity of the scene. Much of the religious expressiveness of early Christian
painting is due to this. The eye may, however, be used to indicate the rela-
tionship of the figures. This relationship is effected by general direction
rather than direct glance. The direction is not indicated by the tridimen-
sional expedient of turning the head so that it faces the other figures, for the
three-quarters view is fixed. The direction is expressed in a conceptual man-
ner on a two-dimensional plane by the tilt of the head, so that a line pro-
longing the horizontal axis of the eye roughly indicates the focus of the
figure's attention.[8] When the pupil is placed in the corner of the eye, it helps
to propel the direction of the glance.[9]

The combination of the two tendencies, (1) to isolate the figure and
(2) to direct its attention away from the pictorial field, resulted in a predi-
lection for the frontal position. The frontal figure, although not so expedient
in narrative representation, is especially well adapted to hieratic and cere-
monial scenes,[10] and the Byzantine court as well as Christianity provided
ample opportunity and models for this type of representation.

With regard to buildings and objects the two-dimensional tendency was
manifested by telescoping the whole into a flat form, that is, all the parts
which would be visible in optical representation are here depicted without
foreshortening as if they were on the same level, or else the object is simply
indicated by an elevation of the façade or a cross section.

It was mentioned above that in the composition of groups the tendency
was to isolate the figures and to align them along the picture plane. There is
also a form of collective isolation which Berstl calls "cubic groups."[11] This
form is typical of early Christian representation. The cubic group consists

[8] Schapiro, "The Romanesque Sculpture of Moissac," Art Bulletin, XIII (1931), 482.

[9] Riegl, Spätrömische Kunstindustrie, p. 246.

[10] Rome, SS. Cosma e Damiano, mosaic of the apse (Komstedt, Vormittelalterliche Malerei,
Pl. LXXI). Ravenna, S. Vitale, "Justinian, Archbishop Maximian, and Attendants" (ibid., Pl.
LXVI).

[11] Das Raumproblem, pp. 42 ff.

of a number of elements combined to preserve the interrelationship for clarity of exposition. Several figures massed to form a crowd, a compact arrangement of landscape motives including animals as well as vegetation, or a closely packed jumble of roofs, towers, and walls to indicate a city, are some of the typical cubic groups encountered. The group as a whole under' went the same modifications as did the individual object and figure. The original optical arrangement was almost lost in what seems to be simply schematic juxtaposition on a vertical plane. The telescoping and the some' times arbitrary juxtaposition of the elements tended to eliminate the con' sistency of the point of view, resulting in a conceptual arrangement of pro' file and front elevations combined with ground plans. The isolation of the individual figures and cubic groups and the tendency to represent them on a vertical plane frequently led to a conceptual form of organization in the scene as a whole. Hence, an object that is intended to be behind may be extended to the side or above or else completely disconnected from the figures or objects to which it is related spatially.

It has often been observed that the spatial form of early Christian art is expressive of the content of early mystery cults and Christianity, and consequently due to contact with oriental methods of representation.[12] In reference to the oriental form, the nonplastic and two-dimensional quality of the figures and their relation to a vertical picture plane rather than to a tridimensional pictorial space has been observed. The tendency toward two-dimensionality, individualized composition, the expression of hierarchy, together with a feeling for richer decorative surface effects—as has been mentioned—appears in late Roman sculpture and coincides with the spread of oriental cults in Roman society.[13] The lack of a systematic method of representing tridimensional space and of a substantial concept of space itself facilitated the modification of the optically visualized forms of Roman painting. Early Christian and medieval religious ideals gave added impetus to these tendencies. Many features expressive of the religious con' cepts are reflected in changes in the pictorial form. The emphasis on a transcendental rather than on the experienced world favored a symbolic rather than a wholly imitative art. The symbolism, however, was not pre' sented in diagrammatic form. It retained a basic reality as an aid to its didactic purpose. The tridimensional illusion of space was superseded by a

[12] Ibid., pp. 41, 52 ff. [13] Strong, Roman Sculpture, pp. 306, 342.

form which has less variability. In place of the atmospheric medium a fixed gold or blue background or definite bands were used. Blue and gold, in contrast to other colors, express the special environment surrounding the religious figures, for these colors enrich the setting not only by their association with precious materials but also by their symbolic significance: blue for Heaven; gold for Divine Light. Other features of the modified form, such as the tendency to frontal position, isolation, and hierarchic composition, express the hieratic ceremonial qualities of religious representations in which each individual has a fixed place that is determined not so much by his activity and spatial position in connection with the other figures as by qualities which set him apart and are symbolized by his presence rather than by his behavior. In narrative scenes, in which the activity of the figures must be depicted to some extent, compositional relationships from a spatial standpoint are secondary to the didactic clarity of the message. The emphasis, as in dramatic presentation, is on the principal figure and the significant gesture, and factors which would distract the attention of the spectator or obscure the principal phase of the action or the meaning are eliminated as much as possible. Hence, features of the environment, the setting, and subordinate figures are presented in a brief indicative form and as cubic groups.

In an interpretative analysis of the tendencies in early Christian and medieval art, the fact that much of the painting, especially the illumination of manuscripts, is the work of copyists must be borne in mind. The copyist, like the scribe, was engaged in a task which itself was considered to be of a religious nature, and his work was in accord with the religious ideals. He did not renew and verify his images by referring to the living world, but rather preserved the form of his pictorial models. This favored the development of forms derived from the reduction or misunderstanding of the original model and at the same time intensified the movement away from an art based primarily upon optical representation.

Spatial form in early Christian art is thus the result of many factors operating on the optical representation in Roman art. Briefly, the spatial character may be described as the reduction of tridimensional figures and objects to two-dimensional forms on a vertical surface. The forms are, however, sharply defined areas which retain a hint of their previous optical characteristics. In accordance with the tendencies in the representation of the figures, the picture plane became a concrete background which is not de-

pendent on the figure or its accessories for constructive features. It is some-times symbolic, as when gold was used, and it is sometimes but a solidi-fication of an illusionistic representative space, but above all it is a definite pictorial surface.

THE CAROLINGIAN PERIOD

In the medieval period there are distinguishable in the development of the background two different courses which derive from the two types of spatial representation—the stage and the stratified—found in early Chris-tian painting.[14] In the eighth and ninth centuries there is discernible the beginning of a fairly definite geographical distribution which continued until the Renaissance. In Italy, however, at first both types appeared, continuing without interruption the forms and the tendency toward the elimination of tridimensional values observed in the early Christian period. A number of illustrations of stage space may be found, especially among the mosaics. The apse of Santa Prassede (Fig. 12) is a typical example. The component parts of the representative background have been reduced to the simple form of two bands of unequal width. In the larger of these, the sky, the uniformity of the color, and the schematization of the clouds result in the elimination of any effect of depth. The ground, which is the narrow band, appears as a cross section rather than a horizontal plane, for the figures do not stand within the plane itself but rather hover near the upper edge. The relation of the figures to the ground is occasionally more definite, as in the "Angels Leading the Elect" in the same church,[15] where the figures form a frieze near the upper contour of the ground plane, but within the plane, and thus pre-serve to some extent the effect of the ground as a horizontal member.

In the apse mosaic the frieze formation of the figures, the isolation of one figure from the other, and their frontal position accentuate the lack of depth in the background. In the individual figures the linearity of the structure in place of modeling is in accordance with the tendency to flatten the composi-tion to a single plane. The ceremonial quality which is brought out by the symmetrical composition and by the static poses of the figures is further em-

[14] Hinks (*Carolingian Art*, p. 164) makes a different kind of distinction which he calls coulisse and "bird's-eye view," attributing the former to Asiatic sources and the latter to Roman Alexandrian. The Boscoreale prospects exemplify the coulisse type, and the topographical land-scapes, the "bird's-eye view."

[15] Muratoff, *La Peinture byzantine*, Pl. LXIII.

phasized by the use of hierarchic scaling, whereby the figure of Christ is represented considerably larger than the others in the scene. Yet, despite the disregard for the laws of optical perspective with respect to the size of the figures and despite the consistent reduction of tridimensional values in the background, a vestige of stage space, which is essentially a tridimensional representation of space, remains as a result of the juxtaposition of a narrow ground plane band to a broad surface of sky. Even when representative color and objects are to a great extent excluded, the contrast in the sizes of the two planes preserves the distinction between them as ground and background proper and consequently some illusion of stage space.

The significance of the divisions of the background may be observed by comparing the apse mosaic of Santa Prassede with the fresco of a scene from the Old Testament in Santa Maria Antiqua (Fig. 13). In the latter, stratified space—the second type of background found in early Christian painting—is used. The tendency to separate the colors of the pseudo-impressionistic backgrounds into horizontal zones reaches the stage in which the bands are definite and of uniform color. This affects the spatial relationships in the picture in two ways. First, in contradistinction to the Santa Prassede type of background, the ground loses its identity as a plane different from the plane of the rest of the background and is seen instead as one of a series of bands. Even when the bands vary in width, as in the fresco of the "Assumption of the Virgin," in San Clemente (Fig. 14),[16] where the second band is considerably wider than the others, the ground plane is a member of the whole zoned arrangement rather than an essential part of an implied tridimensional relationship. Secondly, the stratification affects the relationship between the background and the figures. It is the first step in the disassociation, or discoördination,[17] of the two. The pseudo-impressionistic back-

[16] The representation of Pope St. Leo IV (847-55) with a square nimbus makes the middle of the ninth century the approximate date of the fresco. Cf. Nolan, The Basilica of S. Clemente, pp. 124-26. The Santa Maria Antiqua fresco is earlier than the S. Clemente "Assumption." It is grouped with the frescoes in Santa Maria Antiqua that are dated about the beginning of the eighth century. See Avery, "The Alexandrian Style at Santa Maria Antiqua, Rome," Art Bulletin, VII (1925), 146 ff.

[17] The term "discoördination" is employed to express the relationship that exists between two features, such as the composition of the figures and the background, each of which gives the impression of having been composed independently and brought together without a definite systematic or proportional connection between their individual parts. It does not necessarily signify that the relationship is inharmonious or that it lacks pictorial unity. Hence, the use of the particular word "discoördination," to avoid the negative and derogatory impliciation of "unco-ordinated." See Schapiro, "The Sculptures of Souillac," Medieval Studies in Memory of A. Kingsley Porter, p. 362.

grounds of Roman painting create an atmospheric medium—although vague insofar as measurable spatial relationships are concerned—in which the action takes place. The stratification lessens the ambient, tridimensional quality of the background and erects the pictorial surface as a foil behind the figures. The more definite the bands, the more decided is the transformation of the background into a vertical plane. When the color of the zones can no longer be associated with a naturalistic environment, the background emerges as a construction independent of the action of the figures. In this period in Italian painting the discoördination of the background and the figures is in a transitional stage. The background as a whole has become a vertical plane, but the position of the figures in connection with the lowest stratum, which is the ground plane, preserves some effect of the naturalistic relationship. In the Santa Maria Antiqua illustration (Fig. 13) the figure stands within the ground plane. In the "Assumption" of San Clemente (Fig. 14), however, with the exception of St. Leo at the left and St. Vitus at the right, the figures are massed on the upper edge of the ground plane rather than within it.[18] Representative elements of the background are retained to some extent. In the frescoes of Santa Maria Antiqua the ground plane occa- sionally has an irregular contour with some indications of vegetation cling- ing to it. In general the color of the bands cannot be said to be arbitrary although the tones are not naturalistic. The lower bands are usually either green, yellow, or red, whereas the upper strata commonly include blue. Given a choice of the colors found in the spectrum of the sunset sky, one cannot state that the colors used in these frescoes have no connection with reality, yet, although there are vestiges of naturalistic elements, the impres- sion created by the tones and the schematic form of bands is definitely non- naturalistic.

From this brief description it is clear that Italian painting in the eighth and ninth centuries carried on without interruption the course, followed in the early Christian period, of gradual elimination of tridimensional space from the background, employing either the stage or stratified form as the basis. The tendency to reduce the elements of the background to two-dimen- sional planes serves to accentuate the difference between the two forms.

[18] The different position and the immobility of the figures of SS. Leo and Vitus, in contrast to the other figures who represent the Apostles, may be explained by the fact that the Saints are not historically part of the scene. Nolan, *The Basilica of S. Clemente,* p. 124.

Although both types were used in Italy at this time, elsewhere a distinct regional distribution may be noted. In Byzantine painting the backgrounds adhere to the principle of stage space, whereas the early Christian stratified background became the model for Carolingian illumination. Both Byzantine and Carolingian painting differ from the contemporary Italian painting in that the elimination of tridimensional values had not progressed so far.

The number of extant Byzantine manuscripts of this period is scarce, partly due to the fact that there were iconoclastic persecutions under Constantine V (753-787) and Theophilus (829-842), and two destructive library fires, one in the Octagon and the other in the patriarchate of S. Sophia.[19] From the manuscripts which have survived, from the Homilies of Gregory of Nazianzus[20] in particular, some idea of the spatial character may be ascertained. The construction of the background according to the principle of stage space is more clearly expressed than it is in Italian painting because the tendency to reduce the picture plane to a vertical surface is not as strong as it was in Italy and because the additional element of a high background object, which is frequently present, helps to preserve the effect of the perpendicular relation between the ground plane and the background proper.[21]

Generally the background consists of sky, a high background object— either a building or rocky hills—and a ground plane. The sky is usually blue, occasionally rose, and it is shaded somewhat to create an atmospheric effect.[22] Only one color is used, however, and the tonal variations are not distributed in any regular zoned fashion. Some impression of an ambient medium is achieved by this treatment of the sky, but in other manuscripts there is a tendency to replace this atmospheric area by a uniform blue or, later, gold background. Here, the uniformity of the color produces a vertical surface. One should observe, however, that gold is a medium in which special light effects are created by the luster from the material itself.

In the Homilies of Gregory of Nazianzus the background objects, in keeping with the depth created by the tonality of the sky, are tridimensional at the top. The rocks have high-lighted horizontal planes. This type of rock

[19] Ebersolt, La Miniature byzantine, p. 16.
[20] Paris, Bibl. Nat., MS gr. 510.
[21] Paris, Bibl. Nat., MS gr. 510, Homilies of Gregory of Nazianzus, fol. 347v, "Samson, Gideon, and Isaiah" (Omont, Manuscrits grecs, Pl. XLIX).
[22] Ebersolt, La Miniature byzantine, p. 20.

becomes a formula for landscape construction that continued in Byzantine art for several centuries. The buildings are frequently at an angle, the slant of the roof lines indicating the recession and, in a general way, the point of view. Whether this is high or low seems to be a matter of chance, since there is no consistent point of view for the whole scene. At the base, however, of both the rocks and the buildings the planes in depth are usually telescoped to a single frontal plane terminated by a horizontal base line. The background object generally rests on the upper contour of the ground plane. Occasionally, where the ground plane consists of two narrow bands, the object rests on the upper contour of the lower band. The meeting of the background object and the ground plane is definite, with the result that the two planes are distinct. The obvious verticality of the façade of the buildings or rocks brings out the horizontal nature of the long and narrow ground plane with which it is related. Thus, the effect of the limited tridimensionality of stage space is maintained not simply by the contrast of a large surface above a narrow one, as in the Italian mosaics, but also by the emphatic termination of the narrow ground plane by a representative, vertical object.

The appearance of the ground as a horizontal plane is helped by the fact that the figures often stand within it, but the tendency to place the figures on the contour of the ground plane or on the frame is encountered in Byzantine as well as in Italian painting.

Although stage space predominates in Byzantine illuminations, other ways of handling the spatial elements occur. For the story of Jonah in the Homilies of Gregory of Nazianzus (fol. 3),[23] a panorama is employed to accommodate the various incidents of the text. The high point of view in which the greater part of the picture plane is the ground is also used where the figures are numerous, as in the "Crossing of the Red Sea."[24]

In a number of portraits of the evangelists[25] the spatial character differs from that in the narrative scenes. The picture plane is a uniform gold background with no ground plane. The only objects are those connected with the evangelist: his seat, footstool, and writing desk. These are usually represented in a compact, connected group touching the frame at some point. In this type of scene the picture plane is a positive, nonrepresentative pictorial

[23] Omont, Manuscrits grecs, Pl. XX. [24] Ibid., Pl. XLII.
[25] Paris, Bibl. Nat., MS Coislin 20 (Omont, Manuscrits grecs, Pl. LXXX). Paris, Bibl. Nat., MS Coislin 21 (ibid., Pl. LXXXIII).

surface, in which the quality of the medium used combines the two elements, light and preciousness, which so aptly interpret the religious nature of the content. Such backgrounds are significant spatially and show to what extent the tridimensional, representative background was considered unnecessary and was given up in favor of a richer material which has symbolic value. Except in the portraits of the evangelists, the departure from the representa' tive background was not so radical. In the narrative illustrations, even where gold replaces the blue of the sky, the divisions of the picture plane and the representative features which remain contain some signs of the tradition of stage space. It is this factor which distinguishes the Byzantine background from the Carolingian.

Carolingian painting differs from both Byzantine and Italian in that it is, not the product of a continuous indigenous development, but the result of a conscious effort to assimilate the art of a different region and an earlier period. Before the establishment of the Carolingian empire art in the north differed in purpose and in ideal from the classic and Christian art of the south. Until the second half of the eighth century the infiltration of classic forms and Christian content from Italy was hardly enough to do more than color the native Folk-wandering art without changing its dynamic and linear character. With the advent of Charlemagne and the establishment of the Holy Roman Empire, however, a deliberate attempt was made to imitate the form as well as the content of early Christian art. The Carolingian Renais- sance played a major role in the relatively minor issue of the history of space and perspective, for in the selection of prototypes the direction of the evolu- tion of space in the north was, to some extent, determined. Carolingian illumination was modeled upon fifth- and sixth-century art rather than upon contemporary Italian painting, and the type of background preferred was derived from the impressionist landscapes in which stratification was already manifested (such as the Vatican Virgil [No. 3225], the Quedlinburg Itala, and the mosaics of Santa Maria Maggiore) and in which there was a wide range of color. This preference may be explained in part, perhaps, by the fact that previously the artist of the north was concerned primarily with surface pattern rather than with tridimensional, representative space. The variety of color and the opportunity for contrast in the stratified background offered a compensation for the lack of linear pattern, while the lack of clarity from a naturalistic spatial point of view was not disturbing, since it

had not been an essential factor in the native art. Furthermore, the stratified arrangement of a series of zones on which the figures are superimposed was more in accord with the pre-Carolingian principle of overlapping layers of ornament than was the form containing vestiges of stage space.

Although there are marked stylistic differences in Carolingian illumination which have led to the classification of the manuscripts according to schools, such as the Franco-Saxon, Ada, Tours, Reims, and Corbie, there is an underlying similarity in the treatment of the picture plane in the manuscripts as a whole. The handling of the picture plane in the Carolingian illuminations is representative insofar as the features of the natural environment are recognizably portrayed, but, as in the early Christian prototypes mentioned, the color is distinctly graded so that instead of a fused atmospheric spaciousness throughout the background there are more or less pronounced horizontal divisions. The tendency to grade the color into horizontal zones varies. Examples of backgrounds occur in which the color is fused to such an extent that some atmospheric effect remains despite the horizontal divisions (Fig. 16). In other illustrations the stratification of the background produces a series of bands with sharply defined contours (Fig. 15). Despite the stratification, the color remains representative. Scenes such as "Christ in Majesty," and illustrations for the Apocalypse are sometimes exceptions, as are those in the Vivien Bible,[26] for the content does not require a naturalistic setting. The fact that these scenes are banded without reference to naturalistic effect indicates how generally the horizontally zoned background was used. Usually, however, representative elements were retained which act as links between the background and the figures. The strength of the connection depends to a great extent on the presence of a ground plane, on architectural constructions in the background, and on the position of the figures in relation to these. In Carolingian illumination several different ways of handling this relationship may be distinguished.

The "Genesis" in the Moutier-Grandval Bible (Fig. 15) illustrates one method. The stratification of the background is definite, the ground plane forming the first band.[27] The ground plane is distinguished from the rest of the background, however, by its function, for it serves as a support for the

[26] Paris, Bibl. Nat., MS lat. 1, fol. 415v (Köhler, Die karolingischen Miniaturen, Pl. I, 75). The colors are blue-gray, violet, and blue-gray. Ibid., I (Pt. II), 37.

[27] In another illustration from the same Bible, "Moses Reading the Law," the ground plane itself has been stratified into two bands (Köhler, Die karolingischen Miniaturen, Pl. I, 51).

figures, which are occasionally placed within the plane, but frequently stand on its upper contour. In these scenes the contour is further differentiated from the rest of the strata by its irregular shape, which gives the impression of uneven ground. The irregular contour and the tendency to stand the figures on it give the ground plane the form of a cross section—in other words, a vertical plane—rather than the form of a plane perpendicular to the background.[28] Thus, despite the preservation of characteristics of function and shape, the ground is treated like the rest of the picture plane, where the stratification produces a series of sections that combine to make a vertical plane behind the figures.[29]

A different treatment of the ground plane in relation to the background on the one hand and to the figures on the other may be observed in other illuminations in which there is more pronounced uniformity in the representation of the elements of the picture plane than there is in the "Genesis" of the Moutier-Grandval Bible. In these illuminations the ground plane is not distinguished from the rest of the background by its contour or its function, but it becomes one of a whole series of zones in the same vertical plane. This is illustrated in the "Genesis" of the Bible of Charles the Bald,[30] commonly called the Vivien Bible after its donor, and in the "Presentation Page" of the same book (Fig. 16). In the "Presentation Page" the ground plane consists of the lowest two strata of the background, but it no longer functions as a direct support for the figures. This service is performed by individual ground lines, or occasionally, as in the Expulsion scene of the "Genesis," by a collective ground line. Since these ground lines appear despite the fact that a ground plane is represented, and since they are often individualized, it is quite possible that they are the vestiges of cast shadows transformed into their present appearance and use by repeated copying with-

[28] Köhler (Die karolingischen Miniaturen, I [Pt. II], 20) calls this type of representation Bühnenraum ("stage space") because the ground plane supports the figures and differs from the rest of the background, in contradistinction to the Schichtenraum ("stratified space") of the Vivien Bible. In this study the terms "stage space" and "stratified space" are employed to characterize the background as a whole including the ground plane. Used in this way the term "stage space" would not be applicable to the "Genesis" of the Moutier-Grandval Bible. The distinction between the terms as they are used here is clarified in the discussion of the backgrounds in Italian and Byzantine painting (vide supra, pp. 44 ff.).

[29] Other illustrations of this type may be found in: Bamberg, Bibl. Roy., MS H. J. IV. 12, Arithmetic of Boethius, fol. 2v (Boinet, La Miniature carolingienne, Pl. LVII). Paris, Bibl. Nat., MS lat. 1152, Psalter of Charles the Bald, fols. 1v, 3v, 4 (ibid., Pls. CXIII, CXIV).

[30] Paris, Bibl. Nat., MS lat. 1, fol. 329v (Boinet, La Miniature carolingienne, Pl. XLVII).

out understanding their original spatial significance. The "Presentation Page" shows that to a considerable extent the ground lines have superseded the ground plane as a support for the figures, for more than half the figures and the enthroned king are placed in the sky area of the picture plane. The position of the figures in relation to the background is usually not so unnaturalistic. The ground lines, which act as a link between the figures and their environment, generally appear in the ground plane, which, as has been mentioned, is the lowest zone in the uniformly stratified background.[31]

The pen drawings on an untreated picture plane in the Utrecht Psalter[32] fall into a class by themselves, but they are closely related to the second type of manuscript described. Although there is no framed picture plane with a stratified background, the action is carried through on the ground lines, which here not only assume the function of the ground plane as a support for the figures but also represent the environment.

Just as the drawings in the Utrecht Psalter may be considered a reduced version of the form found in the Vivien Bible, so the illuminations in the Golden Psalter of St. Gall[33]—where the action is supported on fragments of irregular ground planes against an untreated picture plane—may be classed as a reduced form of the type of ground observed in the Moutier-Grandval Bible.

The third variation in the composition of the picture plane found in Carolingian miniatures retains the feature of stratification, but in contradistinction to the first two types, a high object, either a building or a hill, becomes part of the background. The high background object which characterizes these illuminations appears for the most part, although not exclusively, in scenes portraying the evangelists. Generally the background object is large, higher than the seated evangelist; and with few exceptions[34] it extends across the whole scene from frame to frame. This extension accords with the prevalent tendency to emphasize the horizontality of the elements of the background, and at the same time it weakens the impression of the

[31] For another illustration of this type of background see Paris, Bibl. St. Geneviève, MS 1190, Gospels of St. Frambourg of Senlis, fol. 14v (Boinet, *La Miniature carolingienne*, Pl. LXXXII).

[32] Utrecht, Bibl. de l'Université, MS 32 (Boinet, *La Miniature carolingienne*, Pls. LXI-LXV).

[33] St. Gall, Stiftsbibl., MS 22 (Boinet, *La Miniature carolingienne*, Pl. CXLV).

[34] Exception: Berlin, Preuss. Staatsbibl., Lat. theol. Fol. 730, Gospels of Prüm (Boinet, *La Miniature carolingienne*, Pl. XXXVI).

cubic value of the object.[35] In architectural background objects the horizontal courses of the building are stressed. Projections of the façade are indicated by inclined lines in the upper part of the construction. At the base of the building the junction with the ground is indefinite, as can be seen in the St. Luke of the Ada Gospels.[36] This affects the spatial character of the ground plane, because it obscures the perpendicular relationship between it and the background object. In this respect the Carolingian form differs from the Byzantine, where there is a more definite juxtaposition of the two features. The indefinite juncture between the object and the ground supplies a vulnerable point for the breakdown of the representative features of the background, as will appear from the "St. Matthew" of an Evangeliary, in the British Museum (Fig. 17). Here some articulation has been retained in the upper part of the walls, but a fairly large part of the background between the ground plane and the building has been transformed into a series of irregularly shaped horizontal zones of no architectural significance.

Without maintaining a strict chronological succession, but within the broad limits of the Carolingian period, the changes that occur in the representation of the architectural background object may be said to be: first, the reduction of the plasticity of the building by relinquishing the articulation of the façade, thereby emphasizing the vertical two-dimensional surface of the background; and, secondly, the loss of representative characteristics, such as brick work and windows. The horizontal courses are the last vestiges of the building that are given up. This is to be expected when the strong tendency to divide the background into horizontal zones is considered.

[35] The architectural background of "Moses Reading the Law" in the Moutier-Grandval Bible (London, Brit. Mus., Add. MS 10546, fol. 25v [Boinet, La Miniature carolingienne, Pl. XLIV]) is exceptional in that it represents an interior clearly. The impression of depth is created by the converging lines of the coffers in the ceiling of the portico, but it is lost in the side walls, where the perspective has not been carried through consistently in the representation of the curtains and the juncture of the walls with the ground. Hinks (Carolingian Art, p. 169) remarks on the rarity of an adequate representation of an interior in Carolingian illumination. He compares this scene with the "Death of Dido" in the Vatican Virgil (MS lat. 3225, fol. 40 [Komstedt, Vormittelalterliche Malerei, Pl. XXXII]), in which the converging coffers of the ceiling form a conspicuous part of the construction. It is noteworthy that this unusual feature is found in early Christian manuscript in which the backgrounds of the other scenes are stratified. In the Carolingian Evangeliary of St. Livinus (Ghent, St. Bavon, Church Treas.) the settings in the representations of SS. Matthew and John suggest shallow interiors; for the ceilings, as in the "Moses Reading the Law" of the Moutier-Grandval Bible, are constructed of coffers, the receding lines of which converge. Köhler, "Die Denkmäler der karolingischen Kunst in Belgien," in Belgische Kunstdenkmäler, Vol. I, Pls. II-III.

[36] Trier, Stadtbibl., MS 22 (Boinet, La Miniature carolingienne, Pl. VIII).

In some of the portraits of the evangelists the high background object is not a building but a hill or a rock, as in the Aachen Evangeliary,[37] or the Ebbo Gospels (Fig. 18). Occasionally there occurs a variation which appears to be a bank of clouds.[38] In the landscape background object, as in the buildings, the indefinite extension at the sides helps to emphasize the horizontal zoning of the picture plane and at the same time lessens the tridimensional effect of the object itself. The gradual change in the depiction of this type of landscape object, which can be followed in a series of manuscripts from the Ebbo Gospels (Fig. 18) through the Evangeliaries of Clèves[39] and Blois,[40] are similar in effect to those that took place in the architectural background object. The contours were simplified until they approached straight lines, and the indications of light and shade were eliminated, resulting finally in a flat surface. The possibilities of the background object as a constructive feature in the representation of tridimensional space were weakened in the landscape object, just as in the architectural, by the indefinite juncture of the base with the ground plane or else by the representation of the ground plane as a vertical section so distinctly as to preclude any illusion of a perpendicular relation between it and the object. The latter form is illustrated in the Matthew page of the Ebbo Gospels (Fig. 18), where the ground with its irregular upper contour and the background object have the appearance of two overlapping vertical planes.

In the Carolingian illuminations with a high background object the ground plane is occasionally omitted altogether. In such cases the seat and the footstool which accompany the figure are supported by the base line or frame of the picture. Even when the ground plane is present the figure is sometimes supported by the frame, thus emphasizing the fact that the figures and the ground have no tridimensional interrelationship, that is, the figure is not set in its environment but placed in front of the background. Examples do occur in which the ground must be interpreted as a horizontal plane because the figure stands within it, but these are few compared with the

[37] Aachen, Cath. Treas., fol. 13 (Boinet, La Miniature carolingienne, Pl. LX).

[38] Paris, Bibl. Nat., MS lat. 266, Evangeliary of Lothaire (Boinet, La Miniature carolingienne, Pl. XXXII).

[39] Berlin, Preuss. Staatsbibl., Lat. theol. Fol. 260 (Boinet, La Miniature carolingienne, Pl. LXX).

[40] Paris, Bibl. Nat., MS lat. 265 (Boinet, La Miniature carolingienne, Pl. LXXII).

number of works in which the ground appears as a cross section because its upper contour or the frame of the picture serves as a support for the figure.

The tendency to eliminate tridimensional values in the ground plane and in the background object and the accentuation of the horizontal axis of the latter is in accord with the principle of stratification characteristic of Carolingian illumination in general. In the miniatures containing a high background object stratification itself is frequently present in the sky. This may be seen in the Matthew page of the Ebbo Gospels (Fig. 18) and in the illumination representing the "Fountain of Life" in the Gospels of St. Medard de Soissons.[41] Many of the evangelist scenes, however, are framed by an arcade, in the tympanum of which the symbol of the evangelist appears. This area is not always stratified, perhaps because it was not associated with the sky of the natural environment. In the Matthew page of Harley 2788 (Fig. 17) the background of the symbol is distinguished from the stratified sky which belongs to the world of the Evangelist.

The classification of the Carolingian illuminations in this study into three types which are roughly differentiated by the form of the ground plane or by the presence of a high background object is for convenience in describing a number of miniatures in which, despite many variations, the common characteristic is stratified space. There are illuminations which do not fit into any of these classifications, such as those in the Gospels of St. Aure,[42] where the evangelists are placed in octagonal walled courtyards seen from a high point of view. In other manuscripts, for example, the Codex Aureus of St. Emmeran of Regensburg,[43] combinations of elements of two types occur, while in the evangelist scenes of the Gospels of Prüm[44] there are exceptional features, such as the small isolated buildings standing on the upper contour of the ground plane and the stars scattered across the lightly stratified sky. Although the elements of the background vary, indicating uncommon sources and models, stratification and the inclination to disregard the tridimensional values of the ground plane and the high background object are manifested just as in the other Carolingian illuminations discussed.[45]

[41] Paris, Bibl. Nat., MS lat. 8850, fol. 6v (Boinet, La Miniature carolingienne, Pl. XVIII).

[42] Paris, Bibl. de l'Arsenal, MS 1171 (Boinet, La Miniature carolingienne, Pl. CXXXVII).

[43] Munich, Staatsbibl., MS lat. 14,000 (Boinet, La Miniature carolingienne, Pl. CXVIII).

[44] Berlin, Preuss. Staatsbibl., Lat. theol. Fol. 730 (Boinet, La Miniature carolingienne, Pl. XXXVI).

[45] Manuscripts are the primary source of information on Carolingian painting, for there are few examples of monumental painting extant. In the apse mosaic of the church of Theodulf,

To summarize briefly, the tendency to telescope the tridimensional planes of the background as a whole into a two-dimensional surface is general, but there are two distinct forms in which this tendency is most noticeably expressed. In both, the atmospherically depicted sky tends to become a solid area. In the Byzantine paintings and in many Italian paintings this area is reduced to a single plane which by virtue of its size and position in relation to the ground plane (no matter how much of its tridimensional character the ground loses) is vestigial of stage space. In the Carolingian manuscripts, on the other hand, each color of the atmospheric sky is solidified, resulting in a series of bands. Here the numerous divisions and the lack of a distinct contrast with the ground plane tend to make the ground lose its identity as the horizontal supporting member and become part of the general stratification. In the next stage of development the strata tend to lose representative features of color and shape, with the result that no vestige of a tridimensional construction of space remains. Liberated from the ties to representative, tridimensional space, the backgrounds in the painting north of Italy went through a series of transformations before they again presented the illusion of a naturalistic environment. In Italy and in Byzantium, however, in the centuries that follow, the type of picture plane showing some traces of stage space continued until the component parts of the background resumed their tridimensional form.

The position of the figures with relation to the background and to each other and the torsion and plastic quality of the individual figure are factors which have spatial significance. The tendency to support the figure on the frame or on the upper contour of the ground plane promotes the effect of separation of figure from background; it indicates that the artist did not attempt to pose the figure in tridimensional space. Especially when the figure stands on the lower border one has the impression that it is on a plane in front of the background. This relationship between the figures and the background appears in frieze compositions. In the Italian mosaics it is empha-

Germigny-des-Prés, the background appears to be stratified, as far as can be judged from a photograph and with the reservations necessitated by restoration (Van Berchem and Clouzot, *Mosaiques chrétiennes*, pp. 233-34, Fig. 288). The Carolingian frescoes of St. Germain d'Auxerre are extremely mutilated. In the scenes from the life of St. Stephen (King, "The Carolingian Frescoes of the Abbey of St. Germain d'Auxerre," *Art Bulletin*, Vol. XI [1929], Figs. 1-5) only the presence of a ground plane with flowers can be ascertained. In the representation of the bishops, however, there are wavy bands in the background (*ibid.*, Fig. 7). Professor Meyer Schapiro believes that these frescoes are later than the scenes from the life of St. Stephen.

sized by the isolation and frontality of the figures. In Byzantine and Caro-
lingian illumination there is more communication among the figures, which
is limited considerably, however, by the frieze arrangement and by the predi-
lection for the three-quarters view of the head. The expression of communi-
cation, therefore, depends on gesture and glance to a great extent. The con-
ventional three-quarters view does not permit a direct glance from one figure
to another, but the difficulty is partly overcome by the conceptual expedient
of indicating the direction of the attention of the figure by the inclination of
the head and by placing the pupil in the corner of the eye.[46] The importance
of the position of the pupil for showing the direction of the glance is illus-
trated clearly in the Genesis page of the Moutier-Grandval Bible (Fig. 15).

One striking exception to the frieze composition usually employed to
represent a group of figures is the Presentation page of the Bible of Charles
the Bald (Fig. 16).[47] The frieze of figures which appears in the major-
ity of illuminations is in accord with the general tendency to telescope tri-
dimensional planes. In the Presentation scene the semicircular formation of
the figures in front of the throne of the emperor is a direct means of obtain-
ing the illusion of depth by the composition of the figures, yet the whole
arrangement is inconsistent with the background which has been stratified
so that the ground plane is not extensive enough to support all the figures.
Although the figures are composed in depth, the background tends to be two-
dimensional. In the semi-circular formation of the group confronting the
emperor, however, the individual figures have conventional positions. All
the ecclesiastical figures in the group in front of the throne, except the
central figure, are depicted in a stereotyped form with frontal legs, frontal
or slightly turned torso, and head in three-quarters view, with the result
that most of them have their backs to the emperor.

The representation of the figures in the Presentation scene may be used
also as an illustration of the conceptual principle of hierarchic scaling, which
is not uncommon in medieval painting. Especially in this example it is at
variance with the semicircular arrangement of the figures in depth. In ac-
cordance with his rank the emperor is the largest member of the group, and
the figures closest to his person are second in size, despite the fact that he

[46] Vide supra, p. 41.
[47] See Köhler, Die karolingischen Miniaturen, I (Pt. II), 66 ff., for a discussion of the repre-
sentation of the figures in the Presentation scene.

and they are in the rear and farther from the spectator than the ecclesiastical figures. In the Genesis page of the Moutier-Grandval Bible (Fig. 15) the same principle governs the size of the figure of God. Here, however, in most of the scenes God stands a little in front of Adam and Eve. This might lead one to conclude that an optical rather than a conceptual principle determined the size. The optical point of view does not appear to be tenable, however, because of the religious importance of the figure, the presence of hierarchic scaling in other illuminations, and the evidence of the uppermost register where, in the "Creation of Eve," God is placed behind Adam and is considerably larger. In the "Creation of Adam," although God stands in front, He holds Adam's head, a position which is possible only if the distance between the figures is so slight as to make the difference in size scarcely noticeable. Despite this proximity, however, God is represented as considerably larger. Thus, it would seem that the relative position in depth has no effect on the size of the figure, whereas from a practical point of view placing the figure of God lower in the ground plane provides additional room in the narrow registers for the increase in size dictated by His rank.[48] The presence of conceptual principles is in accord with the general reduction of tridimensional values.

In the representation of individual figures there was a tendency to repeat certain combinations. The head in three-quarters view with frontal shoulders and legs or with slightly turned torso and one leg in profile, serves for the standing figure. The seated figure, which is generally used in portraying the evangelists, appears in a few typical positions: the frontal, the completely profile, and the contraposto with head, body, and legs in three different planes. All the positions involve some consideration of the third dimension by foreshortening. In the seated figure in contraposto, especially, the juxtaposition of planes creates an impression of potential movement in depth, but the tridimensionality expressed by such a form is not as pronounced as might be expected. This is due to the fact that the transition from one plane to another either is too abrupt or is masked by folds of drapery that tend to fall into a pattern rather than to follow the contours

[48] Köhler (*Die karolingische Miniaturen*, I [Pt. II], 32) remarks on the optical perspective principle which governs the size of the figures in the "Genesis" of the Vivien Bible. This principle does not seem applicable for reasons similar to those presented for the "Genesis" of the Moutier-Grandval Bible.

of the body. Judging by the representation of the figures as a whole, the repetition of a few typical poses creates the impression that an established formula was followed, with the result that the individuality and the move-ment of the figures are reduced to a stereotype.

In general, the plastic structure was changing to a linear one with sharp outlines rather than molded curves. The plastic quality of the figure varies and is very often in accord with the spatial handling of the background. Thus, in the St. Matthew of the Senlis Evangeliary[49] there is a pronounced use of shadow in the face, hands, and feet, which is consistent with the atmospherically graded stratification of the background. In the Matthew page of the Ebbo Gospels (Fig. 18) the fluid linear technique and the repe-tition of short curved strokes gives the impression of rolling hills in the back-ground and creates an analogous effect of modeling in the figure. In contrast, in the related Gospels of Clèves[50] and Blois[51] the modeling is eliminated from both the background and the figure. St. Matthew, in Harley 2788 (Fig. 17), is clothed in drapery which forms a shell of angular folds around the body. This indication of tridimensional enclosure is echoed in the back-ground by the recessed walls of the upper part of the building. Although there are exceptions, the parallel effects of drapery and architecture may be traced in a number of illustrations from the extremely shell-like drapery and articulated walls of the Luke page in the Ada Gospels,[52] to the almost flat drapery and two-dimensional façade of the seated Christ in the Godescalc Gospels.[53] Thus, the figure was undergoing the same sort of transformation which was occurring in the background. The naturalistic elements are pre-served, but they have been stereotyped by the elimination of individualizing

[49] Paris, Bibl. St. Geneviève, MS 1190, fol. 14v (Boinet, *La Miniature carolingienne*, Pl. LXXXII).

[50] Berlin, Preuss. Staatsbibl., Lat. theol. Fol. 260 (Boinet, *La Miniature carolingienne*, Pl. LXX).

[51] Paris, Bibl. Nat., MS lat. 265 (Boinet, *La Miniature carolingienne*, Pl. LXXII).

[52] Trier, Stadtbibl., MS 22 (Boinet, *La Miniature carolingienne*, Pl. VIII).

[53] Paris, Bibl. Nat., Nouv. acq. MS lat. 1203 (Boinet, *La Miniature carolingienne*, Pl. IV). Since the more two-dimensional of the examples just cited, the illumination in the Godescalc Gospels, is the earlier, one cannot say that the tendency to eliminate tridimensional factors is always consistent from a chronological standpoint. One must not lose sight of the fact that in the Carolingian period, as compared with the art of the north of the previous period, there is a revival of plastic values inspired by early Christian models. In the history of space of the medieval period viewed as a whole, however, this plastic revival is secondary to the broader movement toward two-dimensional form. Cf. Panofsky, *Vorträge Bibl. Warburg*, 1924-25, p. 310, note 33.

factors and detail, and the tridimensionality has been lessened by sharpening the contours and flattening the planes.

The representation of objects—seats, footstools, writing desks, and books —exhibits the same characteristics as the representation of the figures. There was an even greater tendency to overlook tridimensional values in these comparatively subordinate elements, which are present as accessories of the figures rather than as part of the background. The furniture appears in several typical positions: at an angle, profile, or frontal. When an object is placed at an angle, the receding planes outline its tridimensional form and give a greater impression of depth than is found in the other positions. But in dealing with this position, as with the others, the tendency toward surface composition was accompanied by disregard for the optical tridimensional form of the object. The tridimensional structure was undermined by the violation of the basic rule of optical perspective, that receding lines which in nature are parallel are represented as converging. In general, in representing objects from an angular point of view the departure from the rule is so extreme that parallel lines of the same plane in depth, whether the plane is horizontal or vertical, diverge rather than converge. This weakens the effect of recession considerably and makes the horizontal surfaces appear as inclined planes.

Very often different parts of the same object are presented from different points of view. In the chair of the Matthew page in the Ada Gospels[54] and in Harley 2788 (Fig. 17), the seat is placed at one angle, the base at another, while the back is parallel to the picture plane. Such lack of coördination is common. It is not strange, therefore, that telescoping should appear, since the point of view was inconsistent and the general tendency was to understate the depth of a plane. In the seat of St. Matthew, in Harley 2788 (Fig. 17), the plane of the side is drawn into the plane of the front at the base in much the same way as in the high background buildings.

Objects which are parallel to the picture plane rather than at an angle reveal fewer planes in depth. In frontal positions the receding parallel lines of the horizontal planes were generally made to converge, as in the seat in the representation of Christ in the Godescalc Gospels.[55] The angles, however, are rarely drawn acutely enough to avoid an upward tilt of the plane.

[54] Trier, Stadtbibl., MS 22 (Boinet, La Miniature carolingienne, Pl. VIII).
[55] Paris, Bibl. Nat., Nouv. acq. MS lat. 1203 (Boinet, La Miniature carolingienne, Pl. IV).

Consequently, the movement inward of the object is checked and the effect of tridimensionality weakened. In objects which are simply profiled (Fig. 18) there are no planes in depth, except for the slight projections occasioned by moldings.

When objects are grouped so that they overlap, the disregard for tri-dimensional values is strikingly apparent. Frequently two bodies appear to occupy the same space, as in Fig. 17, where the footstool is set against the base of the seat. In this illustration the ground plane, the seat, and the foot-stool appear as three overlapping planes rather than as two cubic forms supported on a horizontal surface.

Thus, in the representation of objects, as well as of figures and back-grounds, the planes in depth are reduced or eliminated, thereby promoting the effect of two-dimensional surface composition. The degree of departure from naturalistic tridimensional representation varies. In general, there is noticeable in the form of the objects an indifference to the fundamental laws of perspective, laws which could be ascertained from observation alone.[56] In the representation of the figures the tendency was to repeat a few typical forms, with increasing emphasis on linear pattern at the expense of model-ing in light and shade. Thus far Italian, Byzantine, and Carolingian painting developed from early Christian art along similar lines. In the representation of the backgrounds, however, although the basic tendency was the same in all three regions, the component parts of the background differ, with the result that in Byzantine painting and in some Italian painting a vestige of stage space remains, while in Carolingian illumination the stratified form was the first step in the development of a nonrepresentative, decorative pic-torial surface.

[56] An analysis of the positive pictorial qualities of the distortions of optical perspective in Carolingian painting is unfortunately beyond the scope of this study. One should observe that these distortions help to give the illuminations an expressive dynamic character.

CHAPTER IV

THE TENTH AND ELEVENTH
CENTURIES

HE PARTITION of the Carolingian empire after the death of Charlemagne made the regional distinctions in the north more marked than before. In the tenth and eleventh centuries the illuminations may be distinguished as French, German, or English, and in each of the countries, particularly in Germany, a number of schools flourished. Insofar as the spatial representation is concerned, a variety of backgrounds which are clearly derived from the early Christian and the Carolingian principle of stratification made their appearance. In general, the tendency to reduce the picture plane to a vertical surface was accompanied by a gradual loss of representative elements. The figures and the objects became flat forms, arrested in three-quarters and frontal poses, parallel to the vertical picture plane. Usually they were placed on the upper contour of the ground plane or on the frame. Thus, the ground has the appearance of a cross section rather than a horizontal plane of support. Atmospheric gradations of color in the strata gave way to uniformly colored areas. The linear boundaries between these areas became more regular, and finally, the color itself began to lose all reference to reality. Consequently, the horizontal divisions, which were essential to the stratified form, lost their significance as suggestive of nature. The elimination of the vestiges of representative space which were inherent in the color and in the horizontal structure of stratified space is important, for it preceded the complete conversion of the background, in the twelfth century, into a backdrop which is a nonrepresentative, decorative unit, independent of the action, although a foil for it.

In the post-Carolingian illumination of the tenth and eleventh centuries, although in general the changes described above occurred, the rate and degree of transformation differed according to regional types. In Germany during this period, which is known as the Ottonian, the production of illuminated manuscripts was perhaps the outstanding art. Of the numerous schools, Reichenau, Trier, and Echternach adhere most closely to the early Christian or the Carolingian type of stratification.[1] Atmospherically graded color that has some reference to reality, although the tone itself may appear non-naturalistic, lingered longer here than elsewhere.[2] There is, however, a regularity in the zoning which, despite the attempt to grade the color, diminishes the little naturalistic effect that remains. In a number of illuminations, although the strata are uniform in color, some effect of fusion is suggested by a series of horizontal lines terminating the bands.[3] The principle of stratification is fundamental in the composition of these backgrounds, but examples frequently occur in which the central band is considerably wider than the other strata, thus introducing an element of stage space.[4] This form is not, however, a true vestige of stage space such as is found in Italian or Byzantine painting of this period, but is analogous to the Carolingian type

[1] In some manuscripts, such as the Codex Egberti (Trier, Stadtbibl., MS 24), there is a direct revival of early Christian forms. In other manuscripts Carolingian illumination, particularly of the Ada school, served as models. See Michel, Histoire de l'art, I (Pt. II), 720; Köhler, "Die Tradition der Adagruppe," Festschrift Clemen, pp. 256 ff.; Boeckler, Abendländische Miniaturen, pp. 44 ff.

[2] Trier, Stadtbibl., MS 24, Codex Egberti (Goldschmidt, German Illumination, Vol. II, Pl. XXI). Aachen, Cathedral, Otto Codex (Beissel, Die Bilder der Handschrift des Kaisers Otto). Bamberg, Staatsbibl., Msc. class. 79 (E. III. 16) (Fischer, Mittelalterliche Miniaturen, Vol. II, Pl. I). Strahow, Monastery (near Prague), Gospels from St. Martin (near Trier) (Goldschmidt, German Illumination, Vol. II, Pl. XIII A). Chantilly, Mus. Condé, Cab. des livres, MS 1447, Sacramentary (ibid., Pl. XII). Brussels, Bibl. Roy., MS 9428, Gospels (photographs in the P. Morgan Library, New York City). Upsala, Univ. Lib., Gospels of Henry III, fols. 3v, 4 (Goldschmidt, German Illumination, Vol. II, Pls. LXIII-LXIV). The more pronounced atmospheric effect and the less schematic form of the stratification in the Codex Egberti (Trier, Stadtbibl., MS 24), as compared with other illuminations of this south-west German group, substantiate the opinion that the miniatures in this manuscript were influenced by early Christian sources (vide supra, note 1).

[3] Munich, Staatsbibl., MS lat. 4453 (cim. 58), Gospels from Bamberg, fols. 23v, 24 (Goldschmidt, German Illumination, Vol. II, Pl. XXIV). Berlin, Preuss. Staatsbibl., Theol. lat. Fol. 283, Gospels of St. Maximin of Trier, fol. 88v (ibid., Pl. XIII B). Bremen, Stadtbibl., Lectionary of Henry III, fol. 23v (ibid., Pl. LIV A).

[4] Examples: Trier, Stadtbibl., MS 24, Codex Egberti, fol. 22 (Goldschmidt, German Illumination, Vol. II, Pl. IV B). Bamberg, Staatsbibl., Msc. class. 79 (E. III. 16) (Fischer, Mittelalterliche Miniaturen, Vol. II, Pl. I). Munich, Staatsbibl., MS lat. 4453 (cim. 58), Gospels from Bamberg, fols. 23v, 24 (Goldschmidt, German Illumination, Vol. II, Pl. XXIV). Solothurn, Sacristy of the Collegiatstift, Sacramentary from Hornbach (ibid., Pl. XXIII).

of background with a high background object, for several strata appear above and below the central band. Nevertheless, in some instances, where there are two registers in the illumination and the form of each register is a rectangle longer than it is high, only two bands appear in the background of each scene, the narrow ground plane and the wider area above it.[5] The effect of stage space which is thus obtained may be considered fortuitous perhaps, a result of the limited frame of the illustration rather than a con-scious effort to use a different spatial principle. When gold is introduced into this type of background, as in the Gospels of Henry II,[6] the similarity to the Byzantine form of construction is even more marked. In the same manuscript, however, the backgrounds in the New Testament scenes[7] have a greater number of strata including the central gold band. Thus, the gold appears here in somewhat the same manner as in the mosaics of the nave of Santa Maria Maggiore, where it is introduced as a more brilliant repre-sentation of light on the horizon.[8]

The relationship of the ground plane to the background varies as it did in the Carolingian manuscripts. The ground plane is sometimes the lowest two strata of the background differentiated from the other bands simply by its color and its connection with the figures, or it may have a different struc-tural appearance. In the Ottonian illuminations of the latter type, the tend-ency is to pattern the ground rather than to suggest the naturalistic effect of an irregular surface. The ground is sometimes decorated with parallel diagonal striations (Fig. 19),[9] and sometimes it consists of a number of

[5] Berlin, Preuss. Staatsbibl., Theol. lat. Fol. 34, Epistolary for St. Paul, Trier, from Santa Maria ad Martyres (photographs in the P. Morgan Library, New York City). Bamberg, Staatsbibl., MS bibl. 140 (A. II. 42), Apocalypse, fol. 49v (Goldschmidt, German Illumination, Vol. II, Pl. XXXIX). Munich, Staatsbibl., MS lat. 23338, Evangelistary, fol. 158v (ibid., Pl. XXXIV).

[6] Munich, Staatsbibl., MS lat. 4452 (cim. 57), fol. 105v (Goldschmidt, German Illumination, Vol. II, Pl. XXXVII). Other examples may be found in: Munich, Staatsbibl., MS lat. 4453 (cim. 58), Gospels, fol. 32v (ibid., Pl. XXVII). Bamberg, Staatsbibl., Msc. bibl. 22 (A. I. 47) (Fischer, Mittelalterliche Miniaturen, Vol. I, Pl. VI). Munich, Staatsbibl., MS lat. 23338, Evangelistary, fol. 158v (Goldschmidt, German Illumination, Vol. II, Pl. XXXIV).

[7] Leidinger, Miniaturen aus HS. der Kgl. Hof.- und Staatsbibl. in München, Vol. V, Pls. VII-VIII, X-XI.

[8] Gombrich, review of Bodonyi, "Enstehung und Bedeutung des Goldgrundes in der spätan-tiken Bildkomposition," Kritische Berichte, II-III (1932-33), 65-76. Boeckler (Degering and Boeckler, Die Quedlinburger Italafragmente, p. 181, note 1) observes the interchange of yellow and gold in the backgrounds of the nave mosaics of Santa Maria Maggiore.

[9] Also Brussels, Bibl. Roy., MS 9428, Lectionary, fol. 23 (Goldschmidt, German Illumination, Vol. II, Pl. LVI A).

rocks, which are replicas of each other.[10] The rock form of ground gives the impression of a cubic group independent of the structure of the background. It anticipated the type of ground, characteristic of the next period, which is an accessory to the individual figure. In the Ottonian illuminations the separation of ground and background was not as pronounced as it was in the twelfth century, for the background retained its representative character to some extent. In the later period, however, the ground alone remains as an indication of the naturalistic environment, and it appears on a plane with the figures, distinct from the decorative surface of the background.

An exceptional element in the representation of space in the Reichenau and Echternach manuscripts is the differentiation between interior and exterior. The distinction was made by choosing for the area within the architectural frame representing the interior a color which differs from the color of the rest of the background. This is a notable feature, since the general tendency was not only to ignore the tridimensional values of the background by reducing it to a vertical surface and to depart from representative color but also to disregard tridimensional spatial logic when dealing with architectural elements. A characteristic example of such an optically inconsistent form is the construction which might be called "the city in the clouds." A cluster of small buildings symbolic of a city is placed at one side, high in the background. The group usually has an irregular scalloped base.[11] Neither the position nor the proportions have any spatial relationship to the background from an optical point of view. The form of representation is not in conformity with an optical perspective method, according to which the spatial relationship between the parts of the structure and also their connection with the figures would be clearly depicted. This indifference to optical relationships is present also in the representation of the large individual buildings that enframe the action. Here, although the orientation is to the ground plane, the architectural members were drawn without any regard for relative size, consistency of point of view, or spatial overlapping. The

[10] Munich, Staatsbibl., MS lat. 4452 (cim. 57), Gospels of Henry II, "Annunciation to the Shepherds" (Goldschmidt, German Illumination, Vol. II, Pl. XXXVI). Bamberg, Staatsbibl., Msc. lit. 5 (Ed. V. 9) (Fischer, Mittelalterliche Miniaturen, Vol. II, Pls. V-VI). Bremen, Stadtbibl., Lectionary of Henry III, fol. 66 (Goldschmidt, German Illumination, Vol. II, Pl. XXVII).

[11] Cologne, Dombibl., MS 218, Gospels from Limburg an der Hardt, fols. 31, 34 (photographs in the P. Morgan Library, New York City). Bamberg, Staatsbibl., Msc. lit. 5 (Ed. V. 9) (Fischer, Mittelalterliche Miniaturen, Vol. II, Pl. VII). Munich, Staatsbibl., MS lat. 4453 (cim. 58), Gospels from Bamberg, fol. 35v (Goldschmidt, German Illumination, Vol. II, Pl. XXVII).

details of towers, roofs, and clearstory which appear in some of the illustra-tions[12] are so well observed that we could reconstruct from them the plan of the original building, but this observation did not extend to the representa-tion of the building in optical perspective. Thus, it is all the more surprising that in a number of illuminations the difference between the interior and the exterior is indicated. Within the architectural frame the color is uniform, usually gold, purple, or red,[13] even when the picture plane outside the build-ing is stratified.

In general the type of stratification in the miniatures of Reichenau, Trier, and Echternach remained fairly close to that of the Carolingian period.[14] In the other German schools of illumination of the tenth and elev-enth centuries the development was carried further, and, in the case of Hil-desheim and Regensburg, it resulted in a type of background which in principle, although not necessarily in form, approaches the Romanesque backgrounds in the twelfth century.

In the illuminations of the school of Cologne stratification is as preva-lent as it is in Reichenau and Echternach. In Cologne, however, the atmos-pherically shaded strata tended to give way to more definitely demarcated zones. There was also a tendency to increase the number of bands, thus weakening the representative effect of the background and strengthening the impression of a vertical plane divided into regular horizontal rows.[15] This impression is emphasized by the fact that the figures are often supported by the frame of the scene rather than by the ground plane. Nevertheless, the

[12] Cologne, Dombibl., MS colon. XII, Hillinus Gospels, fol. 16v (photographs in the P. Mor-gan Library, New York City). Brussels, Bibl. Roy., MS 9428, Lectionary, fol. 38 (photographs in the P. Morgan Library, New York City).

[13] Munich, Staatsbibl., MS lat. 4453 (cim. 58), Gospels from Bamberg, fols. 25v, 139v (Goldschmidt, German Illumination, Vol. II, Pls. XXV-XXVI). Munich, Staatsbibl., MS lat. 4452 (cim. 57), Gospels of Henry II, fols. 3v, 4 (ibid., Pl. XXXV). Munich, Staatsbibl., MS lat. 4454 (cim. 59), Gospels, fols. 86v, 194v (ibid., Pl. XL). Gotha, Landesbibl., MS I. 19, Gospels of Otto III (ibid., Pl. XLVI). Brussels, Bibl. Roy., MS 9428, Lectionary, fols. 2, 3 (photographs in the P. Morgan Library, New York City).

[14] This is true of the schools judged as a whole, but within each school progress toward more two-dimensional, linear, and schematic forms may be observed. Boeckler (Das Goldene Evangelien-buch Heinrichs III, pp. 68 ff.) analyzes in detail the spatial development of the illuminations from the school of Echternach.

[15] Examples: Darmstadt, Landesbibl., MS 1640, Evangeliary of Abbess Hitda von Meschede (Swarzenski, Vorgotische Miniaturen, p. 39). Cologne, Stadtsarchiv., MS 312, Gospels from St. Gereon in Cologne, fols. 21, 160 (Goldschmidt, German Illumination, Vol. II, Pl. LXXXII). Milan, Ambrosiana, MS 53 sup., Gospels, fols. 19, 118 (ibid., Pl. LXXXIII). Stuttgart, Landes-bibl., MS bibl. 402, Gospels of Gundold, fol. 71v (ibid., Pl. XC A).

background remains as an indication of the environment not only because the color is vaguely representative but also because within the strata appear plant and cloud forms, transformed somewhat by a decorative and rapid, linear technique.[16] Although vestiges of landscape elements are preserved, the representative significance of these is obscured by the definite and regular banding of the colors of the background.

In the illuminations of Fulda, stratification also made its appearance. In this school, however, it is not the composition of the colors of the background into horizontal zones—although this does occur occasionally[17]— which illustrates the principle, so much as the tendency to reduce the ground plane, the features of the landscape, and the clouds, to decorative forms arranged in horizontal rows.[18]

The backgrounds in the schools of illumination discussed above, although stratified, retained representative features to a certain extent. Landscape elements are recognizable through the patterning, and the color, which at times appears to be arbitrary, for the most part retains a hint of reality in that the green, brown, or yellow tones were used for the ground plane, and the blue, violet, and rose tones, for the sky. In many of the illuminations of Hildesheim, however, scarcely any indication of a representative background remains. In the form of the background the derivation from stratification is obvious, but the horizontal divisions are numerous and the color is arbitrary, frequently in alternating stripes (Fig. 20).[19] The striped background that is found in the Hildesheim illuminations is devoid of any vestige of tridimensional space and has become a decorative vertical plane unrelated to the figures from the standpoint of a naturalistic environment. Only the ground

[16] Vide supra, note 15. The linear style of the school of Cologne may be due to influence from the Carolingian school of Reims. See Michel, Histoire de l'art, I (Pt. II), 728.

[17] Bamberg, Staatsbibl., MS lit. 1 (A. II. 52), Sacramentary, fol. 25 (Goldschmidt, German Illumination, Vol. II, Pl. CVIII A).

[18] Rome, Vat., MS lat. 3548, Sacramentary, fols. 8, 14 (Goldschmidt, German Illumination, Vol. II, Pl. CX). Peculiar to Fulda is a type of frame consisting of two columns supporting an architrave. It is found in the Sacramentary of Göttingen University (Lib., Theol. Fol. 231 [ibid., Pl. CVI]), a Sacramentary in Bamberg (Staatsbibl., MS lit. 1 [A. II. 52] [ibid., Pl. CVIII A]), and a Sacramentary in the Vatican (MS lat. 3548 [ibid., Pl. CX]). According to Goldschmidt (pp. 27-28) this form is reminiscent of the frame used in mural painting of an earlier period.

[19] Several scenes in the Gospels written for Bishop Bernward (985-1022), Hildesheim, Cath. Treas., MS 18 (photographs in the P. Morgan Library, New York City). Cf. Hildesheim, Cath. Treas., MS 19, Sacramentary of Guntbald (ca. 1014), fol. 2v (Goldschmidt, German Illumination, Vol. II, Pl. CIV). This type of background occurs in several illuminations in the Codex Aureus (Escorial, Madrid), dated 1043-46, which belongs to the school of Echternach (Boeckler, Das Goldene Evangelienbuch Heinrichs III, Pls. CXIX-CXX).

plane, which is also patterned, retains some of its representative form. Al-
though it frequently extends across the lower part of the scene in place of
the first band, it is not a unit with the background but is on a plane with
the figures and associated with them. Thus, it is not surprising that occa-
sionally the ground plane as part of the background was eliminated alto-
gether and that separate units of rock appear as supports for individual fig-
ures and objects in the manner of private pedestals.[20]

The elimination of representative elements and tridimensional space from
the stratified background deprives the horizontal divisions of their original
significance. The proportions and the color of the horizontal bands have
become elements of a decorative scheme, and as such they can be altered at
will. In the background of the Mark page in the Evangeliary of Bishop
Hezilo[21] horizontal bands alternate with a series of short vertical stripes,
and in an illumination in the Bernward Codex (Fig. 21) the lines of the
background are all vertical. These variations in the axis and the proportions
of the bands complete the transformation of the background from a repre-
sentative tridimensional environment to a decorative vertical screen.

In a number of Hildesheim miniatures this new interpretation of the
background goes further. The horizontal divisions have been eliminated
altogether, and the background is covered with a decorative pattern of
rosettes (Fig. 22) or semicircular rock forms.[22] The pattern is generally
large, each unit complete, in contrast to the small allover patterns of Gothic
illumination. It is as if the new-found independence of the background from
the action was being loudly proclaimed. The background has not yet taken
its subordinate place as a foil and a measure for the figures.

[20] Hildesheim, Cath. Treas., MS 18, Bernward Gospels, fol. 76 (Goldschmidt, German Illumi-
nation, Vol. II, Pl. XCIX). Hildesheim, Cath. Treas., MS 19, Sacramentary of Guntbald, fol. 2v
(ibid., Pl. CIV).

[21] Hildesheim, Cath. Treas., MS 34 (Döring and Voss, Meisterwerke, Pl. CV).

[22] Hildesheim, Cath. Treas., MS 61, Bible of St. Bernward, fol. 1 (Goldschmidt, German
Illumination, Vol. II, Pl. CII). Patterned picture planes occur in the illuminations of other
schools. In an Evangelistary (New York City, Public Lib., MS 1) and in the Psalter (Cividale,
cod. Gertrudianus [Sauerland and Haseloff, Der Psalter Erzbischof Egberts, Pls. V-XXXIII])
made for Bishop Egbert of Trier (977-93), which belong to the Reichenau group, there are
a number of richly patterned backgrounds. The motives are large, consisting of floral, animal,
and geometric forms. A later example of patterned background may be found in the John
page of the Gospels of Henry III (Upsala, Univ. Lib., written for the Cathedral of Goslar
between 1050-56 [Goldschmidt, German Illumination, Vol. II, Pl. LXVI]). In this illumina-
tion the motive is a small rosette form. The Gospels of Henry III belong to the Echternach
group which, as a school of illumination, flourished in the middle of the eleventh century, later
than the scriptoria of Reichenau and of Hildesheim under Bishop Bernward.

The miniatures of the school of Regensburg also have backgrounds that are decorative and patterned. The small allover design of dots and checks of the Regensburg illuminations,[23] approaches the thirteenth-century Gothic type rather than that of Hildesheim, but, taking the background as a whole, the effect is analogous with Hildesheim. In the Regensburg miniatures the background is not a uniform field covered with a single repeat pattern, as it is in the thirteenth-century French manuscripts, but it is divided into fairly large areas, each of which contains an allover motive which differs from that of the adjacent area. Therefore the background, as in Hildesheim, is divided into large units. In comparing the form of background of the Regensburg with the other German schools of illumination, one should note that the systematized symbolic rather than narrative character of the iconography of the Regensburg miniatures accords with the choice of a decorative picture plane in preference to the quasi-representative stratified background.[24]

Thus, in the illuminations of Regensburg and Hildesheim the transformation of the background from a representative, tridimensional environment into a decorative vertical plane is accomplished. The striped background of Hildesheim is a remarkable example of the transitional stage in which the outward form of stratification lingers in the horizontal bands, but the color, proportions, and effect of the whole point to a new interpretation of the role of the picture plane. The other German schools of illumination—Reichenau, Trier, Echternach, Fulda, and Cologne—are more truly post-Carolingian in that they accepted the principle of stratification with fewer modifications.

In English and in French manuscripts, as far as spatial principles are concerned, the illuminations can be classed as post-Carolingian for the same reason as the German, namely, that stratification appears although modified by nonrepresentative and decorative stylistic tendencies. Where the background is not stratified, an uncolored picture plane or one of a single color, usually gold or purple, takes its place. The picture plane of only one color, which appeared at this time, may be said to indicate an emphatic termina-

[23] Munich, Staatsbibl., MS lat. 4456 (clm. 50), Sacramentary of Henry II, fol. 11 (Goldschmidt, *German Illumination*, Vol. II, Pl. LXXII). Munich, Staatsbibl., MS lat. 13601 (cim. 54), Evangelistary, fols. 2, 3v (*ibid.*, Pls. LXXVI-LXXVII A).

[24] Cf. Michel, *Histoire de l'art*, I (Pt. II), 738.

tion of the concept of the background as a tridimensional, representative environment for the figures of which the stratified form is a vestige.

The English illuminations of this period are distinguished for their pen and ink technique.[25] The majority of the illustrated manuscripts have simple pen drawings, sometimes in ink of various colors, on uncolored backgrounds. In some there is no indication of a ground plane, and the figures and objects are either unsupported or stand on the frame.[26] In many of the drawings the ground is indicated by irregular lines suggesting rocks.[27] This type of spatial representation recalls that of the Utrecht Psalter, but it loses the naturalistic effect of the latter because of simplification and stylization.

Of the English illuminations with colored backgrounds, a few use only one color, for example, purple in the Edgar Charter,[28] and green in the background of a Gospel book in the Royal Library of Copenhagen.[29] The Benedictional of St. Aethelwold (Fig. 23)[30] and the Missal of Robert of Jumièges,[31] however, have multicolored backgrounds which are stratified. In these manuscripts the arrangement of the strata is unique. Above the rocky indications of ground there is a wide central area of uniform color which has, to some extent, the effect of the vertical background of stage space, but above this area the picture plane is filled with numerous bands arranged either as agitated ribbons of clouds (Fig. 23) or in regular divisions filled with rapidly drawn linear forms.[32] The wide central area in combination with the multiple strata in the upper part of the picture plane recalls the type of Carolingian background having a high background object

[25] London, Brit. Mus., Stowe MS 944, Register of New Minster, fol. 7 (Schools of Illumination, Pt. I, Pl. XIII).

[26] London, Brit. Mus., Add. MS 34890, Grimbald Gospels (Millar, English Illuminated MSS from the Xth to the XIIIth Century, Pl. XVI). London, Brit. Mus., MS Tiberius B. v, Aratus (Westwood, Facsimiles, Pl. XLVIII). London, Brit. Mus., MS Claud. A. iii (ibid., Pl. L).

[27] London, Brit. Mus., MS Tiberius C. vi, Psalter (Westwood, Facsimiles, Pl. XLVI). London, Brit. Mus., Cotton MS Cleop. C. viii, Prudentius Psychomachia, fols. 8v-9 (Millar, English Illuminated MSS from the Xth to the XIIIth Century, Pl. XXVI). Oxford, Bodleian, MS Junius XI, Caedmon (Gollancz, The Caedmon MS). London, Brit. Mus., Harley MS 2904, Psalter, fol. 3v (Schools of Illumination, Pt. I, Pl. IX).

[28] London, Brit. Mus., Cotton MS Vesp. A. viii (Westwood, Facsimiles, Pl. XLVII).

[29] Ibid., Pl. XLI.

[30] Chatsworth, Coll. of the Duke of Devonshire (Warner and Wilson, The Benedictional of St. Aethelwold).

[31] Rouen, Bibl., MS 274 (Y 6) (Wilson, Missal of Robert of Jumièges).

[32] Missal of Robert of Jumièges (Leroquais, Les Sacramentaires et les missels MSS, Pls. XX-XXIII). In another manuscript, the Benedictional of Archbishop Robert (Rouen, Bibl., MS Y 7 [Wilson, The Benedictional of Archbishop Robert]), the stratification of the background is less complex. The strata have regular divisions and the color is graded to some extent.

rather than the stage space of Byzantine illuminations. The treatment of the upper part of the picture plane with the many narrow bands filled with linear vestiges of naturalistic forms is analogous to the handling of the back' ground in the Cologne manuscripts. This is an indication not so much that there was direct relationship between the Winchester and Cologne schools as that they were both inspired stylistically by Carolingian illumination.

The stratification in the English manuscripts retains very little effect of tridimensional space. The three-part division of background, the wide central area, and the banded sky preserve the representative features of the environment, but the linear technique, the decorative manner, and the juxtaposition of narrow bands of contrasting color prevent an effective representation of depth. The lack of depth in the background is emphasized by the fact that the figures do not actually stand on the ground or on its edge, but hover in the vicinity of the ground lines. Further evidence of the indefinite spatial relationship between the figures and the background is frequently found when action carries the figures in front of and sometimes beyond the frame (Fig. 23).[33] The overlapping indicates clearly that the background and the figures have become two separate planes. In some instances, such as the "Three Marys at the Tomb" (fol. 51v) in the Benedictional of St. Aethelwold, the overlapping is accompanied by a marked isolation of cubic groups of figures, which not only indicates the weakening of the tridimensional spatial interrelationship between the figures and the background but also a lack of interest in the tridimensional spatial relations among the figures themselves. In the "Nativity" (Fig. 24) this tendency results in a pronounced segregation of groups in different parts of the pictorial field. The Christ Child in the crib is separately framed in one corner of the scene and is balanced in the corner diagonally opposite by a rectangle of ribboned bands. The chiasmal composition is completed by the bed on which the Virgin lies, which is part of a cubic group with Joseph and the maid. The diagonal position of the bed suggests spatial recession, but the absence of a tridimensional relationship with the background and the framed segregation of the Christ Child obviate the effect of depth.[34]

[33] Other examples: Chatsworth, Coll. of the Duke of Devonshire, Benedictional of St. Aethelwold, "Three Marys at the Tomb," "Baptism" (Warner and Wilson, The Benedictional of St. Aethelwold).

[34] The same scene is handled in a similar manner in the Missal of Robert of Jumièges (Homburger, Die Anfänge der Malschule von Winchester, Pl. XII). Here, however, instead of the

The conceptual arrangements of the figures occasionally cause modifica-
tions in the composition of the features of the background. The rectangular
area of clouds in the "Nativity" of the Benedictional of St. Aethelwold is
an illustration of this (Fig. 24). In the "Annunciation" of the same manu-
script (fol. 5v), the direction of the bands of clouds is modified to make
the partitioned composition of the figures more distinct. These modifications
in the background are followed in the next century by a form in which the
divisions no longer show vestiges of naturalistic spatial relationships, but
have a completely nonrepresentative and decorative character.

French illumination of the late tenth and the eleventh centuries does
not form a homogeneous group, but it presents a variety of backgrounds
which insofar as the development of space is concerned, show tendencies
similar to those observed in English and German miniatures. Several manu-
scripts produced in the scriptoria of northwestern France at the turn of the
eleventh century were influenced by the English calligraphic style. They in-
clude pen-drawn illustrations on simple backgrounds, uncolored or tinted
in one color.[35] A more complex spatial composition occurs in a manuscript
of the Life of St. Amand in Valenciennes[36] where the upper part of the pic-
ture plane in fol. 119 is covered with irregular, multicolored, undulating
lines, reminiscent of the ribboned clouds in the Benedictional of St. Aethel-
wold. In a later eleventh-century manuscript of the Life of St. Omer,[37] the

diagonal composition, the groups are arranged in superposed rows. The horizontal axis of the
bed has necessitated a change in the position of Joseph, who has been taken out of his original
cubic group and placed below the Virgin on a level with the Christ Child. The disregard for
optical values of representation is strikingly illustrated by the position of the ass, part of whose
body appears outside the frame enclosing the Christ Child, and part within it.

[35] Examples: Boulogne-sur-Mer, Bibl., MS 20, Psalter from the monastery of St. Bertin in
St. Omer (989-1008), "David Playing the Harp" (Boeckler, Abendländische Miniaturen, Pl. LII).
Douai, Bibl. Mun., MS 849 (ibid., Pl. XLIX). New York City, P. Morgan Lib., MS 333,
Gospels from the monastery of St. Bertin in St. Omer. Other French illuminations of the tenth
and eleventh centuries with pen-drawn illustrations are: Reims, Bibl., MS 214, Sacramentary of
St. Thierry, fol. 9v (Leroquais, Les Sacramentaires et les missels MSS, I, 91-94). Yates Thomp-
son Coll., MS 69, Gallican Missal, fol. 155v (Illustrations of 100 MSS in the Library of Henry
Yates Thompson, Vol. I, Pl. II). Paris, Bibl. Nat., MS lat. 12117, Chroniques de St. Germain-
des-Près, fol. 128 (Lauer, Les Enluminures romanes, Pl. XLVIII).

[36] Valenciennes, Bibl. Mun., MS 502 (Boeckler, Abendländische Miniaturen, Pl. L; photo-
graphs in the Frick Art Reference Library, New York City).

[37] St. Omer, Bibl., MS 698 (Schott, Zwei Lüttischer Sakramentare, Figs. 22-26), dated 1080-
1100 by Schott (p. 94). Vide infra, note 49. In a north French Gospels of the eleventh cen-
tury (Paris, Bibl. de l'Arsenal, MS 592 [photographs in the P. Morgan Library, New York City])
a rudimentary form of a rinceau pattern is introduced into the one-color picture plane.

backgrounds, which are in a single color—gold, purple, or blue—are some' times patterned.

The nonrepresentative and two-dimensional character of backgrounds which are not colored or are in one color is apparent. The choice of purple and gold, whether the interpretation is religious or aristocratic, emphasizes the nonrepresentative and decorative nature of the picture plane, which is further enriched when a pattern is introduced. In the patterned backgrounds the motives tend to be large and dominating, as in the Hildesheim illumina' tions, rather than small and subordinate like the allover designs character' istic of French miniatures of the thirteenth century.

The effect of the background as a single plane behind the figures is fre' quently stressed by the omission of the ground plane. When the ground is indicated it sometimes extends as a plane across the lower part of the scene, but it is occasionally an irregular stylized area intended to support an indi' vidual figure.[38]

Besides the picture planes which are uncolored or in one color, stratified backgrounds may be found in French illumination. Two manuscripts, the Commentary of Beatus on the Apocalypse, from St. Sever[39] and the Life of St. Radegonde (Fig. 25),[40] both produced in southwestern France in the third quarter of the eleventh century, offer excellent illustrations of the sim' ple form of stratification in which the background is divided into a series of horizontal bands. The transformation of the stratified background, which still bears some marks of tridimensional and representative space, to a banded background which is a vertical plane and nonrepresentative is more advanced in these French manuscripts than in the German illuminations of Reichenau and Echternach. This is due to several factors: the absence of gradation in the color of the bands, the almost equal widths of the divisions, and the similarity of the construction of the lowest stratum, which is the ground plane, to the rest of the bands. In many instances the ground plane has no distinctive contour or features of vegetation to identify it. The tend' ency to include the stratum of ground in the pattern of the background is

[38] Paris, Bibl. Nat., MS lat. 9436, Sacramentary of St. Denis, fol. 16 (Leroquais, Les Sacra' mentaires et les missels MSS, Pl. XXXII). Several illuminations in this manuscript have unpat' terned purple backgrounds (Lauer, Les Enluminures romanes, pp. 109-10).

[39] Paris, Bibl. Nat., MS lat. 8878 (Lauer, Les Enluminures romanes, Pls. XV-XXII).

[40] See also fol. 129 in the Sacramentary of St. Denis (Paris, Bibl. Nat., MS lat. 9436 [Lauer, Les Enluminures romanes, p. 110]) for a stratified background.

promoted by the fact that the connection between the figures and the ground is rather indefinite. The weak foreshortening of the feet gives the impression that the figures are not standing on the ground but that they are set against the background which is seen as a whole. In several illustra' tions in the Apocalypse of St. Sever[41] this effect is strengthened because the figures do not hover in the neighborhood of the base line or of the contour of the lowest band, but are scattered over the whole picture plane.[42]

In contrast to the German illuminations, where some attempt was made to differentiate between interior and exterior space, in these manuscripts, although an interior is indicated by an architectural frame, the banding of the background is not necessarily affected (Fig. 25). Indifference to the distinction between interior and exterior in the background indicates that the background as environment has been disassociated from the action to a considerable extent. The background is not, in general, entirely decorative, for the color is associated with reality in some instances, and there are too few bands, usually three or four, to give the impression of a regular striped pattern. In several illuminations, however, the background is more decora' tive in character. In these the succession of colors has little or no connection with a naturalistic order and one color is sometimes used twice in the back' ground, thereby suggesting a patterned arrangement.[43] The banded form itself is modified in some cases. The number of bands is occasionally in'

[41] Paris, Bibl. Nat., MS lat. 8878, fols. 108v-109, 145v, 148v (Lauer, *Les Enluminures romanes*, Pls. XVII-XIX, XXII).

[42] Although the scattered composition frequently has a conceptual form, in some instances, notably in the representation of the "Four Horsemen" (fols. 108v-109 [Lauer, *Les Enluminures romanes*, Pl. XVIII-XIX]) and the boats on the lake in the "Fall of the Mountain of Fire" (fol. 139v [ibid., Pl. XX]) optical spatial relationships between the figures are indicated. This tend' ency toward optical composition in the figures may be observed in a different form in the scene of "Daniel in the Lions' Den" (fol. 233v [Neuss, *Die katalanische Bibelillustration*, Pl. XVII, Fig. 51]). Here, in contrast to the representation of the same scene in Spanish Beatus manu' scripts (ibid., Figs. 52-54) where the composition is schematic with a central orans figure flanked by two lions, Daniel is seated at one side in profile, opposite the lions. His gesture is directed upward to Habakkuk. Thus, in the St. Sever illumination there is a change to a narrative form, emphasizing a momentary incident and the communication between the figures rather than the symbolic significance of the scene.

[43] See Ginot, "Le Manuscrit de Sainte Radegonde de Poitiers," *Bull. de la Soc. fran. de reprod. de MSS à peintures*, Vol. IV (1914-20), for detailed notes on color the illuminations in the manuscript. In Fig. 25 each register has a purple band at the top and bottom, the series in each background being purple, green, blue, purple. In the illuminations of the manuscript a purple band often occurs twice in one background, either in alternation with the other bands or at the extremities of the field (cf. ibid., p. 35). For an example of arbitrary color in the St. Sever Apocalypse see fol. 148v (Lauer, *Les Enluminures romanes*, p. 98; Pl. XVII).

creased considerably[44] and the stratified background is sometimes converted into a checkerboard, as in fol. 145v of the Apocalypse of St. Sever,[45] where a vertical line divides the picture plane into rectangles and the color is applied in an alternating scheme.

Although the Spanish manuscripts of the Commentary of Beatus on the Apocalypse are not, properly speaking, northern works, they should be mentioned in connection with the stratified background. In the Beatus illuminations of the tenth and eleventh centuries the picture plane is generally divided into comparatively few bands of fairly equal width.[46] The bands are regular in outline and the colors are applied uniformly without atmospheric gradation, the tones having little relation to a naturalistic environment. The lowest zone is not distinguished in shape from the other zones, but it becomes part of the banded background seen as a whole. Only with regard to position is the lowest band suggestive of a naturalistic ground plane. In many instances the figures hover near the frame or near the upper boundary of the lowest band, but the flat, linear form of the figures and the conceptual character of the composition of the scenes nullify any effect of a tridimensional relationship. The reduction of the stratified background to a series of two-dimensional bands is in accordance with the simplified, linear representation of the figures and the abbreviated, conceptual form of architectural and other scenic properties. In general the Spanish illuminations retain fewer vestiges of tridimensional, optical form than do the stratified miniatures of other regions.[47]

[44] Poitiers, Bibl. Mun., MS 250, fol. 21v (Ginot, *Bull. de la Soc. fran. de reprod. de MSS à peintures*, Vol. IV [1914-20], Pl. I).

[45] Lauer, *Les Enluminures romanes*, Pl. XXII.

[46] New York City, P. Morgan Lib., MS 644, Beatus from S. Miguel de Escalada (926 A.D.); Gerona, Cath. Archives, Beatus (975 A.D.); Valladolid, Bibl. Santa Cruz, Beatus (*ca.* 970 A.D.); Madrid, Bibl. Nac., MS B. 31, Beatus (1047 A.D.). See Neuss, *Die Apokalypse,* for numerous reproductions of illuminations from these manuscripts. The illustrations of Jerome's Commentary on Daniel that accompany the Beatus Commentary on the Apocalypse do not have colored backgrounds and are unframed (*ibid.,* p. 222).

[47] The illuminations of the original Beatus manuscript (*ca.,* 785 A.D.) were probably derived from early Christian paintings belonging to the stratified group (*vide supra,* p. 40). Cf. *ibid.,* pp. 243, 272. The relationship of the St. Sever Apocalypse to the Spanish manuscripts may lead one to the conclusion that Spanish illumination had a great influence on the painting of southern France. However, a number of iconographic features in the St. Sever manuscript which differ from the Spanish Apocalypses have been traced by Professor Meyer Schapiro to north Carolingian sources (Miner, review of Neuss, "Die Apokalypse," *Art Bulletin*, XV [1933], 390-91) and the illumination of the southern French schools is an independent development from Carolingian painting (Schapiro, review of Lauer, "Les Enluminures romanes," *Art Bulletin*, X [1927-28], 398).

A review of the spatial development in the north would be incomplete without a brief discussion of a group of Belgian manuscripts localized in Liége by Schott.[48] These have been linked stylistically with the later illumina-tions of St. Omer.[49] They show, however, strong affiliations with the west German Ottonian schools, and, as Schott has pointed out, especially with Reichenau.[50] This opinion is borne out by the spatial form, for a number of elements—such as stratification in conjunction with a wide gold band, large geometric patterned backgrounds, and patterned rock ground planes—which are found in the Reichenau miniatures, appear in the Liége illumina-tions.[51] In the group as a whole there is a pronounced tendency toward a two-dimensional, decorative picture plane. The vestiges of a naturalistic en-vironment are limited to traces of stratification in the sky and patterned rock ground planes, which appear sporadically in the earlier manuscripts.[52] Back-grounds of one color, usually gold or purple, predominate and are frequently enriched with large geometric patterns.[53]

In the Liége miniatures the artists tended to multiply the frames and to present a comparatively wide unornamented inner border to the picture plane.[54] This development is significant spatially because it may be viewed

[48] Zwei Lüttischer Sakramentare. Schott has isolated the manuscripts which form the Liége group and has put them in a chronological order which ranges from the second decade to the end of the eleventh century.

[49] Boeckler, Abendländische Miniaturen, p. 59. The illuminations in the Life of St. Omer (St. Omer, Bibl., MS 698) show the influence of both the English style of northwestern France and the Liége group (Schott, Zwei Lüttischer Sakramentare, p. 100).

[50] Zwei Lüttischer Sakramentare, pp. 45, 60, 100.

[51] Stratification in conjunction with a wide gold band: Bamberg, Staatsbibl., MS lit. 3 (Ed. V. 4), Sacramentary, fol. 68v, "Ascension"; Paris, Bibl. Nat., MS lat. 819, Sacramentary, "Agnus Dei"; Paris, Bibl. Nat., MS lat. 278, Evangeliary, "St. Matthew" (Schott, Zwei Lüt-tischer Sakramentare, Figs. 9, 11, 15, 16). Patterned backgrounds: Bamberg, Staatsbibl., MS lit. 3 (Ed. V. 4), Sacramentary, "Noli me Tangere" (fol. 62); Brussels, Bibl. Roy., MS II. 175, Evangeliary, "St. Damasus" (fol. 2) (ibid., Figs. 8, 18). Vide supra, note 22. In connection with the patterned backgrounds in the Liége manuscripts one should note their presence in the St. Omer Life of St. Omer (St. Omer, Bibl., MS 698). Patterned rock ground planes: Bamberg, Staatsbibl., MS lit. 3 (Ed. V. 4), Sacramentary, "Adoration of the Magi," "Noli me Tangere," "Ascension"; Paris, Bibl. Nat., MS lat. 819, Sacramentary, "Agnus Dei" (ibid., Figs. 5, 8, 9, 11).

[52] Bamberg, Stattsbibl., MS lit. 3 (Ed. V. 4), dated ca. 1015; Paris, Bibl. Nat., MS lat. 819, dated ca. 1025; and Paris, Bibl. Nat., MS lat. 278, listed next in order by Schott.

[53] Schott, Zwei Lüttischer Sakramentare, p. 140.

[54] Ibid. Examples: Bamberg, Staatsbibl., MS lit. 3 (Ed. V. 4), Sacramentary (photographs in the P. Morgan Library, New York City, Pls. II, X-XI). See also a Gospels related to the Liége group, Brussels, Bibl. Roy., MS 18383, fol. 84v (Gaspar and Lyna, Principaux Manuscrits, Pl. VIII).

as a tendency toward—if not an incipient form of—the Romanesque pan-eled background of the following century.

The Liége manuscripts offer an excellent opportunity to observe in a limited group the direction of the spatial development characteristic of the period as a whole. The development of a two-dimensional background that is a foil for the action is accompanied by modifications in the representation of the figures and the objects. The figures gradually change from a more plastic and organic structure to a more linear, schematized form.[55] The archi-tecture shows a movement away from arrangements in which relationships from an optical point of view play some part to compositions in which deco-rative balance is the major consideration. As a result of the modifications in the picture plane and in figures and objects, the Liége manuscripts form a group which is more closely related to twelfth-century spatial concepts than to Carolingian.

In reviewing the spatial representation in the backgrounds of northern illumination in the tenth and eleventh centuries the attempt has been made to present the general character of the space despite the numerous variations of the form and the stylistic differences that occur. In the different regions there are illuminations in which the backgrounds are clearly derived from the principle of stratification found in the Carolingian and early Christian painting. The extent to which tridimensional and representative space in the strata is preserved varies considerably, but the modifications, however slight, are on the whole in the direction of two-dimensional and non-representative space. Furthermore, there is a decorative tendency which ap-pears in the patterning of individual elements, such as the ground plane, or in the arrangement of the whole picture plane, as in the striped backgrounds of the Hildesheim manuscripts.

In the illuminations which do not have vestiges of stratification in the background, references to tridimensional and representative space are elim-inated. The gold, purple, or patterned backgrounds are two-dimensional, nonrepresentative surfaces behind the figures. They are decorative foils for the action rather than indications of the environment. References to the set-ting are reduced to essentials. The buildings and patterned strips or mounds

[55] Schott, *Zwei Lüttischer Sakramentare*, pp. 146 ff. An interesting departure from the tradi-tional positions for the figures occurs in the "Pentecost" (fol. 58v) of the Sacramentary in Paris (Bibl. Nat., MS lat. 819 [photograph in the P. Morgan Library, New York City]). In this illumination the figures in the lower row are seated with their backs toward the spectator.

of ground are not part of the spatial construction of the background, but are accessories related to the figures in the same way as is the furniture of the scene.

The elimination of tridimensional and representative space from the background is a universal tendency in this period and can be observed in the painting of Italy and Byzantium. But the degree of elimination is smaller than in the north. To a great extent this is due to the basic form of the spatial construction of the picture plane, namely, the preservation of the divisions of stage space in the painting of Italy and Byzantium in contrast to the stratified background in that of the north. The vestigial form of stage space is more prevalent in Byzantine painting than in Italian, for in Italy, in this period as in the eighth and ninth centuries, both the stage and the stratified forms occur.

In the Italian frescoes and manuscripts in which the background is composed according to the principles of stage space[56] the form is little changed from that of the previous century. In general the elements of the background have been reduced to the two essential horizontal bands—the broader representing the sky, and the narrower, the ground plane. Taken by themselves the bands are vertical planes, yet in the background as a whole the relationship of the bands to one another and their color still suggest representative, tridimensional space. The figures are usually composed in a frieze near the frame or the upper contour of the ground plane, and in this position they do little to suggest that the ground is a plane in depth opposed to the vertical plane of the sky band. Usually the proportions of the bands and the color alone link the background to the representative environment. In several frescoes,[57] particularly in the St. Clement and St. Alexis scenes of the subterranean basilica of San Clemente in Rome, there are high background objects. Although in keeping with the general tendency toward two-

[56] Magliano-Pecorareccio, Grotto degli Angeli (Van Marle, *Italian Schools*, Vol. I, Fig. 76). Rome, Palatine, S. Sebastianello (Ladner, "Die italienische Malerei," *Jahrbuch der kunsthistorischen Sammlungen in Wien*, N. F., Vol. V [1931], Fig. 64). Rome, Chapel of Santa Pudenziana, "Madonna and Child between Saints" (Wilpert, *Die römischen Mosaiken und Malereien*, Vol. IV, Pl. CCXXXIV). Monte Cassino, MS 73. 129 (*Les Miniatures des MSS du Mont Cassin*, Pl. VII).

[57] Rome, Santa Cecilia-in-Trastevere, Scenes from the Legend of St. Cecilia (Wilpert, *Die römischen Mosaiken und Malereien*, Vol. IV, Pl. CCXXXVIII). Rome, S. Giovanni in Laterano, "St. Peter with Ananias and Saphira" (Ladner, *Jahrbuch der kunsthistorischen Sammlungen in Wien*, N. F. Vol. V [1931], Fig. 47). Rome, S. Clemente (subterranean Basilica), Story of St. Clement and St. Alexis (*ibid.*, Pls. XII-XVI).

dimensionality these buildings are little more than façades, they are signifi-
cant additions to the representative character of the background.[58] Further-
more, as vertical representative objects on the ground, they break up the
continuity of the background as a single vertical plane and thereby help to
preserve the distinction between the green band of ground and the blue sky
as separate elements in the picture plane.

The retention of representative color in the background, that is, blue for
the sky and green for the ground, is characteristic of Italian painting of this
period, not only where the divisions of the background follow the principles
of stage space, but also where stratification appears. In this respect Italian
painting differs from that of the north. In the latter there is a greater variety
of hue and tone, even where the range of color may still be associated with
nature. In the stratified backgrounds found in Italian frescoes and illumina-
tions, besides the conservative selection of color, another distinctly Italian
tendency may be observed. In the northern illuminations there are usually
not less than four strata, and in many instances the number of bands was
increased to such an extent that they have lost their significance from a
tridimensional and representative spatial point of view. In the Italian fres-
coes and in the giant Bibles in which stratification is preserved the tendency
was to reduce rather than to multiply the number of bands.[59] Some of the
scenes in the frescoes of Sant' Angelo in Formis[60] and the "Genesis" in the
Vatican Bible (MS lat. 10405)[61] have four bands of fairly equal width,
but elsewhere, as in the fresco of the "Virgin between Martyrs and Angels,"
in Santa Maria in Pallara,[62] there are only three. In this fresco the central
band, which is green, is wider than the other bands and therefore has to

[58] In the S. Clemente frescoes the buildings are not merely skeletal frames, because the
openings are purple, giving the buildings substance against the blue sky and carrying through
the distinction between exterior and interior.

[59] The locality of the source of the giant Bibles is a disputed point. Toesca (Miniature
romane, p. 8, note 1) is of the opinion that they derive from central Italy, while Boeckler
(Abendländische Miniaturen, p. 71) believes that they came from northern Italy. In view of
the stratified backgrounds it is notable that the question of a connection between these manu-
scripts and Carolingian illumination has been raised. Toesca (Miniature romane, p. 8) and
Boeckler (Abendländische Miniaturen, p. 69) believe that there are similarities in the initial
ornament, and Professor Meyer Schapiro has indicated to me iconographic connections, especially
in reference to the representation of the scenes of King David and also in the type of armor.
G. Swarzenski, however, is of the opinion that the giant Bibles originated in Italy independently
of the Carolingian illuminated Bibles (Die Salzburger Malerei, pp. 64 ff.).

[60] Van Marle, Italian Schools, Vol. I, Fig. 64.

[61] Toesca, Miniature romane, Fig. 6.

[62] Wilpert, Die römischen Mosaiken und Malereien, Vol. IV, Pl. CCXXIV.

some extent the character of the high background hill of a composition in stage space. In several instances, such as the fresco illustrating the legend of St. Cecilia in Sant' Urbano alla Caffarella,[63] or the illuminations in the giant Bible of Cividale[64] and the one in the Vatican (MS Barb. lat. 587),[65] the background is divided into two bands only, thus approaching the simple form of stage space. In these backgrounds, however, the form is not always truly vestigial of stage space, for the proportions of the divisions are fre-quently reversed, that is, the ground is wider than the band of sky.

In Italy, as in the north, there are a number of manuscripts with illustra-tions on uncolored backgrounds. In the Monte Cassino manuscripts, which form a large part of this group, the scenes, although not marginal, are gen-erally unframed, with or without a ground line to support the figures.[66] Although in these illustrations there is no formal picture plane and most of the details of the environment have been eliminated, the figures and objects are composed according to the same principles as in the other types of back-ground. The opportunity for spreading the composition out conceptually in all directions, which is latent in the untreated picture plane, is not used. Instead, the figures and the objects remain on the same horizontal level as if limited by a ground line, and the planes in depth are telescoped. Thus, al-though representation in depth is eliminated, the façade, so to speak, of the optical rendering remains.[67]

From this brief résumé of the various types of background found in

[63] Ibid., Pl. CCXXX.

[64] Ladner, Jahrbuch der kunsthistorischen Sammlungen in Wien, N. F., Vol. V (1931), Figs. 25, 26.

[65] Ibid., Figs. 21-23. The simplification of the elements of the background in the giant Bibles reaches the point where in the Bible in Munich (Staatsbibl., MS clm. 13001 [ibid., Figs. 28, 29]) the background is not colored except for a blue rectangle set like a square nimbus behind the heads of the figures.

[66] Paris, Bibl. Mazarine, MS 364, Breviary (Leroquais, Les Bréviaires MSS, Pls. I-VIII). Monte Cassino, MS 109. 25, Homilies (Les Miniatures des MSS du Mont Cassin, Pls. V-VI). Monte Cassino, MS 99. 206, Homilies (ibid., Pl. IX). Monte Cassino, MS 98 H, Homilies (Ladner, Jahrbuch der kunsthistorischen Sammlungen in Wien, N. F., Vol. V [1931], Figs. 10-12).

[67] In contrast to the constrained movement and compact composition of many of the Monte Cassino illustrations, the action in the Sacramentary of Warmund (Ivrea, MS 86 [Ladner, Jahr-buch der kunsthistorischen Sammlungen in Wien, N. F. Vol. V (1931), Figs. 96-160]) is much more free, although the scenes are framed. There is no ground line, and the figures stand near the center of the pictorial field instead of standing near or on the frame. The position of the figures together with the presence in many instances of pronounced diagonal lines in the objects, give the impression of movement in depth despite the inadequate foreshortening and the neutral background.

Italian painting of this period it can be seen that both stage and stratified space were used as the basis of the construction of the background. Since both types of space were present in Italian painting before the tenth century, it is difficult to evaluate the influence from the Ottonian and Byzantine Empires as far as spatial principles are concerned. Where stratified space appears, it is a continuation of the nonatmospheric bands of the eighth and ninth centuries found in the frescoes of Santa Maria Antiqua and San Clemente. The development is conservative; the number of bands was reduced rather than multiplied and the representative color was retained. There are few patterned backgrounds.[68] In the Ottonian manuscripts, however, those from Reichenau and Echternach usually have atmospherically graded color, whereas in the other schools there was a tendency to increase the number of bands, to use nonrepresentative color, or to pattern the background.

The use of stage space in Italian painting can also be explained by its prevalence in the previous century; it was not necessarily dependent on contact with Byzantium. The simplification of the features of the background and the elimination of the background object shown in many of the Italian frescoes, as in the Grotto degli Angeli, Magliano-Pecorareccio (near Nepi),[69] are characteristic of Italian painting in contrast to Byzantine. In general the Italian form preserved less environmental detail than did the Byzantine, and the effect of the background as a vertical plane is more pronounced.

In the Byzantine manuscripts representative features were retained in the background to a considerable degree. In the stage space divisions of the picture plane, tridimensionality is implicit. By telescoping the background objects and by stylizing the ground plane, however, the depth of the scene was further reduced. The substitution of gold for blue in the sky lessened the suggestion of a representative environment.[70] In the Menologium of Basil II,[71] are a number of illuminations which are typical of the period.

[68] Example of patterned background: Nepi, S. Elia (Van Marle, *Italian Schools*, Vol. I, Fig. 68).

[69] *Ibid.*, Fig. 76.

[70] Gold is generally used for the sky, but there are examples of blue in some of the Octateuchs (Ebersolt, *La Miniature byzantine*, p. 31) and in the Book of Job in Venice (Marciana, MS gr. 538 [Dalton, *Byzantine Art and Archaeology*, Fig. 283]).

[71] Rome, Vatican, MS gr. 1613 (*Il Menologio di Basilio II*). Another example is the Psalter of Basil II, in Venice (Marciana, MS gr. 17).

The three-part division of the background—ground plane, high background object, and sky (gold)—presents the essential features of stage space (Fig. 27). The usual division of the ground plane into two strata by an undulat-ing line, probably a vestige of cast shadows which has become a stylized contour that frequently supports the figures, gives a slight impression of depth because the division is often accented by a change from a darker to a lighter tone of the same color (Fig. 26).[72] The high background objects, buildings or rocks, preserve the limited boundaries in depth of stage space[73] and separate the ground plane from the background proper, thereby pre-venting the impression that the two are continuous on the same plane. The introduction of nonrepresentative color into the background objects, such as violet in the rocks and blue and violet trim in the buildings, does not nullify the representative character of the objects, because the linear con-struction identifies them definitely. The fact that the color is decorative rather than naturalistic is, however, in accordance with the general loss of tridimensionality in the objects. The reduction to two-dimensional form is arrested somewhat by the preservation, in part, of the cubic construction of the high background object, for, although the bases of the buildings and the rocks are telescoped, the rocks have formalized horizontal ledges, and the roof lines of the receding planes of the buildings are inclined. On the whole, the Byzantine background underwent fewer changes than did those of the north and of Italy, and as a result it suggests a more complete representative environment for the figures.[74]

This review of the types of spatial representation in the tenth and elev-

[72] London, Brit. Mus., Burney MS 19 is dated eleventh century by Herbert (*Illuminated Manuscripts*, p. 64). Lazareff ("The Mosaics of Cefalù," *Art Bulletin*, XVII [1935], 209, note 47), however, lists it with the twelfth-century manuscripts.

[73] In this period the background building begins to assume the form of a long, low wall—occasionally with towers—extending from one side of the frame to the other. This type of building becomes characteristic of Byzantine illumination and is adopted in Italian painting in the thirteenth century.

[74] Although the three part stage space background has been described as typical, there are various other forms of background in Byzantine painting. Briefly, these are: the stage space divisions of gold sky and narrow ground plane without the background object (Venice, Marciana, MS gr. 564, Gospels), the uncolored background with a ground plane (London, Brit. Mus., Add. MS 19352, Psalter [Dalton, *Byzantine Art and Archaeology*, Fig. 260]; Venice, Marciana, MS gr. 479, Cynegetica of Oppian [*ibid.*, Fig. 289]), the gold background without any indications of the representative environment. The last type, which occurred in the previous century, appears in the Homilies of James (Paris, Bibl. Nat., MS gr. 1208 [Ebersolt, *La Miniature byzantine*, Pl. XXXVI, 2]) and is used frequently for scenes portraying the evangelists (Venice, Marciana, MS gr. I. 53, Gospels).

enth centuries shows that stage space and stratified space were still distinct and that the geographical distribution was the same as in the previous period. Germany, England, and France continued with modifications the principle of stratification which was characteristic of Carolingian illumina- tion. In Italian painting both stratified and stage space are found, a co- existence which goes back to the Roman period, when they appeared in their original tridimensional form. In Byzantine painting, the tradition of stage space was continued.

The tendency on the whole was to eliminate tridimensionality and to introduce nonrepresentative elements. In each of the countries mentioned this tendency may be said to reach its conclusion in the single-color back- grounds which are two-dimensional and nonrepresentative. Many paintings, however, retain some vestiges of tridimensional and naturalistic space. The presence of these vestiges is to some extent dependent on the spatial prin- ciple which is followed. In stage space the division of the picture plane into two bands, with the narrow band below the wide one, preserves both the natural distinction between ground and sky and the implied tridimensional relations between them. In Byzantine painting, besides the spatial type itself, there are the factors of representative color in the ground plane and the represented objects, buildings and hills, judiciously placed on the upper contour of the ground plane. On the other hand, in the stratified background the distinction between ground and sky tends to be lost because of the greater number of bands and the fact that they are more nearly equal in size. This factor and the tendencies to straighten and to outline the contours of the bands, to increase their number, and to introduce brilliant tones verging on the nonrepresentative appear in the illuminations of the north, with the result that the background as environment began to be transformed into a background that is a decorative foil for the action. In Italy changes in the stratified background were less radical. Perhaps the tradition of stage space acted as a check. The retention of representative color in both types of background in Italian painting attests the conservative character of the development.

As in the previous century, the representation of figures and objects accords with the tendencies noted in the construction of the background. The form of the figures is linear rather than plastic. A few characteristic poses are repeated. The three-quarters view of the head is the form most

frequently used for all positions of the figure. The standing figure follows tradition in having one straight leg and one relaxed. In Italian and Byzantine painting, however, in monumental work of a hieratic nature the completely frontal rigid figure appears. The seated figure is usually in three-quarters view, and the moving figure combines the three-quarters view of the head with profile limbs. The two-dimensional character of the background and the restraining conventions with regard to the positions limit the action to movement from right to left. Therefore, there is no movement or composition in depth.

There is a general concordance between the amount of plasticity in the figures and the manifested or implied tridimensionality of the background. Present in individual paintings, this also applies to the schools as a whole. By broadly comparing Byzantine and northern painting it will be found that the more pronounced vestiges of tridimensionality found in the stage space backgrounds of Byzantine illuminations are accompanied by more plastic figures where linear high lights offset by shadow model the form. The edges of the drapery create a shell for the body (Fig. 26). The figures in the northern illuminations are flatter. The sharply outlined silhouette is angular, and the form of the body is not depicted by a contrast of light and shade so much as by dark outlines. The edges of the drapery are either straight or they flutter lightly. The fluted folds at the edges are small and scarcely suggest an envelope for the body (Fig. 25). Furthermore, in Byzantine painting the figures usually stand on the undulating contour which divides the ground plane. The impression of bulk in the figure and its statuesque character give the appearance of a firm stance. In the north the light, flat figures and the very slightly foreshortened feet give a vague impression of contact with the ground, a vagueness which is emphasized because the figures are usually suspended near the frame and the ground plane itself tends to become absorbed in the banded pattern of the background.

As far as the perspective of the objects is concerned, there is little to add to the description of the previous period. The tendency to reduce the tridimensional structure to a single plane by telescoping continued. Where planes in depth are represented, the inclination of the receding lines is slight and the object has the appearance of being tilted upward. The receding lines in depth of the same plane were as frequently made to diverge as to con-

verge. Objects or parts of buildings are superimposed upon one another or are adjacent to one another without regard for the assumption of tri-dimensional space implied by their cubic form. In the northern manuscripts interiors are frequently indicated by an architectural frame with dispro-portionately small roofs and turrets presented singly or clustered in cubic groups. This type of frame, distinguished by the roofs and turrets which are an attempt to make the setting more specific, is not a substitute for the border of the picture plane, as are the simple arched frames usually found in portraits of the evangelists, but is placed within the border. The upper part of the picture plane is visible behind and above the roofs and preserves to some extent the distinction between exterior and interior. This distinction was lost gradually in the succeeding centuries when the upper part of the architectural construction was raised until it coincided with the frame of the picture plane and the architectural frame itself was used indiscriminately for exterior as well as interior scenes.

Thus, the representation of the figures and the objects was modified slowly in accordance with the general tendency toward two-dimensionality, and there was a corresponding decrease in the correctness of the rendering from an optical point of view. The more noticeable changes appeared in the background as a whole. However, the change is not so great in Italian and Byzantine painting as in northern painting. The modifications which the Carolingian stratified background underwent in Germany, England, and France in the tenth and eleventh centuries precede a new concept of the background in the twelfth century, which may be called Romanesque.[75]

[75] The term "Romanesque" is conventional, and its use is not necessarily limited to the art of the twelfth century. Certain forms and qualities which are regarded as "Romanesque" appear in the eleventh century, particularly in the second half of the century. The chronological division of the chapters in this study does not indicate abrupt changes in the development, for the evolution of forms does not lend itself to such rigorous subdivision.

CHAPTER V

THE TWELFTH CENTURY

IN THE twelfth century a new type of background was developed in German, French, and English illumination. The gradual loss of representative elements and tridimensional values through stratification may be said to have culminated in the tenth and eleventh centuries in the backgrounds of a single color—usually gold, purple, or blue. Since there are no limiting features except the frame or associations with a natural environment and since the colors themselves suggest symbolic values, this form of background presents a decorative concept of the picture plane which may be interpreted spatially as abstract, or ideal and unbounded, in contrast to the more definite and particularized space of a tridimensional, representative background. Although the background of one color was still employed in the twelfth century, another type was developed which apparently grew more directly out of the stratified form and which combines characteristics of both the stratified background and the background of a single color. In this type, which may be designated as Romanesque, the picture plane is partitioned as in the stratified background, but the divisions have no implication, in form or color, of a naturalistic environment. Thus, the background has, like that of one color, a nonrepresentative character. The effect, however, is different, for, although the form of the background itself is, in a sense, abstract and ideal, it does not give the impression of unbounded space, because the divisions in the picture plane create a distinctly delimited, substantial, and vertical pictorial field.

The development of a nonrepresentative background was due partly to the preceding stratified form, which lent itself to such modification, and also to cultural influences. In the Middle Ages illumination was primarily reli-

gious in content, and was produced in the monasteries. Both factors tended to preserve traditional forms and to concentrate on the content rather than on the pictorial effect. The locality and the details of the environment were relatively unimportant, for not only was the setting remote in time and place, but it was also associated with divinity. Ideally the monk was not preoccupied with aspects of the everyday world; hence, he was not inclined to imitate its features in his painting. It was consistent, therefore, with the monastic point of view that the naturalistic features of the stratified background were replaced gradually by the nonrepresentative forms of the Middle Ages, only to be revived to some extent in periods in which there was a strong secular influence, such as the early Carolingian and the Ottonian.

In the Romanesque background, variations in form are numerous, but the general character was not changed. In the stratified background the horizontal position of the bands was a vestige of the zones in the ground and the sky. When the background is conceived as a nonrepresentative surface, however, the divisions are not controlled by naturalistic associations, and the possibility of invention is thus extended considerably. The picture plane is partitioned in many ways. Panels, vertical bands, and combinations of horizontal and vertical bands occur.

In German illumination, the Romanesque form was anticipated in the eleventh century in the manuscripts from Hildesheim and Regensburg, which have backgrounds with alternating stripes or patterned divisions.[1] In the twelfth century the paneled type was developed, and it illustrates clearly the general principle that the background is a delimited, substantial, and nonrepresentative surface. The manuscripts emanating from the Saxon, Westphalian, Rhenish, Swabian, and Bavarian schools present, in general, the same form—the framed rectangular picture plane in which the nonrepresentative uniform surface of the enclosed area is interrupted by a central panel (Fig. 28).[2] The size of the panel varies from a comparatively small

[1] Vide supra, pp. 67 ff.
[2] In the Liber Florum of Theofried von Echternach (d. 1108) (Gotha, Landesbibl., MS I. 70 [H. Swarzenski, Vorgotische Miniaturen, Pl. XXVII]) of the Echternach school, which is dated at the end of the eleventh century, the title page offers an early example of the paneled background. In connection with the development of the paneled form in the eleventh century one should recall the Liége group of illuminations with prominent secondary frames (vide supra, p. 76). The paneled background occurs in Belgian illumination of the twelfth century: Brussels, Bibl. Roy., MS 2034-35, Sacramentary from the Abbey of Stavelot, fol. 25v (Gaspar and Lyna,

rectangle in the center of the picture plane to one which is large enough to appear as a molding inside and connected with the border framing the illumination, such as the representation of St. Michael slaying the dragon in the Sacramentary of the priest Ratmann,[3] in which a series of moldings forming a heavy frame also suggests the panel present in other manuscripts. Occasionally a background contains more than one panel, as in the Evangeliary of Henry the Lion,[4] or has but a single incomplete rectangle, the sides of which pass into the border.[5] A different color distinguishes the panel from the rest of the background (Fig. 28).[6] In several illuminations the introduction of a pattern into the panel increases its prominence (Fig. 29).[7] Despite all these modifications, however, the essential form—a picture plane with a rectangular subdivision—remains constant.[8]

The character of the picture plane is affected by the paneling in several ways. In contrast to the stratified background in which the form of the whole is composed of several unmeasurable and laterally, at least, unlimited

Principaux manuscripts, Pl. XIV a); Brussels, Bibl. Roy., MS 9642-44, Bible from the Abbey of St. Laurent in Liége, fol. 133v (*ibid.,* Pl. XIV b); Brussels, Bibl. Roy., MS 9916-17, Dialogues of Gregory the Great, from the Abbey of St. Laurent in Liége, fols. 2v, 23v (*ibid.,* Pl. XVI a, b).

[3] Hildesheim, Cath. Treas. (H. Swarzenski, *Vorgotische Miniaturen,* Pl. LVII). See also Stuttgart, Landesbibl., MS 28, Evangeliary from Gengenbach, Swabian school, "Annunciation" (*ibid.,* Pl. XLVII).

[4] Gmunden, Kgl. Fideikommis. Bibl. (H. Swarzenski, *Vorgotische Miniaturen,* Pl. LIX).

[5] Salzburg, Stiftsbibl. St. Peter, MS a. xii. 7, Antiphonal, "Descent from the Cross" (H. Swarzenski, *Vorgotische Miniaturen,* Pl. XLIX).

[6] Other illustrations: Salzburg, Stiftsbibl. St. Peter, MS a. xii. 7, Antiphonal (H. Swarzenski, *Vorgotische Miniaturen,* Pl. XLIX). Munich, Staatsbibl., MS lat. 935, *Prayerbook of St. Hildegard* (*ibid.,* Pl. LXVI). In reference to the paneled background that appears in the St. Peter Antiphonal and numerous German illuminations of this period, in which the central part is blue and the bordering area, green, G. Swarzenski (*Die Salzburger Malerei,* p. 117) suggests the possibility of a connection with German enamel work where a similar choice and arrangement of color is to be found. Although other types of partitioned backgrounds occurring in German illumination indicate the continuity of the formal development, the particular popularity of the bluegreen paneled form, which may still be found in German manuscripts of the southern schools in the next century, seems to bear out Swarzenski's suggestion. The relation of blue and green is also typical of Mosan enamels and miniatures.

[7] Gmunden, Kgl. Fideikommis. Bibl., Evangeliary of Henry the Lion (H. Swarzenski, *Vorgotische Miniaturen,* Pl. LIX). Munich, Staatsbibl., MS lat. 935, Prayerbook of St. Hildegarde (*ibid.,* Pl. LXVI).

[8] Occasionally in the German manuscripts there are illuminations with backgrounds partitioned into vertical bands which resemble the French form (*vide infra,* p. 92) rather than the characteristic German type of paneled background. Examples may be found in a Gospel Lectionary (London, Brit. Mus., Egerton MS 809, fol. 1v) and in the Collectae sequentiae of Maria Laach (Darmstadt, Landesbibl., MS 891, photographs in the P. Morgan Library, New York City). In the latter manuscript there are also illuminations with paneled backgrounds.

parts, and in contrast to the more unlimited as well as unmeasurable picture plane of one color, the panel defines the background as a delimited unit. The background becomes in effect a closed decorative form that shows no vestiges of representative space and does not suggest boundless space. Furthermore, the panel helps to create the impression, as does a pattern, that the back-ground is a substantial surface which is vertical, that is, parallel to the standing figure.

As a limited, vertical surface, the paneled background serves as a focus and foil for the action. The panel provides a center of concentration within the picture plane in front of which the figures move and also, to some extent, a scale for the composition as a whole. When the figures are relatively large in proportion to the panel, especially when the composition is limited to only one or a few figures, the paneled picture plane helps to create a monumental effect. Just as the divisions of the background and patterns contribute to the impression that the background is a substantial surface, so too do they offer points of contact with the figures that accentuate the silhouette as a con-crete form separate and distinct from the background. Although the picture plane and the figures are thus related with regard to focus and foil, the con-nection between the background and the action is essentially indefinite. There is no complex tridimensional spatial interrelationship, for the figures remain on a plane in front of the paneled wall which curtails any movement in depth. The freedom of movement laterally, which the frequent overlap-ping of the frame (Fig. 29) and the segmentation of the figures by the frame[9] attest, indicates the mutually independent although not discordant composi-tion of the background and the action, an independence that is also indicated by the fact that the background is neither the natural environment nor an ambient medium in which the action takes place. Since the background does not provide a horizontal plane of support, frequently the figures hover near the lower frame of the picture. Their detachment from the background is enhanced by the effect of levitation caused by the weakly foreshortened feet. In many instances, however, there is some indication of the ground. A stylized stratum of ground such as was used in the previous period occasion-ally appears across the lower part of the picture plane as a support for the

[9] Salzburg, Stiftsbibl. St. Peter, MS a. xii. 7, Antiphonal, "Descent from the Cross" (H. Swarzenski, *Vorgotische Miniaturen*, Pl. XLIX).

figures and as an indication of the environment.[10] Sometimes this stratum is reduced to a fragment which acts as a pedestal for an individual figure[11] or is a free-standing object signalizing the locale.[12] These representations of the ground, however, do not give the impression of being an integral part of the background construction. They have, rather, the character of a property which is on the same plane as the figures and which belongs to them.

Thus, except for the slight indication of the general environment afforded by the fragmentary representation of the ground and occasionally by the introduction of an architectural frame to indicate an interior, the setting in the illuminations received little attention. The form of the background itself includes no representative elements, and it is a vertical surface rather than a tridimensional space. The background is not, however, an indefinite void, for as a result of the paneling it is a limited pictorial surface, which adds substance to the figures and provides a decorative center for the composition of the action.

While the paneled background of German illumination presents a form which differs considerably from the stratified type of the previous period, in French painting the break with the post-Carolingian form is not so pronounced. Types of background characteristic of the tenth and eleventh centuries appear in a number of works. There are uncolored picture planes,[13] and the single-color background is not uncommon.[14] Occasionally, a pattern is superimposed on the background of one color, introducing an impression

[10] Paris, Bibl. Nat., MS lat. 17325, Gospels, fol. 30v, "Resurrection" (H. Swarzenski, Vorgotische Miniaturen, Pl. LIII). Munich, Staatsbibl., MS lat. 935, Prayerbook of St. Hildegarde (ibid., Pl. LXVI).

[11] Gmunden, Kgl. Fideikommiss. Bibl., Evangeliary of Henry the Lion (H. Swarzenski, Vorgotische Miniaturen, Pl. LIX).

[12] Admont, Stiftsbibl., MS I. 1, Bible (H. Swarzenski, Vorgotische Miniaturen, Pl. XLVIII).

[13] Paris, Bibl. Nat., MS lat. 11615, Commentary of Origen on the Old Testament, fol. 2v (Lauer, Les Enluminures romanes, Pl. LVIII). As an example of uncolored picture planes in monumental painting one may cite the frescoes of Tavant which have white backgrounds (Focillon and Devinoy, Peintures romanes, p. 44; Pls. LXIV-LXXIV).

[14] The gold background appears in a manuscript from St. Martin-des-Champs (Paris, Bibl. Nat., MS lat. 17716, fol. 23, "Madonna and Child" [Lauer, Les Enluminures romanes, Pl. XLVII, 1]) and in a Gospel of St. John (Paris, Bibl. Nat., MS lat. 9396, fol. 1v [ibid., Pl. LXVIII]). A blue background is used in the Sacramentary of Limoges (Paris, Bibl. Nat., MS lat. 9438, fol. 29 [ibid., Pl. LIII]). Violet backgrounds appear in the Lectionary of the Abbey of Cluny (Paris, Bibl. Nat., Nouv. acq. MS lat. 2246 [Mercier, Les Primitifs français, pp. 129 ff., Pls. XCII-CVII]).

of substantiality into the otherwise indefinite and unlimited effect of the surface.[15] The stratified background occurs, and it may be found in frescoes[16] as well as in illuminations.[17] The form is nonatmospheric; the color is applied uniformly in bands of fairly equal width.[18] Although the color in some instances has reference to the naturalistic environment, the occasions in which the choice and succession of colors is non-naturalistic seem to be more numerous than they were in the previous century.[19] Gold was introduced into one stratum in the "Transfiguration" in a Lectionary and Antiphonal from St. Martin-des-Champs.[20] Here it may be interpreted, not as a substitute for the blue sky, as in the Byzantine manuscripts—for the blue band appears as the third stratum behind the sleeping apostles—but rather as a symbol of the transcendental world above the earthly scene, into which the figure of Christ rises. In other illustrations the presence of arbitrary color does not lend itself to symbolic interpretation, but seems to be primarily decorative. The decorative character of the background is enhanced when an impression of order is introduced by the repetition of one of the colors. Thus, in the fresco of the "Betrayal" in St. Martin, Vic (Indre), the succession of bands is yellow, red, rose, yellow; and in the illumination representing St. Gregory dictating to the scribes in a Cistercian manuscript of his

[15] Douai, Bibl. Mun., MS 90, Missel d'Anchin, fol. 98v, "Crucifixion" (Catalogue of the *Exposition de la Passion du Christ dans l'art français*, No. 231). Baltimore, Walters Gallery, MS 28, Sacramentary, fol. 6v, "Crucifixion" (Niver, "A XIIth Century Sacramentary," *Speculum*, Vol. X [1935], Pl. II). According to Lenoir the background of the apse in Cluny was gold patterned with lozenges (Mercier, *Les Primitifs français*, p. 86; Pl. LXVII).

[16] Le Liget, Chapel, "Presentation in the Temple," "Dormition of the Virgin" (Focillon and Devinoy, *Peintures romanes*, Pls. LIX, LXIII). Vic (Indre), church of St. Martin, "Presentation in the Temple" (*ibid.*, Fig. 11). Ebreuil, "St. Autremoine and St. Clement," "Martyrdom of St. Pancrace," "Annunciation" (*ibid.*, Pls. LXXXIX-XC, XCII). Tavant, "Deposition" (*ibid.*, Pl. LXXVI).

[17] Dijon, Bibl., MS 132, Commentary of St. Jerome on the Prophets and on Ecclesiastes, fol. 1 (Oursel, *La Minature du XII* s., Pl. XLVIII). Dijon, Bibl., MS 180, Letters of St. Gregory the Great, fol. 1 (*ibid.*, Pl. XLVIII). Paris, Bibl. Nat., MS lat. 9395, Evangeliary of Metz (Lauer, *Les Enluminures romanes*, Pl. LXIV).

[18] The stratified background of the "Transfiguration" (Paris, Bibl. Nat., MS lat. 17716, fol. 7v [Lauer, *Les Enluminures romanes*, Pl. XLVI]) differs from the usual form in that the bands have irregular contours.

[19] Examples of the use of arbitrary color may be found in: Dijon, Bibl., MS 132, Commentary of St. Jerome on the Prophets and on Ecclesiastes, fol. 1 (Oursel, *La Miniature du XII* s., Pl. XLVIII). Dijon, Bibl., MS 180, Letters of St. Gregory the Great, fol. 1 (*ibid.*, Pl. XLVIII). Vic (Indre), church of St. Martin (Focillon and Devinoy, *Peintures romanes*, Pls. LXXX-LXXXV).

[20] Paris, Bibl. Nat., MS lat. 17716, fol. 7v (Lauer, *Les Enluminures romanes*, Pl. XLVI).

letters, there is a simple alternation of red, blue, red.[21] In these examples the duplication of color in the first and last bands helps to define the limits of the picture plane and suggests a partially closed form, somewhat analogous to the decorative unit presented by the paneled arrangement of the German illuminations.

With the increased use of non-naturalistic color the horizontal position of the strata loses its representative significance. It is not surprising, therefore, that variations in the axis of the bands occur, as in the Hildesheim manuscripts of the eleventh century, and vertical divisions appear in combination with the horizontal. The fresco of the "Three Marys at the Tomb," in the chapel of Le Liget (Fig. 30), has three vertical divisions—colored alternately blue, green, and blue—which are suggested by the trefoil form of the arch in the architectural frame and which appear above the horizontal bands.[22] In the frescoes on the vault of the nave of the church of Saint-Savin-sur-Gartempe (Fig. 31), vertical divisions were also employed in the composition of the background. In general, the backgrounds in the frescoes of Saint-Savin are exceptional in this period of French painting, because they approximate the stage space form. The ground plane is usually made up of a band and a series of closely spaced horizontal lines and is narrow in proportion to the rest of the background, which is not further stratified. Although horizontal strata do not appear above the ground plane, vertical partitions frequently occur. In Fig. 31 an example may be seen behind the figure of Abraham in the scene in which God appears to Abraham. In the register below, which is somewhat mutilated, there is a vertical division behind the group of figures representing Joseph and his brothers in the episode in which he is sold to the Ishmaelite merchants. Placed behind one figure or a group of figures, without regard to centralization in the composition of a scene as a whole, these zones of color are in effect vertical bands.

The vertical divisions combined with the horizontal in the frescoes of Le Liget and Saint-Savin-sur-Gartempe may be considered a transitional stage in the development of the background, indicating a definite departure

[21] Dijon, Bibl., MS 180, fol. 1 (Oursel, *La Miniature du XII^e s.*, Pl. XLVIII). Cf. the Life of St. Radegonde (Poitiers, Bibl. Mun., MS 250) for a similar tendency to repeat a color in the eleventh century. *Vide supra*, p. 74, note 43.

[22] Examples of vertical bands which are suggested by the form of the architectural frame occur in English illuminations (*vide infra*, pp. 94 ff.) and in the German Gospel Lectionary (London, Brit. Mus., Egerton MS 809, fols. 1v, 35 v) dated *ca.* 1100 by Herbert (*Illuminated Manuscripts*, p. 153).

from the form of construction that is based on a vestige of representative space. In the Exposition of Leviticus, by Raoul de Flay, (Fig. 32) the horizontal strata have disappeared, and the background is composed only of vertical bands,[23] with the result that the form of the background is entirely nonrepresentative.

The vertically banded background, although it differs in appearance from the paneled background of the German manuscripts, has more in common with the latter than its nonrepresentative character. The effect is directly that of a vertical surface parallel to the standing figure, as it is in the paneled background. Furthermore, although not as definite a decorative unit as the paneled background, the vertically banded background is a limited surface. In contrast to the segmental character of the horizontal bands of the stratified picture plane and to the effect of indefinite extension resulting from the repetition where there are multiple narrow vertical stripes, as in the eleventh-century Gospels of Bishop Hezilo, which belong to the Hildesheim school, the background as a unit becomes clear where there are comparatively few vertical bands. Their widths assume a fixed ratio in relation to each other and to the picture plane as a whole. In addition, the fixed character is aided by the fact that the verticals are self-supporting. Whereas in the horizontal bands the greater part of the contour is in active contact, either resting upon the band below or supporting the one above, in the vertical bands, as in the human figure, the longest axis is from top to bottom and the line of greatest contact along the sides is inactive and self-supporting. The vertical bands are not analogous to the ground or to the sky—horizontal elements capable of indefinite extension in three directions—a portion of which is segmented by the frame for the purpose of illustration. They are analogous to trees, buildings, and the human figure—objects which stand upon the ground and are self-contained substantial units that lend themselves to measurement. Like the paneled background, the vertically banded background may be compared to a wall—a material, two-dimensional surface, the limits of which are defined to some extent by the internal divisions.

In contrast to the paneled background, however, which provides a focal

[23] In this illumination, which is in two registers, the upper, representing the Sacrifice of Aaron, is colored yellow and red. In the lower register, illustrating the Presentation of the Manuscript, the bands are from left to right: red, gold, dark red, blue, and yellow. The two scenes are thus unified to some extent by the diagonal alternation of color in the upper bands with those at the extreme right and left in the lower register.

center for the action, the vertically banded picture plane may separate the figures in a scene and thus draw attention to the principal person or group or emphasize the difference in rank between two figures. The division of the background may also be used to further the expression of conflict in the action. In the representation of God and Abraham in Saint-Savin-sur-Gartempe (Fig. 31) the difference between the figures is accentuated by the change of color in the background. In the fresco "Two Knights in Combat," in the church of Poncé,[24] the conflict of the action is expressed in the background by the opposition of a dark band behind the light horse to a light ground behind the dark horse. The vertically banded background may have, therefore, an expressive as well as a decorative function.

Both the paneled and the vertically banded background may be found in English illumination of the twelfth century, although other forms, such as the uncolored,[25] the single color,[26] and the stratified,[27] carried over from the previous period, also occur. In order to account for the various ways in which vertical bands were introduced into the background, one must describe this phase of Romanesque construction in English illumination as a partitioning of the picture plane into areas of different color without reference to the naturalistic environment. In one illumination in the Miracles of Saint Edmund,[28] two vertical divisions are framed at the top and at the bottom by horizontal bands. In the "Massacre of the Innocents," in the Albani Psalter (Fig. 33), the partitioning, involved with an architectural structure and curved contours, is more irregular. The use of an architectural structure

[24] De Lasteyrie, L'Architecture religieuse en France à l'époque romane, Fig. 557.

[25] London, Brit. Mus., Harley Roll Y. 6, Guthlac Roll (Warner, The Guthlac Roll). Cambridge, Pembroke College, MS 120, Gospels from Bury St. Edmunds (Millar, English Illuminated MSS from the Xth to the XIIIth Century, Pl. XXXV). Oxford, Bodleian Lib., Univ. Coll. MS CLXV, Life of St. Cuthbert by the Venerable Bede (ibid., Pl. LIV a).

[26] London, Brit. Mus., Cotton MS Nero C. iv, Psalter, St. Swithin's Priory (blue background [Millar, English Illuminated MSS from the Xth to the XIIIth Century, Pl. XLIV; Schools of Illumination, Pt. III, Pls. VII-IX]). Oxford, Bodleian Lib., Ashmole MS 1511, Bestiary, fols. 15v, 26 (Millar, English Illuminated MSS from the Xth to the XIIIth Century, Pl. LVIII). London, Brit. Mus., Royal MS 2 A. xxii, Westminster Abbey Psalter (gold background except fol. 14v, which is paneled [ibid., Pl. LXIII, reproduction of fols. 12v, 13, 13v, 14]). Glasgow, Hunterian Mus., MS 229 (U. 3. 2) (ibid., Pl. LXI). Leyden, University Lib., B. P. L. MS lat. 76 A, Psalter of St. Louis (Omont, Miniatures du Psautier de St. Louis).

[27] Hildesheim, Lib. of St. Godehard, Albani Psalter, fol. 19 (Millar, English Illuminated MSS from the Xth to the XIIIth Century, Pl. XXXIV a). London, Brit. Mus., Lansdowne MS 383, Psalter from Shaftesbury Abbey, fol. 168v (ibid., Pl. XXXII d). Both the above mentioned manuscripts also have illuminations with other forms of background.

[28] New York, P. Morgan Library, MS 736, fol. 16v (Millar, English Illuminated MSS from the Xth to the XIIIth Century, Pl. XXXVI).

to define the limits of a band occurs frequently in English illumination. It may be seen also in the illustration of the "Three Marys at the Tomb," in a Psalter from Shaftesbury Abbey (Fig. 34).[29] Although there are no horizontal zones in this picture, the picture plane is divided by the superposition of three vertical bands over the two within the architectural frame.[30]

Besides the partitioned picture plane, a number of English manuscripts have paneled backgrounds.[31] In general these are late twelfth-century illuminations, indicating that chronologically the paneled form probably superseded the vertically banded type.[32] Occasionally the paneled background appears in only one or two illuminations of a manuscript, usually as a change from a gold ground.[33] In several manuscripts, however, the paneled background occurs with few exceptions in all the illuminations.[34] In contrast to the German miniatures, in which the composition of the panel varies, in the English background of this type the form is fairly consistent. The panel is usually a simple rectangle centered within the picture plane and differentiated in color from the surrounding surface (Fig. 35). Gold is frequently one of the colors employed, either in the panel or in the bordering area.

The substantial and decorative character of the paneled background is

[29] In the same manuscript (Lansdowne MS 383) see also fol. 14, "Pentecost" (Millar, *English Illuminated MSS from the Xth to the XIIIth Century*, Pl. XXXIII b).

[30] In these manuscripts the form may vary in the different illuminations. In the Psalter from Shaftesbury Abbey, besides the scenes with vertical bands (fols. 13, 14), others with stratified (fols. 13v, 168v) and one-color (fol. 12v) backgrounds appear.

[31] Cambridge, C. C. C., MS 2, Bible of Bury St. Edmunds (Millar, *English Illuminated MSS from the Xth to the XIIIth Century*, Pls. XXXVII-XL). New York, P. Morgan Library, MS 619, Leaf of a Bible from Winchester (*ibid.*, Pl. XLVIII). New York, P. Morgan Library, MS 81, Bestiary (*ibid.*, Pl. LV). London, Brit. Mus., Add. MS 39943, Life and Miracles of St. Cuthbert (Forbes-Leith, *The Life of St. Cuthbert*). London, Brit. Mus., Royal MS 10 A. xiii, Smaragdus on the Rule of St. Benedict, fol. 2v (Millar, *English Illuminated MSS from the Xth to the XIIIth Century*, Pl. LIX a). London, Brit. Mus., Royal MS 2 A. xxii, Westminster Psalter, fol. 14v (*ibid.*, Pl. LXII). London, Brit. Mus., Harley MS 5102, Psalter, fol. 68. London, Brit. Mus., Harley MS 4751, Bestiary.

[32] The chronological development seems to be similar in German illumination, where the introduction of vertical stripes in the representation of St. Mark in the Evangeliary of Bishop Hezilo (Hildesheim, Cath. Treas., No. 34 [Döring and Voss, *Meisterwerke*, Pl. CV]), of the partitioned background in the Sacramentary of Henry II (Regensburg school, Munich, Staatsbibl., MS lat. 4456, fol. 11 [Goldschmidt, *German Illumination*, Vol. II, Pl. LXXII]), both of the eleventh century, and of the vertical bands in the Gospel Lectionary (London, Brit. Mus., Egerton MS 809, fol. 1v) dated about 1100, preceded the paneled form characteristic of the twelfth century.

[33] London, Brit. Mus., Royal MS 2 A. xxii, Westminster Psalter, fol. 14v (Millar, *English Illuminated MSS from the Xth to the XIIIth Century*, Pl. LXII). London, Brit. Mus., Harley MS 5102, Psalter, fol. 68.

[34] London, Brit. Mus., Harley MS 4751, Bestiary. London, Brit. Mus., Add. MS 39943, Life and Miracles of St. Cuthbert (Forbes-Leith, *The Life of St. Cuthbert*).

enhanced in several instances by the addition of a pattern.³⁵ Typical motives are: small circles, three dots arranged as a triangle, and stars.³⁶ These are scattered over the surface, and, especially in the later manuscripts, they have an alternating formation that has some semblance of a regular order (Fig. 35). The small size and the ordered arrangement anticipate the Gothic patterns of the thirteenth and the fourteenth centuries. The Romanesque pattern, however, is composed of unconnected units, while a prominent feature of the Gothic is the web spun around the motives by a continuous checkered design.

The repetition of the same nonrepresentative paneled form in a series of illuminations accentuates the absence of a specific relationship in content between the background and the figures. The few indications of environment, such as the ground for an exterior, an architectural frame for an interior, and an arc-en-ciel for the sky, sometimes cut off a corner or the edge of a panel, but they are not part of the construction of the background. They give the impression, rather, of being on a plane with the figures. The form of these features representing the environment is two-dimensional like the background. The architecture is telescoped, and the ground appears as a cross section. The absence of depth is clearly brought out in representations of the sea, where the water is built up like a hill by a series of scalloped lines (Fig. 35).³⁷

From the brief review of the types of background current in the twelfth century in Germany, England, and France it is evident that a uniform concept of spatial representation may be distinguished for the north as a whole, despite superficial variations in design. The background became a nonrepresentative surface, with subdivisions in form and color which create a limited, decorative plane. The gradual elimination of tridimensional and

³⁵ London, Brit. Mus., Add. MS 39943, Life and Miracles of St. Cuthbert (Forbes-Leith, The Life of St. Cuthbert). London, Brit. Mus., Royal MS 2 A. xxii, Westminster Psalter, fol. 14v (Millar, English Illuminated MSS from the Xth to the XIIIth Century, Pl. LXII). New York, P. Morgan Library, MS 81, Bestiary and Physiologus (Illustrated Catalogue, No. 55). The pattern is present occasionally in the vertically banded backgrounds, as in the Psalter from Shaftesbury Abbey (London, Brit. Mus., Lansdowne MS 383 [Fig. 34]) and, in French illumination, in the Exposition of Leviticus by Raoul de Flay (Paris, Bib. Nat., MS lat. 11564 [Fig. 32]).

³⁶ There are exceptions in which a geometric motive is used, as in the illustration of Hadwald's Fatal Fall in the Life and Miracles of St. Cuthbert (London, Brit. Mus., Add. MS 39943, fol. 63v), and the Crucifixion in the French Sacramentary in the Walters Collection, Baltimore (MS 28, fol. 6v [Niver, Speculum, Vol. X (1935), Pl. II]).

³⁷ Cf. Panofsky (Vorträge Bibl. Warburg, 1924-25, p. 274) who discusses the same form with reference to the representation of the Baptism.

representative features from the stratified background of the previous cen-
turies preceded the Romanesque concept, which itself bears some imprint of
the former type in the partitioning of the picture plane. Nevertheless, the
character of the space is essentially different, for, whereas the stratified back-
ground has in its horizontal zones and its colors some reference, however
remote, to a naturalistic, tridimensional environment, the Romanesque back-
ground is definitely a nonrepresentative, two-dimensional, vertical surface.
The decorative effect is enhanced occasionally by the addition of a pattern,
and the nonrepresentative structure of the background is emphasized by the
fragmentary and individualized form of the features representing the envi-
ronment. It is notable that despite the elimination of vestiges of naturalistic
space from the construction of the background, the uncolored and one-color
picture plane, although employed in the twelfth century, did not actually
supersede the stratified form. The picture plane remained a positive and
active pictorial surface which had solidified into a decorative, vertical back-
drop acting as a foil for the figures.

The distinction between the north and the south with regard to the rep-
resentation of space, which was observable in the previous centuries, became
more pronounced when the Romanesque spatial form was developed in the
north. In Italy and in Byzantium the preservation of vestiges of representa-
tive features and the implied tridimensionality of the stage space divisions
continued to play an important part in the composition of the background.

In Italy, in the twelfth century as in the former periods, there was no
consistent application of any one principle of background composition. Al-
though the stage space type seems to predominate, vestigial forms of strati-
fied space were employed, and in a few illuminations traces of the paneled
background may be found which suggest northern influence to some extent.

The type of background derived from stage space does not differ essen-
tially from the backgrounds of similar origin in the tenth and eleventh
centuries. This form may be found primarily in the mosaics and usually
consists of the division of the picture plane into a wide, uniformly col-
ored area above a narrow band representing the ground. In contrast to
the vertically banded or paneled background the divisions of this type of
background alone are vestiges of representative space. The form and the
color of the ground also contribute to the preservation of the background as
a representative environment, despite the fact that the ground has the ap-

pearance of a vertical plane rather than a horizontal plane in depth. The ground is sometimes depicted as a single band and sometimes as several bands colored in various tints of green and yellow.[38] Occasionally the con-tours are irregular, as in the mosaics of Monreale,[39] giving the effect of a ground line rather than a ground-plane band. The picture plane above the ground is sometimes blue, as in the frescoes of San Giovanni a Porta Latina,[40] in which case it contributes to the representative character of the back-ground. More often, however, this area is gold. Thus, the composition of the background is reduced to a few essential features, which, despite the use of gold and the absence of tridimensional effectiveness, retain their associations with a naturalistic representation of space.

Although apparently not numerous, examples of stratified and paneled backgrounds may be found in Italian painting of the twelfth century.[41] The stratified form is present in the fresco of Christ between SS. Peter and Paul in San Pietro, Civate,[42] and in an Evangeliary in the Cathedral of Padua, dated 1170. In the latter, together with illuminations that have backgrounds of one color[43] and those derived from stage space,[44] the stratified type ap-pears in the "Massacre of the Innocents."[45] Here, however, a wide central

[38] Torcello, Cathedral, apse mosaic of the Apostles (Van Marle, *Italian Schools*, Vol. I, Fig. 113). Palermo, Martorana, "Death of the Virgin" (*ibid.*, Fig. 119). Rome, Santa Maria-in-Trastevere, apse mosaic (*ibid.*, Fig. 79). Padua, Cathedral, Gospels dated 1170, "Adoration of the Magi" (D'Ancona, *La Miniature italienne*, Pl. VIII). Venice, S. Marco, Scenes from the Life of Christ (Van Marle, *Italian Schools*, Vol. I, Fig. 109). Milan, S. Ambrogio, mosaic of the apse (*ibid.*, Fig. 116).

[39] *Ibid.*, Fig. 123.

[40] Wilpert, *Die römischen Mosaiken und Malereien*, Pls. CCLII-CCLV.

[41] Other types of background found in Italian painting of the twelfth century are the un-colored and the one-color picture planes. These are forms which are continued from the previous period and are employed universally, occurring, as we have seen, in northern as well as in Byzantine painting. The uncolored background may be found in the Regesto di Sant'Angelo in Formis (*Miniature e altre reproduzione*). In Cefalù some of the mosaics have gold backgrounds with no indication of a ground plane or pedestal for the figures (Muratoff, *La Peinture byzantine*, Pl. CXXII). In a Psalter in the British Museum (Add. MS 9350) the illustration of King David and his musicians has a blue background covered with a scattered pattern of white dots.

[42] Toesca, *La pittura*, Fig. 69. The date of the Civate frescoes is uncertain. Toesca (p. 120) believes that they are of the twelfth century whereas Ladner (*Jahrbuch der kunsthistorischen Sammlungen in Wien*. N. F., V [1931], 154) is of the opinion that they belong to the end of the eleventh century. Stratified backgrounds may be found in other frescoes in S. Pietro, Civate (Toesca, *La pittura*, Figs. 76, 78), as well as in frescoes in S. Giorgio, Como (*ibid.*, Fig. 97) and in S. Pietro, Ferentillo (Van Marle, *Italian Schools*, Vol. I, Fig. 82).

[43] "Presentation in the Temple" (Venturi, *Storia*, Vol. III, Fig. 423).

[44] "Three Marys at the Tomb" (Venturi, *Storia*, Vol. III, Fig. 425). "Adoration of the Magi" (D'Ancona, *La Miniature italienne*, Pl. VIII).

[45] Venturi, *Storia*, Vol. III, Fig. 424.

band introduces some effect of stage space. In a giant Bible in the Vatican the illumination of the "Vision of Ezekiel"[46] is an exceptional instance in Italian painting showing stratification with numerous bands. This form of stratification and the paneled backgrounds in other illuminations in the same manuscript (Fig. 36),[47] suggest a connection with northern work. The paneled backgrounds in the Vatican Bible and in another giant Bible, in Perugia,[48] differ slightly from the type usually found in the north, for the panel is not centered, but is placed in the upper part of the picture plane, leaving room for a strip of ground below. The position of the panel off center, even when the ground plane is not present, introduces a feature of stage space, for it preserves the unequal division of the picture plane.[49]

Not only are the backgrounds in Italian painting of the twelfth century predominantly of the type derived from stage space, but also in the instances in which a different form was used it was frequently modified in such a way as to give some effect of stage space.

A vestige of representative space more pronounced than that which per-sisted in the form of the background and in part in the color in Italian paint-ing is noticeable in Byzantine illumination, for, besides the division of the picture plane into ground and backdrop, the high background objects, such as rocks and architecture, remain a characteristic part of the composition (Fig. 37).[50] Their presence as an integral part of the structure of the back-

[46] Vat., MS lat. 12958, fol. 156 (Toesca, Miniature romane, Pl. VIII b).

[47] See also fol. 2v (Toesca, Miniature romane, Pl. VIII a).

[48] Bibl. Comunale, MS L. 59 (Toesca, Miniature romane, Pls. X-XI).

[49] See also the fresco of St. John the Baptist in S. Teodoro, Pavia (Toesca, La pittura, Fig. 87). An exceptional example in which the division of the background is the reverse, that is, a comparatively narrow band above a panel centered on the wider, lower surface, occurs in the Works of S. Ambrogio (Milan, Archivo di S. Ambrogio [ibid., Fig. 52]).

Paneling similar to that in the "Genesis" of the Bible in Perugia (Bibl. Comunale, MS L. 59 [Toesca, Miniature romane, Pls. X-XI]), in which the panel is not only off center but is an incom-pleted rectangle with the sides running into the frame at the top, may be found in some of the illuminations of a German Antiphonal (Salzburg, Stiftsbibl. St. Peter, MS a. xii. 7 [H. Swarzen-ski, Vorgotische Miniaturen, Pl. XLIX]). In connection with this similarity in form, it is notable that G. Swarzenski (Die Salzburger Malerei, pp. 64 ff.) believes that influence from the Italian Bibles is manifested, in the twelfth century, in the painting of Salzburg by a special type of initial. Toesca has suggested an iconographic relation between the giant Bible of Perugia (Bibl. Comunale, MS 1. 59) and the Carolingian illumination of the Ada school (Miniature romane, p. 25). Although in this manuscript the background does not have the older stratified form, the paneled form which does appear suggests northern influence, but of the contemporary period.

[50] See also Athos, Monastery of Iviron, Gospels (Dalton, Byzantine Art and Archaeology, Fig. 284). The background object is not always omitted from Italian painting of this period, but the hills and buildings generally appear as individual units on the ground-plane band rather than

ground is affirmed by the tendency to represent the object as a series of rocks or a low wall extending across the picture plane on the contour of the ground-plane band rather than as individual units perched on the ground. Although the area above the background object is generally gold, the object itself and the ground plane, which is usually in two shades of green, preserve the representative character of the scene and suggest the environment. Furthermore, despite the fact that there is no perspective representation of depth at the juncture of the ground and the background object,[51] the tridimensional relationship between the two is implied by the representative form. The ground has the effect of a support to which both the figures and the object are oriented.

The adherence to some features of stage space in Byzantine and in much Italian painting clarifies the difference between the nature of the development of the background in the north and that in the south. The tendency, observed in both regions, toward the elimination of tridimensional values and the solidification of the component parts of the background into vertical planes resulted in different conceptions of the background, due to the basic difference in the form of stage space and of stratified space. In the Byzantine type, in which classification may be included the Italian paintings which have a trace of stage space, the representative and tridimensional relations are never completely lost in the fundamental divisions of the picture plane. The representative significance of the divisions of the background, of the ground, and of the high background object continued to be apparent despite stylization and the introduction of arbitrary color. The two-dimensional tendency was arrested in Byzantine painting by the preservation of representative elements, and the type of background remained essentially the same from the ninth century to the fourteenth. In the north, on the contrary, the background underwent a series of transformations, for, as the features became more two-dimensional in form, the tridimensional spatial relationship between the strata was obscured. The use of nonrepresentative color and the increase in the number of bands contributed to the loss of representative and tridimensional significance, and they were followed by the introduction of

as a continuous wall of representative features forming a definite part of the picture plane, as in Byzantine work.

[51] The typical Byzantine form persists, in which the horizontal planes at the top of the rocks and the planes in depth of the roofs of the buildings are preserved, although the bases of both rocks and buildings are telescoped into a single vertical plane.

divisions into the picture plane which are decorative rather than suggestive of naturalistic space. Thus, the type of background that was evolved in the twelfth century, in contrast to the Byzantine, has no implied tridimension-ality and is a frankly nonrepresentative, two-dimensional surface.

The difference between Romanesque and Byzantine painting with re-gard to the spatial form of the background is paralleled in the representation of the figures. The composition of the action and the form of the individual figures are usually determined to some extent by the type of background or are stylistically in accord with it. In general, the friezelike composition, the linear modeling, the stereotyped positions, and the absence of adequate fore-shortening from the optical point of view correspond to the elimination of tridimensional values from the background and the consequent limitation in depth present in both the Romanesque and the Byzantine forms. There are, however, differences in detail. The Byzantine background, as a result of its representative character, is related to the action and actually provides a sup-port for the figures. The figures are aligned on a common band representing the ground. The Romanesque background, on the other hand, although a foil for the action, has no representative or implied tridimensional inter-spatial relationship with the figures. Therefore there was greater freedom of composition, and, although the figures are usually oriented with respect to the base line of the picture plane or stand on a fragment of ground, they frequently overlap the frame of the scene at the sides or at the bottom (Fig. 34).[52] Other evidence of this freedom from the limitations imposed by a representative setting can be found in the conceptual arrangements that are occasionally employed. In the illustration of the "Three Marys at the Tomb" (Fig. 34) the spatial relationship in the composition of the figures could not have been resolved satisfactorily by a simple horizontal alignment. Hence, the conceptual expedient of placing the soldiers below—although from an optical point of view they should be in front of—the tomb was resorted to, despite the fact that the arrangement involves a distortion of the frame.[53]

[52] In the Leyden Psalter of St. Louis (University Lib., B. P. L. MS lat. 76. A) the tendency to carry the action beyond the frame into the margin of the page is very pronounced, especially in the "Journey of the Magi" (Omont, *Miniatures du Psautier de St. Louis*, Pl. X). In the frescoes of Saint-Savin-sur-Gartempe (Fig. 31), although there is an indication of the ground, the figures frequently overstep the lower boundary.

[53] Occasionally the composition is even more schematic, as in a Missal from Hildesheim (Schloss Stammheim, Bibl. des Grafen Furstenberg-Stammheim [H. Swarzenski, *Vorgotische Miniaturen*, Pl. LVIII]), where the illumination is arranged in the form of a cross with scenes

The conceptual method, which here concerns only the position of the fig-
ures, is similar to that governing the composition of the whole scene in the
representation of King David in the Bible of St. Stephen Harding.[54] In this
scene the arrangement of the walls of the courtyard at right angles to each
other and the orientation of the soldiers with respect to the position of the
walls present a conceptual composition that recalls the parallel-plane method
employed to represent a pond surrounded by trees in Egyptian wall painting
(Fig. 3).[55]

In the representation of individual figures general differences can be dis-
tinguished between the Romanesque and the Byzantine types.[56] The figures
in Italian and Byzantine painting give a stable and majestic impression aris-
ing from the predilection for frontal and three-quarters views and the avoid-
ance of violent contraposto and movement. This impression is promoted also
by the connection of the figures with the ground. The folds of drapery, al-
though stylized, retain some effect of plasticity (corresponding to the implied
tridimensionality of stage space) because of the heaviness of the high lights
and shadows and the presence of some transitional gradations in shade. In
contrast to the Italian and the Byzantine figures, those in Romanesque paint-
ing are slighter and more restless, although in some regions there was a tend-
ency toward increasing the solidity and the plasticity of the forms. The
three-quarters view prevails, but it is notable that in several English manu-
scripts, such as the Albani Psalter (Fig. 33) and the Psalter from Shaftes-
bury Abbey (Fig. 34), the profile was used extensively, and in several late
twelfth-century illuminations there is some increase in the foreshortening of

filling the corners as well as the center. The "Two Marys at the Tomb" are represented in the
center, while the sleeping soldiers who belong to the scene are segregated at one side.

[54] Dijon, Bibl. Mun., MS 14 (Oursel, La Miniature du XIIᵉ siècle, Pl. VI).

[55] These examples, the "Three Marys at the Tomb" and the King David illustration also show
hierarchic scaling, a form of conceptual representation that was present in the previous periods
and may be found in the twelfth century in both northern and southern painting. In Italian
work the apse mosaic of S. Ambrogio in Milan may be cited as an example.

[56] In certain regions of the north there is, at times, a clear Byzantine influence in the figure
style which may be due to contact with Byzantine or Italian painting. This is true of French
painting connected with Cluny, at the end of the eleventh and the beginning of the twelfth
century (Cf. Mercier, Les Primitifs français, pp. 21, 43, 51, note 1, 194 ff.) and may be seen also
in the Belgian illuminations from Stavelot (London, Brit. Mus., Add. MS 28106-7, Bible [ca.
1097]). G. Swarzenski discusses the Byzantine style of the drapery in Salzburg painting of the
second half of the twelfth century (Die Salzburger Malerei, pp. 119-20, 145-46). In England
traces of Byzantine influence in the style of the figures appears in several manuscripts dated ca.
1150-80 (London, Brit. Mus., Cotton MS Nero C. iv, Psalter of Bishop Henry of Blois; Win-
chester, Chapter Library, Bible [cf. Herbert, Illuminated Manuscripts, p. 137]).

the three-quarters view of the head (Figs. 28, 35), thereby furthering the
impression of active communication between the figures.[57] The effect of
intercommunication is greater in northern than in southern painting as a
result of the movement of the figures and the use of more violent gestures.
The type of figure with crossed legs and turned-in toes (Fig. 31), found in
French painting and sculpture, may serve as an extreme example of the inter-
est in movement. The impression of instability, which is derived in this
instance from the stance of the figures, is produced elsewhere by the unfore-
shortened form of the feet and by the lack of a supporting ground.

The representation of the drapery in northern painting is generally, as
it was in the previous period, more linear and flatter than in Italian or
Byzantine painting. In comparison with the tenth and eleventh centuries
there is a more systematic decorative quality and precision in the representa-
tion of the folds. Stylistically the form is similar to the calligraphic drapery
of the sculpture of the period. The high lights, as well as the shadows of the
folds, fall into linear patterns. Flying folds and fluted edges which envelop
the limbs (Fig. 31) were developed in the twelfth century and accentuate
the activity of the figures. These forms of drapery, especially the fluted
edges, while freeing the figure from the plane of the background, show,
together with the movement, an incipient interest in volume and naturalistic
representation, which was carried further in the Gothic figures of the follow-
ing century. In this connection it is noteworthy that in the illuminations of
the late twelfth century there is a tendency to replace the stylized and angu-
lar folds by freer and more naturalistic, although still predominantly linear,
forms (Figs. 28, 35).

In the twelfth century the method of representing objects was very
much the same as in the earlier period. The tendency to reduce the number
of accessories in the setting to a minimum prevailed. Landscape features,
such as fragments of ground, trees, and flowers, were stylized (Fig. 34), and
the thrones, tombs, and altars were simplified in form. One side of the ob-
ject is usually parallel to the picture plane. If the adjacent side is seen at an

[57] See also the Psalter of St. Louis in Leyden (University Lib., B. P. L. MS lat. 76. A [Omont,
Miniatures du Psautier de St. Louis]). In the "Last Supper" (*ibid.*, Pl. XVII) there is an at-
tempt to portray a communicating circular group by varying the position of the heads so that one
figure is seen from the rear while others are in three-quarters view or in pure profile. Interest in
foreshortening is also evident in the "Journey of the Magi" (*ibid.*, Pl. X), in which the artist has
endeavored to depict one of the horses in a frontal position rather than the more usual profile.

angle, the receding plane is indicated by an inclined line in the upper part of the object, but rarely at its base. The artists remained timid where the convergence of parallel lines of planes in depth was concerned. In the Byzantine illuminations the planes at the base of the high background objects are telescoped, while the upper parts of the buildings and the rocks retain their tridimensional form to some extent. In contrast, the roofs and turrets, which form part of the architectural frame in Romanesque painting, are more twodimensional, grouped from a decorative rather than a realistic point of view. As in the fresco of the "Three Marys at the Tomb" at Le Liget (Fig. 30), the composition is generally symmetrical. The architectural frame still serves to indicate an interior and remains, for the most part, within the picture plane, so that the roofs do not coincide with the upper border, although, in many instances, the finials overlap it.

In the representation of both the objects and the figures there are, therefore, factors which correspond to the difference in the type of background in northern and southern painting. There is a general tendency toward twodimensional form, but while the Byzantine figures and objects retain some of their plastic quality and tridimensional structure in accordance with the implied tridimensionality and the representative character of stage space, the Romanesque forms are primarily linear and decorative, corresponding to the two-dimensional, nonrepresentative background. There is further consonance between the decorative background and the figures, for, just as the picture plane is arbitrarily partitioned without reference to the environment of the action, so the figures are freer than the Italian and Byzantine figures, both in composition and in individual activity. Finally, there is an essential difference in the development of space in northern and southern painting, which is emphasized by the marked difference in the types of background in the twelfth century. In Byzantine and in much Italian painting the form of the space remained virtually the same for several centuries, until its tridimensionality was more fully realized. In the north, on the other hand, the elements were continually modified and transformed, and by the twelfth century the picture plane was a nonrepresentative but material surface which has the character of a limiting wall standing behind the figures. The substantial and decorative qualities of the background were retained in northern painting in the following century, but continuous modifications in the composition and the design of the pictorial elements created a characteristic Gothic spatial form.

CHAPTER VI

THE THIRTEENTH CENTURY

I N THE THIRTEENTH century, as has often been noted, a distinctive style that pervades all the arts was developed. An analysis of the relationship of the political, economic, and social factors to the formation of Gothic art is beyond the scope of this study. One may observe, however, that the interrelated and cumulative effect of the various movements begun in the eleventh and twelfth centuries—the crusades, the growth of the communes and a secular culture with a vernacular literature showing pagan and humanistic tendencies—contributed to the formation of a new point of view. The rise of civil communities as intellectual centers promoted the infiltration of secular elements into the arts. The erection of cathedrals was an artistic as well as a religious manifestation of the importance of the towns, and the foundation of universities tended to concentrate in the cities the educational facilities hitherto centered in the monasteries. The growing self-consciousness of society fostered by travel, chivalric ideals, and municipal government was manifested in the religious movements which began to come into prominence at the end of the twelfth century. On the one hand there were the heretical sects, such as the Albigensians and Waldensians, which criticized ecclesiastical authority and organization, and on the other hand there were the approved orders, the Franciscans and Dominicans, which counteracted the influence of the unsanctioned sects by supplying the need for more intimate contact between the people and the clergy. The Franciscans, with their simple and human approach, with their appreciation of the present world as well as the promised heavenly realm, especially illustrate the trend in popular feeling. The more human and sympathetic approach was manifested further in the development of the cult of the Virgin. The appeal to the

Virgin as the intercessor on behalf of mankind demonstrated the desire for a less dogmatic and more earthly connection with transcendental matters.

It is noteworthy that with these changes, which indicate an interest in the material world, came the improvement in the thirteenth century of two objects connected with space and vision—the mariner's compass and the lens. A number of manuscripts of this period mention the use of the compass and describe its construction,[1] while books on optics[2] were written by Roger Bacon, Vitellio, and John Peckham, among others. Peckham's book contains what is probably the earliest diagram of the eye to appear in print.[3] The manufacture of lenses seems to have been unknown before the thirteenth century, and the first authentic mention of their use for spectacles dates from shortly before 1280.[4] These interests which anticipated the Renaissance were but part of the beginning of scientific inquiry, based at first primarily on the study of Aristotle from Arabic sources.

These early scientific investigations did not have an immediate effect on spatial form in painting, but the general movement toward secularization promoted the loosening of the bonds of tradition and the infusion of the popular spirit and a secular point of view into the older forms. This was partly accomplished by the more frequent employment of the layman as artist. The lay artist was not only in closer contact with the secular point of view than his monastic predecessors and colleagues were, but, prompted by a spirit of competition which was accelerated by economic necessity, he was more inclined to accept and experiment with new forms.[5] There was also a growth in production of secular as well as religious books. Vernacular poetry was passing from an oral tradition to a written form, and scientific and moralistic works were in demand. The interpolation of religious and secular illuminations in different kinds of manuscripts was reciprocal. Scenes from the Passion were interspersed with illustrations of dislocations in a treatise on surgery (Fig. 38), Biblical events were used to exemplify vices and

[1] *Encyclopedia Britannica*, 14th ed., art. "Compass."

[2] Optics and perspective were interchangeable terms in the Middle Ages, and some of the works referred to are designated by their authors as studies of perspective rather than optics. The subject, however, pertains to the general laws of vision and light rather than to the more specialized problem of perspective, that is, the representation of objects in tridimensional form on the two-dimensional picture plane. See Sarton, *Introduction to the History of Science*, p. 23.

[3] Sarton, *Introduction to the History of Science*, pp. 1028-30.

[4] *Encyclopedia Britannica*, 14th ed., art. "Lens."

[5] Cf. Martin, *Les Peintres de manuscrits*, p. 23.

virtues (Frontispiece), while in the Books of Hours, profane drolerie plays around the margins of the page.[6] These changes in the content and the source of manufacture of the illuminations naturally had repercussions on the form of representation. As a result, in the thirteenth century there are significant modifications everywhere in some aspects of the spatial form— either in the background or in the representation of the figures. The develop' ment among the schools of the various regions continued to be dissimilar. France, benefiting from the political unification and organization of Philippe Auguste (1180-1223) and of St. Louis (1226-70) and from the intellectual predominance of the university of Paris, led in the development of the Gothic style. In place of the various regional schools of the Romanesque period, there emerged a homogeneous style emanating from the school of Paris.[7]

The new style is apparent in the representation of the background and the figures from the beginning of the thirteenth century, but the character' istic Gothic features do not appear with any regularity until the second half of the century. The spatial form is basically Romanesque. The background is a nonrepresentative, two-dimensional substantial surface, and the composi' tion of the figures is limited to a single plane in depth. However, certain changes in the form of the background and in the representation of the figures created an effect different from the Romanesque and were precursors for a change in the spatial concept. Traces of stratified divisions such as were used in the backgrounds of French illuminations of the twelfth century are no longer present,[8] but in the "Crucifixion" of the Psalter of St. Louis and Blanche de Castille[9] there is a vestige of the Romanesque form in the vertical divisions, which are decorated with a characteristic Romanesque pattern of scattered dots arranged as triangles and rosettes. The example is exceptional, however, for the background in the manuscripts of the first half

[6] A tendency to introduce secular figures as drolerie appears in eleventh' and twelfth-century Spanish and French work. See Schapiro, "From Mozarabic to Romanesque in Silos," *Art Bulletin,* XXI (1939), 347.

[7] Cf. Herbert, *Illuminated Manuscripts,* p. 192.

[8] Exceptions may be found in the mural painting of the period, such as that in the vault of the chapel of the crypt of Montmorillon (Vienne) (De Lasteyrie, *L'Architecture religieuse en France à l'époque gothique,* Vol. II, Fig. 775). In general, the Romanesque forms were continued in French monumental painting of the thirteenth century (*ibid.,* p. 158). Not until the beginning of the fourteenth century do the typical features of the Gothic style as developed in illumination appear (*vide infra,* p. 152, note 64).

[9] Paris, Bibl. de l'Arsenal, MS 1186, fol. 24 (Martin and Lauer, *Les Principaux Manuscrits,* Pl. VIII).

of the thirteenth century is almost exclusively of one color, generally gold. Occasionally a pattern is introduced, as in the "Annunciation" and the "Visitation" of the Ingeburge Psalter (Fig. 39), that anticipates the characteristic Gothic type developed in the second half of the thirteenth century, when the background—usually gold, rose, or blue—is covered with a small allover diapered or rinceau design (Frontispiece). In the Ingeburge Psalter the pattern consists of small motives bound together by a continuous checkered design on the surface of the background. The motives themselves are found in Romanesque painting and are continued in the repertory of developed Gothic forms. The combination, however, of the small motive with the continuous, checkered design typifies the Gothic pattern in contradistinction to the Romanesque.[10] In the Ingeburge Psalter the large size of the geometric pattern signalizes a transitional stage, for in the developed Gothic the pattern is small, densely covering the surface of the picture plane.

The characteristic Gothic pattern accentuates the substantiality of the surface of the background, as does the Romanesque. In contrast, however, to the Romanesque form of pictorial surface, which presents the background as a plane delimited by either a central panel or by a number of definite but dissimilar partitions, the Gothic allover pattern gives the background the effect of indefinite continuity by the repetition of the same unit terminated arbitrarily by the border of the picture plane. When a pattern occurs in the earlier illuminations, it generally consists either of scattered dots and small circles which lack the geometric continuity of the Gothic style and which, moreover, are usually secondary to the larger units of the background (Fig. 34), or else it is made up of large forms that break up the surface of the

[10] The possibility of a relation between the development of the geometric pattern in illumination and in stained glass should be noted. From about the middle of the twelfth century and in the thirteenth century the medallion type of historiated window became popular and led to a rich development of geometric designs to fill the interspaces. The medallion form as a frame for the scene appears in illuminations as well as in enamels, stained glass, and relief. An early example is the columnar arrangement of medallions in the Genesis initial of the Stavelot Bible (London, Brit. Mus., Add. MS 28106-7, dated 1093-97). The medallion was used in the twelfth century, but it was developed especially in Gothic illumination of the thirteenth and fourteenth centuries. The shapes were elaborated into polylobed forms. For a series of related scenes several medallions are sometimes grouped or interlaced against a common background, while a columnar arrangement is usually employed in the Bible moralisée. The medallion is also adapted to the small historiated initial. In the fourteenth century it was introduced into the border decoration, appearing in this form first in Italy (Pächt, "A Bohemian Martyrology," Burlington Magazine, LXXIII [1938], 197, note 13). It is notable that in the representation of Christ in Majesty, the polylobed medallion eventually replaced the mandorla.

background by a coloristic contrast between the interspaces and the motive. The large motives result in a forceful assertion of the independence of the background from the action, and the lack of subordination tends to confuse the pattern of the background with the pattern of the figure (Fig. 22). The effect is the same even when a geometric network appears, for usually not only is this larger than the Gothic type but also it either does not cover the surface of the background uniformly[11] or is contrasted with a patterned area elsewhere on the picture plane (Fig. 21). The Gothic pattern, however, is a repetition of small units superimposed on the uniform color of the back-ground. It does not destroy the continuity of the surface, but preserves it and makes it more substantial. Furthermore, the pattern serves to enhance the suggestion of substance and corporeality in the figures by presenting innumerable points of contact between the two. This relationship is less effective in the Romanesque type of background divisions and in the previous large motive and small dot patterns. Finally, an element of commensurability is introduced by the geometric and continuous form of the Gothic pattern, which serves as a scale and contributes appreciably to the general effect of delicacy and intimacy that is so characteristic of Gothic illumination.

Besides the pattern, there are other elements which distinguish the spatial form of the thirteenth century from that of previous periods. One of these is the architectural frame. When a skeletal architectural construction appears in post-Carolingian and Romanesque illumination,[12] it almost al-ways signifies an interior. The arches are usually sprung well within the picture plane, leaving a free space between the roofs of the architectural frame and the upper border of the scene. The individual parts—the roofs, towers, and arcades—are drawn from contemporary Romanesque buildings. In the course of the thirteenth century all these factors underwent a change. The Romanesque roofs and towers were gradually replaced by typical

[11] Dijon, Bibl., MS 130, Commentary of St. Jerome on Jeremiah, fol. 104 (Oursel, La Minia-ture du XII[e] s., Pl. LI). Baltimore, Walters Collection, MS 28, Sacramentary (Niver, Speculum, X [1935], Pl. II). The latter illustration, the "Crucifixion," has a gold background with an incised pattern that changes form slightly, above the arms of the cross. Gmunden, Kgl. Fideikom-mis. Bibl., Evangeliary of Henry the Lion, "Baptism" (H. Swarzenski, Vorgotische Miniaturen, Pl. LIX).

[12] Le Liget, Chapel, "Three Marys at the Tomb" (Fig. 30). London, Brit. Mus., Add. MS 39943, Life of St. Cuthbert, fol. 21, "Boisil on His Deathbed" (Forbes-Leith, The Life of St. Cuthbert).

Gothic forms. The influence of Gothic architecture is reflected not only in the pointed arches and slender proportions but also in the general relationship of the members. In the Romanesque, the roofs are grouped with a decorative rather than a realistic purpose, but in the Gothic architectural frame the skeletal structure is clearly expressed and the superposition of parts is logically carried out, as, for example, in the illuminations of the Psalter of St. Louis (Fig. 42), in which the main arcade is composed of small arches embraced by large ones, while above the arcade there is a regular alignment of clearstory windows alternating with pinnacles. It is notable, however, that although the composition of the parts is less eccentric from a realistic point of view than the Romanesque, it is not completely logical, for, like the Romanesque, there is a mingling of interior and exterior members in the architecture, which in this example is illustrated by the open nave arcade and the exterior clearstory wall.

In taking over the framework of the Gothic cathedral the miniaturist limited himself to the elevation of the lateral or front façade. The spatial composition of the cathedral interior, with its concentrated movement in depth, had no effect on the spatial form of the background in this period. In the thirteenth century the two-dimensional form of the architectural frame is clarified by the skeletal, cross-section type of construction, in contrast to the Romanesque form in which the structure is more complex as a result of the cubic groups of roofs and towers.

The regularity of alignment and the logical superposition of parts, together with the attenuated proportions of the Gothic architectural frame, led to another change: the elimination of free space between the roofs and the upper border of the picture plane. The space decreased gradually. In the Psalter of St. Louis (Fig. 42), there is still a small space between the roof and the border for the finials of the pinnacles. Toward the end of the century the architectural frame is simplified by the omission of the construction above the main arcade, thus leaving a continuous row of arches directly under the upper border of the picture plane (Fig. 38). In the following century the border itself is frequently replaced by the arcade. The result is an architectural frame which has the effect of a proscenium arch and, like the proscenium arch of the stage, has no significance for the interior and exterior setting of the scene. The use of the architectural frame as a standard for all

types of scenes developed in the thirteenth century. It appears in exterior settings in which not only the rough ground but also trees[13] and even buildings are indications of the environment.[14] The disassociation of the architectural frame from its significance as a representation of the interior may have played some part in the indifference to the possibilities of tri-dimensional space as demonstrated in the cathedral nave itself. Then, again, in cathedral architecture the emphasis was on the vertical rather than on the limitations of walled-in space, and this is reflected in the attenuated proportions of the architectural frame as well as in the raising of the open arcades to the upper limit of the picture plane.

The form of the architectural frame, like the pattern, distinguishes the Gothic background from the Romanesque. Because of its position as a proscenium arch and its indiscriminate use for all types of scenes the archi-tectural frame became part of the background. On the other hand, it re-mained on a plane with the action, as is illustrated by the interweaving of figures and columns without regard for the relative thickness of these mem-bers (Fig. 42). Thus, the architecture acts as a link between the figures and the background. By embracing both and by orienting them to a common base line it coördinates them and provides a unifying feature for the scene as a whole.

The change from individualization to interrelated and coördinated forms which is manifested by the allover pattern and the proscenium-arch frame is also evident in a less striking manner in the representation of the ground plane. Like the patterned background and the architecture, the ground plane retained its two-dimensional form, that is, it is a vertical cross section. This is illustrated clearly by the type of support, occurring frequently in the thir-teenth century, which resembles the side of a bridge with a series of arches brought to a horizontal level.[15] In fact, this form is used commonly to span

[13] Paris, Bibl. Nat., MS lat. 10525, Psalter of St. Louis, "Sacrifice of Cain and Abel" (Psautier de St. Louis, Pl. I). Paris, Bibl. Nat., MS lat. 10434, Psalter, fol. 16, "Crucifixion." London, Brit. Mus., Add. MS 17868, Psalter, fol. 19, "Flight into Egypt." In the last two illustrations traces of the Romanesque type of roofs and towers are present, although the main arcade has the Gothic proscenium-arch form.

[14] London, Brit. Mus., Add. MS 28162, La Somme le Roy, fol. 9v, "Misery, Charity, and Avarice" (Millar, Souvenir de l'Exposition de MSS français, Pl. XX). In the Psalter of St. Louis (Fig. 42) an edge of clouds borders the inner line of the arcade, illustrating further the mingling of interior and exterior features.

[15] See Fig. 45 for a similar form in an English manuscript.

the awkward curve at the bottom of medallion frames, although it appears also occasionally in rectangular scenes.[16]

The architectural frame orients the figures to a common base line, which in many instances is provided simply by the border of the picture plane. When the ground appears, however, it is usually not like the individualized mound for one figure or a group of figures that is so common in the Roman-esque period, but it is a strip of irregular ground or the bridge mentioned above, which extends across the picture plane from side to side. It is a return to the collective ground plane, an element that, taken together with the proscenium arch and the allover pattern, strengthens the unified structure of the scene and suggests the simplified background divisions of stage space.

The movement toward coördination and interrelationship that was be-ginning to be expressed in the background, architectural frame, and ground, on the one hand, and between the background and the figures, on the other, is also evident in the increased communication among the figures themselves. The groups of individual figures[17] are more closely knit than they were in the earlier periods when there was a tendency toward isolation. The figures do not overlap the picture plane as much as formerly, and, although they are still cut off by the frame, the segmentation usually occurs in the cubic groups of crowds, where it is less noticeable than in the individual figure. The closer juxtaposition of the figures, aided by the characteristic sway, increases the effect of communication, which, as always, depends to a great extent on the gesture and the inclination of the head. The gestures are still striking but, on the whole, less violent as a result of the general movement toward delicacy and grace and more naturalistically proportioned figures. A change in the position of the head increased the intercommunication. In the previous periods the stereotyped three-quarters view of the head, in which the head is but slightly turned in the direction of the neighboring figure, was generally used. In the thirteenth century the three-quarters view still pre-dominated, but the head is usually more sharply turned toward the neigh-boring figure, away from the spectator (Figs. 38, 42). Whereas earlier both eyes were visible, now one is partly cut off. This minor modification of the traditional form helps considerably to effect the change from the transfixed

[16] London, Brit. Mus., Add. MS 17868, fol. 16v, "Annunciation," fol. 18v, "Presentation in the Temple."

[17] A crowd is represented in the traditional form of a cubic group in which several complete figures are on the front plane, while a mass of heads indicates the people behind.

religious gaze to the more naturalistic, intercommunicative glance of the Gothic figures. The direction of the glance still depended on the inclination of the head and placing the pupil in the corner of the eye, but aided by the more foreshortened three-quarters view, it falls more directly on the neighboring figures. The tension caused by the strained position of the pupil in the corner of a frontal eye was reduced as the angle of the profile was more nearly approached.

Although the modified three-quarters head was generally employed, the profile was more frequently used than hitherto, and there was a tendency to experiment with other positions of the head, arising from attempts to present the figures from rear, as well as from profile and frontal, points of view (Fig. 42). These tentative efforts were not very frequent as yet. The figures are still aligned and move from side to side rather than in depth, and the study of foreshortening had not progressed very far. The unforeshortened representation of the feet gives a weightless effect, and the transition from the position of one plane of the body to another is abrupt. This is apparent in representations of the nude, but is masked in the clothed figure by the folds of the drapery and the graceful sway. The masking is all the more effective because of the striking development in the representation of the drapery in the thirteenth century as compared with the Romanesque. The movement toward naturalism, which is evident in the position and proportions of the figures, is present in the drapery due to an effort to have the fall of the folds motivated directly by the contours of the body and an attempt to grade the transitions from light to dark more carefully (Fig. 42). In the Romanesque period the folds of the drapery were stylized, and although the concentric circles and V's were, in the last analysis, determined by the part of the body they covered, the immediate effect was of a decorative arrangement to which the calligraphic technique of light and shade contributed (Fig. 31). In the thirteenth century both the stylized repetition and the linearity of the forms disappeared. They were replaced by folds more naturalistically determined and by a technique of graduated shading from light to dark, although the edges of the drapery and the contours of the figure as a whole are sharply outlined. The Ingeburge Psalter (Fig. 39) illustrates the transitional stage, where the crisply delineated loops and triangles can be distinguished, though the concentric repetitions have been eliminated to a great extent. The transition from light to dark is still abrupt, but the linear lights have been omit-

ted, and an intermediate shade follows the sharp outlines of the folds. In the Psalter of St. Louis (Fig. 42) the stylized forms are no longer present and the combination of the plastic with the linear technique creates a more naturalistic effect.

The reflection in painting of the contemporary movements in the other arts, which is illustrated in the background by the forms taken from archi-tecture and by the geometric pattern and medallion frame reminiscent of stained glass, is evident in the figure in its correspondence to the develop-ment in sculpture. This accord, which was observed in the Romanesque period, was continued in the thirteenth century. The drapery in the Inge-burge Psalter (Fig. 39) may be compared with the transitional style exempli-fied by the tympanum of the "Coronation of the Virgin," of the Cathedral of Laon,[18] while the Psalter of St. Louis approaches the High Gothic of the second school of Amiens.[19] But, whereas the architectural features were adapted to the two-dimensional form of the background, in the representa-tion of the figures the influence of sculpture introduced a tridimensional element in the modeled form of the drapery. This is a significant step in the spatial development in which until then the tendency to eliminate tridimen-sional values and telescope the planes in depth prevailed.

The relationship of the figures to the background is also comparable, to some extent, to the development in sculpture. The gradual emergence of a more plastic, naturalistic figure from the wall or in front of a column until it is almost free-standing in sculpture is paralleled in painting, where a simi-lar development of naturalistic technique, together with the increased inter-communication and the substance lent by contact with the small allover pat-tern, tended to free the action from the background. The characteristic Gothic divisions of the scene into ground plane, action, and proscenium arch have their counterparts in sculpture, where the portal figure is accompanied by its pedestal and protective canopy.

In the thirteenth century the modification of the background and the figures in French illumination was of considerable importance for the de-velopment of the spatial form. Although the form is related to the Roman-esque by the background, which is still a nonrepresentative, material surface, and the movement of the figures, which is limited to a single plane; it differs

18 *University Prints*, Series K, Pl. LIX.
19 Reims Cathedral, Angel of the Annunciation; *University Prints*, Series K, Pl. LXXXII.

from the art of the previous century because of the increased manifestation of communication among the figures and the coalescence of the architectural frame and the ground plane with the construction of the background. The figures and the background are coördinated by the unified composition of the picture plane due to the proscenium arch and the collective ground plane. Furthermore, there is an element of commensurability in the effect of scale created by the pattern. And finally tridimensional values have been reintro duced by the modeling of the drapery.

The characteristics just summarized, which distinguish the Gothic from the earlier form of representation, have been selected from the generalized conclusions of a survey of the manuscripts of both periods. It is instructive, therefore, to observe the modifications made in the specific instance of a thirteenth-century copy of a late eleventh-century work for the relationship they bear to these characteristics. Instances in which both a model and a copy are extant are sufficiently rare to warrant notice;[20] and it is illuminat ing to observe that despite the limitations imposed by the use of a model the characteristics of the period to which the copyist belonged are mani fested.

Both the text and the illustrations in a manuscript containing the three ancient royal privileges granted to the monastery of St. Martin-des-Champs, now in Paris (Bibl. Nat., Nouv. acq. MS lat. 1359) and dated the middle of the thirteenth century on paleographic grounds, show that it is a copy of a late eleventh-century manuscript in London (Brit. Mus., Add. MS 11662).[21] In the eleventh-century manuscript the representation of Philippe I and his court (Fig. 40) is an unframed pen and ink drawing; the composi tion is conceptual rather than optical, with the figures aligned in registers. The scene represents Philippe I at the left seated beneath an architectural frame. At the right there are two buildings, one above the other, and be

[20] Other instances in which both the copy and the model are extant are the late tenth or early eleventh-century English copy (Copenhagen, Gl. Kgl. Samml., MS 10. 2°, fol. 17v [Mackeprang, Madsen and Petersen, Greek and Latin Illuminated MSS, p. 9, Pl. VII]) of the St. Matthew in the Lindesfarne Gospels, ca. 700 A.D. (London, Brit. Mus., Cotton MS Nero D. iv [Millar, The Lindesfarne Gospels, Pl. XX]), and the early eleventh-century copy (London, Brit. Mus., Harley MS 603 [Schools of Illumination, Pt. I, Pl. II]) and the thirteenth-century ver sion (Paris, Bibl. Nat., MS lat. 8846) of the ninth-century Utrecht Psalter (Utrecht, Bibl. de l'Université, MS 32 [Boinet, La Miniature carolingienne, Pls. LXI-LXV]).

[21] Prou, "Dessins du XI° s. et peintures du XIII° s." Revue de l'art chrétien, XL (1890), 123-25. I wish to express my indebtedness to Professor Erwin Panofsky, of the Institute for Advanced Study, Princeton, for this reference.

neath these a row of ecclesiastical figures. Underneath Philippe I and the prelates there is another register of figures representing lords. The lords, like the prelates, are three-quarter length figures segmented by a base line. In the thirteenth-century copy of the scene (Fig. 41) the artist substituted a painted illumination for the pen and ink sketch. He retained the conceptual form of the composition, but made the whole more compact and precise by placing the two buildings at the right on one level, and by clearly defining the limits of the registers with bands bearing inscriptions. He unified the composition still further by enclosing the whole scene in a frame.[22]

In the eleventh-century manuscript the figures in the alignment of prelates and lords overlap each other slightly. The trunk of each figure is frontal and the head is full face or turned slightly. The eyes are full and large, and the pupils are placed in the center. The same hierarchic gesture is repeated by each figure. The drapery is drawn in the crude calligraphic style which preceded the more precise and decorative manner of the more developed Romanesque form of the twelfth century. Philippe I is seated with legs crossed and toes turned in. His head is in three-quarters view, but the eyes, with the pupils in the center, are frontal and complete. Both the seat and the telescoped footstool accompanying the figure overlap the round arched frame which isolates him from the rest of the scene.

In the thirteenth-century manuscript the representation of the figures underwent a marked change. Intercommunicating, expressive groups replace the hierarchic alignment of prelates and lords. The proportions of the figures are more naturalistic and the gestures vary. The heads are inclined and turn to the right or the left with variations in the degree of the foreshortening of the three-quarters view. The illusion of direct communication among the figures is increased by showing only part of the eye on the foreshortened side of the face. Evidence of the Gothic style is also present in the drapery. Aided by the change in medium, the thirteenth-century artist substituted more naturalistic folds, graded in light and shade, for the calligraphic form of the model. The position of Philippe I has also been altered. The legs are not crossed, and there has been some attempt to give them a natural fore-shortened appearance. The body is turned to the right, and the gesture and

[22] The copyist added the procession of monks below the original composition. This row of figures is outside the border which enframes the original composition. The copyist also added the two figures at the left of Philippe I. These are segmented by the architectural frame which encloses the monarch.

glance are directed toward the court. The architectural details are Gothic. The simple round arch which enframed Philippe I in the eleventh-century manuscript has become a pointed arch with a trefoil archivolt.[23]

Thus, in this instance when a model and the copy are compared, the change in spatial form from one period to another is reflected both in the details and, to a lesser degree, in the composition as a whole. The modifica- tions made by the copyist in the architectural membering, the position and proportions of the figures, and the drapery style, are characteristic of Gothic representation. The tendency of the Gothic artist to show interrelationship and intercommunication may be observed in the thirteenth-century illumina- tion not only in the modified position of the heads, the form of the eyes, and the gestures but also in his attempt to make a more compact and unified composition of the conceptual form of the model by drawing the elements together and enclosing them in a frame.

The factors in the spatial development which characterize the Gothic period were caused not so much by the introduction of new elements as by the combined effect of innovations in the previous form of such fea- tures as the architectural frame, the pattern, the three-quarters view of the head, and the style of the drapery. These innovations, however, created a distinctive spatial form as far as the background and the representation of the figures are concerned.

The spatial development in English illumination in the thirteenth cen- tury is for the most part similar to that in French illumination. In the late twelfth-century manuscripts several modifications heralded the ap- proach of the Gothic style. The background in "Hadwald's Fatal Fall," in the Life of St. Cuthbert,[24] is not covered with the usual triangles and dots, but it has a geometric pattern of large diamond-shaped squares, each of which contains a quatrefoil flower. Therefore, it anticipates the transitional stage found in the Ingeburge Psalter (Fig. 39).[25] The architec-

[23] The substitution of Gothic forms for Romanesque may be observed in such minor details as the furniture. In the eleventh-century manuscript, Philippe I is seated on a faldstool, a type of chair common in Romanesque illumination and one in which the crossed legs have a stylistic affinity with the crossed legs so characteristic of the figures in the painting of the period. In the thirteenth-century manuscript the seat is the more substantial blocklike throne prevalent in Gothic miniatures.

[24] London, Brit. Mus., Add. MS 39943, fol. 63v (Forbes-Leith, The Life of St. Cuthbert).

[25] The large geometric pattern may be found occasionally in English manuscripts of the early thirteenth century, as in the Psalter of Robert of Lindseye, Abbot of Peterborough (London,

tural frame of the late twelfth-century English illuminations[26] may also be compared with early thirteenth-century French work.[27] There is a similar simplification of the cubic groups of Romanesque roofs and towers, while the arrangement remains decorative, and the architectural frame is raised so that it comes just beneath the upper border of the picture plane. In the representation of the figures there is a tendency toward naturalism in the folds of drapery, although the technique is still linear; and the head is frequently turned more sharply although still in the traditional three-quarters pose.[28]

Despite this preparation in the late twelfth century, the characteristic Gothic type of illumination did not emerge until the second half of the thirteenth century. The background in the first half of the century is of one color—usually gold, blue, or red. Generally the colored grounds are covered with a small pattern of alternating circles and dots.[29] Although the motive itself is continued from the Romanesque period, the regularity of the spacing foreshadows the geometric quality of the Gothic diapered pattern, which, as Herbert observes,[30] came into vogue after 1250 (Figs. 44, 45).[31]

The architectural frame did not become as prominent a feature in English illumination as in French until the fourteenth century. Where it appeared, however, its development followed the course of the French. Gothic forms were substituted for Romanesque, and the proscenium-arch type which does not necessarily indicate an interior setting occurred in the second half of the thirteenth century.[32]

In French illumination the unity of the scene as a whole and the co-

Society of Antiquaries, MS 59 [Millar, English Illuminated MSS from the Xth to the XIIIth Century, Pl. LXIX b]).

[26] London, Brit. Mus., Royal MS 2 A. xxii, Psalter of Westminster Abbey, fol. 12v, "Annunciation," fol. 13v, "Virgin and Child" (Millar, English Illuminated MSS from the Xth to the XIIIth Century, Pl. LXIII a, b).

[27] Chantilly, Mus. Condé, MS 1695, Ingeburge Psalter, fol. 7, "Presentation in the Temple."

[28] London, Brit. Mus., Add. MS 39943, Life of St. Cuthbert, fol. 21, "Boisil on His Deathbed" (Forbes-Leith, The Life of St. Cuthbert).

[29] London, Brit. Mus., Lansdowne MS 420, Psalter. London, Brit. Mus., Royal MS 1 D. x, Psalter (Millar, English Illuminated MSS from the Xth to the XIIIth Century, Pl. LXV). London, Brit. Mus., Arundel MS 157, Psalter. London, Brit. Mus., Royal MS 14 C. vii, Historia Anglorum by Matthew Paris, fols. 8v, 9.

[30] British Museum Guide, Pt. III, p. 11.

[31] Other illustrations of the Gothic pattern: London, Brit. Mus., Add. MS 24686, Tenison Psalter, fols. 2, 2v, 3, 3v, 4, 4v. London, Brit. Mus., Royal MS 1 D. i, Bible, fols. 4v, 5 (Millar, English Illuminated MSS from the Xth to the XIIIth Century, Pl. LXXVII).

[32] London, Brit. Mus., Egerton MS 1151, fol. 95v (Schools of Illumination, Pt. II, Pl. XII b).

ordination of the background with the action was strengthened by the pro-scenium-arch frame and the collective ground plane. In the English illumina-tion of this period this feeling for coördination is weaker, as is shown by the less frequent use of the architectural frame and by the general omission of any representation of the ground. The individual mound of ground occurs in the first half of the thirteenth century[33] and may also be found in a manuscript from St. Albans (now in the Fitzwilliam Museum, Cambridge) which is dated about 1270 (Fig. 43). In the second half of the cen-tury, however, the ground plane was usually omitted, except in irregularly framed scenes, such as initials, where the bridgelike construction found in French illumination was employed to provide a level support for the figures above the curve of the frame (Fig. 45).[34]

In representing the figures the English illuminators kept pace with the French. The graceful, more naturally proportioned figures characteristic of the Gothic style may be found in a number of manuscripts (Figs. 43, 44). The modeling of the drapery advances from delineation by dark lines only to gradation by light and shade.[35] Greater communication between the figures was developed by modifying the traditional three-quarters view of the head, as was observed in the French manuscripts, and by more frequent use of the profile, as in the illumination of St. Martin sharing his cloak with the beggar (Fig. 43). This illumination also shows an attempt to represent a horse from a frontal point of view. The problem of foreshortening has been solved by leaving out the rear legs. The advanced representation of the figures is in contrast to the somewhat Romanesque concept of the back-ground with the individualized ground and the overlapping of the frame by the figure of the beggar.[36] Although the example is extreme for the period—for the diapered background is common and the proscenium-arch frame does

[33] London, Brit. Mus., Burney MS 3, fol. 5v (Millar, English Illuminated MSS from the Xth to the XIIIth Century, Pl. LXXVI). London, Brit. Mus., Lansdowne MS 420, fol. 7v, "Annun-ciation to the Shepherds," fol. 8, "The Three Magi," fol. 9, "Flight into Egypt." London, Brit. Mus., Royal MS 1 D. x, fol. 1v, "Annunciation to the Shepherds."

[34] The ordinary type of collective ground plane does occur occasionally, as in the representa-tion of the "Betrayal" (fol. 8) in a Book of Hours (London, Brit. Mus., Harley MS 928).

[35] Cf. Herbert, British Museum Guide, Pt. III, p. 11.

[36] Similar features occur in the late-twelfth-century illumination of the "Journey of the Magi" in the Leyden Psalter of St. Louis (University lib., B. P. L. MS lat. 76. A [Omont, Miniatures du Psautier de St. Louis, Pl. X]). The horse in the center is foreshortened in the same manner as is the horse in the St. Albans manuscript, and the composition of the scene as a whole is carried beyond the frame into the margins of the page. Vide supra, pp. 101, 103, notes 52, 57.

occur—it illustrates how differently the French and English illumination of the thirteenth century developed. In the French illuminations of the second half of the thirteenth century the background and the figures are interrelated and coördinated to a degree which was not reached in the English illumina-tions until the fourteenth century.

The spatial form in the German miniatures of the thirteenth century was not as homogeneous as that of French and English painting, nor does it resemble the latter in its development. Not only is the background of a different type from the background in the French and the English illumina-tions, but even in Germany it varies according to regional centers. In general there are two characteristic forms: one current in the north, in Thuringian and Saxon manuscripts; the other, in the south, in the illuminations from Scheyern, Franconia, Bavaria, Swabia, and Weingarten. In other centers, such as the Rhenish, various influences from the southern and from the Thuringian-Saxon schools may be observed. And toward the end of the century, in the illuminations from Cologne particularly, contact with French painting is evident in the adoption of Gothic features.[37]

Most of the backgrounds in the illuminations of the Thuringian-Saxon school are in gold. The architectural frame is used sparingly and only when the content calls for it. Where it appears it is a composite, generally of Romanesque and Byzantine elements arranged more or less decoratively.[38] The striking feature of the Thuringian-Saxon illuminations is the ground plane, which frequently takes the form of a platform of jagged rocks with the front vertical surface partially visible (Fig. 46). This precocious at-tempt, which appears early in the thirteenth century, to introduce a tri-dimensional ground plane, may perhaps be considered a manifestation of a Gothic feeling for plasticity. The character of the construction and its sud-den appearance without any preparatory stages point to a foreign influence as its immediate source. In Byzantine painting, rocks with horizontal sur-faces and jagged edges were traditional for the high background object, but the form is not characteristic for the ground plane, although this form is used as a ground plane in several earlier manuscripts, notably in the Homi-

[37] Cologne, Diocesan Mus., Gradual of Johann von Valkenberg (photographs in the P. Mor-gan Library, New York City). In this manuscript, dated 1299, the patterned backgrounds and the skeletal architectural constructions are indications of French influence.

[38] Haseloff, *Eine thuringische-sächsische Malerschule*, p. 318. Hahnloser, *Das Musterbuch von Wolfenbüttel*, p. 28.

lies of Gregory of Nazianzus[39] and in the Paris Psalter.[40] In the eighth-century fresco of the Crucifixion in Santa Maria Antiqua,[41] in which the background is primarily of the Byzantine stage-space type with high background rocks, the rock platform appears as an individual support for the cross and is indicated summarily in the strata below the figures.[42] The rock platform as a ground plane occurs frequently in the mosaics of the fifth and sixth centuries in Ravenna. It is present in the scenes from the Old Testament in the choir of San Vitale[43] and as the shore in the "Baptism" in the Baptistery of the Orthodox and the Baptistery of the Arians.[44] It is also found in the mosaic of the "Good Shepherd" in the Mausoleum of Galla Placidia.[45] The form may be traced further back, for it appears in several Roman works, notably in a small mosaic representing the "Personification of Autumn," taken from the House of the Faun in Pompeii, now in the National Museum at Naples,[46] and in a fresco interpreted as the "Wedding of Zephyr and Chloris," also in Naples.[47]

The model for the ground plane in the Thuringian-Saxon illuminations was undoubtedly of a later period, but whether the form is evidence of influence from early Christian art or ninth-century Byzantine illumination, or whether it is an adaptation of the more contemporary Byzantine high

[39] Paris, Bibl. Nat., MS gr. 510, fol. 52v, "Moses Receiving the Law," fol. 143v, "The Good Samaritan" (Omont, Manuscrits grecs, Pls. XXIV, XXXIII).

[40] Paris, Bibl. Nat., MS gr. 139, fol. 1, "King David," fol. 422v, "Moses on Mount Sinai," fol. 431v, "Prayer of Jonah" (Omont, Manuscrits grecs, Pls. I, X, XII).

[41] Van Marle, Italian Schools, Vol. I, Fig. 42.

[42] The individual rock platform at the foot of the cross may be observed in several Thuringian-Saxon illuminations of the Crucifixion: Magdeburg, K. Domgym., MS 152, Ordo Consecrationis Crismatis, written by Heinrich von Jericho, 1214 (Döring and Voss, Meisterwerke, Pl. CXVII, 3). Hanover, Kestner Mus., Missal from Braunschweig Cathedral (ibid., Pl. CXVIII, 2).

[43] Van Berchem and Clouzot, Mosaiques chrétiennes, Figs. 184, 191.

[44] Ibid., p. 100 and Fig. 173. Cf. the representation of the Baptism in the Psalter of Landgraf Hermann von Thuringia (Wurtemberg, Landesbibl., fol. 31v [Löffler, Der Landgrafenpsalter, Pl. XIII]).

[45] Komstedt, Vormittelalterliche Malerei, Pl. L.

[46] Rizzo, La pittura ellenistico-romana, Pl. LXXXII.

[47] National Museum of Naples, Catalogue of the Archaeological Collection, Fig. 129. An analogous effect of a raised platform is present in mosaics such as the "Battle of Alexander" (Fig. 6) and the scene from a New Comedy by Dioscurides of Samos (Herrmann, Denkmäler, Pl. CVI), in which in place of the vertical front surface of rocks there is a dark strip with level contours at the base of the ground plane. According to Bieber and Rodenwaldt this form was derived from votive reliefs or paintings (vide supra, p. 28, note 58). Above the strip in the "Battle of Alexander" (Fig. 6) are little clusters of rocks with horizontal surfaces, a form which survives and which may be found in the apse mosaics of SS. Cosma e Damiano (Komstedt, Vormittelalterliche Malerei, Pl. LXXI) and Santa Prassede (Fig. 12).

background rocks is an open question.[48] To find that the source was more remote than Byzantine manuscripts would not be unprecedented, since the north, in both the Carolingian and Ottonian periods, turned to early Christian art for models.

The rock-platform ground, with its clearly delineated horizontal plane, introduces stage space into the background. In the Thuringian-Saxon manuscripts, however, although the construction of the ground plane itself is tridimensional, its composition in relation to the background and to the figures is similar to the vertical ground plane of the previous century. Frequently it is individualized and therefore does not become part of the background, but belongs to the figure or group which it supports.[49] Nevertheless, in several examples it does extend as a collective ground plane across the bottom of the picture plane (Fig. 46),[50] or else two sections are run so closely together that they appear as a continuous plane.[51] The tridimensional space offered by the rock platform was not used for the composition of the figures in depth, for the figures are generally aligned at the rear of the horizontal plane with their heels touching its farther edge, just as if they were on the upper contour of a vertical ground plane (Fig. 46). In an altartable from the church of St. Giles, Quedlinburg,[52] a number of the figures do not even touch the platform, but stand in the gold background above it. The method of representing the ground in relation to the figures has not changed, although the form of the ground has changed. The suggestion of tridimensional space in the form of the platform ground plane was not developed in German painting, for at the end of the thirteenth century there was a wave of French influence,[53] and the characteristic Gothic picture plane was introduced into Thuringian-Saxon illumination.

The tridimensional rocks used as high background objects, which is

[48] Goldschmidt (Das Evangeliar im Rathaus zu Goslar, p. 18) notes briefly that the rocky landscape of classic painting was schematized into this type of ground plane.

[49] Goslar, Rathaus, Evangeliary, "Adoration of the Magi, St. Matthew" (Goldschmidt, Das Evangeliar im Rathaus zu Goslar, Pl. II). See also Cividale Mus., Psalter of St. Elizabeth, "Annunciation to the Shepherds" (Haseloff, Eine thuringische-sächsische Malerschule, Pl. XIX).

[50] See also the altartable from St. Giles, Quedlinburg, in Berlin, Kaiser Friedrich Mus. (Döring and Voss, Meisterwerke, Pl. CXXII). Psalter in Donaueschingen, Furstl. Bibl., MS 309 (ibid., Pl. CXX).

[51] Goslar, Rathaus, Evangeliary, "Annunciation, Visitation, Nativity" (Goldschmidt, Das Evangeliar im Rathaus zu Goslar, Pl. VIII). Hanover, Kestner Mus., Missal from Braunschweig Cathedral (Döring and Voss, Meisterwerke, Pl. CXVIII, 2).

[52] Berlin, Kaiser Friedrich Mus. (Döring and Voss, Meisterwerke, Pl. CXXII).

[53] Michel, Histoire de l'art, II (Pt. I), 369.

typical of Byzantine illumination, but which may also be found in the fresco of the Crucifixion in Santa Maria Antiqua,[54] in the fifth- and sixth-century mosaics of Ravenna[55] and in less stylized form in a number of Pompeian frescoes,[56] appear in the Goslar Evangeliary. Like the rock ground plane, the form has been represented without a complete understanding of its tridimensional spatial relation to the other features of the setting. In the "Miraculous Draught"[57] and in the "Nativity"[58] the rocks appear behind the shoulders of the figures without any apparent connection with the ground.[59]

Thus, in the Thuringian-Saxon illuminations the features of the environment remain individualized and separate from the structure of the background, a method of spatial composition which is essentially Romanesque. The tridimensional form of the individual elements, however, is a distinctive characteristic of the school. This contrast between the form of the object and its spatial composition is also present in the representation of the figures. The discoördination[60] between the action and the background is shown by the arbitrary segmentation of the figures by the frame[61] as well as by the extension of the figures beyond the picture plane (Fig. 46). The position of the head and the torso follows the traditional types, but in the drapery, although the shading is linear, there is an exaggerated angularity in the folds, which form shell-like envelopes around the figures or independent of them. This angularity expresses the cubic value of the forms and at the same time gives the figures a dynamic character (Fig. 46).[62]

[54] Van Marle, Italian Schools, Vol. I, Fig. 42.

[55] Mausoleum of Galla Placidia, "The Good Shepherd" (Komstedt, Vormittelalterliche Malerei, Pl. L); also the choir mosaics in S. Vitale (Van Berchem and Clouzot, Mosaiques chrétiennes, Figs. 184, 191).

[56] Naples, Nat. Mus., "Europa and the Bull," from Pompeii (Herrmann, Denkmäler, Pl. LXVIII). Naples, Nat. Mus., "Punishment of Dirce," from Pompeii (ibid., Pl. CL).

[57] Goldschmidt, Das Evangeliar im Rathaus zu Goslar, Pl. IV.

[58] Ibid., Pl. VIII.

[59] The composite character of the composition is further illustrated by the representation of a cave spanned by an architectural frame in the "Nativity" (ibid.).

[60] Vide supra, p. 45, note 17.

[61] Wurttemberg, Landesbibl., Psalter of Landgraf Hermann von Thuringia, fols. 31v, 109v (Löffler, Der Landgrafenpsalter, Pls. XIII, XVI).

[62] See also the "Baptism" in the Psalter of Landgraf Hermann von Thuringia (Wurttemberg, Landesbibl., fol. 31v [ibid., Pl. XIII]). The angularity is a feature of the style which is manifested also in the delineation of the rocks, where it is equally effective in emphasizing the cubic value. The angular style of drapery occurs sometimes in Rhenish mural painting, notably in the "Legend of St. Nicholas" in St. Maria Lyskirchen, Cologne (Clemen, Die gotischen Monumentalmalereien, Pl. I). The angular rocks appear in these scenes, but since they are sparse fragments of

124 THIRTEENTH CENTURY

Although in general the Thuringian-Saxon illuminations of the thir-
teenth century have little in common with the French Gothic miniatures,
there are points of comparison in the spatial form. There is a tridimensional
effect in the representation of the drapery, although this effect is achieved
with very different techniques. Further, a suggestion of stage space fre-
quently appears in the background. In French illumination the stage space
is implied by the coördinated structure of the background, proscenium arch,
and collective, vertical ground plane. In the Thuringian-Saxon manuscripts,
on the other hand, although it is present in the tridimensional rock plat-
form, the spatial relationship of the features is still of the discontinuous
Romanesque type.

In the illuminations of the southern German schools, as in the Thurin-
gian-Saxon, there is a mingling of Romanesque spatial principles with a
tendency toward tridimensional form, but the features differ somewhat. In
the southern schools the twelfth-century type of picture plane is retained,
for the background is generally paneled,[63] and the environment is indicated
by an individual vertical ground plane or an architectural frame. In the
representation of the figures, however, new tendencies appeared. There were
attempts at untraditional foreshortened positions, as in the Missal of Ber-
thold (Fig. 47), in which not only the front but also the rear view of a
galloping horse is represented, suggesting movement in depth. Emotional ex-
pressiveness was slightly developed, and occasionally the intercommunica-
tion between the figures was increased by the use of the profile and of the
more foreshortened three-quarters view of the head, as in French illumina-

ground without any indication of the horizontal plane of the upper surface, it is only the general
character of the Thuringian-Saxon style that was adopted, not the particular form of ground
plane.

[63] The type of panel is usually simple, a central rectangle in one color surrounded by another
color, the whole framed by a band. Occasionally, as in the Liber matutinalis from Scheyern
(Munich, Staatsbibl., MS clm. 17401 [Damrich, Ein Künstlerdreiblatt, Pls. III, 6; IV, 7]) the
panel is subdivided, and there is an alternation in color between the divisions of the panel and
the border. Several manuscripts have gold rather than paneled backgrounds, such as the Missal of
Berthold (New York, P. Morgan Library, MS 710) and a Psalter in Bésançon (Bibl. Mun., MS
54 [H. Swarzenski, Die lateinische illuminierten HSS, Pls. XCVI-C]). Some of the illuminations
in a psalter from Zwiefalten (Stuttgart, Landesbibl., MS 125) have patterned gold backgrounds
arranged as panels (photographs in the P. Morgan Library, New York City).

The paneled background occurs in Rhenish mural painting, and, as in the illuminations of
the southern German schools, the favored colors seem to be blue and green (vide supra, p. 88,
note 6). Cologne, St. Maria Lyskirchen, "Legend of St. Nicholas" (Clemen, Die gotischen
Monumentalmalereien, Pl. I). Sinzig, Parish church, frescoes of the south choir (ibid., Pl. IV).
Cologne, St. Cäcilia, New Testament scenes (ibid., Pls. XX-XXIV).

tion.[64] The folds of the drapery remain stylized and linear; but there is a greater effect of plasticity than in the previous century, for the shading seems to be heavier. The angularity is less pronounced than in the Thurin-gian-Saxon style, but where it occurs it helps to give an impression of mobil-ity and tridimensional form.

The discoördination between the figures and the background continued, however, as in the twelfth century. Occasionally the panel in the back-ground was halved by using two colors, yet the line of demarcation between two scenes does not always coincide with the division in the panel, but some-times lies within one of the halves.[65] Furthermore, as in the Thuringian-Saxon school, the discoördination is emphasized by the drastic segmentation of the figures by the frame and the overlapping of the frame by the figures.[66] In the southern schools, however, where segmentation occurs, in several in-stances part of the figure or object passes under the frame and is continued in the margin of the page.[67] Although, on the one hand, the interlacing em-phasizes the discoördination by showing that the frame terminates the back-ground, but not the action of the figure, on the other hand, it interrelates the two planes of background and action, and in a way corresponds spatially to the interweaving of the figures with the columns in the Psalter of St. Louis (Fig. 42).

A further development of the interrelationship of planes in depth is illustrated in several illuminations in which an attempt was made to repre-sent figures enclosed in buildings in a more definite way than is provided by an architectural frame. In a scene from the Aeneid of Heinrich von Veldeke (Fig. 48), the house is a skeletal structure. The figure, however, is not framed by the building, but strides through the doorway between the posts. In an illustration from the Songs of the Magi,[68] a figure leans out of a win-

[64] These changes in the position of the head are anticipated in a late twelfth-century German illumination, the page from the Speculum Virginis (Fig. 28).

[65] Munich, Staatsbibl., MS clm. 17401, Liber matutinalis from Scheyern (Damrich, *Ein Künst-lerdreiblatt*, Pl. IV, 7). In the Aeneid of Heinrich von Veldeke (Berlin, Preuss. Staatsbibl., Germ. Fol. 282) another type of discoördination may be observed in the asymmetrical and seg-mented form of the architectural frame (Fig. 48).

[66] Munich, Staatsbibl., MS clm. 17401, Liber matutinalis, "Adoration of the Magi," "Madonna and Child" (Damrich, *Ein Künstlerdreiblatt*, Pls. VII, 13; VIII, 16). Berlin, Preuss. Staatsbibl., Germ. 8° 109, Songs of the Magi (Degering, *Des Priesters Wernher*, pp. 12, 16, 18, 23, 44).

[67] Munich, Staatsbibl., MS clm. 17401, Liber matutinalis, "Crucifixion" (Damrich, *Ein Künst-lerdreiblatt*, Pl. I, 2). Berlin, Preuss. Staatsbibl., Germ. 8° 109, Songs of the Magi (Degering, *Des Priesters Wernher*, p. 49).

[68] Berlin, Preuss. Staatsbibl., Germ 8° 109 (Degering, *Des Priesters Wernher*, p. 70).

dow set in a wall which is at an angle to the picture plane. The rest of his body passes through the entrance, which is in the front façade of the building parallel to the picture plane.[69] This interweaving, despite the disregard for proportion and substance, is an indication of a greater interest in the spatial position of the figure in relation to the architecture than has been shown up to now.

Thus, in both the southern and the northern German schools of illumination, elements appear in the thirteenth century which point toward a movement opposed to the two-dimensional tendency that prevailed in the previous periods. In the representation of the figures it is apparent in the occasional experiments with untraditional positions, in the attempts to render emotional expression, and the substitution of angular folds of drapery which form shells around the wrists and ankles of the figures for the calligraphic, flat folds of the twelfth century. The change is manifested also in the Thuringian-Saxon school by the adoption of the platform ground plane;[70] in the southern schools it is indicated by the interlacing of the figures with the frame or the architecture. In both regions, however, the coördination and interrelation of background, features of the environment, and figures which were developed in French illumination of this period are absent. In the architectural frame, alone, this is evident in the conceptual and decorative arrangement of cubic groups of Romanesque forms in contrast to the ordered superposition of parts in the French Gothic proscenium-arch frame. Nevertheless, the background as a whole remains a nonrepresentative two-dimensional surface, as it does in France and England. This holds true even when the rock-platform ground plane occurs, for, as was shown, this is not made an integral part of the construction of the background, but is rather an accessory to the figures that is treated spatially like the individual vertical ground plane.

In the north as a whole, the same forms of representation were employed

[69] In the same manuscript, the "Annunciation" (ibid., p. 105) has a form similar to Fig. 48. The Virgin is seated in the entrance of a transparent building. She is not framed by the door-posts, but is behind one and in front of the other. In connection with this question of interweaving, Professor Meyer Schapiro has called my attention to the complex interlacing of the emperor's staff with the figure and the furniture in the tenth-century miniature representing Otto II (Chantilly, Mus. Conde, No. 14, Registrum Gregorii [Goldschmidt, German Illumination, Vol. II, Pl. VIII]).

[70] An exceptional instance of the representation of tridimensional rocks in the southern German schools of illumination may be found in the Songs of the Magi (Berlin, Preuss. Staatsbibl., Germ. 8° 109 [ibid., pp. 34, 168-9]).

for smaller objects, such as footstools, altars, and tables. As in the previous periods, there is no consistent method of organization. Planes in depth are frequently telescoped.[71] When objects are seen from an angle, the parallel receding lines of both the vertical and the horizontal planes diverge rather than converge (Fig. 46). In objects which are in a frontal position, the receding lines of the horizontal plane generally converge, although even in this position examples of divergence may be found (Fig. 39).[72] The concept of perspective organization from a unified optical point of view is still to come, for on the one hand the environment is stenographic in relation to the background, which is nontridimensional and nonrepresentative, and on the other hand, the spectators are still readers rather than an audience viewing a scene. Nevertheless, a slight tendency in the direction of such an organiza-tion may be observed in the representation of some tridimensional values, in the increasing success in creating the illusion that the figures are aware of one another as actors in a common scene, and in French illumination in the coördination and interrelation of the different elements of the representation.

Significant tendencies in the development of the spatial form in the thirteenth century are not limited to the illuminations of France, England, and Germany, but may be discerned also in the painting of Italy. Hitherto in Italy both the northern forms derived from stratified space and the Byzan-tine forms characterized by vestiges of stage space existed side by side, al-though they may not have been as typical or as consistent as in the regions where they predominated. In the thirteenth century, however, the type of stage space which had been crystallized in Byzantine painting was definitely and consistently adopted in mosaics and panels, although various back-ground forms were used in manuscript illumination. Upon the basis of stage space as it existed in Italy, that is, a narrow ground plane and a wide

[71] The habit of drawing objects without direct reference to their optical form persists in the thirteenth century. A notable exception, however, may be observed in the sketches of the apse of the Cathedral of Reims by Villard de Honnecourt (Album de Villard de Honnecourt, fols. 30v, 31. See Panofsky, Vorträge Bibl. Warburg, 1924-25, p. 312, note 37). In the sketches of the interior and exterior of the apse the artist made the distinction between a concave and a convex surface, although the form of his building as a whole is not consistently correct according to optical standards. In other sketches of existing architectural monuments he was not so concerned with the tridimensional form of the buildings, but used the current shorthand method of telescop-ing or the combination of ground and elevation plans.

[72] Other examples are the altar in the "Presentation in the Temple" (London, Brit. Mus., Add. MS 17868, fol. 18v) and the sarcophagus in the "Three Marys at the Tomb" (Paris, Bibl. de l'Arsenal, MS 1186, Psalter of St. Louis and Blanche de Castille).

surface above it, was grafted the other fundamental feature of the Byzantine background, namely, the limiting object—a building or rocks. Although the background object was not drawn in perspective as perpendicular to the ground, nevertheless it achieved that impression by virtue of its representative character and its position on the upper contour of the ground plane.

In a number of panels in which the Crucifixion or the figure of a saint is portrayed in the center surrounded by historical scenes we may see the typical form of spatial representation referred to above (Fig. 49).[73] The background of the central figure is usually gold.[74] In the historical scenes, besides the gold area which fills the upper part of the picture plane the construction of the background consists of one or two and sometimes three narrow bands with straight contours, which form the vertical ground plane. Above this the background object appears. When it is architectural it represents the façades of several buildings in alignment, frequently extending in an uninterrupted series from one side of the picture plane to the other. Usually a predominant horizontal axis in the architectural arrangement is created by a long low building in the center, which is flanked by two higher structures. This type of composition, developed in Byzantine illumination and illustrated in the Menologium of Basil II (Fig. 27), effects a balanced and closed composition, although there is no structural tridimensional enclosure involved. Even when an interior setting is indicated by the content, these generalized street scenes serve as a backdrop. The methods of representation do not differ from those used previously. The telescoping of all the planes to a single level is pronounced. It may be followed in the uniform base line for the whole composition, although parts of the buildings may project and overlap; and it is indicated by the horizontal courses in one straight line of both front and side walls, where the side wall is at an angle to the picture plane. Some impression of depth was created, however, by

[73] Other illustrations: Pescia, S. Francesco, St. Francis and six scenes from his life (signed and dated 1235), by Bonaventura Berlinghieri (Siren, Toskanische Maler, Pls. XII-XVII). Yale, Jarves Coll., scenes from the Passion (ibid., Pl. XVIII). Florence, Academy, Mary Magdalen and scenes from her life (ibid., Pl. XCVIII). Pisa, S. Francesco, St. Francis and scenes from his life (ibid., Pl. LXIV). Florence, Sta. Maria Maggiore, Madonna and scenes from the Passion, by Coppo de Marcovaldo (ibid., Pl. LXXXVI). Siena, Academy, St. Peter Altarpiece (Van Marle, Italian Schools, Vol. I, facing p. 378). Siena, Academy, St. John Altarpiece (ibid., Fig. 215).

[74] In some of the panels the gold background behind the central figure is incised with a geometric pattern. Arezzo, S. Domenico, "Crucifixion" (Siren, Toskanische Maler, Pl. LXXXIX). Assisi, Sta. Maria degli Angeli, "St. Francis" (ibid., Pl. LXVII). Perugia, Nat. Gallery, "Crucifixion" (ibid., Pl. LXVIII).

careful shading of apertures, receding walls, and parts of buildings adjacent to, but emerging from behind another structure. The linear perspective renditions of depth are limited primarily to inclined receding lines in the roofs, but there is no consistent convergence or even parallelism of the receding lines, nor is there a uniform point of view for a group of roofs and domes as a whole. Despite the shading, the effect, in general, is two-dimensional as a result of the telescoping and the alignment of façades. When the background object is a series of overlapping hills, the pronounced flatness of the representation in contrast to the Byzantine is brought out by the fact that the horizontal planes of rocky ledges, traditional in the Byzantine form, are absent. Instead of the structural tridimensionality of the Byzantine rock surfaces, white lines high-light the edges and accent the irregular contours.[75]

In the smaller objects, such as altars and chests, and in the larger thrones of the panels of the Madonna and Child, the same type of perspective representation as in the buildings in the background may be observed. There is a similar mingling of rudimentary optical perspective with conceptual forms as in the previous period. Receding parallel lines were made to converge or to diverge. Planes in depth were telescoped. The point of view varies for different parts of the object, especially in the thrones, in which the back may be parallel to the picture plane while the seat is at an angle. Together with these arrangements may be found the conceptual projection of the plan of an object, as in the top of an altar or in a lake.[76]

The representation of the figures is consistent with the spatial character of the background. The musculature of the torso and face and the folds of the drapery are delineated in the Byzantine manner; the stylized forms are brought out by the sharp juxtaposition of lights and darks. As in the architecture, there is a hint of cubic value in the direction of the lines and in the light and shade, but the formalized linear method of representation creates the impression of a solid but two-dimensional figure. The movement of the figures, in accordance with the lack of depth in the background, is lateral—

[75] In the last quarter of the thirteenth century, when there was a movement toward the reinstatement of tridimensional values in the architecture and the figures, the Byzantine type of rock appears. Illustrations: Siena, Academy, St. John Altarpiece, "Christ Appearing to St. John" (Van Marle, *Italian Schools*, Vol. I, Fig. 215); Florence, Baptistery mosaics (*ibid.*, Fig. 129).

[76] In the scene in which St. Francis is preaching to the birds (Fig. 49) the composition of the birds in rows on a series of ground lines is reminiscent of the parallel-plane method of representation in Egyptian painting. The repetition of profiled forms is interrupted only in the second row, where a variation is introduced in the double wing spread of the birds in flight.

parallel to the picture plane. Generally the figures are aligned on one of the contours of the ground plane; the effect of intercommunication is achieved by means of the traditional three-quarters view with recourse to the profile occasionally. The composition of the figures, on the whole, still bears some trace of the hierarchic isolation characteristic of the earlier mosaics. The principals stand by themselves, and their connection with the compactly massed crowds depends upon the broad gesture of the extended arm.

In general, the masters of the *dugento*—the Berlinghieri, the Tedici, Guido da Siena and his school, to mention a few—followed the type of spatial form developed in the Byzantine illuminations of the twelfth century.[77] The background is representative despite the use of gold in the sky area, for the ground plane and background object indicate the environment, although not the specific locality of the action. The backgrounds in Italian painting differ, however, from those in the Byzantine—particularly from the Byzantine frescoes of the thirteenth century[78]—in that they have a pronounced two-dimensional tendency combined with a simplification of the elements and a markedly unified and symmetrically balanced composition. In this unification there is a similarity to French Gothic illumination, in which the proscenium-arch frame binds the elements together in a way analogous to the long, low building flanked by towers in the Italian background object. The planes in depth in Italian panels are telescoped more

[77] Italian illumination of the thirteenth century differs from panel painting in that the form of the background varies considerably. Byzantine type with high background building: Florence, Laur. Lib., Conv. soppr. 233, Missal, dated late thirteenth or early fourteenth century (D'Ancona, "Un miniatore fiorentino," *Rivista d'arte*, XVI [1934], Fig. 2). Thuringian-Saxon form of gold background with rock platform: Rome, Vat., MS lat. 1369, Decretals of Gratianus, fol. 1 (Olivier-Martin, "MSS bolonais du Décret de Gratien," *Mélanges d'archéologie et d'histoire*, XLVI [1929], Fig. 1). French geometric pattern: Paris, Bibl. Nat., MS lat. 18, Bible attributed to Gubbio (D'Ancona, *La miniatura fiorentina*, Vol. I, Pl. XI, 16). Patterned background and Gothic architectural frame: Venice, Marciana, MS lat. IV. 109, Decretals of Gregory IX, late thirteenth or early fourteenth century. Romanesque architectural frame and gold background: Cambridge, Fitzwilliam Mus., Paduan Psalter. In the thirteenth century there is the beginning of a development of the large historiated initial in which the background is usually of one color, with or without an architectural frame. This type of illustration reaches a high stage of development in the antiphonals of the fourteenth century.

[78] Serbia, Convent of Sopotchany, "The Assumption," *ca.* 1250 (Muratoff, *La Peinture byzantine*, Pl. CLXIII). Bulgaria, Church of Bojana, "Presentation in the Temple," *ca.* 1259 (*ibid.*, Pl. CLXVIII). In these frescoes there is a pronounced feeling for tridimensional values, which does not affect the structure of the background as a whole, but is limited to the upper part of the architectural background objects. The linear perspective is the same rudimentary type that is found elsewhere, but it is applied here with greater energy and more thoroughly.

than in Byzantine painting, producing an effect of solidity in the features of the background and the figures. This solidity may be contrasted with the Gothic form (Figs. 38, 42). The background object—a building or hills—forms a wall behind the figures, whereas in French illumination the architec-ture is a skeletal frame around the action. In the figures there is an impres-sion of weight and substantiality in Italian painting despite the stylized linear technique. The Gothic figure is comparatively weightless and unsub-stantial although the folds of drapery are more naturalistic. The contrast is also present in the ground plane, which in Italian panel painting is a solid band, the upper contour meeting the background object or the gold area in a distinct, straight line. In French illumination the ground plane generally has an irregular contour, which emphasizes its linear rather than its plastic character and accentuates the impression that it is on a vertical plane con-tinuous with the background.

The characteristic French Gothic spatial style developed gradually in the thirteenth century and continued with a few exceptions until the middle of the fourteenth century. In Italy, however, the Byzantinized style was but a prelude to significant changes in spatial representation which became ap-parent at the end of the thirteenth century in the painting of Cimabue and the work of the Roman school, of which Cavallini is the accepted leader. These changes may be observed in the fresco of the "Last Judgment" in Santa Cecilia and in the mosaics in Santa Maria-in-Trastevere in Rome by Cavallini. In place of the schematic delineation of anatomy and drapery derived from the Byzantine manner, Cavallini, as has often been noted, sub-stituted gradual transitions of light and shade and drapery which falls about the body in naturalistic folds. The result is a figure that has volume; the planes emerge gradually from the shaded depths to the high-lighted sur-faces.[79] Cavallini's awareness of tridimensional values did not stop with the figure, but extended to the architectural features of the setting. In the "Birth of the Virgin" in Santa Maria-in-Trastevere the Byzantine background ob-ject is no longer a façade, but an interior.[80] Although in the lower part of the scene the orthogonals at the juncture of the side walls and the floor have not been represented, the depth is indicated by the perspective of the ceiling

[79] Rome, Sta. Cecilia, frescoes by Cavallini (Van Marle, Italian Schools, Vol. I, Figs. 296, 297).
[80] Ibid., Fig. 293.

where the receding lines of the beams converge in parallel pairs. In the Vir-
gin's cathedra in the "Annunciation,"[81] the recession of the parallel lines
in depth is indicated in the convergence of both the upper and the lower
lines of the vertical plane of the object. Not only are the planes in depth
represented by the lines of the upper part, which descend, and the lines of
the lower part, which ascend, but the structure itself is set within the hori-
zontal plane of the ground—here a rock platform.

The method of representing depth which Cavallini used was not new,
since the convergence of parallel receding lines of both horizontal and ver-
tical planes in depth does occur, together with conceptual methods in
smaller objects and in the roofs of buildings, in both Byzantine and northern
painting. Nor did Cavallini apply the optical rule of convergence consist-
ently or with accuracy, for, like his predecessors, he did not always draw
the angles at which two planes intersect acutely enough to prevent diver-
gence, as may be seen in both the horizontal and the vertical planes of the
projecting arms of the cathedra in the "Annunciation." Furthermore, he is
not concerned with the unity of point of view in the scene as a whole. This
is illustrated in the "Adoration of the Magi" in Santa Maria-in-Traste-
vere,[82] where the building in front of which the Virgin is sitting and the
city on the hill to the left are represented from two different points of view.
Nevertheless, the perspective representation in Cavallini's work is signifi-
cant; first, because of his effort to treat a whole structure at the base as well
as at the top as one tridimensional object ("Annunciation"), and secondly,
because it shows a definite attempt to transform the generalized background
object into a specific interior ("Birth of the Virgin") within which, rather
than in front of which, the figures could eventually be placed.

The ground for Cavallini's spatial innovations was prepared to some
extent by the current Byzantinized style. The simplification and unified
composition of the features of the background accentuated the implied tri-
dimensionality inherent in the stage space divisions and presented the back-
ground object as a single unit rather than as a combination of cubic groups.
Cavallini made the environment more specifically representative and endeav-
ored to give tridimensional form to the object as a whole. Although Caval-
lini's contribution to perspective is very limited compared with the advances

[81] Robb, "The Iconography of the Annunciation," Art Bulletin, XVIII (1936), Fig. 2.
[82] Van Marle, Italian Schools, Vol. I, Fig. 294.

made in the ensuing centuries, his achievements in tridimensional form, es-
pecially in the representation of the figures, introduced new artistic values.
They succeeded not only in creating a more naturalistic image but also in
producing richer effects of light and shade in color and an expression of
gravity and strength in the forms.

In the work of Cimabue a similar concern for tridimensional structure
may be observed. Although the Byzantine manner prevails to some extent
in his method of representing the figures, in the throne of the "Madonna
and Child Surrounded by Angels," in the Uffizi,[83] there is a more obvious
appreciation of tridimensional values. In contrast to the thrones in the work
of his predecessors,[84] in which the planes in depth are generally telescoped
and are usually seen from different points of view, Cimabue represents a
tridimensional throne from a uniform frontal point of view. The throne is
composed of a series of superimposed blocks, the cubic masses of which are
pronounced. Although the perspective method involves no more than the
general convergence of receding parallel lines and the structure itself is not
supported by a ground plane, the tridimensional form is clearly expressed.

The spatial innovations of Cavallini and Cimabue were carried further
early in the following century by Duccio and Giotto, upon whose contribu-
tions, as has often been observed, much of the spatial development in the
Renaissance depends. The promise of representative and tridimensional
space in the work of Cavallini and Cimabue was fulfilled in the trecento, a
period which also anticipated the ultimate unification and systematization
of the represented space by the mathematical system of perspective evolved
in the fifteenth century.

[83] Ibid., Fig. 262.
[84] Siena, Palazzo Pubblico, "Madonna and Child," Guido da Siena (Khvoshinsky and Salmi,
I pittori toscani, Fig. 8). Siena, Chiesa dei Servi, "Madonna and Child," Coppo di Marcovaldo
(ibid., Fig. 15).

CHAPTER VII

THE FOURTEENTH CENTURY

T THE END of the thirteenth century and the beginning of the fourteenth significant changes in the representation of space appeared in the work of Duccio and Giotto which mark the transition from the medieval to the Renaissance concept of space.[1] The economic and cultural factors involved in the florescence of Renaissance art are well known, and since they affect the development of painting as a whole, they are indirectly responsible for the changes in the representation of space. The religious revival of the Franciscan and Dominican orders and the growth of lay patronage resulting from political organization and commercial progress, both played their parts in the evolution of space, for as a consequence of popularization and humanization the hieratic and didactic atmosphere that clung to the Byzantine style was unsatisfactory, and a more representative and naturalistic, that is, optical rather than conceptual approach to painting was demanded. The new concept of space that arose at the end of the thirteenth and the beginning of the fourteenth century in Italian painting has been attributed directly to the confluence of Byzantine and Gothic elements in Italian art.[2] The preservation of representative features of the environment and the implied tridimensional structure of stage space in Byzantine illu-

[1] Reference to the medieval concept of space in Italian painting should be made with reservation, for, as we have seen, although the tendency to eliminate tridimensional values and representative features was present, a vestige of stage space persisted throughout the Middle Ages, principally in monumental painting.

[2] It is generally agreed that the Gothic factor was derived from sculpture rather than from painting. Cf. Panofsky, *Vorträge Bibl. Warburg*, 1924-25, p. 277, and Weigelt, *Sienese Painting*, p. 11. As has been noted in this study there is a similarity between Gothic sculpture and painting, especially in the development of the figure. Cf. Panofsky, *Vorträge Bibl. Warburg*, 1924-25, p. 312, note 37.

minations and mosaics, together with the movement toward naturalism in the figure and toward coördination and interrelationship of figure and background in Gothic art,[3] combine in Italian painting to produce not only a tridimensional representative space, but eventually a theoretically measurable pictorial representation of space. The importance of the *trecento*, especially the first half of the century, for the development of spatial representation in the Renaissance has long been recognized and has received the careful attention of a number of scholars, notably Panofsky[4] and Kern.[5] After a re-examination of the field, little can be added here to the results of their investigations, but a survey of the development in the fourteenth century in Italy and in the north is essential in order to conclude this study of the history of the forms of space in medieval painting.

In Italian painting of the *trecento* the transformation of the picture plane into a representative and tridimensional environment for figures which have mass and volume and are composed in intercommunicating groups was accomplished. Furthermore, the beginning of a systematic application of optical perspective for the organization of the features of the environment and the figures in a unified composition in depth may be observed. The tridimensional delineation of a representative setting introduced the problem of the foreshortened plane, either in its simple form as the floor of the stage of the picture plane or, in the more complex arrangement, as one of several adjacent planes in an exterior view of a building or in a boxed interior. One of the primary laws of optical perspective involved in the representation of the foreshortened plane is the principle of the convergence of parallel lines in depth. The problem of systematizing the convergence varies with the complexity of the spatial pattern. The single plane without figures presents a pattern which differs from that which appears in a plane obstructed by figures and objects. These forms differ from the spatial unit which involves the coördination of several planes in depth. Furthermore, the spatial units themselves vary. The boxed interior parallel to and centered in the picture plane presents a problem of coördination different from that created by the

[3] Panofsky (*Vorträge Bibl. Warburg*, 1924-25, p. 276) discusses a similar interrelationship between the figure and its background in Gothic architectural sculpture, in which the figure is habitually represented with its pedestal and canopy.

[4] *Vorträge Bibl. Warburg*, 1924-25, pp. 258-330.

[5] "Die Anfänge der zentralperspektivischen Konstruktion," *Mitteilungen des kunsthistorischen Instituts in Florenz*, 1912-13, pp. 39-65.

building parallel to the picture plane but seen from the side. Both these spatial units differ from the structure so placed that two adjacent sides form an angle with the picture plane, that is, a building in angular perspective. Hence, there are many factors which enter into the question of the systema' tization of linear perspective. The clarity, the position, and the number of planes involved in a particular spatial pattern are among these factors. It is apparent that certain forms will lend themselves more readily than others to coördination into a unified system and may even anticipate some of the principles of measurable, geometric perspective.[6]

Early in the fourteenth century definite indications of a systematic, al' though not mathematical, approach to the problem of linear perspective may be observed. The more outstanding developments in the representation of space were contributed principally by the masters of the first half of the century. Cavallini, in the mosaics in Santa Maria'in'Trastevere, had intro' duced tridimensional values into the stage space divisions of the picture plane, which up to that time had been in two'dimensional form. Upon the foundations of this tridimensional background, with its limited depth, the advances of Duccio and Giotto in spatial form were made. The simple divi' sion of the picture plane into a foreground which is perpendicular to the surface of the background remained essentially the same. In panel painting the use of gold for the background persisted while in fresco, blue—more representative from the point of view of realism—was employed. The back' ground object, however, was transformed from a façade standing on the upper contour of the band of ground to a tridimensional building which is supported by the horizontal plane of the ground. The attempts of Cavallini to make the buildings tridiménsional and to represent the spatial enclosure of an interior were realized by Duccio and Giotto.

The scenes of the Life and Passion of Christ on the retable of the "Ma' donna in Majesty" in the Museum of the Cathedral of Siena illustrate to what extent Duccio developed tridimensional form within the limits of stage space and with the traditional gold background. For this type of setting the term stage space seems particularly apt.[7] Duccio's scenes have a quasi'

[6] See Panofsky, "Once More 'The Friedsam Annunciation,' " *Art Bulletin*, XX (1938), 422 ff., for a detailed discussion of the question of spatial units in relation to the problem of perspective.
[7] It has been suggested that there was a direct influence from medieval drama on painting of this period. Weigelt (*Sienese Painting*, p. 13) mentions the striking reminder of the stage of the Mysteries in Duccio's work. Guthmann (*Die Landschaftsmalerei*, pp. 33-34, 48, note 65) notes

realism usually associated with the theater. Against the unrealistic gold background and within the limited depth of the foreground plane there is a careful distinction of exterior and interior in setting. Landscape is repre-sented by the rock-platform ground plane and the traditional Byzantine shelf rocks, which form the background object or the coulisse of the set.[8] The interiors are porticoes or one-room houses. The latter occasionally have entrances at the side, through which people pass,[9] but the doorways in the rear wall do not reveal the rooms beyond, with the exception of the scene of the "Denial of Peter."[10] Furthermore, in the numerous scenes of the retable the unity of place is maintained, for, as has often been observed, Duccio employed the same setting for the successive episodes enacted in the same room.[11]

The space in these one-room houses that depict interiors is enclosed or boxed. It is limited by the planes of the floor, walls, and ceiling, which theoretically make its cubic volume measurable. The representation of tri-dimensional forms requires some observation of the laws of optical perspec-tive. In the interiors, moreover, since the space is boxed, that is, since the planes of the structures are adjacent to and dependent on one another for size and shape, the need for a coördination of the perspectively delineated forms is more apparent than in landscapes, where the natural features sel-

the possibility of the relationship between the background in Giotto's painting and the *Sacre rappresentazione*. For a detailed discussion of the influence of the Mysteries on northern painting from the end of the fourteenth century, principally in iconography, see Mâle, "La Renouvellement de l'art par les 'Mysteres,'" *Gazette des beaux-arts*, XXXI (1904), 89-106, 215-30, 283-301, 379-94. Millet does not accept Mâle's opinion that the Mysteries had an important influence on the development of iconography, but believes rather that the birth of religious drama and the changes in iconography were simultaneous developments due to the same cause (*Recherches*, p. 623). La Piana, on the other hand, in an article on the Byzantine theater (*Speculum*, XI [1936], 184) accepts Mâle's conclusions.

[8] "Entombment," "Three Marys at the Tomb" (Weigelt, *Sienese Painting*, Pl. XXI).

[9] "Christ before Caiaphas" and "Christ Beaten with Rods" (*ibid.*).

[10] *Ibid.* In later Sienese painting the feature of doors which open into other rooms or onto vistas was developed.

[11] Compare the settings in the representation of the "Washing of the Feet," the "Last Supper," and the "Farewell Discourse"; see also the settings in "Christ in the White Robe," the "Flagella-tion," the "Crown of Thorns," "Pilate Washing His Hands," the "Pharisees accuse Christ," and "Christ before Pilate"; compare also "Christ Beaten with Rods" and "Christ before Caiaphas." (Weigelt, *Sienese Painting*, p. 11 and Pl. XXI). Between the scenes of "Christ before Annas" and the "Denial of Peter" an architectural unity is provided by the stairway connecting both rooms (Panofsky, *Vorträge Bibl. Warburg*, 1924-25, p. 314, note 46). The same method of con-necting the two scenes is employed by Segna di Buonaventura in the panel in the Cathedral of Massa Maritima (Van Marle, *Italian Schools*, Vol. II, Fig. 88).

dom have a regular geometric shape, or in exterior views of buildings, where fewer adjacent planes in depth are visible. In Duccio's interiors one may observe the beginning of a systematic application of optical perspective in that there is an attempt to coördinate the different parts of the building according to a uniform perspective plan. This is rudimentary, to be sure. The orthogonals of the juncture of the floor with the side walls are generally hidden by figures or objects, and where they are indicated too little is visible for an accurate tracing of their direction. Where buildings are seen from the side, the lines in depth have scarcely more organization than that specified later by Cennini:

And put in the buildings by this uniform system: that the moldings which you make at the top of the building should slant downward from the edge next to the roof; the molding in the middle of the building, halfway up the face, must be quite level and even; the molding at the base of the building underneath must slant upward, in the opposite sense to the upper molding, which slants downward.[12]

Where there is a frontal view of a ceiling, however, two systems of depicting the lines in depth have been noted. According to the first system corresponding pairs of receding lines converge toward the center and intersect approximately along an imaginary vertical line, which has been called the vanishing axis.[13] The second system was used when the ceiling was to be coffered, as in the "Last Supper" (Fig. 51). Here, only the orthogonals of the coffers of the central bay converge toward a limited vanishing area,[14] thus anticipating, more than the vanishing-axis procedure, the focused system of perspective, in which the form of the planes in depth is controlled by a vanishing point.

In Duccio's painting there is no question as yet of a geometric system of perspective, nor does the approach to the vanishing point construction occur in more than part of a plane. Furthermore, as far as the scene as a whole is concerned the relatively systematic application of perspective appears only in the building. Objects within the house are not drawn from the

[12] Il libro dell'arte (A Craftsman's Handbook), translated by D. V. Thompson, Jr., Yale Univ. Press and Oxford Univ. Press, 1933, p. 57. Cennini's treatise, written at the end of the fourteenth century, probably gives the general idea of perspective current in his period. Individual ateliers, however, may have had their own more detailed methods, which he did not describe.

[13] Panofsky, Vorträge Bibl. Warburg, 1924-25, p. 314, note 42. A good example of the application of the vanishing-axis procedure by Duccio, in this instance in an object rather than an interior, is afforded by the throne of the "Madonna in Majesty" (Fig. 50).

[14] Kern, Mitteilungen des kunsthistorischen Instituts in Florenz, 1912-13, pp. 278-79.

same point of view as the house itself, as exemplified by the table in the "Last Supper" (Fig. 51).[15] There is not the same concern for tridimensional structure in the perspective delineation of the smaller objects as in the buildings, for, in indicating the perspective planes in depth, parallel receding lines were made to diverge as frequently as to converge—as in the previous century.

In the representation of tridimensional space there is a noticeable contrast between the construction of the buildings and the composition of the figures which is similar to that between the buildings and the form of the objects. Although in the representation of the individual figure light and shade and the folds of the drapery were handled with greater plasticity and naturalism than in the *dugento* or even in the French Gothic, the composition of the figures does little to enhance the sense of depth created by the boxed interior. The movement is from side to side rather than in depth.[16] There is a repertory of positions and an occasional figure with its back toward the spectator, as the maid in the "Denial of Peter," but the majority of the heads appear in the traditional three-quarters view. The crowds are compact cubic groups with the heads terraced above one another so that the figures in the rear are higher than those in front, an arrangement which is at variance with the point of view, approximately at eye-level, afforded by the architecture.[17] There are frequent conflicts between the position of the figures and the tridimensional space of the buildings. Not only parts of figures but also crowds of people cross in front of columns placed at the edge of the picture plane.[18] In the "Denial of Peter" the maid who stands in front inconsistently reaches across the whole foreground to touch the banisters of the stairs in the rear.[19] Although, from a tridimensional point of view, there are spatial inconsistencies in Duccio's painting, the achievement of enclosed space and the rudiments of systematized perspective methods are a considerable advance beyond the tentative efforts of Cavallini and Cimabue.

In the work of Giotto, in contrast to Duccio, tridimensional space is

[15] Panofsky, *Vorträge Bibl. Warburg*, 1924-25, p. 278.

[16] Exceptions may be found in the "Entry into Jerusalem" and "Christ on the Mount" (Weigelt, *Sienese Painting*, Pl. XXI), in which there is an effect of movement inward.

[17] "Christ before Herod," "Pilate Washes His Hands" (Weigelt, *Sienese Painting*, Pl. XXI).

[18] "Christ before Herod," "Pilate Washes His Hands" (*ibid.*).

[19] *Ibid.*

emphasized by the figures. The sculpturesque quality of Giotto's figures, which gives the impression of mass, has often been noted. This, together with composition in depth, helps to define the ground as a horizontal plane. The composition in depth involves various foreshortened positions and direct communication between the figures by the turn of the head and the glance, which, with the gestures, contribute narrative power to Giotto's painting. The stereotyped three-quarters view of the head is replaced by the profile, more effective from the point of view of intercommunication, and frequently a figure is turned with his back to the spectator.[20] When groups are represented the terracing of heads is not as pronounced as in Duccio's work.[21]

The effect of tridimensional space created by the representation of the figures is carried out in the setting. The use in frescoes of blue rather than gold for the sky adds to the representative character of the scene. In the background as a whole, however, the limited depth of stage space is retained. While the traditional shelf rocks still serve to suggest a landscape, the high background buildings in urban exteriors are not façades, but tridimensional structures, which are not only placed parallel to the picture plane but also in a number of instances seen in angular perspective.[22] Generally the perspective delineation follows the simple rule set down in the treatise written several decades later by Cennini (vide supra, p. 138), in which the principle of convergence is expressed in the inclination of the lines in depth of the roof and base of a building. The treatment of the convergence of

[20] Padua, Arena Chapel: "Presentation of the Virgin in the Temple," "The Praying Wooers," "The Nativity," "The Massacre of the Innocents"; Florence, Sta. Croce, Bardi Chapel: "Death of St. Francis." (Weigelt, Giotto, pp. 14, 17, 25, 32, 134.)

[21] Padua, Arena Chapel: "The Wooers Bring Their Rods to the Temple," "The Praying of the Wooers," "The Marriage of the Virgin," "The Wedding Feast"; Florence, Sta. Croce, Peruzzi Chapel: "Resuscitation of Drusiana by St. John the Evangelist." (Weigelt, Giotto, pp. 16, 17, 18, 20, 128.) The representation of crowds in an isocephalic rather than terraced form helps to produce the impression that the ground is a horizontal rather than a tilted plane and that it is an extension of the ground of the spectator into the picture. Furthermore, the isocephalic form helps to effect a unified point of view. In the trecento terracing persists, although occasionally—especially where the composition of a group involves relatively few figures—an almost uniform eye-level is maintained. Early in the fifteenth century, with the application of the focused system of perspective the isocephalic form is used when it is proper to the point of view depicted. In fact, Alberti, in his treatise on painting (Della pittura, p. 85), written ca. 1435, mentions that in representing a number of people, as in a temple, all the heads should be at the same height, although the feet appear on different levels.

[22] Padua, Arena Chapel, "St. Joachim and St. Anna at the Golden Gate of Jerusalem"; Florence, Sta. Croce, Peruzzi Chapel, "Resuscitation of Drusiana by St. John the Evangelist"; Bardi Chapel, "St. Francis Renouncing His Father" (Weigelt, Giotto, pp. 11, 128, 132).

the parallel lines of the whole vertical plane in depth suggests the vanishing-axis procedure, for the moldings in the upper part of the building usually run parallel to the cornice of the roof. Although this type of convergence is by no means the same as the vanishing-point structure in the focused system, it is interesting to observe that in the buildings seen in angular perspective, when the adjacent walls form approximately the same angle to the picture plane the symmetry of the receding lines on each side tends to produce points of convergence which are on the same level, that is, along an imaginary horizontal axis. One may see in this form an empirical approach to one of the rules of measurable, angular perspective, namely, that the vanishing points on both sides of the point of sight are at the same height (*vide supra*, p. 9).[23] However, in Giotto's painting of exteriors the vanishing-axis procedure for vertical planes in depth was not used according to the clearly defined systematic form of converging pairs of parallel receding lines, but was only suggested, since in many instances the base and the moldings of the lower part of the buildings are covered by the figures. Despite his rudimentary method of linear perspective, the disproportion of the size of the buildings in relation to the figures, and the limitations in the form of stage space, there is in Giotto's work some illusion of a contemporary street scene, which is created by the tridimensional form and the architectural design of the buildings.

For scenes enacted in interiors Giotto employed the boxed form of a little house or portico, but, occasionally, as in the "Death of St. Francis" in Santa Croce,[24] a screen presenting only the walls of the room suffices. The screen or the partially boxed interior used by Giotto and other artists of the *trecento* may be considered a transitional form of setting in the development from the generalized two-dimensional picture plane to the localized tridimensional background. One cannot speak of it as a transitional stage of development chronologically, for it occurred at the same time when

[23] Panofsky (*Art Bulletin*, XX [1938], 423) mentions the strong psychological impulse to locate both centers of convergence on one horizontal line in buildings symmetrically placed in angular perspective. This, he points out, is an empirical achievement of one of the principles of focused perspective. Although in this article Panofsky is concerned primarily with early Flemish painting, his observation is verified in Italian work of the *trecento*. A good illustration is to be found in the small altar in Giotto's "Sacrifice of St. Joachim" (Padua, Arena Chapel [Weigelt, *Giotto*, p. 9]), in which the two points of convergence are not only on the same horizontal line but also approximately at the eye-level of the standing figures of the angel and a shepherd.

[24] Weigelt, *Giotto*, p. 134. Another example may be found in the "Fire Ordeal before the Sultan," Bardi Chapel, Sta. Croce, Florence (*ibid.*, p. 137).

the boxed interior was in vogue. Nevertheless, as a form it is intermediate between the two-dimensional generalized background object characteristic of *dugento* painting and the completely boxed and specific setting of the one-room house.

In Giotto's painting the boxed interior appears in various points of view. It is present not only in various aspects of parallel perspective but also in angular perspective.[25] In Duccio's work the boxed interior is restricted to the points of view of parallel perspective, a limitation that is in accordance with the lateral movement of the action and the comparatively limited repertory of positions for the individual figures. In Giotto's frescoes, on the other hand, the more numerous points of view of the buildings in general, and the use of angular perspective in particular are evidence of a tendency to realize and to exploit the possibilities of the tridimensional extension of stage space. In the representation of the action this tendency was expressed by greater interest in the composition of the figures in depth.

As far as the perspective organization of the interior is concerned, the restorations which Giotto's frescoes in Santa Croce have undergone make it difficult to come to any conclusions with certainty.[26] From the state of the frescoes at present, however, it appears that although the lines in depth of horizontal planes, such as beamed ceilings, are fairly parallel in buildings seen at an angle to the picture plane,[27] the receding lines of frontal horizontal planes converge toward what may be called a vanishing area (Fig. 52). The vanishing-area type of perspective construction is generally asymmetrical, having the convergence at one side (Fig. 52).[28] This perspective organization, which may be observed in some of the representations of the ceiling, is not extended to include the convergence of the floor or the lines in depth of the objects within the room (Fig. 52).[29] With the understanding that the observation depends on work which has been restored to some

[25] Florence, Sta. Croce, Peruzzi Chapel, "Birth and Naming of St. John the Baptist," "Salome's Dance" (*ibid.*, pp. 125, 126).

[26] Kern, *Mitteilungen des kunsthistorischen Instituts in Florenz*, 1912-13, pp. 49-50.

[27] Florence, Sta. Croce, Peruzzi Chapel, "Birth of St. John" (Weigelt, *Giotto*, p. 125).

[28] See also "Christ before Annas and Caiaphas" (Padua, Arena Chapel [Weigelt, *Giotto*, p. 52]), in which the convergence is a little off center to the left, and the "Vision of St. Augustine and the Bishop" (Florence, Sta. Croce, Bardi Chapel) reproduced and traced by Kern (*Mitteilungen des kunsthistorischen Instituts in Florenz*, 1912-13, Fig. 10).

[29] Other illustrations: Padua, Arena Chapel, "Christ before Annas and Caiaphas"; Florence, Sta. Croce, Bardi Chapel, "Vision of St. Augustine and the Bishop" (Weigelt, *Giotto*, pp. 52, 138).

extent, one may say that Giotto approached the vanishing-point system of perspective only in single horizontal planes.

In the work of Simone Martini there are a few features which are significant with regard to the development of tridimensional space. As far as perspective methods are concerned, Simone Martini used the vanishing-axis procedure.[30] In the more general aspect of perspective organization, however, is an observable effort to present a unified point of view for a group of separate scenes.[31] This is exemplified in the retable of the "Life of St. Augustine" in the church of Sant' Agostino, in Siena, where the buildings in the compartments on both sides of the central panel are composed asymmetrically, the receding lines leading toward the center.[32] The unity of point of view was not extended to landscapes or to the organization of all the elements of the individual scenes. Its application to the general position of the buildings, however, is significant; for, besides considering the compositional values of balance and coördination, either accidentally or intentionally Simone Martini was bringing into greater prominence the factor of the position of the spectator in relation to the painting, a factor which is one of the fundamental considerations in a mathematical perspective system.

Simone Martini attempted to give a greater impression of depth than is afforded by the comparatively narrow ground plane of stage space. In the altarpiece in the church of Sant' Agostino, Siena,[33] this impression was created by increasing the width of the ground plane and, in one of the scenes, by so arranging the architecture that an arcade between two buildings leads back toward a small opening to the gold background. In the fresco representing Guidoriccio da Fogliano in the Palazzo Pubblico, Siena,[34] there is a suggestion of a vista beyond the foreground, which is due to the view of distant encampments rather than to a subdivision of the ground into diminishing planes in depth. These efforts to suggest greater depth in the setting are a prelude to the transformation of stage space into a naturalistic environment.

The conversion of the picture plane into a representative space which

[30] Kern, *Mitteilungen des kunsthistorischen Instituts in Florenz*, 1912-13, pp. 41-42 and Fig. 1.
[31] Weigelt, *Sienese Painting*, pp. 24-25.
[32] *Ibid.*, Pl. XLIX. The same principle is followed in the predella scenes of the "Coronation of King Robert of Naples by St. Louis of Toulouse" (Naples, Nat. Mus.) and in the "Life of St. Martin" in the chapel of St. Martin, lower church of S. Francesco, Assisi (*ibid.*, pp. 24-25).
[33] *Ibid.*, Pl. XLIX.
[34] *Ibid.*, Pl. XLIV.

differs from stage space, first, by substituting more naturalistic subdivisions of the ground into several planes in depth for the limited foreground, and secondly, by suggesting a specific locality rather than a generalized environ-ment, may be observed in the work of Ambrogio Lorenzetti.[35] In the fresco, "The Results and Blessings of the Good Government of Siena," in the Palazzo Pubblico of Siena, the view of the city[36] offers a remarkable il-lustration of the reproduction of a specific locality, while in the landscape next to it foreground, middle distance, and vista create the illusion of panoramic vastness by means of diminution in the planes of the ground and in the figures.[37] The vista is formed by a row of hills, which obscures the horizon line. It is significant that the traditional shelf rocks, which here would be consistent with the high point of view, have been replaced by the more naturalistic little round hills of that region. In the "View of a City" (Fig. 54), one of two landscapes in the Accademia di Belle Arti in Siena attributed to Ambrogio,[38] the scene is also a panorama[39] in which the reces-sion is marked by the progressive diminution of the buildings and the boats.

In the fresco of the "Blessings of the Good Government of Siena" Ambrogio's consideration for the point of view may be detected in the dis-tinction made between the panorama of the landscape, with its high point of view, and the representation of the city as seen from one of its streets. The terracing of the buildings in the city is not an effort to portray a bird's-eye view; it is determined by the hilliness of the site. The employment of the more normal point of view in this scene is corroborated by the fact that the tops of the roofs are not visible and that all the roof lines incline downward. That Ambrogio was conscious of the distinction may be assumed if the

[35] A tendency toward the representation of a specific rather than generalized or conventional setting may be observed in the work of the predecessors of Ambrogio Lorenzetti. This tendency is present in the fresco of Guidoriccio da Fogliano by Simone Martini and is manifested by Duccio in his attention to unity of place. In the frescoes of the life of St. Francis in Assisi there is an effort to create the impression of contemporary street scenes, especially in the "Clares Mourning for St. Francis before the Church of S. Damiano" (Assisi, upper church of S. Fran-cesco [Weigelt, Giotto, p. 155]).

[36] Weigelt, Sienese Painting, Pl. C.

[37] Ibid., Pl. CII.

[38] Opinion on the attribution of these landscapes is divided. Van Marle (Italian Schools, II, 360) believes them to be by Pietro Lorenzetti, while Weigelt (Sienese Painting, p. 54) ascribes them to Ambrogio. I have followed the opinion of Professor Millard Meiss, of Columbia Uni-versity, who is inclined to accept the attribution to Ambrogio.

[39] In this panel the ground actually fills the whole picture plane, but this may be due to the fact that the panel itself may be a fragment of a larger composition. Weigelt, Sienese Painting, p. 54.

"View of the City" (Fig. 54), with its careful delineation of the tops of the roofs, be accepted as his work.[40] Ambrogio's use of the principles of perspective did not extend, however, to the adoption of a uniform point of view in urban and landscape scenes when they exist side by side. The changed point of view between the city and the fields next to it in the Good Government fresco may be compared to a similar change in the small panel of the "Miracle of the Corn" in the scenes from the life of St. Nicholas, in the Uffizi, Florence (Fig. 55), in which the horizon of the sea is much higher than that implied by the parallel receding lines of the building on the shore.

Ambrogio Lorenzetti's contribution to the formation of a systematic method of perspective has been variously evaluated. In vertical planes[41] and in horizontal planes seen from the side[42] the receding lines generally remain parallel; but in symmetrically composed horizontal planes, there is convergence toward a vanishing area. In the pavement of the "Presentation in the Temple," dated 1342 (Fig. 56), the system of convergence is like Duccio's in that the receding lines of the central squares intersect very nearly in a single point, while the outermost lines and the orthogonals of the juncture of floor and side walls converge to points above this. In the pavement of the "Annunciation" (Fig. 57), painted two years later, all the receding lines that start from the edge of the picture plane so very nearly intersect in a point[43] that Kern[44] was led to believe that Ambrogio Lorenzetti had intentionally used a single vanishing point construction for a whole plane. Panofsky[45] believes that, since the outermost squares are covered by the figures and since the orthogonals of the juncture of floor and side walls are not represented, especially if we consider the construction in

[40] In the "City of Siena" (ibid., Pl. CII) and in the "View of a City" (Fig. 54) the buildings are not only placed parallel to the picture plane but also appear in angular perspective.

[41] Example: courses in the building at the left in the "Miracle of the Corn" (Fig. 55).

[42] Example: beams of the ceiling in the room in the upper story of the house in "St. Nicholas Raising a Strangled Child from the Dead" (Weigelt, Sienese Painting, Pl. XCVI).

[43] According to the drawings of Kern (Mitteilungen des kunsthistorischen Instituts in Florenz, 1912-13, Fig. 19) and Panofsky (Vorträge Bibl. Warburg, 1924-25, Pl. XIII) these lines meet exactly in a point. However, in tracing their direction it is possible to find slight discrepancies, which may have been present originally or which may have occurred in the transference of the sketch to the picture plane or because of warping. For a discussion of the possible sources of such inaccuracies to be taken into account when judging the application of a system of perspective see Wolff, Mathematik und Malerei, p. 34, and Kern, "Perspektive und Bildarchitektur," Repertorium für Kunstwissenschaft, XXXV (1912), 54. Vide infra, pp. 201 ff.

[44] Mitteilungen des kunsthistorischen Instituts in Florenz, 1912-13, p. 60.

[45] Vorträge Bibl. Warburg, 1924-25, pp. 280, 314, note 46.

the "Presentation in the Temple," we cannot assert that Ambrogio used a vanishing point for a whole plane, but we can maintain that he used it as Duccio did, but with greater awareness of the mathematical principle involved, for part of a plane. Panofsky's reasoned conclusion is borne out by the picture itself, for behind the angel, in the small angle of pavement, part of a square is visible, the receding line of which if continued will be found to cross the central column at a point much higher than that in which the other orthogonals meet.

Although the importance of Ambrogio's contribution to perspective is somewhat diminished by this distinction between partial and complete planes, there remains another important feature in his perspective representation of the pavement which is of considerable significance—the progressive diminution of the squares as they recede from the edge of the picture plane. The rate of diminution was not geometrically determined;[46] nevertheless, the suggestion of depth was greatly enhanced by decreasing the size of successive rows of foreshortened squares.

The checkered pavement, managed skillfully with regard to convergence and diminution, strengthens the tridimensional appearance of the ground plane and gives a definite impression of measurable space by presenting the square as a unit of measurement. Furthermore, it is an effective means of aiding the composition of the figures in depth. In Ambrogio's panels both convergence and diminution were carefully observed.

Ambrogio Lorenzetti's interest in perspective accompanied an interest in the representation of tridimensional space, which may be observed in varying degrees in the work of Italian artists from the time of Cavallini. That Ambrogio was working toward a perspective system based on geometry and the science of optics more consciously than did the other masters of the trecento cannot be asserted with certainty because of his limited use of the

[46] In an accurate geometric construction of the pavement according to the focused system of perspective, a diagonal drawn through a square of the first row when continued passes unbroken through the angles of the squares of the succeeding rows and intersects the horizon line in a point, known as the distance point: the theoretical distance of the spectator from the scene (Fig. 53 a). In Ambrogio's "Presentation in the Temple" and "Annunciation" the diagonals are broken. Hence, there is no intersection at a distance point (Fig. 53 b). Alberti (Della pittura, p. 80) criticized a system of diminution, which he says was used by some artists of his time, according to which successive rows of squares were reduced progressively by one-third. It is possible that formulae for diminution such as this were employed in the trecento, but I have been unable to determine whether Ambrogio Lorenzetti or any other Italian artist of that period followed a consistent ratio of diminution.

vanishing point and his nonmathematical representation of diminution. Both the convergence and the diminution may have been the result of keen observation combined with a strong feeling for unified composition. In the "View of a City" (Fig. 54) the distinction between a geometric and an optical system of perspective is maintained. The high point of view, which is optically determined, is followed consistently, but the buildings themselves appear to be constructed from the same point of view according to an isometric system, that is, one which does not take into account the distortion of the form occasioned by recession. The parallelism of the receding lines of the planes in depth is carefully retained, which is an application of mathematics to the problem of tridimensional representation; but the union of geometry with the laws of optics for the formation of a theoretical perspective system is not realized. Thus it would seem that, although Ambrogio Lorenzetti made a considerable contribution to perspective representation by observation and by applying some geometry to the problem, he did not go so far as to combine both into a mathematical system of perspective.

No one in the fourteenth century went further than Ambrogio Lorenzetti in developing the representation of space, and few went so far. Naturalistic space with several planes in depth, in place of the simple foreground of stage space, rarely appeared even in frescoes. Where it does appear,[47] the depth is suggested by terracing the traditional shelf rocks and carrying the action backward on these, with abrupt diminution in the figures and buildings, rather than by a uniform ground receding gradually from the edge of the picture plane.[48] The picture plane presents, in general, the stage space form having a fairly wide horizontal ground plane and (in panel painting) a gold background. The architectural background object varies slightly. It is either a street or a screen similar in type to the construction in Giotto's fresco of the "Death of St. Francis," in Santa Croce,[49] or it is a one-room

[47] Pisa, Camposanto, "The Triumph of Death" (Crowe and Cavalcaselle, History of Painting in Italy, Vol. II, Pl. II). Florence, Sta. Croce, "Legend of the Origin and Finding of the Holy Cross," by Agnolo Gaddi (Toesca, Florentine Painting, Pl. CVIII). Siena, Academy, "Adoration of the Magi," by Bartolo di Fredi (Van Marle, Italian Schools, Vol. II, Fig. 318). Gloucester, Parry Coll., "Adoration of the Magi" and "Bathing the Christ Child," Cavallinesque-Riminese school (ibid., Vol. IV, Fig. 144).

[48] See Kallab (Jahrbuch des oesterreichischen Kaiserhauses, XXI [1901], 1-90) for a detailed discussion of the landscape and the sources of its forms.

[49] Berlin, Kaiser Friedrich Mus., "Flagellation," by Ugolino da Siena (Van Marle, Italian Schools, Vol. II, Fig. 62). Florence, Uffizi, St. Cecilia altarpiece (ibid., Vol. III, Fig. 160).

house.[50] In the second half of the century the architectural forms were elaborated by a greater articulation of the wall surfaces, and there was a tendency, advanced by the Lorenzetti, to increase the depth of the building by leading back from one room into another.[51] The abbreviated street scenes used by Simone Martini became popular and were filled out slightly to cover more of the picture plane.[52] The position of the buildings in both street and interior scenes is generally parallel to the picture plane. Occasionally, however, a point of view in angular perspective was chosen.[53]

The perspective methods of the vanishing axis and the approximation of a vanishing point for a small area both appear. The former, however, was by far the more frequently used. It is applied carefully to vertical as well as to horizontal planes,[54] giving an impression of systematic construction. The pronounced symmetry of the buildings in the Santa Cecilia altarpiece, now in the Uffizi, Florence (Fig. 58), in which the parallel lines converge approximately at a uniform angle of 45° with the vertical to a central vanishing axis, helps to create the effect of geometric solidity. Barna da Siena's, "Judas Receiving the Price of His Betrayal," in the Collegiata, San Gimignano,[55] is another good example of vanishing-axis construction, which in this scene was even extended to include the platform on which the building stands.[56]

[50] Siena, Academy, Carmelite altarpiece, by Pietro Lorenzetti (Weigelt, Sienese Painting, Pl. LXXV). Florence, Uffizi, "Annunciation," predella of a polyptych by Bernardo Daddi (Van Marle, Italian Schools, Vol. III, Fig. 225).

[51] Siena, Academy, scenes from the life of the Virgin, by Bartolo di Fredi (Van Marle, Italian Schools, Vol. II, Fig. 322). Siena, Academy, "Nativity of the Virgin," by Paolo di Giovanni Fei (ibid., Fig. 337). London, Nat. Gal., "Marriage of the Virgin," by Niccolo di Buonaccorso (ibid., Fig. 331).

[52] Florence, Uffizi, St. Humilitas altarpiece, by a follower of Pietro Lorenzetti (Weigelt, Sienese Painting, Pl. LXXXV). Rome, SS. Sisto e Domenico, triptych of Madonna enthroned with Saints and scenes from her life (ibid., Pl. CXIV). S. Gimignano, Gallery, altarpiece by Taddeo Bartolo (Van Marle, Italian Schools, Vol. II, Fig. 358).

[53] The examples of angular perspective seem to occur more often in the work of the followers of Giotto than in other Italian schools of painting. Florence, Sta. Croce, Baroncelli Chapel, "St. Joachim Driven from the Temple," "Presentation of the Virgin in the Temple," by Taddeo Gaddi (Toesca, Florentine Painting, Pl. LXXXII). Florence, Sta. Croce, Castellani Chapel, "St. Anthony Listening to the Gospel and Distributing His Worldly Goods," by Agnolo Gaddi (ibid., Pl. CX).

[54] A good example of the use of the vanishing-axis procedure in the receding vertical planes rather than horizontal planes may be found in the "Annunciation" in the predella of a polyptych by Bernardo Daddi (Florence, Uffizi [Van Marle, Italian Schools, Vol. III, Fig. 225]). In this picture the pairs of receding lines converge to points which lie approximately on an imaginary horizontal axis, in contrast to the paintings in which the procedure is used for horizontal planes and the points of convergence lie on a vertical axis.

[55] Van Marle, Italian Schools, Vol. II, Fig. 191.

[56] As Kern (Mitteilungen des kunsthistorischen Instituts in Florenz, 1912-13, pp. 40-56) and Panofsky (Vorträge Bibl. Warburg, 1924-25, p. 268) observe, when the vanishing-axis pro-

There are few followers of the approximate vanishing-point type of con-struction.[57] The most notable is Pietro Lorenzetti, in whose painting of the "Birth of the Virgin," in the Cathedral Museum, Siena, dated 1342 (Fig. 59), the whole picture has become the represented space.[58] The gold in the background has been eliminated, and the room opens directly from the frame, which itself is incorporated in the architecture of the interior. The unity of perspective composition in two of the three bays of the frame has been pointed out by Panofsky.[59] The use of a vanishing area in this panel is notable because the tendency toward the coördination of the point of view of the objects with the architecture of the room, which may be observed in Ambrogio's painting, is followed by Pietro in a number of the features in this interior. Although one cannot say with certainty that Pietro used an approximate vanishing point for more than part of a plane, the separate van-ishing points of the pavement in the central and the right bay of the frame, of the blanket, and the receding lines of the bed and side walls, all come together roughly in what may be called a vanishing area, producing in this painting a unity of organization for the room as a whole which is a nearer approach to the focused system of perspective than any hitherto realized. The separate room represented in the left bay of the frame is not brought into the perspective unity of the main room except for one line on the floor. The few other markings in the pavement and the orthogonals of the side walls remain parallel instead of converging toward the vanishing area.

Another notable feature in this painting, wherein Pietro resembles Am-brogio, is the careful diminution in the squares of the pavement and the

cedure is employed in a coffered ceiling or a checkered pavement, if the plane is deep the con-verging center lines may meet on the plane itself. This awkward form was usually avoided by hiding that particular section with an object or drapery or by breaking through the architecture. Kern traces the vanishing-axis procedure to classic art and believes that it was introduced into trecento painting later than Duccio through contact with illuminations dating before the ninth century (Mitteilungen des kunsthistorischen Instituts in Florenz, 1912-13, pp. 56-57). However, Panofsky (Vorträge Bibl. Warburg, 1924-25, p. 314, note 43) cites examples from the dugento indicating that it was present in the Byzantine tradition, and he points out that Duccio himself used the vanishing-axis procedure for the side bays of the ceiling in the "Last Supper" (Fig. 51).

[57] Siena, Museo dell'Opera del Duomo, "Birth of the Virgin," by Pietro Lorenzetti (Fig. 59). Siena, Academy, "Birth of the Virgin," by Paolo di Giovanni Fei (Weigelt, Sienese Painting, Pl. CXX). London, Nat. Gal., triptych by Giusto da Padova (Van Marle, Italian Schools, Vol. IV, Fig. 82).

[58] A tendency to fill the entire picture plane allotted to the scene by the boxed interior may be observed in the "Last Supper," by Duccio (Fig. 51) and in the frescoes of the life of St. Martin in S. Francesco, Assisi, by Simone Martini (Weigelt, Sienese Painting, Pls. LI-LV).

[59] Vorträge Bibl. Warburg, 1924-25, p. 314, note 46.

blanket. The rate of diminution seems to have been empirically rather than geometrically determined, but it is effective, nevertheless, in giving an impression of measurable depth. One should note that despite the diminution in the checkered areas, there is no corresponding diminution in the size of the figures.

Except in the work of the Lorenzetti, where there is diminution in the coffers of the ceiling and the squares of the pavement, the rate is usually not rapid enough. This, together with the rather uncertain convergence of the orthogonals, results in the tilted appearance of the horizontal plane.[60] In the next century, however, the problem of diminution was solved mathematically in the theoretical focused system of perspective, which provides the method for unified tridimensional construction.

Thus, in Italy in the *trecento*, especially in the work of the masters of the first half of the century, tridimensional values were reintroduced into the vestiges of stage space preserved in Byzantine and *dugento* painting. The interest in tridimensional form was accompanied by a development of the representative character of the environment from the standpoint of naturalism and localization. Although traditional features, such as the gold background and the shallowness of the stage, persisted, in some instances the picture plane was converted into a completely representative tridimensional space. This is exemplified by Pietro Lorenzetti's "Birth of the Virgin," in which the interior fills the architectural frame, and by Ambrogio's fresco of the agricultural aspects of the "Good Government of Siena," in which the landscape is divided into foreground, middle distance, vista, and sky.

The need for an adequate method of perspective which would give a convincing optical illusion of tridimensional space and at the same time promote the compositional unity of the scene was met by the systematized use of the vanishing axis and by the anticipation of the focused system of perspective with the convergence of the lines in depth toward a vanishing area. The single vanishing point, if used intentionally at all, appears for a part of the plane rather than a whole plane. The vanishing area was sometimes used for a single plane, but in Italian painting of the *trecento* it did not control the whole scene.[61] The vanishing-axis type of construction, on

[60] London, Nat. Gal., "Marriage of the Virgin," by Niccolo di Buonaccorso (Van Marle, *Italian Schools*, Vol. II, Fig. 331). Siena, Academy, "Birth of the Virgin," by Paolo di Giovanni Fei (Weigelt, *Sienese Painting*, Pl. CXX).

[61] Pietro Lorenzetti's "Birth of the Virgin" may perhaps be considered an exception, but even

the other hand, was used to coördinate a number of planes, and in several instances it was applied with such zeal that it creates the impression of a unified systematic construction of the background. To these advances in perspective method must be added progressive diminution with depth, although the connection between diminution and the system of convergence had yet to be made. The link between the two is the spectator, upon whose theoretical position both the vanishing point and the distance point depend. In *trecento* painting the spectator is the audience, rather than a reader or an interpreter. The concept of the audience as a single eye, however, is a contribution of the artists of the fifteenth century.[62]

Spatial developments in the *trecento* are not limited to the background, but may be observed also in the representation of the figures. Giotto's advances in methods of representing corporeality and mass, in foreshortening, and in composition in depth were imitated by his followers. In the painting of the *trecento* on the whole, however, the movement of the figures is still predominantly lateral, but in a number of panels the figures are grouped in a circle or move diagonally in depth. Once again the importance of the checkered pavement as an aid to the composition of the figures in tridimensional space should be noted. With regard to the development of the representation of space, Italian painting in the fourteenth century marked the end of the medieval period and the beginning of the Renaissance. To complete the illusion of representative tridimensional space the masters of the *quattrocento* turned to scientific studies of anatomy and the mathematical refinements of perspective.[63]

here the vanishing area is hardly circumscribed enough to be said to control the perspective of the whole scene. The vanishing-area construction for a whole scene is a relatively advanced stage in the development of linear perspective. It is found in Flemish painting of the fifteenth century (*vide infra*, p. 202) at a time when the Italian artists already had a practical solution of focused perspective.

[62] When the picture plane is represented as a pictorial surface and the figures and objects are composed more or less according to conceptual principles, as in Romanesque painting, the spectator has, in a pictorial sense, no spatial connection with the scene. When, as in the *trecento*, the picture plane is a tridimensional space and the figures and objects are represented from an optical point of view, the pictorial space is an imitation of the spectator's experienced space, and the figures are actors upon a stage. The composition of the whole scene, however, is not constructed with reference to a single point of view. The change from a composition created for a general audience to a composition constructed with regard to the point of view of a single spectator is accomplished in the fifteenth century by the focused system of perspective. Such a system, as we have seen, makes the construction of the scene dependent also upon the spectator's theoretical distance from the picture plane.

[63] *Vide infra*, pp. 199 ff.

The trend toward tridimensional and representative space that was evi-dent in Italy in the first half of the fourteenth century advanced more slowly in northern painting, where the preliminary form was Gothic. The Gothic background, despite a suggestion of stage space when the collective ground is présent, does not have as much implied tridimensionality and representa-tive character as the Byzantine type of background. During the first half of the fourteenth century the spatial character of French illumination remained essentially the same as it was in the latter half of the thirteenth century,[64] with the exception of certain features in the work of Pucelle and his atelier. The geometric allover pattern varied with a foliate motive is a prominent feature of the background, and the architectural frame, when it is present, frequently terminates the picture plane. The architectural frame is usually either a simple series of arches or a more elaborate structure resembling the skeletal cross section of a cathedral. Since the architectural frame takes the place of a conventional border and is not necessarily a definite indication of the environment,[65] the background is a nonrepresentative vertical surface.

There is a similarity between this type of background and the gold background with a carved architectural frame that occurs in Italian panels such as the "Annunciation" in the Uffizi by Simone Martini.[66] Like the gold background in Italy, the patterned background of the north was popular throughout the fourteenth century. The representation of the ground plane

[64] Illustrations: Paris, Bibl. Nat., MS fr. 5716, Life of St. Louis, by Guillaume de St. Pathus, fols. 137, 349 (Martin, La Miniature française, Pl. XXX). Paris, Bibl. Nat., MS lat. 13836, Life and Miracles of St. Denis, fol. 78 (ibid., Pl. XXXIII). Paris, Bibl. de l'Arsenal, MS 5059, Bible of Jean de Papeleu, fols. 126v, 365 (ibid., Pl. XXVII). Paris, Bibl. Nat., MS fr. 13568, Life of St. Louis, fol. 1 (ibid., Pl. XXXI). Cambridge, Fitzwilliam Mus., Metz Pontifical (Dewick, The Metz Pontifical). Paris, Bibl. Nat., MS fr. 2090-92, Legend of St. Denis (Martin, Legende de St. Denis). In the fourteenth century Gothic forms were introduced into mural painting. The one-color background, plain or patterned with an individual star or trefoil motive, was preferred to the allover diaper design; but the architectural frame is composed of Gothic features. Clermon-Ferrand, Cathedral, "Virgin and Child" (Lemoisne, Gothic Painting, Pl. II). Cahors, Cathedral, west cupola, "The Prophet David" (ibid., Pl. III). St. Geniés (Dordogne), chapel, "Betrayal of Christ" (ibid., Pl. V). Ste.-Croix-en-Jarez (Loire), "Coronation of the Virgin" (De Lasteyrie, L'Architecture religieuse en France à l'époque gothique, Vol. II, Fig. 781).

[65] There are illuminations in which the architectural frame appears where the suggestion of an ecclesiastical interior is appropriate to the action. We find, however, that the frame is used indiscriminately for interior and exterior scenes. Occasionally, the architecture acquires a symbolic character, as in the "Christ in Majesty" in the Historiated Bible of Jean de Papeleu (Paris, Bibl. de l'Arsenal, MS 5059, fol. 1 [Martin, La Miniature française, Pl. XXVI]), in which a cross section of cathedral architecture is compartmented to frame the figure of Christ enthroned and angels.

[66] Weigelt, Sienese Painting, Pl. XLVI.

in Italy and in France, however, illustrates the difference in the development of tridimensional space in the two countries, for, while the ground is a horizontal plane in Italian paintings dating from the end of the thirteenth century, in French illuminations of the first half of the fourteenth century it is either omitted or appears as a cross section across the bottom of the picture plane. Although the ground in French painting of this period is two-dimensional, it has some representative character as a result of the irregular contour and the color. The modifications in the form of the ground rather than in the background proper change the type of space in French illuminations in the second half of the fourteenth century. The ground is enlarged and supports the figures. Thus it becomes a horizontal plane and presents, in conjunction with the patterned background, tridimensional stage space. Together with the assumption of tridimensional form there is the beginning of a much clearer distinction between the grassy plane of a landscape and the level floor of an interior.

Before the adoption of tridimensional and more definitely representative form in the ground plane took place, tridimensional features occurred in the work of Pucelle and his atelier which are remarkable for their early appearance in Gothic illumination and which may be explained by the fact that Pucelle was influenced by Italian spatial forms.[67] These features consist of exterior views of small buildings,[68] interiors depicted by the open-front house,[69] and, occasionally, indications of shelflike rocks in landscapes.[70] The buildings usually appear in the Calendar scenes or in the marginal illustrations at the bottom of the page, against an uncolored parchment background, and on a narrow grass strip or the stem of a vine border. The most

[67] Michel, Histoire de l'art, Vol. II (Pt. I), 358. Panofsky, Vorträge Bibl. Warburg, 1924-25, p. 315, note 49.

[68] Paris, Rothschild Coll., Hours of Jeanne d'Evreux, "St. Louis in His Prison Recovers His Breviary" (Delisle, Heures de Jean Pucelle, Pl. LVIII). Paris, Rothschild Coll., Calendar scenes of the Hours of Jeanne de Navarre (Thompson, Hours of Joan II, Queen of Navarre). Cambridge, Fitzwilliam Mus., Calendar scenes of the Hours of Yolande de Flandres (Cockerell, Hours of Yolande of Flanders). Paris, Bibl. Nat., MS lat. 10483-84, Calendar scenes of the Belleville Breviary.

[69] Paris, Rothschild Coll., Hours of Jeanne d'Evreux, "Annunciation," "La Statue de St. Louis" (Delisle, Heures de Jean Pucelle, Pls. XXVI, XLIV). Paris, Rothschild Coll., Hours of Jeanne de Navarre, fol. 39, "Annunciation" (Thompson, Hours of Joan II, Queen of Navarre, Pl. XIV). Cambridge, Fitzwilliam Mus., Hours of Yolande de Flandres, fol. 13v, "Annunciation" (Cockerell, Hours of Yolande of Flanders). Paris, Bibl. Nat., MS lat. 10483-84, Belleville Breviary (Martin, Les Peintres de manuscrits, Fig. 4).

[70] Cambridge, Fitzwilliam Mus., Hours of Yolande de Flandres, "Visitation" (Cockerell, Hours of Yolande of Flanders).

striking use of the boxed interior is found in the illuminations placed in the text. It is important to observe, however, that the boxed interior is employed infrequently—generally only in representations of the Annunciation[71]—and that except for the Belleville Breviary,[72] in which the buildings are placed against a patterned background, it appears on the uncolored parchment. The other illuminations in the text have typical Gothic features: architectural frames, patterned backgrounds, and vertical ground strips. In connection with the appearance of tridimensional structures in the work of the Pucelle atelier, it is noteworthy that in the Bible written by Robert de Billyng[73] and illuminated by Pucelle, which is dated 1327, the spatial form is entirely in the traditional Gothic manner. In the Hours of Jeanne d'Evreux, dated 1325-28,[74] which would place it in the same period or shortly after the Billyng Bible, the "Annunciation" takes place in the tridimensional setting of an interior.[75]

A number of architectural settings in the manuscripts attributed to the Pucelle atelier exhibit inconsistencies that show poor assimilation of the idea of tridimensional structure.[76] The more consistent structures, however, such as the "Annunciation" in the Hours of Jeanne d'Evreux (Fig. 60), have characteristics which are comparable to the spatial form in Italian painting of the first quarter of the fourteenth century, particularly in the work of Duccio.[77] The interior is represented by a one-room house with an ante-room. The impression of depth is enhanced by the ceiling, which is beamed or coffered, rather than by the floor, which is undecorated. The lines in depth in the ceiling remain parallel in asymmetrical horizontal planes[78] and converge in parallel pairs, according to the vanishing-axis procedure, in sym-

[71] Cf. Robb, Art Bulletin, XVIII (1936), 494, note 55.

[72] Paris, Bibl. Nat., MS lat. 10483-84.

[73] Paris, Bibl. Nat., MS lat. 11935.

[74] Paris, Rothschild Coll. (Delisle, Heures de Jean Pucelle).

[75] Robb (Art Bulletin, XVIII [1936], 494) notes the dissimilarity between the backgrounds of the "Annunciation" in the Hours of Jean d'Evreux and a manuscript (Vat., MS Urbin. 603, fol. 103) attributed to Pucelle by Delisle on the basis of comparison with the Billyng Bible (Delisle, "La Bible de Robert Billyng," Revue de l'art chrétien, LX [1910], 299-308). The Vatican manuscript has the traditional patterned background.

[76] Robb (Art Bulletin, XVIII [1936], 494) mentions these inconsistencies in reference to the "Annunciation" of the Belleville Breviary (Paris, Bibl. Nat., MS lat. 10483, fol. 163v) and suggests that because of the lack of understanding in the architectural construction it is probably the work of an assistant rather than of Pucelle.

[77] Cf. Panofsky, Vorträge Bibl. Warburg, 1924-25, p. 315, note 49.

[78] Paris, Rothschild Coll., Hours of Jeanne de Navarre, fol. 39, "Annunciation" (Thompson, Hours of Joan II, Queen of Navarre, Pl. XIV).

metrically composed planes (Fig. 60). Diminution is not observed,[79] and the figures interlace with the architecture in a manner inconsistent with the tridimensional form.

Although the use of tridimensional buildings is limited to a few illumina' tions in the text, besides the Calendar and the marginal illustrations, some factors of tridimensional construction are carried over into the scenes which have the characteristic Gothic form. Interest in tridimensional values is evi' dent in the architecture and perspective delineation of the throne in the "Trinity," in the Hours of Jeanne II, Queen of Navarre,[80] and in the "En' throned Christ," in the Hours of Jeanne d'Evreux.[81] In the latter manuscript the architectural frames occasionally have corbels and projecting buttresses which are at variance with the general two-dimensional form.[82]

The importance of this appearance of interiors and tridimensional build' ings for the general development of space in French painting should not be overemphasized, because their use is limited. More significant than their limited use is the fact that while the building itself was conceived in three dimensions, the picture plane had not been transformed into tridimensional space. In the Calendar and in the marginal scenes the ground is a narrow strip and in the illuminations of the text the buildings are free standing, that is, they are not placed on a horizontal ground plane. In the Belleville Breviary, in which the buildings appear against a patterned background, there is no indication of ground except the floor of the building. Tridimen' sional space is present, therefore, only in the building, not in the picture plane as a whole.

The course of the development of tridimensional and representative space in French painting was not furthered by the introduction of boxed interiors into Gothic illumination by Pucelle[83] so much as by the gradual and

[79] Ibid.

[80] Paris, Rothschild Coll. (ibid., Pl. XIII).

[81] Paris, Rothschild Coll. (Delisle, Heures de Jean Pucelle, Pl. LXVIII).

[82] Paris, Rothschild Coll., "Deposition," "Flight into Egypt," "St. Louis on His Knees Serving a Sick Man" (ibid., Pls. XXXVIII-XXXIX, LII).

[83] The boxed interior does not seem to have been adopted immediately by the French artists after its introduction by Pucelle. It appears in the Flagellation of the Parement of Narbonne (Fierens-Gevaert, Les Très Belles Heures, documentary Pl. II) which is dated ca. 1365. There is a small Italo-Gothic house set in a landscape in the Poésies de Guillaume de Machaut (Paris, Bibl. Nat., MS fr. 1584, fol. D [Martin, La Miniature française, Pl. XLVII]) which may antedate the Parement of Narbonne; and there are indications of interiors in the representation of the "Interview of Clement VI with Jean le Bon, then Duke of Normandy," which took place in 1344 (Dimier, Histoire de la peinture française, Pl. III), and in the painting formerly in the

156 FOURTEENTH CENTURY

more fundamental conversion of the picture plane into stage space by modi-
fications in the representation of the ground. The ground was widened until
it became a horizontal plane supporting the figures. Although the Gothic
vertical ground strip has some representative character, the horizontal
ground plane receives more attention, leading to a clearer distinction be-
tween pavement and grass, which in turn develops into interior and land-
scape.

In the majority of illuminations the ground is widened only enough to
present an adequate stage for the action, whether designated for the interior
or exterior (Fig. 62).[84] This provides an elementary form of stage space,
both from the tridimensional and the representative standpoint. The ground
appears as a horizontal plane because the figures stand within it, although
at times unconvincingly, as when the feet are not adequately foreshortened.
The figures are still aligned or move parallel to the picture plane, so that
the advantage of the horizontal ground plane, however limited, is not used
for composition in depth. From the representative standpoint the patterned
background and the absence of background objects preserve the decorative
character of the setting. The suggestion of environment depends on the
ground plane, which distinguishes between exterior and interior. In interiors
the representation of the ground has not at first the tridimensional space-
making character found in Italian painting, for the floor does not appear as
a checkered pavement.[85] Occasionally it is covered with various geometric

Abbey of St. Denis of "King Jean II Presented by St. Denis and Jeanne of France and Blanche of
Navarre Presented by St. Louis" (Lemoisne, Gothic Painting, Pl. XII). It is difficult, however, to
draw conclusions from the last two examples cited, for both are extant only in copies made for
Gagnières in the seventeenth century. It is notable that toward the end of the fourteenth century,
when there is a general development of tridimensional form, the features used by Pucelle, espe-
cially those in the Calendar scenes, were imitated in the Grandes Heures du Duc de Berry (Paris,
Bibl. Nat., MS lat. 919) attributed to Jacquemart de Hesdin (Cf. Fierens-Gevaert, Les Très Belles
Heures, pp. 40-41, documentary Pl. VI).

[84] Other illustrations: Paris, Bibl. Nat., MS fr. 1792, Le Livre des Voies de Dieu (Delisle,
Fac-similé de livres, Pl. III). Paris, Bibl. Nat., MS fr. 5707, Historiated Bible of Charles V, fol.
204 (Martin, La Miniature française, Pl. XLIV). London, Brit. Mus., Royal MS 19 D. xvii, The
Golden Legend of Jacques de Voragine, trans. into French by Jean de Vignay (dated 1382),
fol. 5 (Millar, Souvenir de l'Exposition de MSS français, Pl. XXX). Paris, Bibl. de l'Arsenal,
MS 5058, Historiated Bible of the Duke of Berry, fol. 300 (Martin, La Miniature française, Pl.
LXXV). Paris, Louvre, miniatures from a Book of Hours made for the Duke of Berry. Paris, Bibl.
Nat., MS fr. 24287, Polycratique of Jean de Salisbury, fol. 2 (ibid., Pl. LXI). Paris, Bibl. Nat.,
MS fr. 22912, Cité de Dieu (1376), fol. 2v (ibid., Pl. LVIII). London, Brit. Mus., Add. MS
23145, Book of Hours. For a review of the spatial form in this period see Ganz, Das Wesen des
französischen Kunst im späten Mittelalter, pp. 54-64.

[85] Exceptions are the "Interview of Clement VI with Jean le Bon, then Duke of Normandy"

patterns, which have a decorative quality comparable to the background (Fig. 61).[86] In the last quarter of the century, however, in the work of the Franco-Flemish artists, the checkered pavement frequently occurs (Figs. 63, 65).[87] Methods of representing the parallel receding lines of the pavement vary. The receding lines may diverge slightly, remain parallel, or converge. Diminution and convergence are observed in a number of instances, showing at times a grasp of Italian systems in the use of the vanishing axis[88] as well as the approximation of a vanishing point for partial planes.[89]

The checkered pavement, constructed in accordance with Italian methods of perspective, is but one indication of active interest in tridimensional form in the last quarter of the fourteenth century among Franco-Flemish artists. This interest was manifested by several features which are characteristic of Italian spatial representation. Besides the floor paved in squares, the boxed interior embellished with Gothic architectural elements became

(Dimier, Histoire de la peinture française, Pl. III) and "Jean II Presented by St. Denis and Jeanne of France and Blanche of Navarre Presented by St. Louis" (Lemoisne, Gothic Painting, Pl. XII), if the date suggested—in the fourth and fifth decades of the fourteenth century—and the authority of the existing copies (vide supra, p. 155, note 83) are to be accepted.

[86] Other illustrations: Paris, Bibl. Nat., MS fr. 2813, Les Grandes Chroniques de France (Delisle, Fac-similé de livres, Pl. XIV). Niort, Cuvillier Coll., "Annunciation" (Lemoisne, Gothic Painting, Pl. XXVI).

[87] Other illustrations: London, Brit. Mus., Royal MS 2 B. vi, Epistle to Richard, King of England, by Philippe de Mazières (Millar, Souvenir de l'Exposition des MSS français, Pl. XXXIV). Geneva, Bibl., MS fr. 77, Décades de Tite-Live (Martin, La Miniature française, Pl. LXXIII, Fig. 98). Paris, Bibl. Nat., MS lat. 18014, Petites Heures du Duc de Berry, attrib. to Jacquemart de Hesdin. Brussels, Bibl. Roy., MS 11060, Très Belles Heures de Jean de France duc de Berry (Fierens-Gevaert, Les Très Belles Heures). Paris, Bibl. Nat., MS lat. 919, Grandes Heures du Duc de Berry, attrib. to Jacquemart de Hesdin (ibid., documentary Pl. XI). Paris, Rothschild Coll., Très Belles Heures de Notre Dame du Duc de Berry (Durrieu, Les Très Belles Heures, Pls. III, VI, VIII, XXI). Brussels, Bibl. Roy., MS 10767, Book of Hours (Van den Gheyn, Deux Livres d'Heures). Brussels, Bibl. Roy., MS 11051, Book of Hours (ibid.). Dijon, Mus., "Annunciation" and "Presentation in the Temple" by Broederlam (Dimier, Les Primitifs français, pp. 17, 21).

[88] Panofsky, Vorträge Bibl. Warburg, 1924-25, pp. 281, 315, note 50. Brussels, Bibl. Roy., MS 11060, Très Belles Heures de Jean de France duc de Berry, "Madonna and Child" (Fierens-Gevaert, Les Très Belles Heures, Pl. II).

[89] Paris, Bibl. Nat., MS lat. 18014, Petite Heures du Duc de Berry, attributed to Jacquemart de Hesdin, "Annunciation" (Robb, Art Bulletin, XVIII [1936], Fig. 21). In this illustration the convergence of the orthogonals in the mid-section of the floor to a small vanishing area, although the outermost orthogonals of the floor and those of the courses of the wall converge according to the vanishing-axis procedure, may be compared with the similar composition of receding lines in the "Presentation in the Temple," by Ambrogio Lorenzetti (Fig. 56). Brussels, Bibl. Roy., MS 11060, Les Très Belles Heures de Jean de France duc de Berry, "Duke Jean kneeling between St. Andrew and St. John" (Fierens-Gevaert, Les Très Belles Heures, Pl. I). Dijon, Mus., Broederlam altarpiece. Cf. Panofsky, Vorträge Bibl. Warburg, 1924-25, pp. 281, 315, note 50.

158 FOURTEENTH CENTURY

common (Fig. 65).[90] The boxed interior appears not only in the various points of view of parallel perspective but also in angular perspective, as in the "Annunciation" by Broederlam.[91] Abbreviated street scenes occur[92] as well as terraced rock landscapes.[93] Although the patterned background persists in illuminations, the gold background is employed in panels.[94]

The complete transformation of the picture plane into a naturalistic environment did not become general in France until toward the middle of the fifteenth century. Its appearance in the fourteenth century is rare and confined to landscape scenes, such as fols. D and E in the Poésies de Guillaume de Machaut,[95] to which may be added the miniatures in the Books of Hours illuminated for the Duc de Berry at the end of the fourteenth and the beginning of the fifteenth centuries.[96] In the Poésies de Guillaume de Machaut, in contrast to the form of exterior setting usual in French illumination of this period, in which the ground is a limited stage and the background is patterned, the artist has endeavored to present a panoramic landscape with an extremely high horizon and a representative sky. Compared to the form of panorama developed in Italy by Ambrogio Lorenzetti, the

[90] Other illustrations: Cambridge, Fitzwilliam Mus., St. Augustine, La Cité de Dieu, trans. into French by Raoul de Praelles. Geneva, Bibl., MS fr. 77, Décades de Tite-Live, fol. 9 (Martin, La Miniature française, Pl. LXXIII). Paris, Bibl. Nat., MS fr. 13091, Psalter of Jean de France duc de Berry, "David Playing the Harp" (photographs in the P. Morgan Library, New York City). Paris, Bibl. Nat., MS lat. 18014, Petites Heures du Duc de Berry. Paris, Bibl. Nat., MS lat. 919, Grandes Heures du Duc de Berry. Brussels, Bibl. Roy., MS 11060 Très Belles Heures de Jean de France duc de Berry. Dijon, Mus., Broederlam altarpiece.

[91] A preference for angular perspective, especially in the setting of the Annunciation, seems to have arisen in Franco-Flemish painting at the end of the fourteenth century and in French and Flemish work in the early fifteenth century. See also the "Annunciation" in the Très Riches Heures (fol. 26), illuminated for the Duc de Berry by the Limbourg brothers (Chantilly, Cab. des Livres [Durrieu, Les Très Riches Heures, Pl. XIX]) and the "Friedsam Annunciation" (New York, Metropolitan Mus., "The Michael Friedsam Collection," Bulletin, XXVII [1932], Fig. 14). For examples of angular perspective in a French manuscript of the early fifteenth century see the Psalter of Henry VI (London, Brit. Mus., Cotton MS Domitian A. xvii).

[92] Paris, Louvre, "Scenes from the Life of St. Andrew."

[93] Dijon, Mus., Broederlam altarpiece (Dimier, Les Primitifs français, pp. 17, 21).

[94] Dijon, Mus., Broederlam altarpiece (ibid.). Paris, Louvre, "Scenes from the Life of St. Andrew." The interest in tridimensional construction, which was shown by the adoption of Italian forms, was extended to other features of the setting, such as thrones, which are of the Italo-Gothic type (Fig. 63), or the canopied Gothic form (New York, Arthur Sachs Coll., "Annunciation," attributed to the school of Avignon [Kleinberger Galleries, Loan Exhibition of French Primitives, No. 4]). The latter encloses the figure in a box and is therefore comparable spatially to the one-room house.

[95] Paris, Bibl. Nat., MS fr. 1584 (Martin, La Miniature française, Pls. XLVII-XLVIII).

[96] Brussels, Bibl. Roy., MS 11060, Très Belles Heures de Jean de France duc de Berry (Fierens-Gevaert, Les Très Belles Heures). Chantilly, Cab. des Livres, Très Riches Heures du Duc de Berry (Durrieu, Les Très Riches Heures).

rendering of depth in these landscapes is rudimentary. The effect of depth depends primarily on the extent of the ground and the number of small objects depicted rather than on a gradual diminution of planes and figures. The principal figures, which are near the edge of the picture plane, are large, while the figures and buildings behind, which are conceived as part of the landscape and which have no direct connection with the principal figures, are considerably smaller. Thus, there is an abrupt change in scale. Further-more, a point of view consistent with the high horizon is not maintained in the objects represented.[97]

In the Très Belles Heures du Duc de Berry (Fig. 64) there is an abrupt change of scale between the figures in the foreground and the features of the landscape that form part of the vista. The transition between the foreground and the vista, however, was accomplished by means of hills or ledges, some-what analogous to the high background rocks of the Byzantine tradition. The transition provided by these ledges is similar in principle to the terraced form found in Italian landscapes (vide supra, p. 147). Beyond the ledges, in contrast to the landscapes of the Poésies de Guillaume de Machaut, there is some observation of diminution in the planes and objects of the vista.

The change in scale between foreground and vista is no longer so pro-nounced in the Calendar scenes of the Très Riches Heures du Duc de Berry (Chantilly), illuminated by Pol, Hennequin, and Hermant Malouel, of Limbourg.[98] A middle distance has been introduced which provides an inter-mediate plane of transition. The diminution in the planes and the figures is somewhat abrupt and the point of view shows many inconsistencies; never-

[97] The fishing and hunting scenes in the Garderobe of the Palace of the Popes, Avignon (Lemoisne, Gothic Painting, Pl. IX), should be mentioned in connection with the panoramic landscapes. These frescoes, dated ca. 1343, have been variously classified as French or Italian, because they have stylistic features of both schools. Spatially the composition consists of a magnified foreground that covers all but a fraction of the picture plane. The figures, animals, and trees are seen from a normal eye-level, with no diminution to give the illusion of recession. How little attention was paid to optical perspective is shown by the divergent sides of the pond. The effect of these scenes is not so much a panorama as a luxuriantly patterned tapestry. Illuminations with related landscape forms appear in the Livre de la Chasse of Gaston Phébus (Paris, Bibl. Nat., MS fr. 616, dated ca. 1400) and the Livre de Merveilles (Paris, Bibl. Nat., MS fr. 2810, listed in the inventory of 1413 of Jean sans Peur). Although the ground does not fill as much of the picture plane as in the Garderobe frescoes, it is comparatively wide. Diminution in the planes and in the figures is not governed by recession. Hence, the impression created is of a magnified foreground rather than a panorama. In the Livre de la Chasse the decorative character of the illuminations is enhanced by diapered backgrounds in place of the naturalistic sky.

[98] Durrieu, Les Très Riches Heures, Pls. II-XII.

theless, an impression of gradual recession in depth is obtained. In these miniatures, the realistic effect is enhanced by the observation of seasonal modifications in the landscape, and the impression of a definite locale is achieved by the depiction of specific *châteaux* in the distance. In the Très Grandes Heures du Duc de Berry (Turin-Milan Hours), particularly in the scenes on which Hubert and Jan van Eyck are believed to have worked, the realistic form of interior as well as landscape scenes is advanced consid-erably by the linear and atmospheric perspective, the concept according to which space is here represented bearing few, if any, traces of the medieval tradition.[99]

In the last quarter of the fourteenth century the development of tri-dimensional and representative space in French painting was involved with Franco-Flemish artists interested in Italian spatial forms. This interest was probably fostered by the work of Italian painters in France, at Avignon and elsewhere under French patronage,[100] and also by contact with painting in Italy.[101] The development of tridimensional space at this time seems to have no specific connection with the Flemish nationality of the artists, for, on the one hand, Flemish illumination preceding this period followed the traditional

[99] Hulin de Loo, *Heures de Milan*, pp. 27 ff.; Pl. XX ("Birth of St. John," "Baptism"). The achievement of depth of vista by means of systematic atmospheric blurring and fading of color is already well advanced in the landscapes attributed to the van Eycks. Interest in atmos-pheric effects of depth was manifested relatively early in the north, and tentative efforts in this direction may be detected in the vistas of the Books of Hours of the last quarter of the fourteenth century. A different method of perspective manipulation of color, aimed at a clearer modeling of tridimensional form rather than depth of vista, also appears in the fourteenth century. This is the method of shading the ground plane toward the rear contour. It is an application to the ground plane of the principle of shading which enhanced the tridimensional values in the drapery and sometimes in the objects in the thirteenth century. The problem of regional distinc-tions in the application of color and its relation to perspective requires further investigation. The preference for tonal gradation in the north as against contrast of hue in the south, which has been observed in early fifteenth-century painting, may be the persistence of analogous tendencies in the painting of the earlier periods.

[100] Italian painters worked in France under royal and ecclesiastical patronage as early as the beginning of the fourteenth century, several decades before the influx of Italian artists in Avignon. See Meiss, "Fresques italiennes cavallinesques et autres, à Béziers," *Gazette des beaux-arts*, XVIII (1937), pp. 275-86.

[101] Cf. the "Purification of the Virgin," in the Très Riches Heures du Duc de Berry (Chan-tilly, Cab. des Livres, fol. 54v [Durrieu, *Les Très Riches Heures*, Pl. XXXIX]) with the com-position of the "Presentation of the Virgin in the Temple," in a fresco by Taddeo Gaddi in the Baroncelli Chapel of Sta. Croce in Florence and the copy in the Rinuccini Chapel of the same church. Durrieu (pp. 60 ff.) does not believe that the "Purification of the Virgin" is a direct copy of Taddeo Gaddi's fresco. See Durrieu (pp. 67, 93-94) for a discussion of French artists known to have visited Italy.

Gothic form,[102] and, on the other hand, tridimensional structures appeared early, in the work of Pucelle, and were followed by the introduction of a simple form of stage space in the French illuminations of the third quarter of the century. This form may have facilitated the adoption of the Italian contributions to spatial representation. One should note that French painters were reluctant to give up the decorative background completely in favor of a realistic representation of space until about the middle of the fifteenth century. After the first two decades of the fifteenth century, however, a Flemish school of painting distinct from the French arose,[103] in which realistic representation is one of the most characteristic features.

The history of the representation of space in England in the fourteenth century is much the same as in France. The spatial character of English illumination of the first half of the century, exemplified by the Queen Mary Psalter (Fig. 66),[104] is typically Gothic. The background has a geometric or foliate allover pattern, and the conventional proscenium-arch frame appears in various decorative forms. The ground plane is either an individual mound or a narrow strip across the bottom of the picture plane. Although it is not a horizontal surface, it occasionally receives more attention as a representative feature than it did formerly; for, in the illustrations of the Labors of the Months, the differentiation between one occupation and another, especially in the various agricultural scenes, leads to slight distinctions in the type of ground. In the representation of the figures there is no change from the previous century. The figures are aligned on the base line of the picture plane or on the upper contour of the ground, and although there is frequently an impression of much activity and freedom, there is no movement in depth. The forms are slender and weightless, the drapery falling naturalistically, but shaded lightly. Despite the fact that the foreshortening

[102] Ghent, University Lib., MS 233, Caeremoneale blandiniense (Lyna, De vlaamsche Miniatuur, Pl. XIII). Brussels, Bibl. Roy., MS 9225, Legendes Pieuses (ibid., Pl. XI). Brussels, Bibl. Roy., MS 8469, Missal (ibid., Pl. X). Oxford, Bodleian Lib., MS 264, The Romance of Alexander, written and illuminated by Iehan de Grise (1339-44), fol. 182.
[103] Lemoisne (Gothic Painting, p. 65) dates the separation of the Flemish and French schools from 1419, when, after the assassination of Jean sans Peur, the Burgundian capital was moved from Dijon to Flanders by his successor, Philippe le Bon.
[104] London, Brit. Mus., Royal MS 2 B. vii (Warner, Queen Mary Psalter). Other examples: London, Brit. Mus., Arundel MS 83, Fragment of Peterborough Psalter and Psalter of Robert de Lisle (Schools of Illumination, Pt. III, Pls. II-IV; Millar, English Illuminated MSS of the XIVth and XVth Centuries, Pls. VIII-XIV). London, Brit. Mus. Royal MS 15 D. ii, Apocalypse (Schools of Illumination, Pt. III, Pl. IX). Oxford, Bodleian Lib., Douce MS 366, Ormesby Psalter and Bestiary (James, A Peterborough Psalter and Bestiary).

of the limbs and the arms is inaccurate and the three-quarters view used repeatedly, an effect of variety and grace of movement is achieved in the composition. Objects essential to the setting are depicted, but there is no evidence as yet of an interest in a systematized method of perspective delineation.

In the latter part of the fourteenth century a change in the spatial form of the background similar to that which took place in French illumination occurred, namely, the introduction of stage space by widening the ground plane and presenting it as a horizontal surface supporting the figures. The change is exemplified in the wall paintings from St. Stephen's Chapel, Westminster Palace. Unfortunately, there remain only fragments of the scenes from the north wall illustrating the story of Job (Figs. 69, 70),[105] now preserved in the British Museum, and several copies in the Society of Antiquaries of London, of scenes from the east wall: the "Adoration of the Magi" above St. George, Edward III and his sons (Fig. 67), and the "Presentation in the Temple," "Nativity," and "Annunciation to the Shepherds," above Queen Philippa and her daughters (Fig. 68). The paintings have been dated 1350-60,[106] which, from the representation of space in some of the scenes at least, appears to be too early, judging from developments in French painting. The decoration of the chapel was started in 1350, and in 1363 there was recorded a change of masters in charge.[107] Thus, it is possible to assume that the painting was continued after 1360. Without going deeply into the question of chronology, some suggestions presented by the representation of space are offered here.

The scenes from the New Testament have patterned backgrounds and horizontal ground planes decorated with geometric motives, except the "Nativity" and the "Annunciation to the Shepherds," which are landscapes. The "Adoration of the Magi" is divided into three sections, and the "Presentation in the Temple" into two, by changes in the pattern of the

[105] These and Figs. 67-68 are reproduced from the engravings made by James Basire after the drawings of Richard Smirke. They were done from 1805 to 1807, soon after the discovery of the paintings which, except for the fragments in the British Museum, were destroyed by the fire of 1834. See Topham, *Some Account of the Collegiate Chapel of St. Stephen, Westminster*, and Englefield, *Description of the Additional Plates*, for additional reproductions, descriptive details, and color notes.

[106] Borenius and Tristram, *English Medieval Painting*, half titles preceding Pls. LVI-LXI.

[107] *Ibid.*, p. 22. The records were published by Topham, *An Account of the Collegiate Chapel of St. Stephen*, pp. 18-19.

background and the ground plane. The action, however, is continuous despite these divisions. In the "Adoration of the Magi" there are indications that an architectural frame formed part of the spatial composition. A striking feature of these scenes is the elaborate decorative patterns, especially those that appear in the ground plane of the "Adoration of the Magi" (Fig. 67). The complexity of the patterns in this scene tends to obscure the fact that some form of perspective was used in delineating the tiles of the floor. That diminution was used to some extent is readily discernible. From casual inspection, however, it is more difficult to grasp the fact that a form of convergence was used which approaches correct vanishing-point construction. An analysis of the pattern of the floor in the first section at the left in the "Adoration of the Magi" reveals the formula for convergence that was followed in one other section at least, regardless of the difference in the motives of the design. In the first section the floor is paved with diamond-shaped tiles. A foliate motive, which appears in the alternate rows, creates roughly (since it tends to a curvilinear form) an overlying pattern of squares. The receding lines of the diamond-shaped boxes converge toward two fairly limited vanishing areas at approximately the same height from the base of the picture plane. The vanishing area at the right lies on the right edge of this particular section of the scene. The one on the left is placed within the picture, a factor which accounts for the inconsistencies in the perspective of the pattern at the extreme left. But it is notable that the receding lines at the extreme left converge toward the left vanishing area despite the fact that this entails a general change in the direction of these lines. The receding lines of the leaf motive converge with less regularity to a third vanishing area above and approximately midway between the other two. The result is an empirical approach—far from correct or consistent— to the focused system of perspective with a point of sight and equidistant distance points. In other words, we have a pavement seen in angular perspective where the angle is 45° to the picture plane and the vanishing points coincide with the distance points on either side of the point of sight.[108] The

[108] The system of convergence in this illustration is far from correct according to the standards of the geometrical method of perspective which it anticipates. One of the fundamental rules of focused perspective which the artist failed to recognize is that of maintaining a uniform horizon line for the central vanishing area (the point of sight) and the vanishing areas to the right and left. Furthermore, the vanishing area at the left, by being within the picture plane, creates a second central system of convergence inconsistent with the point of view chosen for most of the pavement.

painter of these scenes seems to have been especially preoccupied with angu-
lar perspective, as is shown also by the pavement of the center section of the
"Adoration of the Magi" and by the position of the throne on which the
Virgin is seated.[109]

In the center section the floor is paved with triangular tiles. Again the
formula of two vanishing areas has been used for the perspective of the
pattern. Here, however, the artist did not treat the ground as a single plane,
but divided it into two spatial units, one on each side of the figure, and used
the formula of "bifocal" vanishing-area convergence for each unit.[110] The
vanishing areas are not as limited in this part as in the first section of the
"Adoration of the Magi."

The perspective pattern of the floor in the last part of the scene also
deserves special mention. Squares parallel to the picture plane form the basic
motive. The receding lines of these squares diverge in the center but con-
verge on each side, so that once again there are two vanishing areas for the
ground plane. In this instance, however, the system of convergence may be
interpreted in two ways. Either the artist divided the ground plane into two
spatial units, as in the middle section, and used a single vanishing area for
each unit—a form which is more correct from the point of view of the
focused system of perspective for a pattern of squares parallel to the picture
plane—or he treated the ground as a single plane, but employed the "bi-
focal" vanishing-point formula of angular perspective.[111] Whatever the rea-
son for the perspective in this section, the use of the "bifocal" system of
convergence serves to maintain a decorative uniformity in the perspective of
the patterns in the scene of the "Adoration of the Magi" as a whole.[112]

[109] The architecture of the throne belongs to the Italo-Gothic type. Various forms of this
may be seen in the "Annunciation" by Simone Martini, in the Royal Museum of Antwerp (Van
Marle, Italian Schools, Vol. II, Fig. 161), in the Belleville Breviary by the atelier of Pucelle
(Martin, La Miniature française, Pl. XXXVII), and in the Psalter of the Duke of Berry (Paris,
Bibl. Nat., MS Fr. 13091) attributed to André Beauneveu (Fig. 63). In the illuminations by
Pucelle and Beauneveu the throne is generally frontal, not at an angle to the picture plane as
in the painting from St. Stephen's Chapel.

[110] The use of two spatial units in this section is an excellent confirmation of Panofsky's
observation that in the empirical period of the development of focused perspective there was a
tendency to work with separate spatial units and to make a distinction between unobstructed
planes and planes obstructed by figures and objects (Art Bulletin, XX [1938], p. 422).

[111] In the last section of the "Adoration of the Magi," as in the middle section, the con-
vergence is not rigidly maintained, and consequently the vanishing area is less restricted than in
the first part of the scene. One should note also that a dominant central group interrupts the
continuity of the ground plane (vide supra, note 110).

[112] In the "Presentation in the Temple" (Fig. 68), the pattern is the same for both sections,

The spatial form in the New Testament scenes differs in several ways from that in the scenes in which the donors—Edward III, Queen Philippa, and their children kneel. In the donor scenes the picture plane has been converted into a boxed interior which opens behind an elaborate Gothic frame. As in the New Testament scenes, the patterns of the floor are com-plicated by secondary motives, but in all the donor chapels, as far as one can tell from the portions preserved in the copies, the basic motive is the square placed parallel to the picture plane. In each chapel the system of convergence in the pavement is based on a central vanishing area (Fig. 67).[113] Each chapel is treated as a unit and is conceived as a centralized, boxed structure, parallel to the picture plane. The square motive of the pattern of the floor, which is also parallel to the picture plane, is perspectively as well as decora-tively consistent with the position of the boxed interior. The floor thus becomes a part of the unit as a whole. Such a form is conducive to a system of convergence based on a central vanishing area. The change from a "bi-focal" formula of two vanishing areas in the "Adoration of the Magi" to a central system in the donor scenes, therefore, does not necessarily mean a change in the principle of convergence, but rather indicates that the solution varies with the spatial unit (vide supra, pp. 135 ff.).

Despite the differences in the architectural setting and in the perspective pattern of convergence, it is possible to conclude from the general use of a form of convergence based on the vanishing area and from the observation of diminution that both the New Testament and the donor scenes belong to the same stage of spatial development. The difference in the setting, that is, the choice of a boxed interior composed of architectural features contem-porary with the period of the figures portrayed,[114] on the one hand, and the

but in one part the parallel lines in depth recede to the left without converging, and in the other there seems to be a slight indication of some form of convergence. In the color notes (Englefield, Description of the Additional Plates, p. 15) Smirke mentions the fact that the floor in this scene was painted on a different material from that of the rest of the ground and that it was not on the same level as the other parts of the representation.

[113] In the donor chapels the principle of convergence is present only in the receding orthog-onals of the squares. The diagonals of the secondary motive of diamonds do not converge. Thus, the pattern of convergence differs from that in the first section of the "Adoration of the Magi," in which the principle is applied to the diagonals of the diamond-shaped boxes and is also carried out, although with less exactitude, in the secondary foliate pattern of squares.

[114] St. Stephen's Chapel was destroyed by fire in 1298. It was rebuilt under Edward III from 1330-1348. The similarity in architectural details may be observed by comparing the painting of the donor scenes with the architectural decoration of the chapel itself (Englefield, Description of the Additional Plates, p. 13; Pl. XV).

patterned background with a proscenium-arch frame, on the other, may be explained by the content. In the New Testament scenes the artist had a religious subject for which the decorative background was traditional. In the donor frescoes the secular character of the scenes and the absence of a long, slowly changing tradition for the content, more readily permitted the adoption of the newer boxed interior. The interest in angular perspective, which is so pronounced in the "Adoration of the Magi," may also be observed in the position of the pillars in the donor chapels, and a predilection for elaborate patterns is common to both scenes. These factors together with the connection in the content denoted by the position of the "Adoration of the Magi" above the king and his sons, and the "Presentation in the Temple" and "Nativity" above the queen and her daughters, point to the fact that the frescoes were planned and probably executed about the same time.[115]

In attempting to date the frescoes, however, one encounters a number of difficulties. We can assume from a certain amount of positive evidence, since all the children of Edward III are present except two sons who died in infancy, that the donor scenes were painted after 1355.[116] Comparison of the spatial form with Franco-Flemish work—a comparison of the architectural details, the form of the boxed interior, the system of convergence, and the angular points of view—suggests a date several years later. The boxed interior was introduced early in *trecento* Italian painting, and a system of convergence approximating a vanishing point for partial planes is found in the work of the Lorenzetti in 1342. This method of convergence, however, was not as popular as the vanishing-axis procedure in Italian painting. It occurs more frequently in the Franco-Flemish work generally dated in the last quarter of the fourteenth century.[117] The architectural details of the donor scenes are similar in style to the architectural frame of the Parement

[115] There is no pictorial connection, however, such as a continuous border, between the upper and lower scenes. See Englefield, *Description of the Additional Plates*, pp. 13, 15.

[116] The sons seem to be arranged in order of age behind the king. According to the fragments of inscription beneath the figures they are Edward the Black Prince, Lionel of Antwerp, John of Gaunt, and Edmund of Langley. Therefore the figure in the small chapel to the left of Edmund should be Thomas of Woodstock, the youngest child, who was born in 1355. It is uncertain whether the small size of Thomas, who is dressed like his brothers in a surcoat embroidered with the blazon of Edward III, was dictated by his age or by the architectural composition. A similar form is used for the last female figure represented in the companion donor scenes.

[117] Vide *supra*, p. 157, note 89.

of Narbonne, dated *ca.* 1365,[118] but in the Parement of Narbonne, although the Flagellation is represented in a boxed interior, the interior has no paved floor, and in the ceiling the beams converge roughly toward a vanishing axis. However, in both the architectural details and the perspective of the floor there is basis for comparison between the donor chapels and illuminations such as the "Wedding at Cana" in the Très Belles Heures de Notre Dame du Duc de Berry (Paris, Rothschild Coll.), which may be attributed to the Master of the Parement of Narbonne and dated *ca.* 1375.[119]

In the illustrations of English painting of the second half of the fourteenth century gathered for this study nothing was found which is comparable to the perspective of the New Testament or the donor scenes of St. Stephen's Chapel. A triptych of the Crucifixion with scenes from the life and Passion of Christ,[120] has an architectural frame in which the details are similar to the architecture in the chapels of the donors, but it has not the same pronounced tridimensional features nor does it form part of a boxed interior. In several scenes of the triptych the floor is paved in squares. The parallel lines in depth, however, tend to recede uniformly to the left and to remain parallel rather than to converge according to some definite system. The altarpiece throws little light on the problem of chronology presented by the frescoes in St. Stephen's Chapel, for the date of the triptych is not certain, and, furthermore, there is some question as to whether the painting

[118] Fierens-Gevaert, *Les Très Belles Heures,* documentary Pl. II. In French illumination, the floor paved in diamond-shaped tiles occurs in the Coronation Book of Charles V (Fig. 61), dated 1365. Compared with the pavement in the "Adoration of the Magi" (Fig. 67), it shows the relatively advanced perspective of the latter, for the pattern in the Coronation Book is drawn in two dimensions without any observation of diminution or convergence.

[119] Durrieu, *Les Très Belles Heures,* Pl. VIII. Durrieu (pp. 61 ff., 65) relates this hand to Jacquemart de Hesdin. Hulin de Loo, however, suggests a connection with the Master of the Parement of Narbonne (*Heures de Milan,* pp. 11 ff.). Professor Millard Meiss agrees with the latter opinion, and I have followed his conclusions on attribution and date, which he will discuss in a forthcoming study on Jacquemart de Hesdin. Although it is difficult to make an assertion of a direct communication of forms on the basis of the scanty material at our disposal, one should bear in mind that there was constant political contact between England and France. It is known also that Gerard d'Orleans accompanied Jean le Bon to London after the defeat of the French King near Poitiers in 1356 (Borenius and Tristram, *English Medieval Painting,* p. 24). With no certain work by Gerard d'Orleans, one cannot say what influence, if any, on English painting his sojourn in London had, and it is within the realm of possibility that he himself transmitted spatial forms from England to France.

[120] London, Messrs. Durlacher (Borenius and Tristram, *English Medieval Painting,* Pl. LXII). On the basis of heraldic indications it has been suggested that the triptych belonged to the D'Estouteville family.

itself may be accepted as an English work.[121] The comparison between the triptych and the frescoes serves to point out the relatively advanced form of perspective used in the latter.

A painting representing four scenes from the life of St. Etheldreda,[122] dated 1425, has superficially the same type of picture plane as that used in the New Testament scenes in St. Stephen's Chapel. The backgrounds are patterned, and the ground planes are paved in square' or diamond-shaped tiles, but there is no diminution or convergence in the St. Etheldreda panel.

The English illuminations of this period are similar, spatially, to the triptych and the St. Etheldreda panel mentioned above. They correspond to the transitional type of spatial form found in French painting, where the tridimensional extension of the stage is introduced into the Gothic back-ground by a horizontal ground plane, but where there is no approach to systematic perspective in the pattern of the pavement. The illuminations have patterned backgrounds and sometimes horizontal ground planes (Fig. 71),[123] but where the ground is decorated with a checkered pavement there is no diminution or systematic convergence until ca. 1400 (Fig. 71).[124]

[121] Borenius and Tristram, English Medieval Painting, p. 26; Exhibition of British Primitive Painting, Royal Academy, pp. 18-19.

[122] London, Society of Antiquaries (Borenius and Tristram, English Medieval Painting, Pl. LXXV).

[123] Other illustrations: Oxford, Bodleian Lib., Auct. MS 4. 4., Psalter of Humphrey de Bohun, 7th Earl of Hereford, fol. 243v, "Raising of Lazarus." London, Brit. Mus., Royal MS 1 E. ix, Bible believed to have belonged to Richard II (Schools of Illumination, Pt. IV, Pl. V; Millar, English Illuminated MSS of the XIVth and XVth Centuries, Pls. LXXIV-LXXVIII). London, Brit. Mus., Add. MS 29704, Missal (ibid., Pls. LXXIX-LXXXI). London, Westmin-ster Abbey Lib., MS 47, Coronation Book (ibid., Pl. LXXIII). Alnwick Castle, Coll. of the Duke of Northumberland, Sherborne Missal (1396-1407), illuminated by Siferwas (Herbert, The Sherborne Missal, Pls. IV, V, VI, XII, XIX).

[124] Several illuminations (London, Brit. Mus., Harley MS 7026, Lectionary of Lord Lovel, fols. 16, 18; London, Brit. Mus., Add. MS 29704, Missal, fol. 3 [Millar, English Illuminated MSS of the XIVth and XVth Centuries, Pl. LXXIX]) have settings of interiors. There is no systematic convergence in the pavement, however, and the architecture does not fill the picture plane, but is depicted against a gold background (Fig. 72). The exception is the illumination of Siferwas presenting his manuscript to Lord Lovel (fol. 4v [ibid., frontispiece]), in which a corner of a room fills the picture plane and the beams of the ceiling converge roughly in sym-metrical pairs toward a vanishing axis. The position of the beams is inconsistent with the point of view chosen for the room. Another Presentation scene in the same manuscript (fol. 5, "The King Receives the Manuscript"), in contrast to fol. 4v, has a patterned gold background and no systematic convergence in the receding lines of the floor. The Sherborne Missal (Coll. of the Duke of Northumberland, Alnwick Castle) also by Siferwas, has, in the "Adoration of the Magi," a similar combination of patterned background and pavemented floor without systematic convergence. In the canopy over the Madonna, however, the lines recede according to the van-ishing-axis procedure (Herbert, The Sherborne Missal, Pl. X).

The fact that there are no examples in English painting of the second half of the fourteenth century comparable to the New Testament and the donor scenes in St. Stephen's Chapel with regard to the treatment of space adds to the difficulty of the problem of chronology which is complicated further by the fragments from the story of Job now preserved in the British Museum (Figs. 69, 70). From what little remains of these scenes it may be observed that the architectural setting resembles the Italian type of boxed interior rather than the Franco-Flemish type—in the representation of several slender columns along the edge of the picture plane, which separate the spectator from the interior, and in the anteroom, which is set at an angle to the picture plane. The absence of elaborate tracery and tiled floors accentuates the dissimilarity between these and the donor scenes. The architectural features prompt the suggestion that the master of the Job scenes had some affiliations with the Italian school, perhaps the school established at Avignon, where Matteo Giovannetti da Viterbo was working for Clement VI in 1346.[125] These observations do little to solve the problem of chronology, but they show that there are two styles of spatial composition present in what remains of the painting of St. Stephen's Chapel.

This emphasis on the problem of chronology is necessary because the acceptance of the date 1350-60 would imply that the northern adaptations of Italian spatial forms exemplified by the settings of the donor scenes appeared in England before they did in Franco-Flemish painting. The possibility that these adaptations appeared first in English painting may be accounted for by the apparent presence of all the ingredients, so to speak, that contributed to the formation of the Franco-Flemish style. These ingredients are: the basic Gothic style of the first half of the century; the Flemish affiliations of the court through Queen Philippa, who was the daughter of William the Good, Count of Holland and Hainaut;[126] and the probability of Italian influence in the Job scenes. Thus, it would have been possible for a style similar to the Franco-Flemish style to appear independently in English painting. The possibility is weakened, however, by the fact that the illumina-

[125] In connection with the question of Italian influence, it is noteworthy that what appears from the engraving to be a rock-platform ground plane occurs in the scene of Job conferring with Zophas the Naamathithe (Englefield, *Description of the Additional Plates*, Pl. XXVII).

[126] With reference to Queen Philippa's relations with Hainaut it is interesting to recall that of the Franco-Flemish artists André Beauneveu was born in that province and Jacquemart de Hesdin may have come from there (Fierens-Gevaert, *Les Très Belles Heures*, pp. 31, 38).

tions and the paintings of the second half of the fourteenth century do not have the relatively advanced spatial characteristics of the frescoes in St. Stephen's Chapel. Furthermore, the issue is confused by the fact that we are dependent on copies of the frescoes so that not only must possible inaccuracies on the part of the copyist be considered, but also the possibility that the paintings themselves were restored subsequent to their original execution.[127] Because of insufficient data determination of the date of these paintings must await further investigation. In this study we can only present the general conclusion that in English painting there occurred a development in the spatial form similar to that which took place in France. Tridimensional space was introduced by a horizontal ground plane. Indications of boxed interiors, in addition to those in the paintings from Saint Stephen's Chapel, may be found in a few of the illuminations by Siferwas at the end of the century. In his work there is also an approach to a systematic method of perspective in the approximation of the vanishing axis for the receding lines in the ceilings, but it was not carried out in the pavemented floors. How much sooner Italian and Franco-Flemish spatial forms appeared in England depends on the date of the Job, the New Testament, and the donor scenes in St. Stephen's Chapel.

Thus, in English and in French painting there was a movement toward tridimensional and representative space in the second half of the fourteenth century, which was aided by contact with Italian spatial forms. Although the completely transformed picture plane was attempted in several instances, in the majority of cases the artists were reluctant to give up entirely the two-dimensional and decorative concept of the picture plane, which lingers in the patterned background and is evinced by their hesitation to use the systematically checkered pavement. The tridimensional values which are present in the form of stage space and the perspective methods which were developed for the construction of the boxed interiors are also manifested in the representation of the subordinate objects of the setting, such as thrones and altars. Generally these have a pronounced cubic form, and very fre-

[127] There was a fire in Westminster Palace in 1512, after which the building was no longer used as the residence of the royal family. In 1547 the House of Commons began to hold their sessions in St. Stephen's Chapel (see Encyclopedia Britannica, 14th ed. art, "Westminster Palace"). The period of restoration must have been early, for at a later time, probably after the fire, the murals were covered with wainscotting. They were not uncovered until the beginning of the nineteenth century.

quently they are at an angle to the picture plane.[128] Although there is not in the figures a foreshortening and movement in depth comparable to that in Italian painting of that date, there is an increased plasticity in the model- ing of the head, and the folds of drapery are more voluminous (Fig. 63). This is accompanied by more realistic details of portraiture and costume, especially in the secular personages.

In order to complete the survey of the development of spatial repre- sentation in the north in the fourteenth century, its course in German painting should be mentioned. In contrast to the distinctive types of back- ground employed in the thirteenth century in the Thuringian-Saxon and southern German schools, the spatial character in fourteenth-century Ger- man illumination is largely a matter of the assimilation of forms developed elsewhere—in the north and in Italy. In the first half of the century the typically Gothic background, with its geometric or foliate allover pattern, proscenium arch, or more elaborate skeletal architectural frame, and narrow cross section of ground, may be found everywhere in Germany. Introduced early into the school of Cologne (Fig. 73),[129] either directly from France[130] or from the Belgian and English illuminations,[131] it filtered into the other German centers of production.[132] Occasionally traces of the earlier form—

[128] Niort, Cuvillier Coll., "Annunciation" (Lemoisne, Gothic Painting, Pl. XXVI). New York, Arthur Sachs Coll., "Annunciation" (Kleinberger Galleries, Loan Exhibition of French Primitives, No. 4). London, Brit. Mus., Royal MS 1 E. ix, fol. 229 (Schools of Illumination, Pt. IV, Pl. V).

[129] Other examples: Cologne, Diozesanmus., Gradual of Johann von Valkenberg, dated 1299 (Stange, Deutsche Malerei, Vol. I, Pls. XII-XIII). Berlin, Preuss. Staatsbibl., MS Diez C. 63, Bible dated 1312 (ibid., Pl. XVI). Darmstadt, Bibl., MS 874, Missal of St. Severin of Cologne (ibid., Pl. XIX). Darmstadt, Bibl., MS 876, Missal of St. Cumbert (ibid., Pl. XX). Dusseldorf, Landesbibl., MS D. 10, Antiphonal, and MS A. 5, Bible (photographs in the P. Morgan Library, New York City). Examples of the Gothic style may also be found in monumental paint- ing. Diapered backgrounds appear in the "Coronation of the Virgin" in St. Andreas in Cologne (Clemen, Die gotischen Monumentalmalereien, Pl. XXVIII), and in the "Crucifixion" in the Minorite church of Cologne (ibid., Pl. LIII). In the choir screen of the Cathedral of Cologne, dated about the middle of the fourteenth century, the scenes have elaborate Gothic architectural frames, allover patterned backgrounds, and the drapery has naturalistic folds. Only in the rock- platform grounds, which are collective ground planes, does one find a trace of the Thuringian- Saxon form of the thirteenth century (ibid., Pls. XXXVIII-XL).

[130] Michel, Histoire de l'art, Vol. II (Pt. I), 367-69.

[131] Vitzthum, Die rheinische Malerei, p. 10.

[132] Illustrations: Munich, Staatsbibl., MS clm. 7384, Evangeliary from Hohenwart. Berlin, Preuss. Staatsbibl., Theol. lat. inf.° 52, Lectionary. Heidelberg, MS 687 pal. germ. 164, Sachsen- spiegel. Dresden, Landesbibl., MS 32, Sachsenspiegel. Coblenz, Stadtarchiv., MS 3, Codex Balduini Trevirensi (Irmer, Die Romfahrt Kaiser Heinrichs VII, Pl. X). Coblenz, Archiv., Abt. 701, No. 109, Breviary (Stange, Deutsche Malerei, Vol. I, Pl. LXIX). Stuttgart, Landesbibl., MS H. B. XIII poet. germ. 11, Apocalypse (ibid., Pls. CXXVI-CXXVII).

the individual rock-platform ground plane—mingles with the Gothic fea-
tures,[133] and in the Bohemian manuscripts Italian as well as northern Gothic
influences may be found.[134] It was in this region (which flourished during
the reign of Charles IV, who was king of Bohemia from 1346 to 1378) that
tridimensional and representative space first appeared.[135]

In German paintings of the latter half of the fourteenth century typical
Italian spatial forms may be observed. Although in many instances the de-
velopment of tridimensional space did not go beyond the stage of a horizontal
ground plane in conjunction with a decorated or gold background,[136] never-
theless there are examples of the boxed interior and the screen.[137] Pave-
mented floors and coffered ceilings occur occasionally, and sometimes the
finer points of perspective delineation, such as convergence and more rarely
diminution, were observed.[138] The Retable of Saint Peter by Master Ber-
tram,[139] dated 1379, provides an excellent example of the vanishing-axis
form of convergence without diminution.

[133] Darmstadt, Bibl., MS 874, Missal of St. Severin of Cologne (photographs in the P. Mor-
gan Library, New York City, p. 9). Cologne, Wallraf-Richartz Mus., Antiphonal.
[134] Michel, Histoire de l'art, Vol. II (Pt. I), 370-71.
[135] Various opinions are held regarding the source of the influence on Bohemian painting in
this period. Dvořák ("Die Illuminatoren des Johann von Neumarkt," Gesammelte Aufsätze, p.
142) suggests that Italian influence came into Bohemian manuscript painting from the school of
Avignon. Cf. Glaser, Les Peintures primitifs allemands, p. 13. Stange (Deutsche Malerei, II,
12 ff.) is of the opinion that the influence came directly from Italy, especially in the instance
of the Liber Viaticus of Johann von Neumarkt. See Clemen, Die gotischen Monumentalmalereien,
p. 62, note 196, for bibliographical references for the various theories.
[136] Stuttgart, Landesbibl., MS H. B. XIII poet. germ. 6, World Chronicle of Rudolf von Ems
(dated 1381) (photographs in the P. Morgan Library, New York City). Hohenfurth, Stifts-
galerie, altar (Stange, Deutsche Malerei, Vol. I, Pls. CLXXVI-CLXXX). Karlstein, Mary Chapel,
scenes from the life of Charles IV (ibid., Vol. II, Pl. XVII). Cologne, Wallraf-Richartz Mus.,
altar from Osnabrück (ibid., Pls. CLX-CLXI). Cologne, Cathedral, wings of the retable of St.
Claire (Glaser, Les Peintures primitifs allemands, Pl. XVI).
[137] Stuttgart, Landesbibl., MS H. B. XIII poet. germ. 6, World Chronicle (Jerchel, "Die
bayerische Buchmalerei," Münchner Jahrbuch, N. F., X [1933], Pl. XIV). Karlsruhe, Hof- und
Landesbibl., Jeronianum, "St. Jerome" (Brandt, Die Anfänge der deutschen Landschaftsmalerei,
Fig. 9). Prague, Rudolfinum, "Three Saints" by the Master of Wittingau (Glaser, Les Peintures
primitifs allemands, Pl. VI). Schotten, Church altar, "Adoration of the Magi" (Stange, Deutsche
Malerei, Vol. II, Pl. CXL). Prague, Gallery, Duběceker panel (ibid., Pl. LXXI).
[138] Beamed or coffered ceilings in canopies: Frankfurt, Städel., "Coronation of the Virgin"
(Stange, Deutsche Malerei, Vol. I, Pl. CXV). Berlin, Slg. Fuld., "St. John the Baptist and St.
John the Evangelist" (ibid., Pl. CXIV). Budweis, Mus., "Virgin and Child Enthroned between
Two Saints" (ibid., Pl. CLXXXV). Vanishing axis in coffered ceiling: Prague, Gallery, "Death
of the Virgin," from Košatky (ibid., Pl. CXCI). Elaborate tridimensional form: Prague, Lan-
desmus., MS XIII. A. 12, Liber Viaticus (ibid., Vol. II, Pls. I-II). Pavement patterned with tri-
angles: Cologne, house of Glesch family, frescoes (Clemen, Die gotischen Monumentalmalereien,
Fig. 248). Checkered pavement with slight divergence in the receding lines: Hanover, Landesmus.,
wings of an altarpiece from H.-Münden (Stange, Deutsche Malerei, Vol. II, Pls. CLXIV-CLXV).

Landscapes were depicted in various ways. The Italian type (terraced rocks built up into a high background object) appears.[140] Several paintings show an effort to represent the landscape in a less conventional manner. These either have a rudimentary magnified ground plane[141] or show some diminution. The diminution is abrupt, however, creating the effect of a vista without the transitional plane of the middle distance.[142]

The concept of the picture plane as a completely tridimensional and representative environment penetrated slowly in German painting. Pat-terned and gold backgrounds persisted in the first half of the fifteenth cen-tury, even in the painting of Konrad Witz, in which there is evidence of a keen interest in realistic detail and perspective delineation. Konrad Witz expressed tridimensional values by composing the figures in depth, observ-ing diminution and convergence,[143] and studying cast shadows. Yet in street scenes and interiors he retained the formal decorative background.[144] In landscapes, however, the picture plane was transformed entirely into a vast panorama of tridimensional and naturalistic space.[145]

On the whole, in the history of spatial representation, the fourteenth century was the transitional period between the medieval concept of the pic-ture plane as a formal decorative surface behind the figures and the Renais-sance concept of a tridimensional and representative environment envelop-ing the action. The use of tridimensional and representative space developed rapidly in Italy, where the important innovations of the period were accom-plished by the middle of the century. In Italian painting the change in con-

Checkered pavement with converging receding lines: Cologne, Mus., "Crowning with Thorns," attributed to Master Wilhelm (Schaefer, *Geschichte der Kölner Malerschule*, Pl. XVIII). Munich, Pinacoteca, "St. Veronica," Cologne Master of the early fifteenth century (Glaser, *Les Peintures primitifs allemands*, Pl. XV).

[139] Hamburg, Kunsthalle (*ibid.*, Pl. XII). Cf. Panofsky, *Vorträge Bibl. Warburg*, 1924-25, p. 281.

[140] Hohenfurth, Stiftsgalerie, "Nativity," Bohemian Master (Glaser, *Les Peintures primitifs allemands*, Pl. III).

[141] Munich, Hof- und Staatsbibl., MS cgm. 6, Golden Legend, "St. Maria Aegyptica" (Brandt, *Die Anfänge der deutschen Landschaftsmalerei*, Fig. 2). Regensburg, Fürstl. Bibl., MS Perg. III, World Chronicle, "Nativity" (Jerchel, *Münchner Jahrbuch*, N. F., X [1933], Pl. XX).

[142] Munich, Staatsbibl., MS germ. 5, World Chronicle of Rudolf von Ems (1370), fol. 192 a, "Nativity" (*ibid.*, Pl. XXI; Stange, *Deutsche Malerei*, Vol. II, Pl. CCXXV).

[143] The convergence of the receding lines of the pavement is toward a vanishing point, but only for part of a plane. By this time (1444), the perspective method based on the single vanish-ing point for the whole scene was known in Italy. Vide infra, p. 187.

[144] Geneva, Mus., retable of St. Peter, "Adoration of the Magi" (Glaser, *Les Peintures primi-tifs allemands*, Pl. XXIX). See also "Presentation of Cardinal de Mies to the Virgin."

[145] Geneva, Mus., retable of St. Peter, "Miraculous Draught," "Crucifixion" (*ibid.*, Pl. XLIII).

cept is apparent in the form and composition of the figures as well as in the setting and construction of the background. A significant factor in the development of space in Italy is the interest shown in the constructive aspect of the representation, which took precedence over the realism of detail and which led to attempts to compose the various elements of the scene in some manner that would give not only effective expression to the tridimensional form but also systematic unity and clarity to the composition as a whole. As a means to this end there were employed the optical perspective methods—the vanishing axis and the approximation of a vanishing point, although for only a part of a plane. In the north tridimensional and representative space came into use more slowly. About the middle of the century the introduction of a horizontal ground plane resulted in stage space, a form that in Italy was more readily developed at the end of the thirteenth century because of the implied tridimensionality of the Byzantine spatial form of *dugento* painting. Italian spatial forms, such as the boxed interior and the pavement constructed according to a rudimentary system of perspective, were not generally adopted in the north until the last quarter of the fourteenth century. In the north, as well as in the south, the representation of space remained for the most part in a transitional stage. The patterned or gold background was retained; and the setting and the action were confined to the limited depth of a horizontal foreground plane or to a disproportionately small house or chapel viewed by the spectator from outside. In landscapes the representation of a vast panorama in which the effect of depth is obtained by gradual transitions of scale in the planes of the ground was not accomplished until the fifteenth century. Ambrogio Lorenzetti approached nearer to this form than did any other artist of the fourteenth century. In general, however, the extension in depth is limited by an inclined plane which consists either of the sharp elevation of high background rocks or of the slope produced by abrupt diminution from foreground to vista. The reluctance entirely to give up the formal background persisted for a time in the fifteenth century, except in Italian and Flemish painting, where early in the century a generation of artists was prepared to undertake the solution of the problem of representation presented by the concept of the picture plane as a window through which the spectator views a realistic depiction of tridimensional space.[146]

[146] Alberti, *Della pittura*, p. 79. Cf. Panofsky, *Vorträge Bibl. Warburg*, 1924-25, p. 258.

CHAPTER VIII

CONCLUSION

THE TRANSFORMATION of the picture plane into a tri-dimensional and representative environment and the delineation of figures and objects according to an optical point of view completed the transition from the medieval to the Renaissance concept of space. The history of spatial development then entered a new phase which properly belongs to a study of Renaissance rather than medieval painting. The problems arising from the change in concept—the quest for a mathematical method of perspective which should serve both the practical exigency of optical realism and the aesthetic desire for compositional unity and the studies in foreshortening and anatomy—are problems which owe their solution to the Renaissance. The form had developed gradually. One may turn to the fourteenth century as the direct antecedent of the Renaissance and classify Italian paintings of this period with the later form rather than with the medieval form. The line of demarcation is relative and conventional, for, as we have seen, new spatial concepts are the result of continual modification.

In viewing comprehensively the history of space in painting from the Roman to the Renaissance period, we notice that the reappearance of a representative and tridimensional pictorial concept seems to indicate that with regard to space the medieval period was retrogressive. As Panofsky[1] has so ably pointed out, however, this retrogression was not simply destructive but also creative in the sense that the successive transformations in the picture plane led to the Renaissance concept of space which, although apparently analogous to the Roman, is nevertheless fundamentally different. The differ-

[1] Panofsky, Vorträge Bibl. Warburg, 1924-25, p. 272.

ence lies in the systematic and unified representation of space developed in the Renaissance by means of vanishing-point perspective in contrast to the generalized and unmeasurable representation of space in Roman painting. Although the figures and the background in Roman painting may be related with respect to content—the features of the background depicting the environment in which the action takes place—and although the figures and the objects are represented in an optical rather than a conceptual form, these elements are not structurally interdependent. The size and shape of the figures and objects do not depend exactly on their position in relation to a definite and measurable position of a theoretical spectator, as they did in the Renaissance, but conform more or less loosely to the general optical form of the composition. The degree to which the elements depend on perspective structure varies with the type of representation, whereas in Renaissance painting the systematic perspective structure is theoretically a constant factor, involving and shaping all the elements.

The difference between the character of space in the Roman period and that in the Renaissance period may be presented by juxtaposing a series of sketches schematically representing various types of scene found in Roman painting with a similar series handled in the Renaissance manner (Fig. 74). The first is the composition with a large architectural unit in the background, such as the prospect scene (Fig. 7). In the Roman method of representation (Fig. 74 A) there is some semblance of a consistent point of view in the general convergence of the receding parallel lines, but unlike the Renaissance (Fig. 74 B) there is no strict conformity to a systematic method of perspective delineation in which size and shape are dependent on the theoretical distance from the eye of the spectator (*vide supra*, p. 9). The difference between the two methods of representation is emphasized when the objects are smaller and more numerous, as in a panoramic landscape (Fig. 8), for in the Roman form (Fig. 74 C) each object, although optically foreshortened, is not dependent on a larger, comprehensive, mathematical construction of the picture plane which preserves the uniformity of the point of view, as it is in the Renaissance (Fig. 74 D). The diminution of the objects in the Roman landscape gives the impression of recession, but the change in scale is not proportionate to the distance from the spectator. In the representation of interiors the same general distinctions may be observed, and in addition in classic painting the boxed form of the interior is

usually not clearly depicted. In some South Italian vases[2] there is a sugges-
tion of the boxed form in the portico arrangement and an impression of
systematic perspective in the delineation of the beamed ceilings. The en-
closure is not complete, however, and the perspective method usually sug-
gests the vanishing-axis procedure, which is applied to the construction
of the ceiling only and is not used to determine the direction of other
orthogonals in the building. The representation of interiors in some of the
frescoes from Herculaneum (Fig. 5) gives the impression, on the whole, of
a more definitely enclosed form, but the figures are on the edge of the pic-
ture plane, the orthogonals at the juncture of side walls and floor are
obscured, and the side walls and ceilings which are represented belong for
the most part to rooms behind the one in which the action is taking place.
The peopled quarters, on the other hand, are generally very shallow, and a
dwarf wall or partition of some kind usually blocks the depth (Fig. 74 E).
In none of the examples extant are the receding lines so directed as to give
proof of a unified systematic method of perspective (vide supra, p. 24).
In contrast to this the interior in Renaissance painting, developed from the
small house of the fourteenth century, not only suggests a completely boxed
space, with floor, walls, and ceiling clearly joined and constructed accord-
ing to a geometric method based on the vanishing point, but a unit of
measurement is frequently expressed directly by a checkered floor or coffered
ceiling (Fig. 74 F). The distinction between Renaissance and Roman paint-
ing based on the systematic representation of space which has just been
described in reference to the larger architectural arrangements, extends also
to the form of the figures and the smaller objects in the scene.

Panofsky[3] uses the terms "aggregate space" and "systematized space" to
express the difference between Roman and Renaissance painting. While "ag-
gregate" describes the composite character of Roman space, it is in a sense
too general, for space in ancient painting as a whole and also in medieval
painting may be said to have a composite form. Roman space has not the
conceptual composition of pre-Greek space, since it consists of figures repre-
sented from an optical point of view in a continuous, although vague and
generalized, atmosphere. On the other hand, despite this atmospheric con-
tinuity, or homogeneity, it has not the systematized and measurable char-

[2] Ibid., Pl. III.
[3] Ibid., pp. 269, 272. See also Frey, Gotik und Renaissance, p. 297, note 11.

acter of Renaissance space. Thus, if the term "aggregate" is used in refer-
ence to Roman space, the reservation should be made that it is not necessarily
a unique attribute of this phase of ancient painting, and furthermore, that
it is used in a relative rather than an absolute sense.

A similar difficulty arises with the term "systematized," which may be
clarified if it is understood that the word as used in connection with Renais-
sance space refers to the theoretically measurable relationship between the
background, the figures and objects, and the spectator. The importance of
the measurable factor is evident if one considers the similarity in the linear
perspective of Roman and fourteenth-century Italian painting, for in the
fourteenth century the vanishing-axis procedure observed in Roman pros-
pect scenes was developed as one of the means of spatial coördination. Its
use may be interpreted as the manifestation of a desire for systematic repre-
sentation, but systematic primarily in the sense of a unified and balanced
composition. In this sense both the prospect scenes and, to a greater degree,
the Italian paintings of the *trecento* which are constructed in accordance
with a vanishing axis, do give the impression of methodically arranged
representations. It is significant, however, that the vanishing-axis procedure
was given up eventually in favor of the focused system of perspective, the
beginnings of which may be observed in those paintings of the *trecento* that
are constructed in accordance with a limited vanishing area. The focused
system of perspective, in contrast to the vanishing-axis procedure, enables
the artist to present the mathematical relationship between distance and size
in a direct and distinct manner.

The difference between the perspective method of delineation in Roman
painting and that in Renaissance painting may be explained as a manifesta-
tion of fundamentally different concepts of space. In both, optically repre-
sented figures and objects are composed in a tridimensional environment.
In Roman painting depth is suggested by the optical form of the elements,
by diminution and convergence, and by the atmospheric vagueness of the
background, but the composition as a whole tends to be dominated by planes
parallel to the picture plane and by isolated objects and groups of objects.
The elements are not organized according to a system of geometrical optics
with reference to the eye of the spectator, therefore the space is not measur-
able in relation to the figures represented or to the spectator. In the Renais-
sance, on the other hand, the space is theoretically measurable in relation to

the spectator, and one may say that it has material form. Its skeleton con-
sists of the invisible guides that determine the direction of the lines to the
vanishing and the distance points, and its presence is affirmed by the fore-
shortened squares in the ceiling or the pavement, which theoretically meas-
ure the intervals between objects.

The difference in the conception of space is clear in the, treatment of
the picture plane. In Roman painting it is not transformed into theoretically
measurable planes of distance as it is in the Renaissance painting, but is de-
picted as a more or less vague, ambient medium filling the spaces between
objects and figures. The monochrome landscapes (Fig. 8), are good exam-
ples of this, while in the Odyssey landscapes (Fig. 9) the atmospheric effect
is accompanied, to some extent, by representative color. The effect of vista,
which in these panoramic landscapes is due to the skillful impressionistic
handling of the picture plane, is absent in the prospect and many megalo-
graphic scenes. Here the ground ends with the building or figure and gives
way either to the neutral picture plane or to an indefinite blue field which
is more or less atmospherically handled and is associated with the sky. Thus,
in Roman painting depth was created by the suggestion of atmosphere in
the color of the picture plane, while in the Renaissance it was constructed
by the linear means of focused perspective. Even when the linear construc-
tion of the scene is obscure, as it is sometimes in the paintings of the seven-
teenth and nineteenth centuries in which the emphasis is on atmospheric
effects, the spatial form is not comparable to that in Roman art. It betrays
its development from the Renaissance tradition of geometric perspective,
for the scenes show some unity of perspective structure and reference to a
fixed spectator.

Between the ambient medium of Roman painting and the theoretically
measurable planes of the Renaissance lies the medieval period. Its first con-
tribution was to transform the picture plane into a material and substantial
pictorial surface which has an independent existence apart from the figures
and objects and then to divide this positive and active pictorial agent[4] into

[4] The difference between the two-dimensional picture plane of medieval and classic painting
lies primarily in this positive and active pictorial character. The one-color background in classic
painting, whether black or white, is a material surface insofar as it is the physical or mechanical
bearer of the representation. It remains, however, a neutral surface related to the content in
much the same way as the parchment is related to the typography. On the other hand, the
medieval two-dimensional picture plane has an active pictorial as well as mechanical function,

the essential planes of tridimensional space upon which the Renaissance could elaborate with the aid of a systematic method of perspective that preserves the substantial quality of this space. As we have seen in the review of the history of the development of space in medieval painting, this was done first by solidifying the elements of Roman painting, that is, reducing the figures and objects as well as the picture plane as a whole to a two-dimensional form and then reintroducing tridimensionality into the figures and objects, and into the picture plane with stage space. Although this de-scribes the tendency in general, the forms developed were not similar in all occidental and Byzantine painting, but fall into two groups which corre-spond roughly to the two spatial forms fairly distinct in Roman painting. The first is the type usually referred to as "stage space," to which class belong the prospect scenes and those megalographic frescoes in which the ground plane is terminated by rocks or buildings having the character of the coulisses of a stage set and in which the remainder of the picture plane may be blue or uncolored. The second type is derived from the impressionist form of the backgrounds found in the Odyssey landscapes.

The first part of the medieval program, so to speak, that is, the two-dimensional tendency, cannot be dated arbitrarily at the beginning of the medieval period—which itself has no fixed date. It began in Roman art and was continued in the early Christian era. In late Roman sculpture the de-velopment of a coloristic style in place of illusionism and the substitution of hierarchical criteria for optically determined forms are symptoms of the change. In early Christian painting the tendency to eliminate tridimensional values from figures as well as from background continued, and the two types of picture plane, one derived from stage space and the other stratified, were already distinct. In the painting of the eighth and ninth centuries the beginning of a fairly definite geographical distribution of the two types may be observed. Their paths cross now and then, giving rise to combinations of the two forms, but even in these composites the regional character is fairly clear.

With the aid of the chart (Fig. 75) in which characteristic spatial forms are schematically presented the course of development traced in the preced-ing chapters may be summarized briefly.

since it is either a composition of variously colored areas or in a single color that lends itself to symbolic interpretation. It has, therefore, an expressive as well as decorative character.

In Byzantine painting, throughout the medieval period the underlying principle of the predominant form of picture plane is stage space. The pic-ture plane is divided into two parts; one, the ground plane, and the other, the vertical background proper. At first the tridimensional capacity of these divisions is expressed, because the lower part is a carrying member and actually supports the figures and objects, which make it appear perpen-dicular to the vertical background. The representative connotations of the color also help to define the relationship between the two divisions of the picture plane. In Byzantine painting, in contrast to the Italian, the effect of stage space is enhanced by the presence of buildings or rocks at the rear of the ground plane. These high background objects not only stand on the ground plane and so express its character as a supporting member, but also define its limits and emphasize the perpendicular junction of the two parts of the picture plane. When the process of flattening the forms sets in, however, when the figures lose their plasticity and the objects are telescoped, a two-dimensional influence is also felt in the picture plane. The background and the ground plane become solid areas. The effect is carried further in the relation of figure to ground, for instead of standing within the plane, the figure is supported on its upper contour or on the frame, that is, the base line of the picture plane. The result is a cross section of the ground, or, rather, a vertical ground plane. Yet no matter how two-dimensional the whole construction may be, a vestige of the distinction between ground plane and background always remains, even if in the last analysis it rests solely on the juxtaposition of two areas of different width, the larger above a narrow band.

In Italian painting both the stage space and the stratified type were em-ployed during several centuries. In the painting of this time stage space is present usually in the simplified form of a narrow ground plane and a ver-tical background proper. When stratification appears, it is, in contrast to that of northern art, conservative, for the tendency was to reduce rather than to multiply the number of bands and to preserve some association with naturalistic color. When, as sometimes in the twelfth century, a form of paneling was introduced, this, too, was employed conservatively, so that the implied tridimensionality of the stage-space type of divided picture plane is not wholly absent. In the thirteenth century the type of background de-rived from stage space, reinforced by contact with the Byzantine form and

adopting from it the high background object, became prevalent in panel and monumental painting. In illumination, however, besides the stage-space composition, there are other forms related to those found in the north.

When an impetus toward more plastic representation arose, at the end of the thirteenth century, the tridimensional relationships latent in the pic- ture plane vestigial of stage space were expressed. The ground plane once more became perpendicular to the picture plane, and the figures began to move freely on its surface. The figures were released from their isolated three-quarters or frontal positions to form active communicating groups. In the representation of buildings, which up to that time had been little more than façades, the distinction between street scene and interior was devel- oped. At first the depth was defined by the stage in both interior and ex- terior settings. The one-room house is a boxed form depicting a limited interior space within an equally limited stage, and the landscapes are bounded by the traditional high background hills. Gradually, however, the interiors expanded to fill the whole pictorial space, and the landscapes re- ceded in a series of diminishing planes in depth. These changes modified the limited extent and impersonal character of the stage-space construction, with the result that the picture plane was transformed completely into the tridimensional and representative environment of the action.

In Italy and Byzantium the development is on the whole less complex than that in the north, for at no time were the features of the original stage- space form so modified that they lost entirely their tridimensional and natu- ralistic implications. Here the medieval spatial development was more direct than in the north, because the materialization of the picture plane was ac- complished by solidification, so to speak, into a two-dimensional surface, which preserved the pattern of tridimensional form. In the north, on the other hand, the modifications of the picture plane led eventually to a form that has no relation to the original background in Roman painting from which it was derived. The new form was in turn subject to change, until it finally fused with the Italian in anticipation of the tridimensional and representative space of the Renaissance. The essential features of the devel- opment from Carolingian through Gothic painting, schematically illustrated in the chart (Fig. 75), will be reviewed briefly.

The source of the spatial form of the Carolingian Renaissance is to be found in those early Christian paintings in which the backgrounds are

derived from the quasi-impressionist Roman landscape scenes. In Carolin-gian painting the representative space in the picture plane is usually de-picted by graded color, which produces an atmospheric effect, but, like the similarly derived painting of the early Christian period, the gradation is less subtle than in Roman painting, with the result that the color tends to fall into horizontal divisions. In some cases the atmospheric effect is retained to some extent; in others, definite bands are produced. The stratification has a two-dimensional effect, and the ground plane viewed as the lowest stratum of the series of bands appears to be continuous with the remainder of the background. In contrast to the two-dimensional form of stage space in Italian and Byzantine painting, the ground in the stratified form, incor-porated into the pattern of the whole picture plane, tends to lose its individ-uality. The association of the ground plane with the background on the same plane is still stronger when the relation of the figures to the ground plane as a supporting member is no longer clear.

When the high background object is present in the Carolingian minia-tures, as it is generally in portraits of the evangelists, its effectiveness as an element of stage space is counterbalanced by the stratification in the rest of the background and by the indefiniteness of the juncture of the high background object and the ground plane, or, in some cases, by the omission of the ground plane altogether.

In the tenth and eleventh centuries a variety of background forms were produced which clearly were derived from the Carolingian principle of strati-fication. In general the tendency to make a vertical surface of the back-ground was accompanied by a gradual loss of representative spatial elements. The figures and the objects which have it in their power to make a perpen-dicular plane of the ground became flat forms arrested in three-quarters and frontal poses parallel to the vertical picture plane and associated with the ground only where they are supported on its upper contour. Two-dimen-sionality, present in the form of the vertical ground plane, is found also in the construction of the background as a whole. The color in the horizontal divisions was applied uniformly rather than in atmospheric gradations. The linear boundaries between these areas became more pronounced and regular, and finally, in many instances, the color itself began to lose all relation to reality. Consequently, the horizontal divisions which were essential to strati-fication lost their original significance with reference to nature.

In the post-Carolingian period, although the changes that have been described above occurred in general, the rate and degree of transformation differed according to regional types.

In the following century a different principle of background construction arose out of the modifications that stratification had undergone in the previous period. In Romanesque art the background is a nonrepresentative, distinctly delimited unit, forming a substantial vertical surface parallel to the standing figure. The Romanesque spatial type appears in two forms, with minor variations of each. One of these is the picture plane partitioned into a few vertical divisions, the other is the paneled background. The change from a horizontal to a vertical form or to one that is paneled is significant, for the vestige of representative environment which was implied in the horizontality of the structure has disappeared. Any representative elements, such as ground, water, sky, buildings, and rocks, are depicted as separate cubic groups or as attributes of an individual figure. Thus, the background and the action are independent constructions. This mutual independence, or discoördination, of the background and the composition of the figures is emphasized when the figures and objects overlap the limits of the picture plane. It should be pointed out once more that the picture plane is not a neutral surface against which the scene takes place, but a substantial, active, although two-dimensional pictorial form.

While the background assumed a definite and concrete form in the Romanesque period, the figure began to emerge from its stationary and conventionalized position. The construction was still predominantly linear, and the axially directed glance of the head in three-quarters view was still the rule. Efforts at movement and activity, however, although hampered by the lack of foreshortening and of variety in body torsion, were indicated by more frequent use of profiles, by fluttering draperies, and by striding and crossed legs.

The next style, the Gothic, has a markedly different effect from the Romanesque, yet the change in spatial principle is slight. The picture plane is still a nonrepresentative vertical surface parallel to the standing figure. It is no longer a delimited unit, however, entirely independent of the action, but a decorative plane interrelated and coördinated with the content by such features as the continuous, allover geometric pattern and the proscenium-arch frame. The pattern preserves the uniformity of the surface and

makes it more substantial. The pattern also establishes more points of contact between the background and the figures, thus enhancing the substance and corporeality of the latter. The proscenium-arch frame, developed from the former architectural frame employed for interiors, became a convention rather than an indication of environment, and it promotes the coördination of background and action by embracing the former and orienting the figures to a common base line.

In accord with the coördination effected by the features of the background, the intercommunication among the figures themselves was increased. At the same time a naturalistic and plastic technique in the representation of drapery was developed.

The Gothic style of France and England, which corresponds chronologically to the adoption of the Byzantine type of stage space in Italy, did not appear in Germany until the end of the thirteenth century. During the formative period of the Gothic in the north there was in Germany, as we have seen, an individual although not homogeneous development, which was superseded eventually by the French and English spatial form.

Thus, by a longer and more arduous route representation in the north approached stage space, the first step in the depiction of tridimensional space. One of the components of the stage, the vertical substantial background, is present in Gothic painting. Factors which aided the further development of stage space are plastically conceived figures and their composition along a common base line or, in many instances, on a collective although vertical ground plane. In the latter half of the fourteenth century the horizontal element of the stage definitely made its appearance, when the ground became a plane perpendicular to the screen wall of the background proper. After the achievement of tridimensional space, that is, the limited tridimensionality of the single plane in depth of the stage, the development continued in the same manner as in Italy. Stage space was amplified into a naturalistic scene. The ground plane for landscapes was divided into diminishing planes of foreground, middle distance, and vista; space-defining and representative elements, such as the pavemented floor and the boxed interior, were adopted. Eventually the patterned background was replaced by representative elements, and the scene as a whole became the local environment of the action. The action was no longer confined to a horizontal alignment along the edge of the picture plane, but the figures,

which had already begun to be more plastic and more actively intercom-municative, were closely interrelated by composition in depth.

The development of tridimensional and naturalistic space in the picture plane and optically determined criteria for the representation of the figures and objects concludes this study of space in medieval painting. As was shown, the evolution of the spatial form for the picture plane followed two main lines of development within the universal tendency to make the picture plane a vertical but substantial surface and the figures and objects two-dimensional and then to expand these elements into concrete tridimensional forms. The two lines were: (1) solidifying the surface and preserving in its form a vestige of the original stage space structure and (2) substantializing the surface of an illusionistic, representative picture plane and by a series of modifications arriving at stage space. The first course is characteristic of Byzantine painting in general, and it remained a vital tradition in Italian work. The second course was followed, with regional variations, in the north.

As an outgrowth of the development of the picture plane into a positive pictorial factor that has a substantial and measurable character, or, in other words, of a picture plane composed of definite, substantial planes which enclose and limit a space that is homogeneous and potentially measurable, the problem of the method of perspective delineation came into prominence.[5] Other factors important in explaining the preoccupation with a systematic method of perspective in the Renaissance are interest in realistic, that is, optical rather than conceptual representation, and the aesthetic considera-

[5] In connection with the importance of the spatial form of the picture plane as a pictorial foundation for the development of a geometrical method of perspective, it is notable that in the earliest Renaissance text on perspective, Alberti's *Della pittura*, the method is presented by the solution of the problem of a foreshortened checkered pavement, that is, by the problem of the ground plane as a whole rather than the simplified individual object, such as a cube. The theoretical formulation of the geometric system of perspective may have been facilitated by a modification of Euclid's *Optics*, which appears in the treatises of the thirteenth century. According to Euclid the size of an object is proportional to the visual angle, and in Proposition VIII it is expressly stated that size and distance are not proportional (*vide infra*, p. 197). In the medieval writings on optics, however, are cited exceptional instances in which the size of the object is not proportional to the visual angle (see Panofsky, *Vorträge Bibl. Warburg*, 1924-25, p. 299, note 16), and both Roger Bacon (*ibid.*) and John Peckham (*Perspectiva communis*, Prop. LXXIV) observe that the distance as well as the visual angle must be taken into consideration in determining the size. Although even in the Renaissance, Euclid's angle axiom was not set aside and replaced by a rule of proportional distance, this observation may be seen as a preliminary step to the postulation of an inverse ratio between distance and size, which is a fundamental assumption of focused perspective.

tion of compositional unity and harmony.[6] As was described, in the four-
teenth century, under the leadership of the Italian artists, definite although
rudimentary efforts leading to a systematic method of spatial delineation
began to appear. The facts that parallel receding lines seem to converge,
that roof lines at the sides of buildings seen at an angle to the picture plane
descend, while the corresponding base lines ascend, and that objects grow
smaller in size as their distance from the edge of the picture plane increases
were presented with the organization provided in the vanishing-axis proce-
dure or in the use of a vanishing area or vanishing point for part of a fore-
shortened plane. These efforts at systematic representation were only tenta-
tive in comparison to the method in which all these factors are intimately
and geometrically interrelated, in which convergence for all the horizontal
receding lines of parallel planes is toward a single vanishing point located
on the horizon line, and in which the position of the vanishing point and
the horizon, as well as diminution, depend upon the theoretical position of
the spectator in relation to the picture plane. The discovery of a method of
perspective that would take into account this mathematical relationship oc-
curred early in the fifteenth century.

The first method for constructing a scene according to the focused sys-
tem of perspective was produced in Italy. Credit for the solution of the
problem is generally given to Brunelleschi on the basis of biographical
reports.[7] As an architect he was particularly well fitted for the task. Brunel-
leschi is said to have taught perspective to his friend Masaccio,[8] and Ma-
saccio's fresco of the Trinity in Santa Maria Novella in Florence is one of
the earliest paintings in which the architectural background is correctly
constructed in focused perspective.[9] In 1435, a few years after this fresco
was painted, the first treatise in which a method of focused perspective de-
signed for the use of painters is presented, was written by Alberti.[10] His

[6] Mesnil, Masaccio, pp. 115 ff.
[7] Von Fabriczy, Filippo Brunelleschi, p. 47, and Vasari, Lives, I, 272. See also Filarete, Trat-
tato dell'architettura, pp. 609, 618.
[8] Vasari, Lives, I, 269, 272.
[9] Kern, "Das Dreifaltigkeitsfresko," Jahrbuch der preussischen Kunstsammlung, XXXIV
(1913), 36-58; review by Mesnil, Bulletin d'art ancien et modern, Aug. 1913, pp. 223-24.
[10] Della pittura. Janitschek, who edited Alberti's text, is incorrect in his interpretation of the
method. The correct form was first described by Ludwig in his German edition of Leonardo da
Vinci's Notebooks (Das Buch von der Malerei, pp. 182-85). See also Wieleitner, "Zur Erfindung
der verschiedenen Distanzkonstruktionen," Repertorium für Kunstwissenschaft, XLII (1920),
249-62; Wolff, "Zu Leon Battista Albertis Perspektivlehre," Zeitschrift für Kunstgeschichte,

instruction concerning method is limited to a description of the practical procedure for constructing a foreshortened pavement of squares, called *costruzione legittima*.[11]

Alberti was followed by other Italian writers, some of whom treated the subject in a more thorough manner. Piero della Francesca was the first to describe the fundamental method of construction by projection of the section of ground plan and elevation.[12] His book, on the whole, is more like a manual on perspective than Alberti's. It is more methodical, and various problems are posed and solved with the aid of diagrams. But whether the Italian authors used Alberti's manner of presentation as a model[13] or Piero della Francesca's,[14] some form of the *costruzione legittima* appears in all the books until a more direct procedure was published in 1583 in Vignola's *Le due regole di prospettiva*.[15]

The early Renaissance investigations of perspective were not definitive, nor did they achieve complete mastery of the subject as a science. The mathematical implications of this subject and the concepts from which our terminology today is derived were contributed by geometers of a later pe-riod.[16] But the *costruzione legittima* supplied the Italian artists of the fif-teenth century with a workable method for obtaining a theoretically meas-urable and unified perspective scene in relation to the spectator. The

N. F., V (1936), 47-55. For an English translation of Alberti's passages on perspective with a description and illustration of the method see Ivins, *On the Rationalization of Sight*, pp. 14 ff.

[11] See Ivins, *On the Rationalization of Sight*, pp. 14 ff. for a comprehensive explanation of the *costruzione legittima* and illustrations of the method by the use of a mechanical model.

[12] *Prospettiva pingendi*, written *ca.* 1470-90. See Wieleitner, *Repertorium für Kunstwissen-schaft*, XLII (1920), 251, note 8.

[13] Authors who include a description of the *costruzione legittima* in a general work on the arts (as Alberti does) are: Antonio Averlino Filarete, *Trattato dell'architettura*, written *ca.* 1464; Pomponio Gaurico, *De sculptura*, 1st ed. Florence, 1504 (see Panofsky, *Vorträge Bibl. Warburg*, 1924-25, pp. 319 ff., note 60, for correct interpretation of the method in Gaurico's book). The *costruzione legittima* appears in Leonardo da Vinci's Notebooks. Facsimile reproduction of fol. 42 in Ivins, *On the Rationalization of Sight*, p. 23.

[14] Daniello Barbaro's *La pratica della perspettiva*, Venice, 1568, is a textbook on perspective similar in approach to Piero della Francesca's.

[15] The more direct procedure, which appears in the posthumous edition of Vignola's *Le due regole di prospettiva* (edited by Egnatio Dante, Rome, 1583) together with the *costruzione legittima*, is the one called *tiers points*. The name is derived from Jean Pelerin's description of the method in his text which was published in Toul in 1505 (*vide infra*, p. 191). The *tiers points* method was probably known in Italy before 1583. Vignola refers to it as the *regola ordinaria di Baldassare da Siena* (Peruzzi). (See Wieleitner, *Repertorium für Kunstwissenschaft*, XLII [1920], p. 257.) And it appears incorrectly in Sebastiano Serlio's book on perspective (*Opere d'architettura*, II, 19 [1st ed. Paris, 1545]).

[16] Ivins, *On the Rationalization of Sight*, pp. 10 ff.

CONCLUSION 189

relationships essential for focused perspective (that the rate of diminution in a foreshortened plane is determined by the distance of the spectator from the picture plane and that the point corresponding to this distance should be on the same level as the point to which the parallel lines perpendicular to the picture plane converge) were suggested by Alberti, although these relationships were not expressed in terms of distance point, horizon, station point, point of sight, or vanishing point.[17] More complex problems of perspective could be solved by the method of projecting the ground plan and elevation which was described by Piero della Francesca.

That a number of Italian artists were acquainted with the advances in perspective found in the writings of the early Renaissance is proven by the fact that the method can be traced in constructions in their paintings.[18] There are, nevertheless, many works in which the perspective system is not applied as thoroughly or as accurately as might be expected. Besides the paintings in which the perspective seems to have been drawn without any reference to a theoretical system,[19] there are some in which it is difficult to reconstruct the perspective method. In the latter the careful delineation of the coffered ceilings or checkered pavements gives the impression of systematically unified and measurable space. Yet, when one attempts to trace the perspective skeleton of the background, one frequently finds that although the orthogonals are made to converge to a single vanishing point with great accuracy, the transversals showing the rate of diminution, which depends on the distance of the spectator from the picture plane, are not determined by a means that is clearly related to the point of sight. The failure to establish the relationship between the point of sight and the point corresponding to the distance of the eye of the spectator from the picture plane—in other word, the failure to maintain a uniform horizon—may have resulted from the fact that they did not recognize as a rule of focused perspective Alberti's suggestions about the position of these points,[20] or it may be due to

[17] Alberti, Della pittura, pp. 81, 83. For a discussion of the terminology see Ivins, On the Rationalization of Sight, pp. 21, 32.

[18] Kern, Jahrbuch der preussischen Kunstsammlung, XXXIV (1913), 36-58; Kern, "Eine perspektivische Kreiskonstruktion bei Sandro Botticelli," Jahrbuch der preussischen Kunstsammlung, XXVI (1905), 137-44; Kern, "Der Mazzocchio des Paolo Uccello," Jahrbuch der preussischen Kunstsammlung, XXXVI (1915), 15-38; Mesnil, "La Perspective chez Leonardo da Vinci," Revue archéologique, XVI (1922), 55-76.

[19] Many Sienese paintings of the fifteenth century fall into this group.

[20] Filarete (Trattato dell'architettura, p. 602) instructs the artist to draw a horizontal line three braccia above the base line of his picture plane. He then says that the artist may choose a

aesthetic considerations. It is possible that once having determined the proper ratio of diminution from a sketch the artist modified the design of the squares or coffers either to avoid an effect which would be too mechanical or for reasons of composition. One must remember that in the fifteenth century the spread of information about the latest methods of perspective construction depended to a great extent upon personal contact rather than upon acquaintance with the manuscripts on the subject.[21]

In the north the theoretical solution of the problem of perspective did not advance as rapidly as it advanced in Italy. In Flemish painting, which was most developed from this point of view, one cannot claim with complete certainty that Jan van Eyck or Petrus Cristus was aware of the mathematical basis of perspective construction.[22] In the "Last Supper," ca. 1465, by Dirk Bouts, a single vanishing point for the construction of a whole room has been maintained with a fair amount of accuracy, but it is doubtful that on the basis of this picture one can attribute to the artist theoretical knowledge except with regard to the use of a vanishing point for single planes.[23] It is probable that the careful observations of the Flemish artists were later supplemented by the mathematical procedure either by direct contact with Italian work or through German mediation.[24]

The systematic construction of a scene according to a mathematical method of perspective is not observable in French painting until much later. In the work of Fouquet there is an effect of an ordered skeletal structure. Frequently this may be traced to the use of a vanishing area.[25] In a number of instances the vanishing areas of several planes almost coincide and there-

point above, under, in the middle, or on one side of this line. This point eventually becomes the point of sight. Although Filarete's advice is to select the point in the middle and on this horizontal line, he gives the artist the privilege of choosing. When he comes to the point used to determine the rate of diminution of the transversals, however, Filarete places this point three *braccia* above the extended base line without indicating that it is necessary to maintain a uniform level with the point of sight. When the artist chooses a position above or below the horizontal line for his point of sight, the rule of a uniform horizon is broken.

[21] The earliest publication containing the *costruzione legittima* seems to have been Pomponio Gaurico's *De sculptura*, which was printed in Florence, in 1504. Alberti's text was not published until 1540, in Basle. Filarete's and Piero della Francesca's works apparently remained in manuscript until the nineteenth-century editions, including German translations, were published.

[22] Kern, *Grundzüge*. Doehlemann, "Die Entwicklung der Perspektive," *Repertorium für Kunstwissenschaft*, XXXIV (1911), 392-422, 500-535. Vide infra, p. 201.

[23] Doehlemann, *Repertorium für Kunstwissenschaft*, XXXIV (1911), 418.

[24] *Ibid.*, p. 516.

[25] Chantilly, Mus. Condé, Hours of Etienne Chevalier, "The Marriage of the Virgin."

fore give to the whole scene some degree of perspective unity (Fig. 76).[26] Occasionally part of the checkered pavement seems to be based on geometric construction, which Fouquet could have learned in Italy (Fig. 76).[27] There is, however, no consistent and accurate form of perspective in his work which would indicate a complete apprehension of the mathematical basis of the focused system of perspective.

In 1505 Jean Pelerin, or Viator, wrote a textbook on perspective which was published several times in the next few years.[28] The *tiers points* method he advocated is as practical as and simpler than the Italian *costruzione legit-tima*, for it introduced the direct measurement of the distance from the point of sight rather than from the side of the picture plane as in the *cos-truzione legittima*.[29] Just as Alberti's and Piero della Francesca's works served as models for subsequent Italian writers on perspective, so Pelerin's book became the pattern for later French authors, such as Jean Cousin[30] and Jacques Androuet du Cerceau.[31] Despite the early publication of Pelerin's book, the accurate application of the focused system to painting does not seem to have become common in France until knowledge concern-ing it was disseminated by Italian artists working at the French court later in the sixteenth century.

In Germany it was Dürer who took the step from an empirical to a mathematical construction. From his own account we have learned that he went to Bologna for instruction in perspective.[32] He incorporated his inves-tigations in a book called, *Underweysung der Messung mit dem Zirckel und Richsheyt,* which was published in Nuremberg in 1525.[33] A text de-voted to perspective only, written by Hieronymus Rodler, was published

[26] Other illustrations: Chantilly, Mus. Condé, Hours of Etienne Chevalier, "Visitation," "An-nunciation," "Pentecost," "Burial of Etienne Chevalier." Paris, Bibl. Nat., MS fr. 19819, Statutes of the Order of St. Michael, "Louis XI Presiding at the Chapter of the Order of St. Michael."

[27] See also the "Fountain of the Apostles," in the Hours of Etienne Chevalier, Mus. Condé, Chantilly.

[28] *De artificiali perspectiva,* facsimile of the 1509 edition, edited by A. de Montaiglon, Paris, 1860. A facsimile of the French text alone, without woodcuts, from the Toul edition of 1505 is reproduced in Ivins, *On the Rationalization of Sight,* pp. 47 ff.

[29] For a detailed explanation of the method and illustrative diagrams see Ivins, *On the Rational-ization of Sight,* pp. 27 ff.

[30] *Livre de perspective,* Paris, 1560.

[31] *Leçons de perspective positive,* Paris, 1576.

[32] Rapke, *Die Perspektive und Architektur,* pp. 7-8.

[33] See Ivins, *On the Rationalization of Sight,* pp. 34 ff. for details of the method.

shortly therafter.[34] The method described is not correct with regard to diminution in depth, nor is it based on a measurable relation with the spectator.

This very brief survey of the early history of the focused system of per-spective in the various countries of Europe indicates to what degree the artists were concerned with the systematization of space in the Renaissance. After what may be called the conquest of the method in the Renaissance there followed a period of manipulation manifested by the choice of eccen-tric points of view and by the solution of difficult and often tricky problems of perspective. The development of linear perspective was accompanied by studies in color and light. In the north the interest in atmospheric or aerial perspective, which was manifested by suggesting depth by tonal variations, may be observed as early as the end of the fourteenth century and the be-ginning of the fifteenth century. These studies of the spatial qualities of color reached their culmination in the nineteenth century with the scientific technique of neo-impressionism. Linear perspective was for a time super-seded by aerial perspective, and although solidity in form was only tem-porarily placed in oblivion by impressionism, form as defined in terms of the focused system of perspective was not completely reinstated in painting. Systematic and unified space together with optical representation are no longer stressed as they were in the Renaissance, but have given way largely to new concepts, in some of which the picture plane is once again nonrepre-sentative in character and the objects and symbols combined according to personal conceptual systems. Thus, one may see in the painting of the early twentieth century evidences of a spatial development analogous in some ways to that of the medieval period. The more recent concepts, however, emerge from the dissolution of a geometric perspective in which the tridi-mensional space was theoretically measurable from the fixed point of view of a single spectator, whereas the early Middle Ages transformed a classic space which had never been organized to this extent.

[34] *Perspectiva*, Frankfort, 1546 (1st edition published in Siemeren a. d. Hunsruck, 1531). In his introduction, Rodler explains that he wrote this book because Dürer's is too difficult to understand.

APPENDICES

APPENDIX I

VITRUVIUS ON PERSPECTIVE

TWO PASSAGES by Vitruvius (*De architectura* i, 2, 2; vii, Praef., 11)
are the important literary sources for our knowledge of perspective in an-
cient painting.

i, 2, 2. "item scenographia est frontis et laterum abscedentium adum-
bratio ad circinique centrum omnium linearum responsus."

vii, Praef., 11. "namque primum Agatharchus Athenis Aeschylo do-
cente tragoediam scaenam fecit et de ea commentarium reliquit. ex eo
moniti Democritus et Anaxagoras de eadem re scripserunt, quemadmodum
oporteat ad aciem oculorum radiorumque extentionem certo loco centro
constituto lineas ratione naturali respondere, uti de incerta re certae imagines
aedificiorum in scaenarum picturis redderent speciem et, quae in directis
planisque frontibus sint figurata, alia abscedentia, alia prominentia esse
videantur" (edited by F. Krohn, Leipzig, 1912). See Panofsky, *Vorträge
Bibl. Warburg,* 1924-25, p. 303, note 19.

There is a difference of opinion concerning the translation of these pas-
sages, based principally on the meaning of the phrases *ad circini centrum
omnium linearum responsus* and *certo loco centro constituto lineas ratione
naturali respondere.* It has generally been assumed that these phrases mean
that all lines meet in the center of a circle, which has been interpreted as
referring to the vanishing point. A change in the translation of *responsus*
from "convergence to" to "correspondence to" (Richter, *Scritti in onore di
Nogara,* p. 383; cf. Little, "Perspective and Scene Painting," *Art Bulletin,*
XIX [1937], 488, note 9), and in the interpretation of the *centrum circini*
(literally "point of compasses"; freely "central point of a circle," Panofsky,
Vorträge Bibl. Warburg, 1924-25, p. 266) as the point of sight situated in

the eye of the spectator rather than the vanishing point (*ibid.;* Richter, *Scritti in onore di Nogara,* p. 383), makes a considerable difference in the meaning of these passages.

The following translation is based on Richter's interpretation. The second passage is quoted from her article (*ibid.*).

i, 2, 2. Perspective is the method of sketching a front with the sides withdrawing into the background, the lines all corresponding to the center of a circle.

vii, Praef., 11. "Agatharchus painted a scene for a tragedy of Aeschylus and left a commentary on it which led the philosophers Democritus and Anaxagoras to write on the same subject showing that given a certain central point the lines should correspond as they do in nature to the point of sight and the projection of the visual rays, so that from an unclear object, a clear representation of the appearance of buildings might be given in painted scenery, and so that, though all is drawn on vertical and plane surfaces, some parts may seem to be withdrawing into the background, and others to be protruding in front."

APPENDIX II

THE SPHERICAL VISUAL FIELD
IN ANCIENT OPTICS

THERE APPEARS to be some misunderstanding with respect to the question of the spherical visual field in ancient optics. Schuhl (*Platon et l'art de son temps,* p. 26; see also Richter, *Scritti in onore di Nogara,* p. 382, note 3) and Beyen (*Pompey. Wanddekoration,* I, 159, note 3) differ with Panofsky on this point. Schuhl argues that since Euclid, in his book on optics, describes the visual rays as a cone with the vertex in the eye, the visual field must have been conceived as a plane surface. Beyen cites the comparison of a mirror with a doorway through which one sees a prospect scene by Lucretius (*De rerum natura* iv, 269 ff.), and the close relationship of studies of optics, catoptrics, and scenography in ancient literature as arguments in favor of a plane surface. Kern ("Das Jahreszeiten-mosaik," *Jahrbuch des Instituts,* LIII [1938], 257-58) also disagrees with Panofsky.

A distinction must be made between the plane of the object or the material, painted picture plane, and the visual field which corresponds to the retina and its image. The former is a plane which corresponds to the base of the visual cone described above. It is the visual field, however, to which Panofsky refers, and this is a curved surface. That Euclid considered the retinal visual field a curved surface may be assumed from the facts that in the introduction to his *Optics* he implies that the apparent size of an object is proportional to the visual angle (Heiberg, *Euclides opera omnia,* VII, 3), and in Proposition VIII, which is concerned with the optical image in relation to the size of the object and its distance from the eye, he states that equal magnitudes unequally distant from the eye are not proportional to their distances (Panofsky, *Vorträge Bibl. Warburg,* 1924-25, p. 299,

note 15; see also p. 301, note 17, for changes in the wording of this hypothesis introduced by translators of the latter half of the sixteenth century in order to make the proposition more compatible with Renaissance perspective, in which one of the fundamental rules of the system is the proportional relationship of distance to magnitude). The geometric proof of Proposition VIII rests on the fact that according to Euclid the apparent size of the object depends on the visual angle (for proof of Proposition VIII see Heiberg, *Euclides opera omnia,* VII, 15; Ovio, *L'Ottica di Euclide,* p. 76). The proportional relationship between the optical size of the object and the visual angle involves the use of a sector, which implies that the visual surface is spherical.

Euclid, in his book on optics, is concerned only with the optical image, not with the projected painted image. The latter is the problem of the artist, and the rules which govern its construction according to the focused system of perspective bear a close relationship to the laws concerning the optical image, but differ in the proposition of size-distance relationship, which in turn goes back to the basic difference of the curved retina and the plane pictorial surface. This does not, however, affect the adequacy of the perspective system theoretically to recreate the illusion of the actual object, since the picture itself is projected on the retina.

APPENDIX III

ITALIAN ILLUMINATION IN THE FOURTEENTH CENTURY

IN THE discussion of the representation of space in Italian painting of the fourteenth century the illustrative material was drawn from panels and frescoes rather than from illumination. The illuminations show, as in the previous centuries, a variety of spatial forms. The movement toward tridimensional and representative space in monumental painting is reflected in illumination in a number of instances, especially in the later manuscripts. Horizontal ground planes on which the figures move freely, tridimensional architectural forms in buildings and in smaller objects, and boxed interiors appear. The vanishing-axis procedure is employed for horizontal planes in pavemented floors and beamed ceilings, as well as for vertical planes in buildings seen at an angle. Sometimes, but rarely, the convergence of the receding lines is toward a vanishing area. The following is a list of some of the manuscripts in which these spatial developments are exemplified: Paris, Bibl. Nat., MS lat. 3988, Decretals, prov. Bologna (D'Ancona, *La Minia-ture italienne*, Pl. XXVII). Perugia, Bibl. Comunale, Dominican Choral (*ibid.*, Pl. XLI). Milan, Bibl. Visconti di Modrone, Hours of Gian Galeas Visconti (*ibid.*, Pls. XVIII XX, Pl. II, in color). Florence, Bibl. Med. Laur., MS Edili 107, Missal (D'Ancona, *La miniatura fiorentina*, Vol. I, Pl. XIII). Venice, Mus. Correr, Confraternita di Sta. Caterina dei Sacchi (D'Ancona, *La Miniature italienne*, Pl. XXVI). Padua, Bibl. del Duomo, MS A. 25, The "Apparatus" of Giovanni d'Andrea to the "Constitutiones Clementis V" (Adalberto, Conte Erbach di Fuerstenau, "La miniature bolognese nel trecento," *L'Arte*, XIV [1911], Fig. 5). Paris, Louvre, An-nunciation page from a Choral, prov. Siena (D'Ancona, *La Miniature*

italienne, Pl. XXXIX). London, C. W. Dyson Perrins Coll., The Soliloquia of St. Augustine (Burlington Fine Arts Club, *Illustrated Catalogue of Il-luminated Manuscripts*, Pl. CXXI, No. 179).

Landscape is indicated by the traditional Byzantine rocks (Berlin, Cab. des Estampes, Hamilton Bible [D'Ancona, *La Miniature italienne*, Pl. XLIV]; Florence, Bibl. Naz., MS II. VI. 16, Exposition of the Pater-noster [D'Ancona, *La miniatura fiorentina*, Vol. I, Pl. XXVI]), or by a wide grassy ground plane (Florence, Bibl. Med. Laur., MS Tempi 3, Il biadajolo [*ibid.*, Pl. XI]; Florence, Bibl. Med. Laur., MS Pal. 143, Life of St. Anthony Abbot, fols. 14, 37 [Biagi, *Reproduzione di manoscritti miniati*, Pls. XXI-XXII]). In the illumination for Petrarch's Virgil (Milan, Ambrosiana, fol. lv), attributed to Simone Martini (D'Ancona, *La Minia-ture italienne*, Pl. XXXVI), the form bears some resemblance to the unfore-shortened landscape planes found in the Hunting and Fishing frescoes of the *Garderobe* in the Palace of the Popes at Avignon (Lemoisne, *Gothic Painting*, Pl. IX) and in the Poésies de Guillaume de Machaut, attributed to the Maître aux Bouqueteaux (Paris, Bibl. Nat., MS fr. 1584). *Vide supra*, pp. 158 ff.

Besides the above mentioned forms of representation other types may be found. The patterned background characteristic of northern illumination occurs even in late fourteenth-century work, although when used at this time it usually appears in conjunction with a horizontal ground plane. Examples: Florence, Bibl. Naz., MS II. 1. 122, Laudario, prov. Florence (D'Ancona, *La miniatura fiorentina*, Vol. I, Pl. XV). Paris, Bibl. Nat., MS lat. 757, Book of Hours, prov. Lombardy (D'Ancona, *La Miniature italienne*, Pl. XVI). Milan, Lib. of the Basilica of S. Ambrogio, Missal for Gian Galeas Visconti (*ibid.*, Pl. XXII). Milan, Bibl. Trivulci, MS 691, Lucanus, De Bello Pharsalio, prov. Bologna (*ibid.*, Pl. XXIX).

Backgrounds of one color are frequently employed. With these should be listed the numerous examples of large foliate initials in which the figures almost fill the picture plane leaving little room for indications of the environ-ment. (Florence, Bibl. Naz., MS II. I. 122, Laudario, prov. Florence [*ibid.*, Pl. XXXII]; Florence, Bibl. Med. Laur., MS Cor. Laur. 2, Antiphonal, prov. Florence [D'Ancona, *La miniatura fiorentina*, Vol. I, Pl. XXXIV]).

APPENDIX IV

THE DEVELOPMENT OF FOCUSED PERSPECTIVE IN FLEMISH PAINTING

KERN (*Grundzüge*) and Doehlemann ("Die Entwicklung der Perspek-tive," *Repertorium für Kunstwissenschaft*, XXXIV [1911], 392-422, 500-535) hold different opinions on the question of the development of focused perspective in Flemish painting. Kern (*Grundzüge*, pp. 18 ff.) attributes single vanishing-point construction for whole planes to Jan van Eyck and for a whole scene to Petrus Cristus. He believes that neither artist knew mathematical distance-point construction. Doehlemann (*Repertorium für Kunstwissenschaft*, XXXIV [1911], 418) gives credit to Dirk Bouts for the first single vanishing-point construction for a whole room. The investi-gations of Kern and Doehlemann are most completely presented in the above mentioned studies. In the *Repertorium für Kunstwissenschaft*, XXXV (1912), the question was reopened (Kern, pp. 27-64, 267-73; Doehle-mann, pp. 262-67) and both authors abided by their original opinions.

An essential point in the controversy is the problem of how accurate the perspective must be before one can assume that the artist was working from theoretical knowledge rather than empirically. It is a difficult question to answer since there are many factors, such as warping, overpainting, and photographic distortion, which may modify the original lines of the sketch (*vide supra*, p. 145, note 43). Then there are several intermediate stages where the empirical and theoretical approach may overlap. An artist may be aware of construction in accordance with a single vanishing point, but apply it to individual planes only. He may be aware of vanishing-point

unity for the whole scene and yet not relate it to the horizon. Finally, he may know all these factors and still be ignorant of the mathematical basis of distance-point construction. On the other hand, one must take into con-sideration the possibility that the artist may be aware of the rules of focused perspective but applies them cursorily in his painting. To determine just where the empirical approach ends and theoretical knowledge begins is dif-ficult, especially in the initial years of the development of the method of focused perspective. I cannot presume to decide the issue raised by Kern and Doehlemann, but I have observed that in the perspective reconstructions of paintings by Italian artists of the fifteenth century, the coördination of the orthogonals to a single vanishing point is frequently maintained with much greater exactitude than in the Flemish paintings in question, so much so, that theoretical knowledge of perspective (although not necessarily distance-point construction) cannot be doubted. It is notable that some of these examples, such as the scenes of the "Desecration of the Host," in the Ducal Palace of Urbino, by Uccello (Fig. 78), and the "Flagellation," in the Cathedral of Urbino, by Piero della Francesca (Fig. 77) are by artists whose interest in perspective is known from other sources. In view of the fact that we find greater accuracy in the perspective drawing of many Italian paint-ings, it seems wise to adopt a conservative attitude about the application of theoretical mathematical knowledge in the work of the early Flemish artists of the Renaissance. Nevertheless, they were approaching vanishing-point unity empirically. The findings of both Kern and Doehlemann may be sum-marized as follows: In the work of Jan van Eyck one may note a single vanishing point, or rather vanishing area since there are deviations, for a whole plane. In the "Madonna and Saints" (Frankfort, Städel. Inst.) by Petrus Cristus, the orthogonals of the whole scene recede to a single van-ishing area, which, as Kern observes, coincides with the horizon of the vista. In the "Last Supper" by Dirk Bouts, the vanishing area of all the receding lines of the room can be circumscribed by a small circle (Doehle-mann, *Repertorium für Kunstwissenschaft,* XXXIV [1911], 414; Fig. 5). In view of the numerous orthogonals in this picture one may assume that the artist was familiar with theoretical methods, if only insofar as they con-cern individual planes.

Recently the question has been reopened in connection with the attribu-tion of the "Friedsam Annunciation" in the Metropolitan Museum, New

York City. Panofsky (*Art Bulletin*, XVII [1935], 433-73) believes that the painting is related to the work of Hubert van Eyck, while Beenken (*Art Bulletin*, XIX [1937], 220-41) prefers to attribute it to Petrus Cristus. Panofsky, who is of the opinion that Petrus Cristus employed correct vanishing-point construction, observes that it is not applied consistently in the "Friedsam Annunciation" (*Art Bulletin*, XVII [1935], 438, note 14). On the other hand Beenken finds that the perspective construction in this picture is consistent and correct (*Art Bulletin*, XIX [1937], 223), and therefore confirms the attribution of the painting to Petrus Cristus.

In the "Friedsam Annunciation" we are confronted with the type of construction that requires two vanishing points, that is, angular perspective; for the building in question is placed at an angle to the picture plane. Panofsky notes that the orthogonals of the front and porch meet at a point but that the receding lines of the tiles, floor, and windows of the interior, do not conform to the vanishing-point system (*Art Bulletin*, XVII [1935], 438). Beenken, however, gives an accurate two-point perspective drawing of the building (*Art Bulletin*, XIX [1937], Fig. 3). He makes the reservation that since his perspective drawing is based on a photograph, it may not account for deviations which may exist in the original, but, he says (p. 223, note 2) these deviations would be of no consequence in view of the accuracy of the perspective drawing in general. Working from a photograph, I was unable to obtain the exact convergence that Beenken shows in his illustration. There are numerous deviations which would be more pronounced in the original which is considerably larger than the photograph. The other factor observed by Beenken, that in this "Annunciation" the artist used two vanishing points correctly by placing them on the same level, thus unifying the perspective construction, would carry more weight against an attribution to Hubert van Eyck if there was not a tendency, as Panofsky points out, in the empirical period of the development of angular perspective, to place the points or areas of convergence on the same level. (See Panofsky's reply to Beenken, *Art Bulletin*, XX [1938], 423). In his reply (pp. 419-24; Fig. 5) Panofsky gives a detailed account of the inconsistencies in the perspective drawing of the "Annunciation" and discusses more fully than in the earlier paper on this subject, the problem of the perspective insofar as it concerns the question of attribution.

In view of the inaccuracies in the perspective of the building, the exclu-

sion of Hubert van Eyck from the authorship of the "Annunciation" on the basis of the perspective alone, which Beenken asserts (*Art Bulletin,* XIX [1937], 223), seems to be untenable. Another fact that has some bearing on the problem is the observation by Beenken (p. 228) that there is no horizon in the landscape although for the architecture, according to his perspective drawing, the horizon would correspond to the lintel of the doorway. Kern points out as proof of Petrus Cristus' ability to unify the perspective of a scene, that in the "Annunciation" in Berlin and the "Madonna and Saints" in Frankfort, the vanishing area coincides with the horizon of the vista (*Grundzüge,* p. 18. See also Panofsky's reply to Beenken, *Art Bulletin,* XX [1938], 422). On the whole, in this particular problem of attribution, the perspective cannot be used as a decisive factor, and contrary to the opinion of Beenken, I believe that the way the perspective is handled still leaves the question of authorship by Hubert van Eyck open.

BIBLIOGRAPHY

BIBLIOGRAPHY

Adalberto, Conte Erbach di Fuerstenau, "La miniatura bolognese nel trecento: studi su Niccolo di Giacomo," *L'arte*, XIV (1911), 1-12, 107-17.

Adama van Scheltema, F. Die altnordische Kunst (Grundprobleme vorhistorischer Kunstentwicklung). 2d ed. Berlin, 1924.

Alberti, Leone Battista, Della pittura libri tre, edited by Janitschek. Vienna, 1877. Kleinere kunsttheoretische Schriften.

Ancona, P. de, La miniatura fiorentina (secoli XI-XVI). 2 vols. Florence, 1914.

———— La Miniature italienne du X^e au XV^e siècle, translated by M. P. Poirier. Paris and Brussels, 1925.

———— "Un miniatore fiorentino della scuola di Cimabue," *Rivista d'arte*, XVI (1934), 3-7.

Avery, Myrtilla, "The Alexandrian Style at Santa Maria Antiqua, Rome," *The Art Bulletin*, VI (1925), 131-49.

Barbaro, Daniello, La pratica della perspettiva. Venice, 1568.

Beenken, H. "The Annunciation of Petrus Cristus in the Metropolitan Museum and the Problem of Hubert van Eyck," *The Art Bulletin*, XIX (1937), 220-41.

Beissel, Stephen, Die Bilder der Handschrift des Kaisers Otto im Munster zu Aachen in XXXIII unveränderlichen Lichtdrucktafeln. Aachen, 1886.

Berchem, M. van, and E. Clouzot, Mosaiques chrétiennes du IV^e au X^e siècle. Geneva, 1924.

Berstl, H. Das Raumproblem in der altchristlichen Malerei. Bonn, 1920.

Beyen, H. G. Die pompeyanische Wanddekoration (vom zweiten bis zum vierten Stil). 2 vols. The Hague, 1938.

———— "Die antike Zentralperspektive," *Jahrbuch des deutschen archäologischen Instituts*, LIV (1939), 47-72.

Biago, Guido, Reproduzione di manoscritti miniati da codici della R. Biblioteca Medicia Laurenziana. Florence, 1914.

Bieber, Margarete, Review of Bulle, "Untersuchungen an griechischen Theatern," *Gnomon*, VIII (1932), 471-82.

———— The History of the Greek and Roman Theater. Princeton, 1939.

———— and G. Rodenwaldt, "Die Mosaiken des Dioskurides von Samos," *Jahrbuch des deutschen archäologischen Instituts*, XXVI (1911), 1-23.

Boeckler, A. Abendländische Miniaturen bis zum Ausgang des romanischen Zeit. Berlin and Leipzig, 1930.

Boeckler, A. Das Goldene Evangelienbuch Heinrichs III. Berlin, 1933.

—— see also Degering, H., and A. Boeckler, Die Quedlinburger Italafragmente.

Boinet, A. La Miniature carolingienne. Paris, 1913.

Borenius, T., and E. W. Tristram, English Medieval Painting. Florence and Paris, 1927.

Brandt, Hermann, Die Anfänge der deutschen Landschaftsmalerei im XIV. und XV. Jahrhundert. Strassburg, 1912.

Bulle, Heinrich, Untersuchungen an griechischen Theatern. Munich, 1928.

—— "Eine Skenographie," 94. Winckelmannsprogramm der Archäologischen Gesellschaft zu Berlin. Berlin and Leipzig, 1934.

—— "Ein Beitrag zur Kunst des Mikon und des Agatharchos," Archailogike Ephemeris, 1937, pp. 473-82.

Cennini, Cennino, Il libro dell'arte (A Craftsman's Handbook), translated by D. V. Thompson, Jr. New Haven and London, 1933.

Ceriani, M. Homeri Iliadis pictae fragmenta Ambrosiana. Milan, 1905.

Clemen, Paul, Die gotischen Monumentalmalereien der Rheinlande. Düsseldorf, 1930.

Cockerell, S. C. The Book of Hours of Yolande of Flanders. London, 1905.

Codices e Vaticanis selecti.

 Vol. I. Virgil Vat. 3225. Rome, 1899.

 Vol. II. Virgil Vat. 3867. Rome, 1902.

Cousin, Jean, Livre de perspective. Paris, 1560.

Crowe, J. A., and G. B. Cavalcaselle, History of Painting in Italy. 6 vols. London, 1903-14.

Dalton, O. M. Byzantine Art and Archaeology. Oxford, 1911.

Damrich, J. Ein Künstlerdreiblatt des XIII. Jahrhundert aus Kloster Scheyern. Strassburg, 1904.

Degering, H. Des Priesters Wernher drei Lieder von der Magd. Berlin, 1925.

—— and A. Boeckler, Die Quedlinburger Italafragmente. Berlin, 1932.

Delbrueck, Richard, Beiträge zur Kenntnis der Linienperspektive in der griechischen Kunst. Bonn, 1899.

Delisle, Leopold, Fac-similé de livres copiés et enluminés pour le Roi Charles V. Nogent-le-Rotrou, 1903.

—— "La Bible de Robert de Billyng et de Jean Pucelle," Revue de l'art chrétien, LX (1910), 299-308.

—— Les Heures dites de Jean Pucelle, manuscrit de la Collection de M. le baron Maurice de Rothschild. Paris, 1910.

Della Francesca, Piero, Prospettiva pingendi, edited by Winterberg. Strassburg, 1899.

Dewick, E. S. The Metz Pontifical. London, 1902.

Diepolder, H. "Untersuchungen zu Komposition der römisch-campanischen Wandgemälde," Mitteilungen des deutschen archäologischen Instituts. Römische Abteilung, XLI (1926), 1-78.

Dimier, L. Histoire de la peinture française des origines au retour de Vouet, 1300 à 1627. Paris and Brussels, 1925.

—— Les Primitifs français. Paris, 1929.

Dinsmoor, William Bell, "The Temple of Ares at Athens," Hesperia, IX (1940), 1-52.

Doehlemann, Karl, Review of Wulff, "Die umgekehrte Perspektive und die Nieder-sicht," *Repertorium für Kunstwissenschaft,* XXXIII (1910), 85-87.

———— "Die Entwicklung der Perspektive in der altniederländischen Kunst," *Reper-torium für Kunstwissenschaft,* XXXIV (1911), 392-422, 500-535.

———— "Nochmals die Perspektive bei den Brüdern van Eyck," *Repertorium für Kunstwissenschaft,* XXXV (1912), 262-67.

Döring, O., and G. Voss, Meisterwerke der Kunst aus Sachsen und Thuringen. Magdeburg, 1905.

Du Cerceau, Jacques Androuet, Leçons de perspective positive. Paris, 1576.

Durrieu, Comte Paul, Les Très Riches Heures de Jean de France, duc de Berry. Paris, 1904.

———— Les Très Belles Heures de Notre Dame du duc de Berry. Paris, 1922.

Dvořák, Max, "Die Illuminatoren des Johann von Neumarkt," Gesammelte Aufsätze, Munich, 1929, pp. 74-207.

Ebersolt, Jean, La Miniature byzantine. Paris and Brussels, 1926.

Englefield, Sir H. C. Description of the Additional Plates of St. Stephen's Chapel, Westminster Palace. Bound with Topham, Some Account of the Collegiate Chapel of St. Stephen, Westminster. Society of Antiquaries, London, ca. 1807.

Evans, Sir Arthur, The Palace of Minos. 4 vols. in 6. London, 1921-36.

Fabriczy, C. von, Filippo Brunelleschi, sein Leben und seine Werke. Stuttgart, 1892.

Farina, G. La pittura egiziana. Milan, 1929.

Fierens-Gevaert, H. Lès Très Belles Heures de Jean de France, duc de Berry. Brussels, 1924.

Filarete, Antonio Averlino, Trattato dell'architettura, edited by Wm. von Oettingen. Vienna, 1896.

Fischer, Hans, Mittelalterliche Miniaturen aus der staatlichen Bibliothek Bamberg. Bam-berg, 1926-29.

Focillon, H., and P. Devinoy, Peintures romanes des églises de France. Paris, 1938.

Forbes-Leith, W. Life of St. Cuthbert. Edinburgh, 1888.

Fowler, Harold N., and James R. Wheeler, A Handbook of Greek Archaeology. New York, 1909.

Frey, Dagobert, Gotik und Renaissance als Grundlagen der modernen Weltanschauung. Augsburg, 1929.

Friend, A. M. "Portraits of the Evangelists in Greek and Latin Manuscripts," *Art Studies,* VII (1929), 3-29.

Ganz, Paul Leonhard, Das Wesen des französischen Kunst im späten Mittelalter (1350-1500). Frankfurt am Main, 1938.

Gaspar, Camille, and Frederic Lyna, Principaux manuscrits à peintures de la biblio-thèque Royale de Belgique. Paris, 1937.

Gaurico, Pomponio, De sculptura, edited by Brockhaus. Leipzig, 1886.

Gheyn, J. van den, Deux Livres d'Heures attribué à l'enlumineur Jacques Coene. Brussels and London, 1911.

Ginot, Emile, Le Manuscrit de Sainte Radegonde de Poitiers. La Société française de reproductions de manuscrits à peintures, Bulletin No. IV (1914-20).

Glaser, C. Les Peintures primitifs allemands du milieu du XIV^e siècle à la fin du XV^e. Paris, 1931.

Goldschmidt, A. Das Evangeliar im Rathaus zu Goslar. Berlin, 1910.

—— German Illumination. 2 vols. New York, 1928.

Gollancz, Sir Isreal, The Caedmon Manuscript of Anglo-Saxon Biblical Poetry. London, 1927.

Gombrich, E. Review of J. Bodonyi, "Enstehung und Bedeutung des Goldgrundes in der spätantiken Bildkomposition" (in Archaeologiai Ertesitö, XLVI [1932-33]. German summary, Vienna, 1932), Kritische Berichte zu kunstgeschichtlichen Literatur, II-III (1932-33), 65-76.

Goodyear, W. H. Greek Refinements. New Haven, 1912.

Guthmann, J. Die Landschaftsmalerei der toskanischen und umbrischen Kunst von Giotto bis Raphael. Leipzig, 1902.

Hahnloser, H. R. Das Musterbuch von Wolfenbüttel. Vienna, 1929.

Haseloff, Arthur, Eine thuringische sächsische Malerschule des 13. Jahrhunderts. Strassburg, 1897.

—— see also Sauerland, H. V., and A. Haseloff, Der Psalter Erzbischof Egberts von Trier, Codex Gertrudianus, in Cividale.

Hauck, G. Die subjektive Perspektive und die horizontalen Curvaturen des dorischen Styls. Stuttgart, 1879.

Heiberg, J. L. Euclides opera omnia. Vol. VII. Leipzig, 1883-1916.

Helmholtz, H., and E. Brücke, Principes scientifiques des beaux-arts. Paris, 1878.

Herbert, J. A. Illuminated Manuscripts. 2d ed. London, 1912.

—— The Sherborne Missal. Oxford, 1920.

—— British Museum Guide to the Exhibited Manuscripts. Pt. III. London, 1923.

Herrmann, P. Denkmäler der Malerei des Altertums. Serie I. Munich, 1904-31.

Herzfeld, Ernst E. Archaeological History of Iran. London, 1935. The Schweich Lectures of the British Academy, 1934.

Hinks, R. Carolingian Art. London, 1935.

Hoernes, M., and O. Menghin, Urgeschichte der bildenden Kunst in Europa. 3d ed. Vienna, 1925.

Homburger, Otto, Die Anfänge der Malschule von Winchester in X. Jahrhundert. Leipzig, 1912.

Honnecourt, Villard de, Album de Villard de Honnecourt, edited by M. Lassus and A. Darcel. Paris, 1858.

Hulin De Loo, Georges, Heures de Milan. Brussels and Paris, 1911.

Illustrations of One Hundred Manuscripts in the Library of Henry Yates Thompson. 7 vols. London, 1907-18.

Irmer, Georg, Die Romfahrt Heinrichs VII im Bildercyclus des Codex Balduini Trevirensi. Berlin, 1881.

Ivins, William M., Jr. On the Rationalization of Sight with an Examination of Three Renaissance Texts on Perspective. New York, 1938. The Metropolitan Museum of Art, Papers, No. 8.

James, M. R. A Peterborough Psalter and Bestiary of the XIVth Century. Oxford, 1921.

James, M. R., and E. G. Millar, The Bohun Manuscripts. Oxford, 1936.

Jerchel, Heinrich, "Die bayerische Buchmalerei des 14. Jahrhunderts," *Münchner Jahrbuch der bildenden Kunst*, N. F., X (1933), 70-109.

Kallab, W. "Die toskanischen Landschaftsmalerei des XIV. und XV. Jahrhunderts," *Jahrbuch des kunsthistorischen Sammlungen des oesterreichischen Kaiserhauses*, XXI (1901), 1-90.

Kern, G. J. Die Grundzüge der linear-perspektivishen Darstellung in der Kunst der Gebrüder van Eyck und ihrer Schule. Leipzig, 1904.

———— "Eine perspektivische Kreiskonstruktion bei Sandro Botticelli," *Jahrbuch der preussischen Kunstsammlung*, XXVI (1905), 137-44.

———— "Perspektive und Bildarchitektur bei Jan van Eyck," *Repertorium für Kunstwissenschaft*, XXXV (1912), 27-64.

———— "Antwort auf die Entgegnung des Herrn Prof. Doehlemann," *Repertorium für Kunstwissenschaft*, XXXV (1912), 268-72.

———— "Die Anfänge der zentralperspektivischen Konstruktion in der italienischen Malerei des 14. Jahrhunderts," *Mitteilungen des kunsthistorischen Instituts in Florenz*. Berlin, 1912-13, pp. 39-65.

———— "Das Dreifaltigkeitsfresko in Santa Maria Novella," *Jahrbuch der preussischen Kunstsammlung*, XXXIV (1913), 36-58.

———— "Der Mazzocchio des Paolo Uccello," *Jahrbuch der preussischen Kunstsammlung*, XXXVI (1915), 13-38.

———— "Das Jahreszeiten-mosaik von Sentinum und die Skenographie bei Vitruv," *Jahrbuch des deutschen archäologischen Instituts mit dem Beiblatt archäologischer Anzeiger*, LIII (1938), 245-64.

Khvoshinsky, B., and M. Salmi, I pittori toscani dal XIII al XVI secolo. Rome, 1912.

King, Edward S. "The Carolingian Frescoes of the Abbey of St. Germain d'Auxerre," *The Art Bulletin*, XI (1929), 359-75.

Kleinberger Galleries, Loan Exhibition of French Primitives, Oct. 1927; catalogue. New York, 1927.

Köhler, Wilhelm, "Die Denkmäler der karolingischen Kunst in Belgian," in Belgische Kunstdenkmäler, edited by P. Clemen. Munich, 1923, I, 1-26.

———— "Die Tradition der Adagruppe und die Anfänge des ottonischen Stiles in der Buchmalerei," in Festschrift zum 60 Geburtstag von Paul Clemen. Düsseldorf, 1926, pp. 255-72.

———— Die karolingischen Miniaturen: 1. Die Schule von Tours. Berlin, 1933.

Komstedt, R. Vormittelalterliche Malerei. Augsburg, 1924.

Ladner, Gerhart, "Die italienische Malerei im 11. Jahrhundert," *Jahrbuch der kunsthistorischen Sammlungen in Wien*, N. F., V (1931), 33-160.

Lange, J. "Gesetze der Menschendarstellung in der primitiven Kunst aller Völker und insbesondere in der ägyptischen Kunst." In French from the 1892 edition of Darstellung des Menschen in der älteren griechen Kunst. Strassburg, 1899.

La Piana, George, "The Byzantine Theatre," *Speculum*, XI (1936), 171-211.

Lasteyrie, R. de, L'Architecture religieuse en France à l'époque gothique. 2 vols. Paris, 1927.

———— L'Architecture religieuse en France à l'époque romane. 2d ed. Paris, 1929.

Lauer, Philippe, Les Enluminures romanes des manuscrits de la Bibliothèque Nationale. Paris, 1927.

——— see also Martin, H., and Philippe Lauer, Les Principaux Manuscrits à peinture de la Bibliothèque de l'Arsenal.

Lazareff, Victor, "The Mosaics of Cefalù," The Art Bulletin, XVII (1935), 182-232.

Lehmann-Hartleben, K. Die Trajanssaüle. Berlin and Leipzig, 1926.

Leidinger, Georg, "Das Perikopenbuch Kaiser Heinrichs II Cod. Lat. 4452," in Miniaturen aus Handschriften der Kgl. Hof- und Staatsbibliothek in München. Munich, n.d. Vol. V.

Lemoisne, P. A. Gothic Painting in France. Florence and New York, n.d.

Leroquais, Abbé V. Les Sacramentaires et les missels manuscrits des bibliothèques publiques de la France. 3 vols. Paris, 1924.

——— Les Bréviaires manuscrits des bibliothèques publiques de la France. 5 vols. Paris, 1934.

Little, A. M. G. "Scaenographia," The Art Bulletin, XVIII (1936), 407-18.

——— "Perspective and Scene Painting," The Art Bulletin, XIX (1937), 487-95.

Löffler, Karl, Der Landgrafenpsalter. Leipzig, 1925.

Loewy, E. Rendering of Nature in Early Greek Art, translated by J. Frothergill. London, 1907.

London, British Museum, Schools of Illumination: Reproductions from Manuscripts in the British Museum. VI Parts. London, 1914-30.

London, Burlington Fine Arts Club, Illustrated Catalogue of Illuminated Manuscripts. London, 1908.

London, Royal Academy of Arts, Exhibition of British Primitive Painting, Royal Academy of Arts, London, Oct.-Nov., 1923. Oxford, 1924.

Loo, Hulin de, see Hulin de Loo, Heures de milan.

Lubschez, B. J. Perspective: an Elementary Textbook. New York, 1927.

Lyna, Frederic, De vlaamsche Miniatuur van 1200 tot 1530. Brussels and Amsterdam, 1933.

Mackeprang, M., V. Madsen, and C. S. Petersen, Greek and Latin Illuminated Manuscripts X-XIII Centuries in Danish Collections. Copenhagen and London, 1921.

Mâle, Emile, "La Renouvellement de l'art par les 'Mysteres' à la fin du Moyen Âge," Gazette des beaux-arts, XXXI (1904), 89-106, 215-30, 283-301, 379-94.

Marle, R. van, The Development of the Italian Schools of Painting. 19 vols. The Hague, 1923-38.

Martin, H. Les Peintres de manuscrits et la miniature en France. Paris, n.d.

——— Legende de Saint Denis. Paris, 1908.

——— La Miniature française du XIIIe au XVe siècle. Paris and Brussels, 1923.

——— and Philippe Lauer, Les Principaux manuscrits à peinture de la Bibliothèque de l'Arsenal. Paris, 1929.

Meiss, Millard, "Fresques italiennes cavallinesques et autres, à Béziers," Gazette des beaux-arts, XVIII (1937), 275-86.

Menologio di Basilio II, Codice Vaticano greco 1613. 2 vols. Turin, 1907.

Mercier, Fernand, Les Primitifs français: la peinture clunysienne en Bourgogne à l'époque romane. Paris, 1931.

Mesnil, J. Masaccio et les debuts de la Renaissance. The Hague, 1927.
———— "La Perspective chez Leonardo da Vinci," *Revue archéologique*, XVI (1922), 55-76.
Michel, André, Histoire de l'art depuis les premiers temps chrétiens jusqu'à nos jours. 8 vols. in 17. Paris, 1905-29.
Millar, Eric G. English Illuminated Manuscripts from the Xth to the XIIIth Century. Paris, 1926.
———— English Illuminated Manuscripts of the XIVth and XVth Centuries. Paris and Brussels, 1928.
———— Souvenir de l'Exposition de manuscrits français à peinture organisée à la Grenville Library (British Museum) en Janvier-Mars, 1932. Paris, 1933.
———— The Lindisfarne Gospels. London, 1923.
———— see also James, M. R., and E. G. Millar, The Bohun Manuscripts.
Millet, Gabriel, Recherches sur l'iconographie de l'évangile du XIVe, XVe et XVIe siècles. Paris, 1916.
Miner, Dorothy, Review of Neuss, "Die Apokalypse des Hl. Johannes," *The Art Bulletin*, XV (1933), 388-91.
Miniature e altre reproduzione del regesto di S. Angelo in Formis. Badia di Monte Cassino, 1925.
Miniatures des manuscrits du Mont Cassin, Les; documents pour l'histoire de la miniature. Monte Cassino, 1899.
Morey, C. R. The Sources of Medieval Style. New York, 1924.
Müller, K. "Frühmykenische Reliefs aus Kreta und vom griechischen Festland," *Jahrbuch des deutschen archäologischen Instituts*, XXX (1915), 242-336.
Müller, R. Über die Anfange und über das Wesen der malerischen Perspektive. Darmstadt, 1913. Rektoratsrede.
Muratoff, P. La Peinture byzantine. Paris, 1928.
Naples, National Museum, Catalogue of the Archaeological Collection. 2d ed. Naples, n.d.
Neuss, Wilhelm, Die katalanische Bibelillustration um die Wende des ersten Jahrtausends und die altspanische Buchmalerei. Bonn and Leipzig, 1922.
———— Die Apokalypse des Hl. Johannes in der altspanischen und altchristlichen Bibelillustration. (Das Problem der Beatushandschriften). Münster in Westfalen, 1931.
New York, Metropolitan Museum of Art, "The Michael Friedsam Collection," *Bulletin*, XXVII (1932), No. 11.
New York, Pierpont Morgan Library, Illustrated Catalogue of an Exhibition Held on the Occasion of the New York World's Fair 1939. New York, 1939.
Niver, Charles, "A XIIth Century Sacramentary in the Walters Collection," *Speculum*, X (1935), 333-37.
Nolan, Louis O. P. The Basilica of San Clemente in Rome. Rome, 1934.
Olivier-Martin, F. "Manuscrits bolonais du Décret de Gratien conservé à la Bibliothèque Vaticane," *Mélanges d'archéologie et d'histoire*, XLVI (1929), 215-57.
Omont, Henri, Miniatures du Psautier de St. Louis; manuscrit lat. 76 A de la bibliothèque de l'Université de Leyde. Leyden, 1902.

Omont, Henri, Miniatures des plus anciens manuscrits grecs de la Bibliothèque Nationale du VIe au XIVe siècle. Paris, 1929.

Oursel, C. La Miniature du XIIe siècle à l'Abbaye de Cîteaux; d'après les manuscrits de la Bibliothèque de Dijon. Dijon, 1926.

Ovio, G. L'Ottica di Euclide. Milan, 1918.

Pächt, Otto, "A Bohemian Martyrology," Burlington Magazine, LXXIII (1938), 192-204.

Panofsky, Erwin, "Die Perspektive als 'Symbolische Form,' " Vorträge der Bibliothek Warburg, 1924-25, pp. 258-330. Leipzig and Berlin, 1927.

———— "The Friedsam Annunciation and the Problem of the Ghent Altarpiece," The Art Bulletin, XVII (1935), 433-73.

———— "Once More 'The Friedsam Annunciation and the Problem of the Ghent Altarpiece,' " The Art Bulletin, XX (1938), 419-42.

Paris, Bibliothèque Nationale, Départment des Manuscrits, Psautier de St. Louis. Paris, n.d.

Paris, Musée de sculpture comparée du Trocadero, Sainte Chapelle, Exposition de la Passion du Christ dans l'art français. Paris, 1934.

Parkyn, E. A. Introduction to the Study of Prehistoric Art. New York, 1915.

Peckham, John, Perspectiva communis. Venice, 1504.

Pelerin, Jean, De artificiali perspectiva. Facsimile of the 1509 edition, edited by A. de Montaiglon. Paris, 1860.

Pfuhl, Ernst, Malerei und Zeichnung der Griechen. Munich, 1923.

Prou, M. "Dessins du XIe siècle et peintures du XIIIe siècle," Revue de l'art chrétien, XL (1890), 122-28.

Rapke, Karl, Die Perspektive und Architektur auf den Dürerischen Handzeichnungen, Holzschnitten, Kupferstichen, und Gemälde. Strassburg, 1902.

Richter, Gisela M. A. "Perspective, Ancient, Medieval and Renaissance," in Scritti in onore di Bartolomeo Nogara. Rome, 1937, pp. 381-88.

———— "Two Athenian Jugs," Metropolitan Museum of Art, Bulletin, XXXIV (1939), 231-32.

Riegl, Alois, Spätrömische Kunstindustrie. Vienna, 1927.

———— "Zur kunsthistorischen Stellung der Becher von Vafio," Gesammelte Aufsätze. Augsburg and Vienna, 1929.

Rizzo, G. E. La pittura ellenistico-romana. Milan, 1929.

Robb, David M. "The Iconography of the Annunciation in the Fourteenth and Fifteenth Centuries," The Art Bulletin, XVIII (1936), 480-526.

Rodenwaldt, G. Die Komposition der pompeyanischen Wandegemälde. Berlin, 1909.

———— Das Fries des Megaron von Mykenai. Halle a/S, 1921.

———— see also Bieber, Margarete and G. Rodenwaldt, Die Mosaiken des Dioskurides von Samos.

Rodler, Hieronymus, Perspectiva. 1st ed., Siemern a.d. Hunsruck, 1531. 2d ed., Frankfort, 1546.

Rostovtzeff, M. "Die hellenistische-römische Architekturlandschaft," Mitteilungen des deutschen archäologischen Instituts. Römische Abteilung, XXVI (1911), 1-160.

Sarton, G. Introduction to the History of Science. Baltimore, 1927.

Sauerland, H. V., and A. Haseloff, Der Psalter Erzbischof Egberts von Trier, Codex Gertrudianus, in Cividale. Trier, 1901.

Schäfer, H. Von ägyptischer Kunst. 3d ed. Leipzig, 1930.

—— and W. Andrae, Die Kunst des alten Orients. Berlin, 1925.

Schaefer, Karl, Geschichte der Kölner Malerschule. Lübeck, 1923.

Schapiro, Meyer, "Rendering of Nature in Early Greek Art," The Arts, VIII (1925), 170-72.

—— Review of Lauer, "Les Enluminures romanes," The Art Bulletin, X (1927-28), 397-99.

—— "The Romanesque Sculpture of Moissac," The Art Bulletin, XIII (1931), 249-352, 464-531.

—— "The Sculptures of Souillac," in Medieval Studies in Memory of A. Kingsley Porter. Cambridge, Mass., 1939, pp. 359-87.

—— "From Mozarabic to Romanesque in Silos," The Art Bulletin, XXI (1939), 312-74.

Schott, M. Zwei Lüttischer Sakramentare in Bamberg und Paris und ihre Verwandten. Strassburg, 1931.

Schuhl, P.-M. Platon et l'art de son temps (Arts plastiques). Paris, 1933.

Serlio, Sebastiano, Opere d'architettura. Book II. Paris, 1545.

Siren, O. Toskanische Maler im XIII. Jahrhundert. Berlin, 1922.

Snyder, G. A. S. Kretische Kunst. Berlin, 1926.

Stange, A. Deutsche Malerei der Gotik. 2 vols. Berlin, 1934.

Strong, E. S. Roman Sculpture. New York, 1907.

Swarzenski, Georg, Die Salzburger Malerei von den ersten Anfängen bis zur Blütezeit des romanischen Stils. Leipzig, 1913.

Swarzenski, Hanns, Vorgotische Miniaturen. 2d ed. Leipzig, 1931.

—— Die lateinische illuminierten Handschriften des XIII. Jahrhunderts in den Ländern an Rhein, Main und Donau. Berlin, 1936.

Swindler, M. H. Ancient Painting. New Haven, 1929.

Thompson, H. Y. 32 Miniatures from the Hours of Joan II, Queen of Navarre. London, 1899.

Toesca, P. La pittura e la miniatura nella Lombardia. Milan, 1912.

—— Florentine Painting of the Trecento. Florence and Paris, 1929.

—— Miniature romane dei secoli XI e XII, Bibbia miniate. Rome, 1929.

Topham, John, Some Account of the Collegiate Chapel of St. Stephen, Westminster. Bound with this is Englefield, Sir H. C. Description of the Additional Plates of St. Stephen's Chapel. Society of Antiquaries, London, ca. 1807.

—— An Account of the Collegiate Chapel of St. Stephen, Westminster. London, 1834.

University Prints. Series A, K. Boston, 1916.

Vasari, Giorgio, Lives of the Painters, Sculptors and Architects, translated by A. B. Hinds. New York, 1927.

Venturi, A. Storia dell'arte italiana. 11 vols. Milan, 1901-39.

Vignola, G. Barozzi Da, Le due regole di prospettiva, edited by Egnatio Danti. Rome, 1583.

Vinci, Leonardo Da, Das Buch von der Malerei, edited by H. Ludwig. Vienna, 1882.

––––––– Les Manuscrits de Leonard da Vinci, Le Manuscrit A de la Bibliothèque de l'Institut, edited by C. Ravaisson-Mollien. Paris, 1881.

Vitzthum von Eckstädt, Graf Georg, Die rheinische Malerei zu Anfang des 14. Jahr-hunderts. Leipzig, 1907.

Warner, G. Queen Mary Psalter. London, 1912.

––––––– The Gospels of Matilda, Countess of Tuscany. New York, 1917.

––––––– The Guthlac Roll. Oxford, 1928.

––––––– and H. A. Wilson, The Benedictional of St. Aethelwold. Oxford, 1910.

Weigelt, C. H. Giotto. Klassiker der Kunst. Berlin and Leipzig, 1925.

––––––– Sienese Painting of the Trecento. Florence and New York, n.d.

Westwood, J. O. Facsimiles of the Miniatures and Ornaments of Anglo-Saxon and Irish Manuscripts. London, 1868.

Wickhoff, F. Roman Art, translated by E. Strong. New York, 1900.

Wieleitner, H. "Zur Erfindung der verschiedenen Distanzkonstruktionen in der malerischen Perspektive," Repertorium für Kunstwissenschaft, XLII (1920), 249-62.

Wilpert, J. Die römischen Mosaiken und Malereien der kirchlichen Bauten von IV. bis XIII. Jahrhundert. 4 vols. Freiburg im Breisgau, 1916.

Wilson, H. A. Missal of Robert of Jumièges. London, 1896.

––––––– Benedictional of Archbishop Robert. London, 1903.

––––––– see also Warner, G., and H. A. Wilson, The Benedictional of St. Aethelwold.

Winnefeld, H. "Die Friese des groszen Altars," in Altertümer von Pergamon. Vol. III, Pt. II. Berlin, 1910.

Winter, F. Das Alexandermosaik aus Pompeii. Strassburg i.e., 1909.

Wolff, Georg, Mathematik und Malerei. 2d ed. Leipzig, 1925.

––––––– "Zu Leon Battista Albertis Perspektivlehre," Zeitschrift für Kunstgeschichte. N. F., V (1936), 47-55.

Wulff, Oskar, "Die umgekehrte Perspektive und die Niedersicht; eine Rauman-schauungsform der altbyzantinischen Kunst und ihre Fortbildung in der Renais-sance," in Festschrift Schmarsow, Leipzig, 1907.

ILLUSTRATIONS

a. Parallel Perspective

Figure 1. Focused Perspective

b. Angular Perspective

Figure 2. Inspection of Geese Belonging to Amenemheb at Thebes

London, British Museum

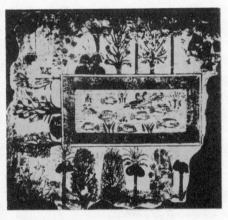

Figure 3. Ornamental Fish Pond in the
Garden of Amenemheb at Thebes

London, British Museum

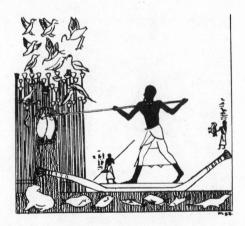

Figure 4. Fishing Scene

Beni Hasan, Tomb of Chnemhotp

[219]

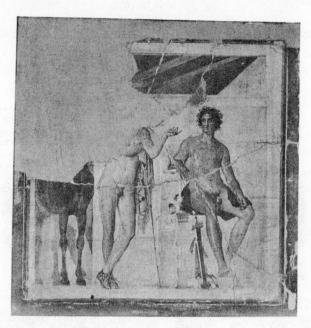

Figure 5. Achilles and Patroclus
Wall Painting from Herculaneum; Naples, National Museum

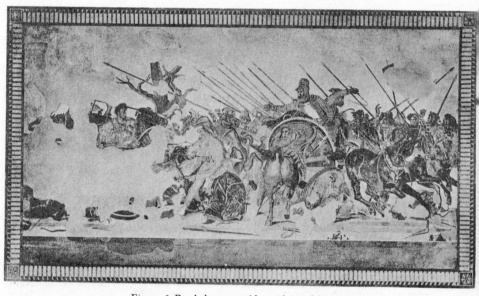

Figure 6. Battle between Alexander and Darius
Mosaic from Pompeii; Naples, National Museum

Figure 7. Wall Painting from Boscoreale
New York, Metropolitan Museum of Art

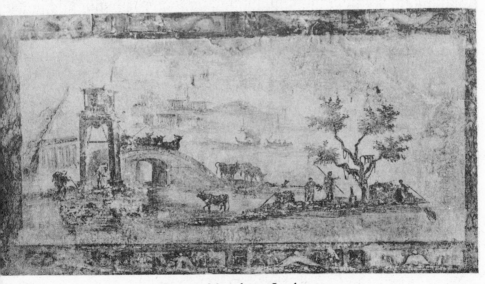

Figure 8. Monochrome Landscape
Rome, Villa Albani

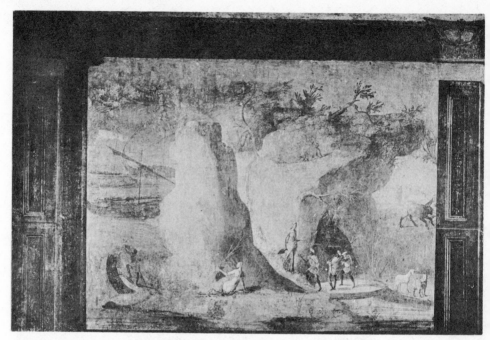

Figure 9. Odysseus in the Land of the Laestrygonians
Rome, The Vatican

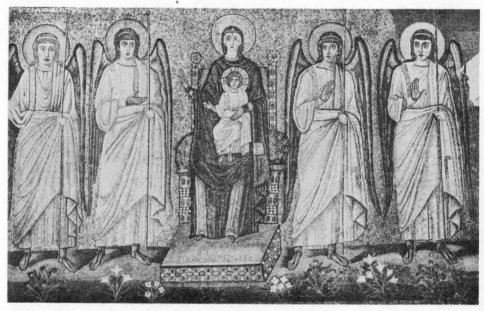

Figure 10. Virgin and Child with Angels
Mosaic of the Nave; Ravenna, Sant' Apollinare Nuovo

Figure 11. Scene from the Story of Joshua
Mosaic of the Nave; Rome, Santa Maria Maggiore

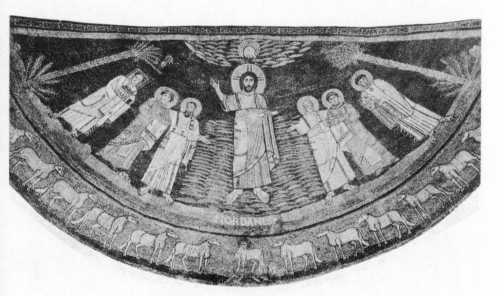

Figure 12. Christ with Saints
Mosaic of the Apse; Rome, Santa Prassede

[223]

Figure 13. Hezekiah and the Prophet Isaiah
Rome, Santa Maria Antiqua

Figure 14. The Assumption
Rome, San Clemente

Figure 16. Count Vivien Presenting the Bible to
Charles the Bald
Bible of Charles the Bald; Paris, Bibl. Nat., MS lat. 1, fol. 423

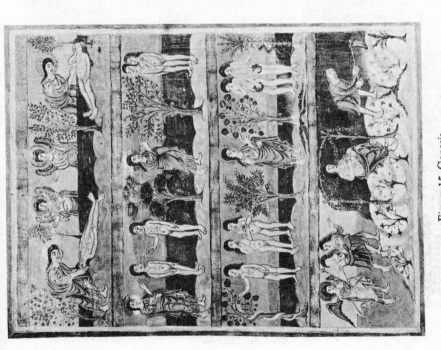

Figure 15. Genesis
Bible of Moutier-Grandval; London, Brit. Mus., Add. MS
10546, fol. 5v

[225]

Figure 18. St. Matthew
Ebbo Gospels, Epernay, Bibl. de la Ville, MS 1, fol. 18v
(Cl. Les Archives Photographiques, Paris)

Figure 17. St. Matthew
Gospels; London, Brit. Mus., Harley MS 2788, fol. 13v

Figure 19. The Angel with the Millstone
Apocalypse; Bamberg, Staatsbibl., MS 140
(A. II. 42) (H. Swarzenski, *Vorgotische
Miniaturen,* Verlag der Blauen Bücher)

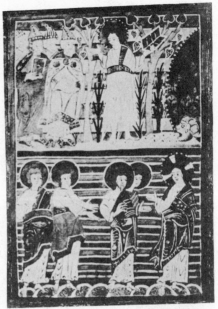

Figure 20. St. John the Baptist Preaching;
Christ and the Disciples
Bernward Gospels; Hildesheim, Cathedral
Treasure, MS 18

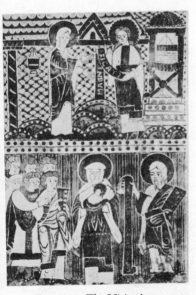

Figure 21. The Visitation;
Birth and Naming of St. John
Bernward Gospels; Hildesheim, Cathedral
Treasure, MS 18

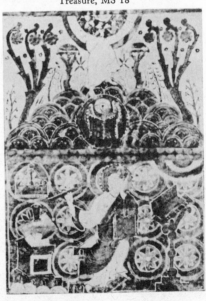

Figure 22. The Ascension;
St. John the Evangelist
Bernward Gospels; Hildesheim, Cathedral
Treasure, MS 18

[227]

Figure 24. The Nativity
Benedictional of St. Aethelwold, Fol. 15; Chatsworth, Library of
the Duke of Devonshire (Copyright of the Duke of Devonshire)

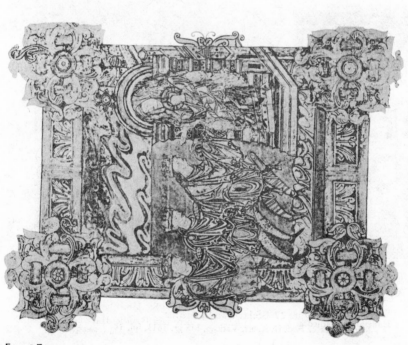

Figure 23. The Adoration of the Magi
Benedictional of St. Aethelwold, Fol. 24v; Chatsworth, Library of
the Duke of Devonshire (Copyright of the Duke of Devonshire)

Figure 25. Episode in the Life of
St. Radegonde
Life of St. Radegonde; Poitiers, Bibl. Mun.,
MS 250, fol. 40
(Cl. Les Archives Photographiques, Paris)

Figure 26. St. John Dictating His Gospel to
His Disciple St. Polycarp
Gospels in Greek; London, Brit. Mus.,
Burney MS 19, fol. 165

Figure 27. SS. Isaac and Meletius
Menologium of Basil II; Rome, Vatican, MS gr. 1613, fol. 54

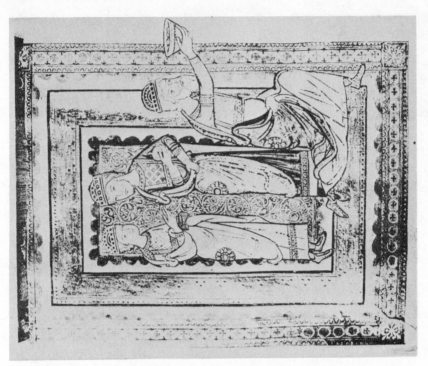

Figure 29. The Adoration of the Magi
Evangeliary from Hardehausen; Kassel, Landesbibl., Theol. Fol. 59
(H. Swarzenski, *Vorgotische Miniaturen*, Verlag der Blauen
Bücher)

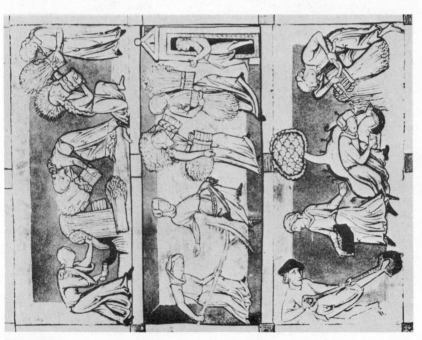

Figure 28. Allegory of Sowing and Reaping
Page from a Speculum Virginis; Bonn, Provinzial Museum
(H. Swarzenski, *Vorgotische Miniaturen*, Verlag der Blauen
Bücher)

Figure 30. The Three Marys at the Tomb
Le Liget, Chapel
(Cl. Les Archives Photographiques, Paris)

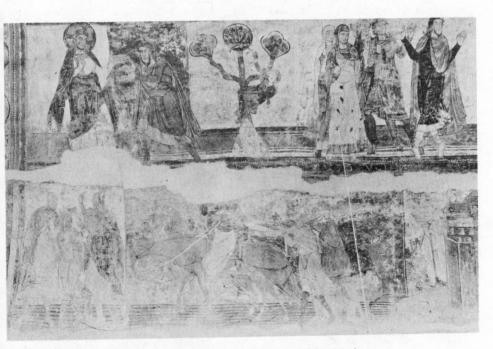

Figure 31. God and Abraham; Joseph and His Brothers
Saint-Savin-sur-Gartempe, Church
(Cl. Les Archives Photographiques, Paris)

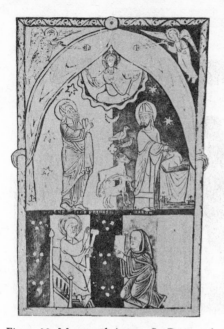

Figure 32. Moses and Aaron; St. Peter and
Andrew, Prior of Cluny
Exposition of Leviticus by Raoul de Flay; Paris,
Bibl. Nat., MS lat. 11564, fol. 2

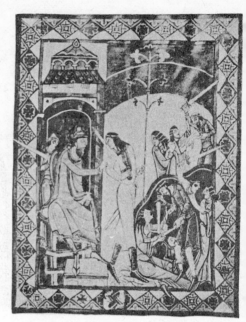

Figure 33. The Massacre of the Innocents
Albani Psalter; Hildesheim, Library of the
Church of St. Godehard

Figure 34. The Three Marys at the Tomb
Psalter from Shaftesbury Abbey; London, Brit.
Mus., Lansdowne MS 383, fol. 13

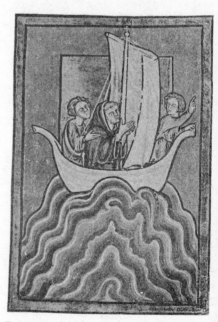

Figure 35. Cuthbert Sails to the Land of the
Picts
Life of St. Cuthbert; London, Brit. Mus.,
Add. MS 39943, fol. 26

[232]

Figure 36. Genesis
Bible; Rome, Vatican, MS lat. 12958, fol. 4v

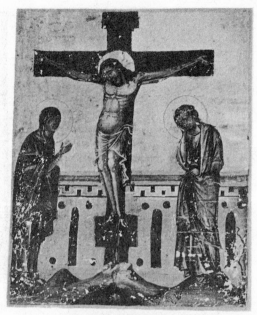

Figure 37. The Crucifixion
Gospels in Greek; London, Brit. Mus.,
Harley MS 1810, fol. 204

Figure 38. Scenes from the Life of Christ;
The Treatment of Wounds and Dislocated
Limbs
Treatise on Surgery; London, Brit. Mus.,
Sloane MS 1977

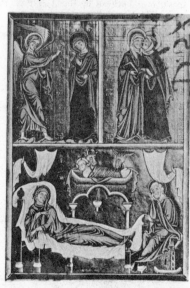

Figure 39. The Annunciation; The Visita-
tion; The Nativity
Ingeburge Psalter; Chantilly, Mus. Condé,
MS 1695, fol. 6
(Cl. Les Archives Photographiques, Paris)

[233]

Figure 41. Philippe I and His Court
Charter of St. Martin-des-Champs; Paris, Bibl. Nat., Nouv. acq.

Figure 40. Philippe I and His Court
Charter of St. Martin-des-Champs; London, Brit. Mus.,

Figure 42. Saul Meeting the Israelites and
the Band of Prophets
Psalter of St. Louis; Paris, Bibl. Nat.,
MS lat. 10525
(Cl. Les Archives Photographiques, Paris)

Figure 43. St. Martin Sharing His Cloak
with the Beggar
Manuscript from St. Albans; Cambridge,
Fitzwilliam Museum

Figure 44. The Visitation
Book of Hours; London, Brit. Mus.,
Harley MS 928, fol. 4

Figure 45. Initial Letter
Book of Hours; London, Brit. Mus., Egerton MS
1151, fol. 47

Figure 46. St. Luke; Christ and the Woman at the Well;
Crucifixion
Evangeliary, Goslar, Rathaus

Figure 47. The Journey and the Adoration of the Magi
Missal of Berthold; New York, P. Morgan Library, MS 710

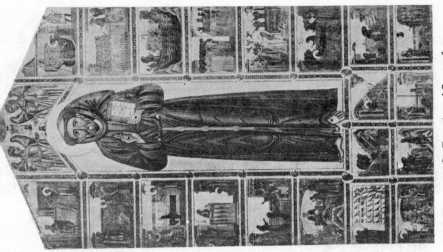

Figure 49. St. Francis and Scenes from
His Life
Florence, Santa Croce

Figure 48. Lavinia Writes to Æneas; She Gives an Arrow
and the Letter to an Archer
Æneid of Heinrich von Veldeke; Berlin, Preuss. Staatsbibl.,
Germ. Fol. 282, fol. 71

Figure 50. Madonna in Majesty, by Duccio
Siena, Mus. dell' Opera del Duomo

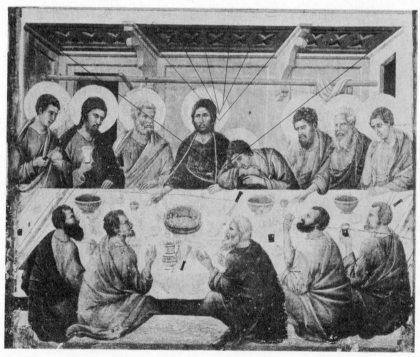

Figure 51. The Last Supper, by Duccio
Siena, Mus. dell' Opera del Duomo

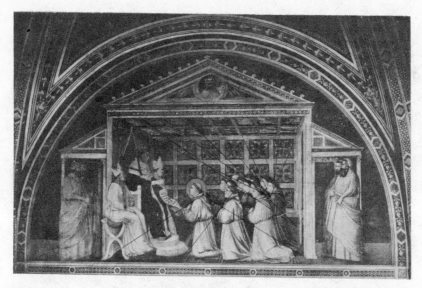

Figure 52. St. Francis Presents Innocent III with the Rules of His Order, by Giotto
Florence, Santa Croce

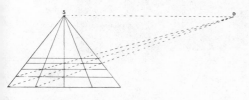

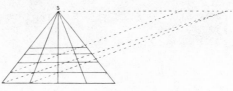

a

b

Figure 53. Distance Point Construction

Figure 54. View of a City, Attributed to
Ambrogio Lorenzetti
Siena, Academy

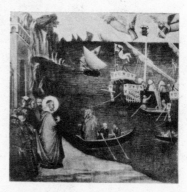

Figure 55. Episode from the Life of St. Nich-
olas: The Miracle of the Corn, by Ambrogio
Lorenzetti
Florence, Uffizi

Figure 57. The Annunciation, by Ambrogio Lorenzetti
Siena, Academy

Figure 56. The Presentation in the Temple, by Ambrogio
Lorenzetti
Florence, Uffizi

Figure 59. The Birth of the Virgin, by Pietro Lorenzetti
Siena, Mus. dell' Opera del Duomo

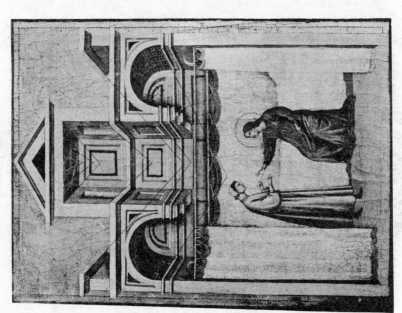

Figure 58. Scene from the St. Cecilia
Altarpiece
Florence, Uffizi

Figure 60. The Annunciation,
by Pucelle
Hours of Jeanne d'Evreux; Paris,
Rothschild Collection

Figure 61. The Duke of Burgundy Putting
on the King's Golden Spurs
Coronation Book of Charles V; London, Brit.
Mus., Cotton MS Tiberius D. viii, fol. 48v

Figure 62. Episodes from the Life of King Solomon
Bible; London, Brit. Mus., Royal MS 19 D. ii, fol. 273

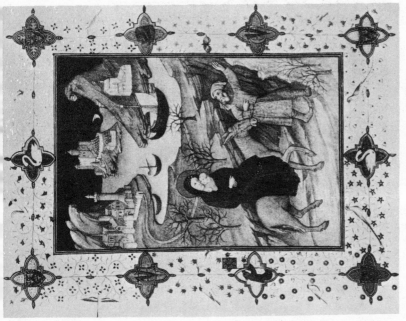

Figure 64. The Flight into Egypt, Attributed to
Jacquemart de Hesdin
Les Très Belles Heures de Jean de France, Duc de Berry;
Brussels, Bibl. Roy., MS 11060, fol. 106

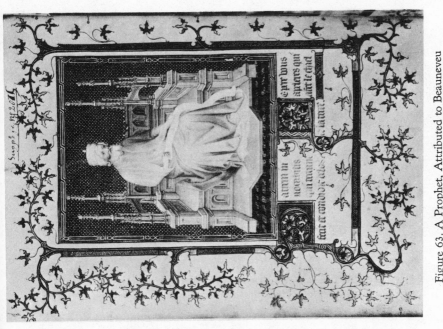

Figure 63. A Prophet, Attributed to Beauneveu
Psalter of Jean de France, Duc de Berry; Paris, Bibl. Nat.,
MS fr. 13091
(Cl. Les Archives Photographiques, Paris)

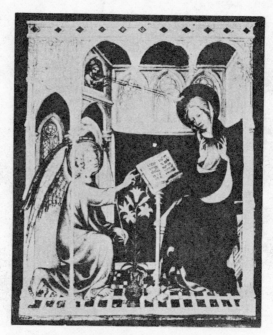

Figure 65. The Annunciation, Attributed to
Jacquemart de Hesdin
Les Très Belles Heures de Notre Dame du Duc de
Berry; Paris, Rothschild Collection

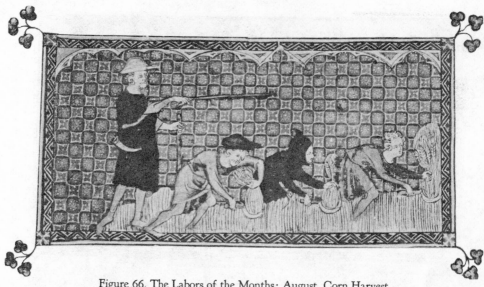

Figure 66. The Labors of the Months: August, Corn Harvest
Queen Mary Psalter; London, Brit. Mus., Royal MS 2 B. vii, fol. 78v

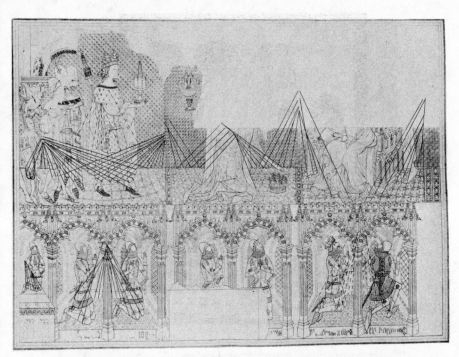

Figure 67. The Adoration of the Magi; St. George, Edward III and His Sons
Westminster Palace, St. Stephen's Chapel

Figure 68. The Presentation in the Temple, the Nativity, the Annunciation to the
Shepherds; Queen Philippa and Her Daughters
Westminster Palace, St. Stephen's Chapel

Figure 69. The Destruction of Job's Children
Wall Painting from Westminster Palace, St. Stephen's Chapel;
London, British Museum

Figure 70. Job Receiving the Messenger with News of
His Children
Wall Painting from Westminster Palace, St. Stephen's Chapel;
London, British Museum

[246]

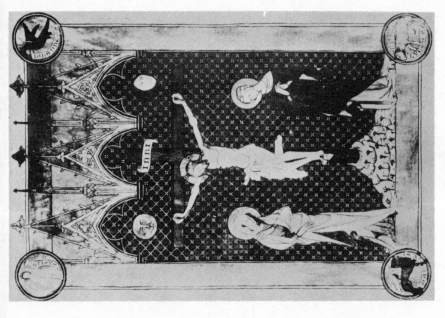

Figure 73. The Crucifixion
Missal; Cologne, Dombibl., MS 149

Figure 71. The Presentation in the Temple, by Siferwas

Lectionary of John, Lord Lovel of Tischmersh; London, Brit. Mus., Harley MS 7026, fol. 12

Figure. 72. Initial Letter
Lectionary of John, Lord Lovel of Tischmersh; London, Brit. Mus., Harley MS 7026, fol. 17

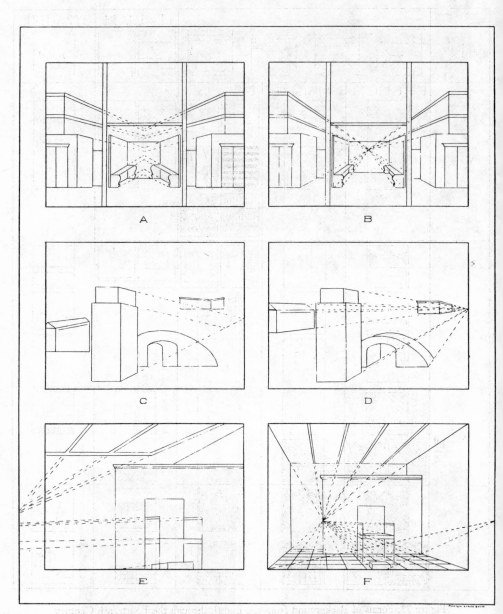

Figure 74. Methods of Representation in Roman and Renaissance Painting

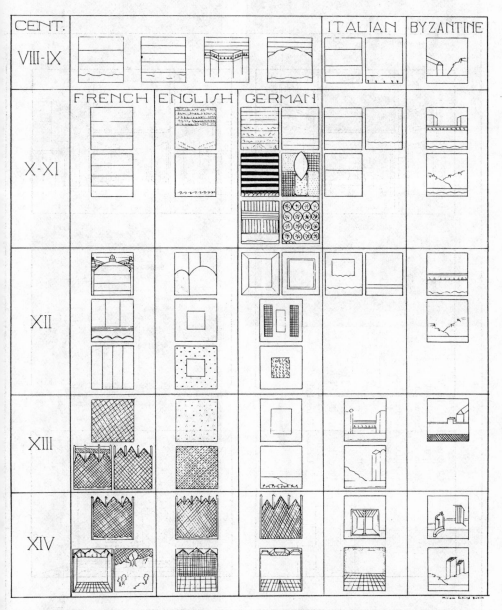

Figure 75. Forms of Background from the Eighth through the Fourteenth Century

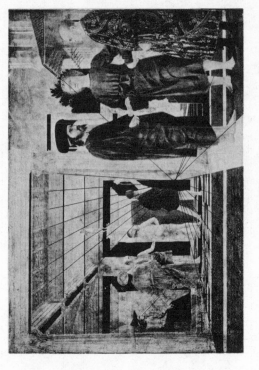

Figure 76 (*left*). The Coronation of the Virgin, by Fouquet Hours of Etienne Chevalier; Chantilly, Mus. Condé (Cl. Les Archives Photographiques, Paris)

Figure 77 (*right*). The Flagellation, by Piero della Francesca Urbino, Cathedral

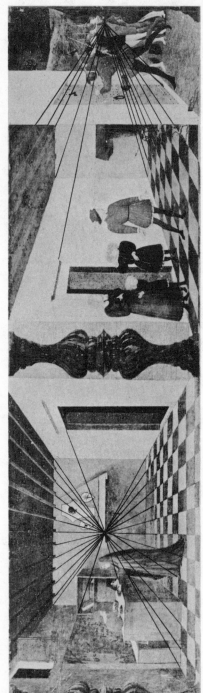

Figure 78. Scenes from the Desecration of the Host, by Paolo Uccello Urbino, Ducal Palace

INDEX

INDEX

INDEX

INDEX 261

150, 153, 170, 180, 182, 185, 186, 199; representative space, 5, 11, 34, 49, 62, 73, 77, 78, 79, 81, 83, 86, 97, 99, 100, 104, 133, 135, 151, 152, 155, 156, 170, 172, 173, 174, 175, 182, 186
Trier school, 63, 66, 69
Two-dimensional space, 15, 39, 89, 90, 122, 136, 141, 170, 182, 184, 185; nonrepresentative space, 73, 83, 97, 101, 104, 107, 126, 127; nonrepresentative space, tendency toward, in Roman sculpture, 39, 42, 180; early Christian painting, 39, 40, 41, 42, 180, 181, 182; in Carolingian period, 46, 53, 56, 57, 61, 183; tenth and eleventh centuries, 66n, 73, 75, 76, 77, 78 f., 82, 83, 84, 85, 183; twelfth century, 90, 93, 96, 97, 100, 101, 104, 184; thirteenth century, 111, 126, 128, 129, 130, 142; fourteenth century, 170

Uccello, Paolo, 202
Underweysung der Messung mit dem Zirckel und Richsheyt, 191
Universities, foundation of, 105
University of Paris, 107
Urban scenes, see City
Utrecht Psalter, 52, 70, 115n

Vanishing area, 8, 138, 142, 145, 149, 150, 157n, 163, 178, 187, 190, 199, 202; bifocal system of convergence, 164, 165; single, 164, 202; see also Convergence
Vanishing axis, 8, 25, 32, 33, 138, 141, 143, 148 f., 150, 154, 157, 166, 167, 170, 172, 174, 177, 178, 187, 199
Vanishing point, 6, 9, 24, 32, 138, 142, 143, 148, 149, 151, 157, 163, 166, 174, 176, 177, 179, 187, 195, 201 f.; see also Optical representation; Perspective, focused
Vanishing point, single, 24, 145, 150, 187, 189, 190, 201, 202

Vase painting, Greek, 20
Vases, South Italian; foreshortening in, 23, 25, 26, 177
Vatican Bibles, 79, 80, 99
Vatican Virgil, 40n, 49, 53n
Vertical bands, 68, 87, 92, 93, 94, 97, 107, 184
Vertical perspective, see Perspective, vertical
Vertical planes, 29, 32, 36, 60, 65-70 passim, 73, 78, 79, 107, 120, 122, 124, 126, 127, 128, 131, 132, 141, 145, 148, 152, 181, 183, 185, 199
Viator, see Pelerin, Jean
"View of a City," 144, 145, 147
Vignola, G. Barozzi Da, 188
Virgin, cult of the, 105; as intercessor, 106
"Virgin between Martyrs and Angels," Santa Maria in Pallara, 79
Vision, conflict between real and apparent in, 5, 10
Vista, 29, 143, 144, 150, 159, 173, 185, 202
Visual field, 197-98
Vitellio, P., 24n, 106
Vitruvius, architect, 22 ff., 195-96
Vivien Bible, 50, 51, 52, 57, 58

Waldensians, 105
Walls, 29, 30, 31, 42, 53, 59, 82n, 100, 128, 129, 131, 137, 141, 145, 148, 177
Warping, 145n, 201
Weingarten, illuminations from, 120
Westphalian school, 87
Winchester school, 71
Witz, Konrad, 173
Wulff, Oskar, 7

Xanthos, foreshortening in reliefs of, 23

Zones, 63, 75, 87, 92; horizontal, 40, 45, 50, 53, 54, 67; see also Bands; Horizontal Bands; Stratified space
Zoning, 16, 45, 50, 53, 54, 63

VITA

MIRIAM SCHILD was born on January 4, 1912, in Brooklyn, New York. She was graduated from the James Madison High School, Brooklyn, in 1928, receiving a New York State Regents Scholarship. She then entered Barnard College, where she took the Honors Course in Fine Arts and received the degree of A.B. in 1932. She continued her studies with graduate work at Columbia University for the next few years, and in 1933 and 1934 was the recipient of a scholarship from the Institute of International Education for the summer sessions at the Institut d'Art et d'Archéologie of the University of Paris, receiving at the completion of the course a Brevet de la Sorbonne. In 1934 she was married to Dr. Joseph J. Bunim. In 1935 she received the degree of M.A. from Columbia University, and she held a University Fellowship for the year 1935-36. She is a member of Phi Beta Kappa and the College Art Association.